1993

ROMAN BAROQUE SCULPTURE

ROMAN BAROQUE
SCULPTURE

THE INDUSTRY OF ART

Jennifer Montagu

YALE UNIVERSITY PRESS · NEW HAVEN · LONDON · 1989

for
Jean Michel Massing

Designed by Elaine Collins

Set in Linotron Bembo by Best-set Typesetter Ltd, Hong Kong.
Printed and bound in Hong Kong through Bookbuilders Ltd.

Library of Congress Cataloging-in-Publication Data
Montagu, Jennifer,
 Roman baroque sculpture: the industry of art / Jennifer Montagu,
 p. cm.
 Bibliography: p.
 Includes index.
 ISBN 0–300–04392–9
 1. Sculpture. Italian—Italy—Rome. 2. Sculpture, Baroque—
Italy—Rome. 3. Sculpture—Italy—Rome—Study and teaching. I. Title.
NBS20.M66 · 1889
730'.945'632—do19 88–30482
 CIP

CONTENTS

PREFACE

This book is based on the lectures I gave as Slade Professor of the History of Art in Cambridge, in the autumn of 1980. At that time I had completed the draft of the text of my book on Alessandro Algardi,[1] and had, in writing it, become very much aware of how little was known about what I came to call 'the industry of art'.

Almost nothing was available on the training of sculptors. One would read, even in contemporary biographies, that a sculptor took a block of stone, but not where he found it, how it was quarried, how he assured it was the right size, how it got to Rome, or what it looked like when he got it. Bronzes are habitually ascribed to sculptors, even though we know that most of them never cast a bronze in their lives, and almost no attention is paid to the founders, nor is it ever suggested that they might have taken the initiative.

Two recent articles on baroque sculpture had raised the question of sculptors working on the designs of others, whether of painters or of architects;[2] we know that this was often the case, but not only did these articles initiate a debate among historians of sculpture as to whether this was indeed the norm,[3] but there was little information on the type of design from which they would expect to work, and how much would be left to the sculptors' initiative. When the position was reversed, and it was a sculptor who gave the design, or model, for a lesser member of his workshop to execute, we had equally little information as to the form of this model, or the relationship between the master and his assistant, nor was there any study of the ways in which a number of sculptors would collaborate on a major project.

While it was well known that many sculptors were employed on the restoration of antique statues, and among them some of the greatest names of the Roman baroque, most of the work on this subject has been done by scholars primarily concerned with antiquity,[4] who assumed that the sculptor was trying his best to reproduce the lost original; my own observations made me doubtful of this, and the subject of restoration also appeared to merit further investigation.

Lastly, the provision of the vast amount of ephemeral decoration that characterised baroque Rome had exercised a number of scholars;[5] it was evident that sculptors had played an important part in such work, but it had never been investigated from their point of view, nor had anyone considered the way their contribution fitted into the general programmes of such festivities.

Some such questions could be answered, at least in part, for the early Florentine renaissance, thanks to the work of Wackernagel,[6] nor were studies lacking that dealt with the actual technique of sculpture,[7] but there had been no published work in which I could find the answers to my own problems.

In the course of my research on Algardi I had found at least partial answers in so far as they concerned his own production, and, while working on the literature and in the archives, I had encountered evidence concerning other sculptors. It seemed a worthwhile undertaking to put this information together. Originally, I had had no intention of publishing the results: I was well aware that much of the material would appear in my book, while many of the other examples had been published, either by others, or by myself.[8] However, I have since become persuaded that such a publication might spare others much of the research that I had to undertake, while providing a useful introduction for students of baroque sculpture.

Although I have eliminated a number of examples taken from the work of Algardi, or relegated them to brief footnotes, it will be seen that many remain; my justification for this is that here they are being looked at from a different angle, from which I hope they may take on a new relevance. I have also taken the opportunity to include corrections, and new material which has appeared since 1985. As for the other sculptors whose names abound in the following pages, a few will be familiar to even to undergraduates, but many are known only to specialists, and some are no more than names in one or two archival documents. Where some readily available summary of their life and work is available (other than the standard dictionaries of artists), I have referred to it, and I have given their dates, when known, after the first reference to the sculptor in the text, either in brackets, or in the relevant footnote. But it should be remembered that this book is not a history of Roman baroque sculpture, and the artists are cited, not for their individual interest or their personal achievements, but merely in so far as their activity exemplifies some aspect of the industry of art.

It may be questioned why I have limited myself to seventeenth-century Rome. I am very well aware that many of the practices discussed here were current in other places, and at other periods, but it has been left to the reader to make such extrapolations. For I am equally well aware of the dangers of the method I am using: there are no written sources to tell us how sculpture was produced, and all we have are individual instances, with no indication as to how widespread or general such practices may have been. One can only quote the specific cases, and attempt to generalise from them, while remaining fully conscious that other students of the Roman baroque will have encountered different documents, possibly offering divergent evidence. Such an inductive method is regarded with suspicion by many historians, and rightly so: it is hazardous to assert that a particular practice was probably used by other sculptors at the same time and place; it would be totally illegitimate to imply that it was also in general use at other times, or in other places. Only very occasionally have I cited similar, or varied, examples from outside seventeenth-century Rome, when these seemed of particular interest or relevance.

The material quoted in the notes has been intentionally limited, in order not to overburden the book with extensive documents. I have quoted the relevant texts of unpublished material, but where the evidence used is given in full in readily available published form, I have been much more selective. In such cases my citation of the original sources of the documents has been inconsistent, and limited to those documents that seemed to me the most relevant, and which the reader might most wish to check.

Three previously unpublished texts have been reproduced extensively in

the 'Documents' appended to the end of the text: The first expands and completes the summary given in the chapter on marble; the second is an unusually detailed and precise contract, which gives precious technical information on bronze casting, and may be of interest to the specialist; the third is a typical example of the work involved in restoration.

In the quotations, I have substituted 'v' for 'u' (or vice-versa), and eliminated much of the capitalisation, but otherwise kept to the spelling of the original. Standard contractions (for example, the crossed 'p' for 'per', 'Cav.^{ere}' or 'Cav.' for 'Cavaliere', 'Ill.^{mo}' for 'Illustrissimo', or, in some cases, 'd.^{to}' for 'detto') have been expanded.

I am grateful to the librarians and archivists who have given me access to the books and documents in their care, and often advice on how to find additional material.

As always, I am deeply indebted to my colleagues at the Warburg Institute for their assistance, their interest, and their forebearance when I have mercilessly abused their time, and taken advantage of their learning. Many of those who heard the lectures[9] have contributed useful comments and suggestions. Among those who have provided information and advice, I should like to thank Cecilia Bernardini, Francesca Bewer, Anthony Blunt, Phyllis Pray Bober, Kathrine Weil-Garris Brandt, Elizabeth David, Jennifer Fletcher, Francis Haskell, Seymour Howard, Ian Jenkins, Katrin Kalveram, Chandler Kirwin, Alastair Laing, S. R. Letman, Elizabeth McGrath, Jörg Martin Merz, Geneviève Michel, Olivier Michel, Nicholas Penny, Alex Potts, Günther Schuster, Janet Southorn, Dean Walker, and Marc Worsdale.

The conversion of the lectures into a book was begun on a scholarship at the Getty Museum, and I am grateful to Peter Fusco and the J. Paul Getty Trust for the invitation, and the opportunity to work at Santa Monica.

Special thanks are due to my mother for checking the typescript, to Charles Hope for helping to prepare the text for printing, and to Elaine Collins for her careful and sympathetic editing.

MONEY AND MEASUREMENTS

The Roman *scudo d'oro* was a gold coin, weighing 3,391 grams.

The *doppia* was also a gold coin, weighing 6,781 grams.

The *scudo*, the most frequently encountered coin, was of silver, and weighed 31.788 grams.

The *scudo* was divided into 100 *baiocchi*.

The Roman *palmo* measured 22.3422 centimetres. It was divided into 12 *once*.

The Roman *libbra* weighed 339.07 grams. It was divided into 12 *once*, each of which was subdivided into 24 *denari*, divisible into 24 *grani*.

ABBREVIATIONS

ADP	Archivio Doria Pamphilj
AFP	Archivio della Reverenda Fabbrica di S. Pietro
Arch.	Archivio
ASR	Archivio di Stato di Roma
ASV	Archivio Segreto Vaticano
Banc.	Bancone
Barb.	Barberini
BAV	Biblioteca Apostolica Vaticana
BL	British Library
Cap.	Capitolino
Card.	Cardinal
Corp. Relig. Masc.	Corporazioni Religiose Maschili
EL	Ellesmere-Bridgewater Collection
Fasc.	Fascicolo
Giust.	Giustificazione(i)
GNS	Gabinetto Nazionale delle Stampe
int.	interno
KB	Kungliga Biblioteket, Stockholm
MS; MSS	Manuscript; manuscripts
Not. Trib. A.C.	Notaro della Tribunale dell'Auditor Camerae
Scaf.	Scaffale
30 Not. Cap.	30 Notai Capitolini
Uff.	Ufficio
Vat. Lat.	[Codices] Vaticani Latini

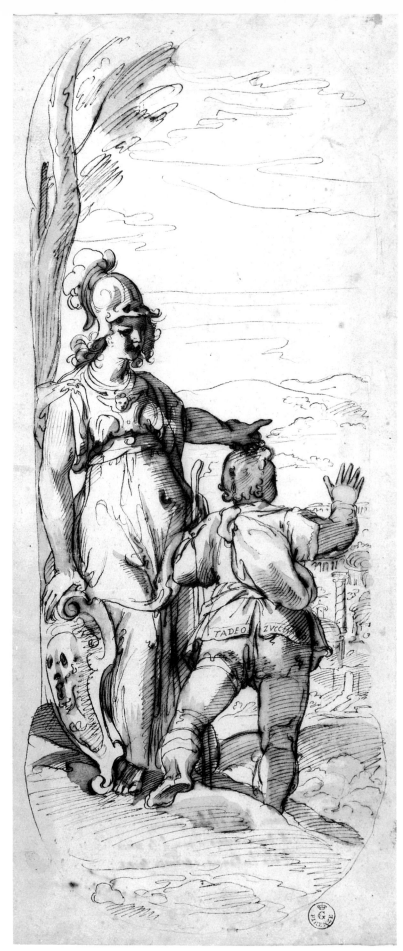

Fig. 1 Federico Zuccaro, *Taddeo Zuc-
caro's First View of Rome, under the Aegis of
Minerva*, drawing. Florence, Uffizi.

I

BEGINNINGS

Rome is a magnet, drawing to herself artists from all over the world, while providing comparatively few major artists of her own. Of the three leading sculptors of the seventeenth century, Gianlorenzo Bernini (1598–1680) was born in Naples, but preferred to remember the Florentine origins of his family; Alessandro Algardi (1598–1654) came from Bologna, and François du Quesnoy, known as Il Fiammingo (1597–1643), was born, as his name suggests, in a village called Quesnoy in Flanders. Stonemasons and sculptors from every region of Italy, and just about every country of Europe, flocked to Rome as part of an unofficial *Wanderjahr*, to study the buildings and sculptures of antiquity and the paintings of the great masters of the renaissance, or hoping to find work at one of the richest and most extensive courts of Italy.

So it had always been, and the series of incidents which the Florentine Federico Zuccaro (1540/41–1609) depicted from the life of his brother, the more illustrious painter Taddeo (1529–66), would apply equally to the sculptors of the succeeding century:[1] the departure from home with a pair of not usually very effective guardian angels; the first view of Rome (Fig. 1) under the aegis of Minerva, goddess of Learning and patroness of the Arts (and, as it happens, also a teacher of Sculpture), and the entry barred by Servitude and Travail. Even the experience of a relative who might have provided work and lodging, but who turned the young artist from his door (Fig. 2), was repeated in the life of the sculptor Lazzaro Morelli (1608–91),[2] but he was rather more fortunate than the infant Taddeo, for as he stood outside weeping and declaiming a speech of rhetorical self-pity (at least if we are to accept the words put into his mouth by his biographer), he was overheard by a passing monk who, as luck would have it, was a friend of du Quesnoy, and introduced Morelli to the great sculptor.

Some of these artists returned to their homelands after a few years in

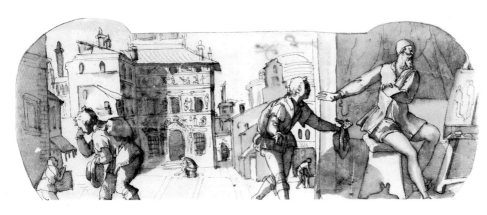

Fig. 2 Federico Zuccaro, *The Young Taddeo Zuccaro Turned Away*, drawing. Florence, Uffizi.

1

Fig. 3 Giovanni Maria Baratta, façade of
S. Nicola da Tolentino. Rome.

Rome; others, like Morelli, stayed on to make their careers there. They
formed nuclei of various nationalities, mostly around the Via Marguta, in
the parishes of S. Lorenzo in Lucina and S. Andrea delle Fratte, sharing
houses, studying together, and enjoying in one another's company the usual
pursuits of young students throughout the ages, drinking, smoking, gam-
bling, and wenching.[3] Some even worked.

While genius may arise anywhere, heredity and environment help in the
formation of more ordinary workmen. One cannot hope to explain the
genesis of a Michelangelo, but he himself claimed to have drunk in his love
of the chisel with his nurse's milk, having been sent to a wet-nurse in a
family of stone-cutters in Settignano.[4] From this same sandstone area near
Florence came the brothers Jacopantonio and Cosimo Fancelli, sons of a
stonemason, who rose to rank among the more competent sculptors of
seventeenth-century Rome, Cosimo being especially favoured by the painter
and architect Pietro da Cortona, while two other brothers, Giovanni and
Francesco Fancelli, followed their father's profession, and Francesco's son
and grandson continued this artisan tradition into the eighteenth century.[5]

But, from Roman times, the two great sources of Italian marble had been
the mountains above Lake Como, and the range of the Apuan Alps inland
from Massa and Carrara.[6] So there was always a preponderance of sculptors
who came from around Como, enterprising Lombards who infiltrated so
many of the leading positions in Italy, or from Carrara, experienced marble
workers, many of whom were forced to seek work elsewhere by the mono-
polistic and restrictive organisation of the Carrara quarries.[7] A good
example is provided by another family, the Baratta of Massa,[8] of whom
Giovanni Maria began by following his father's trade as a stonemason, but
worked his way up to become an architect.[9] He built the church of S. Nicola
da Tolentino in Rome (Fig. 3), while retaining enough skill with his chisel to
carve the cherubs on the holy-water stoups for the same church (Fig. 4).[10]

Fig. 4 Giovanni Maria Baratta, holy-
water stoup, marble. Rome, S. Nicola da
Tolentino.

Within the building he provided the occasion for his less able brother Andrea to produce two reliefs of *Charity* (Fig. 5) and *Religion* on the entrance wall,[11] whereas his more talented but less stable brother Francesco carved the angels above the pediment of the high altar,[12] and worked also as an assistant to Bernini, producing among other sculptures the relief of *The Ecstasy of St Francis* over the altar of Bernini's Raimondi Chapel in S. Pietro in Montorio,[13] and the *River Plate* on the *Four Rivers Fountain*.

There can be no doubt that such family relationships helped in other ways. Most sculptors earned money from time to time by selling marble: sculptors such as Giuliano Finelli (1601–57) and Andrea Bolgi (1601–56) profited from their relationship with the suppliers of marble in Carrara, and Domenico Guidi (1625–1701) belonged to the family of one of the leading quarry owners.[14]

Others came from families of artisans with related skills. The father and grandfather of the brothers Antonio and Giuseppe Giorgetti were wood-carvers,[15] as was the father of du Quesnoy, and Giuseppe Perone's father was a brass-worker.[16]

Not all of these sculptors recognised their true bent at the outset of their careers, and Giuseppe Perone was only one of several who began by studying painting, acquiring, unusually for a sculptor, some ability as a draughtsman.[17] Francesco Mochi (1580–1654) from Montevarchi had studied painting in Florence under Santi di Tito, and when he turned to sculpture his teacher was Camillo Mariani (1556–1611), who had also practised as a painter.[18] Paolo Naldini (1614–91), who studied under the painter Andrea Sacchi (1599–1661), worked for some years as a painter and retained a deep attachment to his teacher. He also established a lifelong friendship with a fellow pupil, the painter Carlo Maratti (1625–1713), who was to exercise a considerable influence over both his style as a sculptor and his fortune, commissioning various works from him, including the busts of the revered

Fig. 5 Andrea Baratta, *Charity*, stucco. Rome, S. Nicola da Tolentino.

3

painters Raphael, and Annibale Carracci.[19] Filippo Carcani (1644–88) started by studying drawing under the painter and mosaicist Fabio Cristofani, before, at 15, entering the studio of Ercole Ferrata (1610–86);[20] Giuseppe Perone, though the son of a brass-worker, studied under the painter Baccio Ciarpi.[21] Algardi too had studied sculpture under the minor Bolognese master Giulio Cesare Conventi (1577–1640), and, at the same time, painting under Lodovico Carracci, a far more powerful personality, and whatever technical competence Algardi may have gained from the former, it was the manner of Lodovico that remained evident in his sculpture.[22]

Several writers emphasise the necessity of a careful choice in the matter of the artist's first master,[23] yet there was very seldom much choice involved. Most often the child was put to work with a member of the family; obviously, if the father were himself an artist he would introduce the son to his profession, but then the boy would often move on to some more competent or successful master. Otherwise, it might be an uncle or a cousin, like the architect Vitale Finelli, one of many Carrarese who had emigrated to Naples, who took his nine-year-old nephew Giuliano back with him after a visit to his native Carrara.[24] Realising Giuliano's aptitude for sculpture, he apprenticed him to Michelangelo Naccherino, and Giuliano Finelli lived in Naccherino's house and learnt his art for eight years till his master's death, after which he returned to his uncle. Vitale made full use of his nephew's talents in various carvings required for his architectural projects, so much so that he was unwilling to let him go to Rome to perfect his studies and deliberately kept him too short of money to undertake the journey; but eventually Giuliano managed to get a message to his father who sent him twelve *scudi* via a business associate.

Or we may take the case of Ercole Ferrata, from the mountains above Como.[25] As he was a rather sickly boy his parents took him from school, hoping by this means to look after him better. But it turned out quite differently, for the young Ercole showed a real talent for art, and a relation of his father offered to establish the boy with his brother-in-law, the sculptor Tommaso Orsolino, who came from the same region of the Val d'Intelvi.[26] So Ercole was sent off to Genoa where Orsolino was living, and working with extraordinary productivity for the Certosa of Pavia, carving no less than eighteen statues during the seven years that Ferrata was with him (Fig. 6). This prolific output was no doubt partly the result of the number of apprentices he had working for him.

Fig. 6 Tommaso Orsolino, *St Bernard in Adoration*, marble. Pavia, Certosa.

What Ferrata's biographer, Filippo Baldinucci, tells us of their life comes from Ferrata himself, who at first was delighted by what he could learn from Orsolino, but soon came to realise the harshness of an apprentice's existence. It was an absolute rule that Orsolino's apprentices pass two hours of each day in drawing, and the rest of the time they spent looking after the studio and their master, performing all the most laborious jobs, with no time to care for their own needs or even to feed themselves properly; yet they had none the less to pay for their own board and lodging. For the slightest fault they were beaten so savagely that even the strongest might be kept to his bed for five or six days. This power and authority to beat the others with impunity and verbally bully the poor apprentices was conceded by the rules of the studio to him who was first to arrive each day at the studio, if he lived in his own home, or the first to tumble downstairs if he lodged with the master, 'so now one and now another had his turn to make life a misery for the rest, ... and for many of them seldom a day passed without a beating, and when their opportunity came they would return what they had received with interest'.[27]

In this place, and in this way of life, Ercole continued for seven years, during which time he learnt to model, to carve, and to polish. Above all, he studied by taking small pieces of marble and making reduced copies of each work his master carved, and as these had a ready sale in France and Spain they helped to pay for his keep.[28]

Alas, Baldinucci does not say what it was that Orsolino's pupils drew, though most probably it would have been those plaster casts of hands, feet, and other portions of the body that seem to have been standard furnishings of an artist's workshop,[29] and possibly they would have posed for each other to make life studies. Equally unhelpful and vague are his words about Ferrata learning to 'modellare, levare, e pulire'. Not surprisingly, on hearing that there were opportunities in Naples, Ferrata left his master to seek work there, rising from carving decorative cherubim and festoons to sculpting proper statues and portraits. Although he visited Rome on a brief trip to study the work of the great masters, he returned south to finish some uncompleted work near Naples before settling permanently in Rome. Since some of the local stone-cutters relied on his help for the more difficult parts of the project on which they were engaged, they tricked him into staying until it was finished by persuading a notary to tell Ferrata that there was a strong suspicion of plague in Rome. Finally, however, he made his escape, arriving in Rome with a letter to Virgilio Spada who was a member of the committee of the Fabbrica of St Peter's, and found him a position with Bernini to work on the decoration of the nave.[30]

Ferrata's experience with Orsolino gives an apprentice's-eye view, and if he was something of a weakling we may imagine that his memory was coloured by having received more than his share of the bullying. Naturally, none of this is covered by legal contracts of apprenticeship, but most of these are even less helpful than Baldinucci, being concerned with who should pay for the lad's clothes and laundry, and what should happen were he to leave his master, or the master to throw him out. Most of those I have come across for various professions say only that the master should teach the apprentice his trade;[31] by good fortune, the only apprenticeship contract I have encountered for a sculptor, Carlo Franceschini, who was apprenticed on 25 July 1606 by his father Francesco to Francesco Caporale,[32] is rather more

specific, laying down that Caporale should teach Carlo the profession of a sculptor, teaching him to 'make heads, hands, feet and drawings, and to work in wax and clay, to study the anatomy of bones and flesh, draped figures, and inventions, and other matters belonging to the said trade'.[33]

Yet no contractual obligation could prevent disagreements between masters and apprentices, and we read of masters who were too severe and treated their apprentices like slaves, or pupils who were ungrateful for the benefits, assistance and protection they received.[34] We are, of course, concerned with adolescents, with all their usual problems; with young sculptors like Giuseppe Perone, who seems to have got on well enough with his master Algardi, acquiring skill in carving marble, taking over the job of restoring the more commonplace antiques which passed through the studio, saving Algardi from the more boring heavy labour, and learning while he did so.[35] But Perone was an unstable youth, with a liking for women that got him into a number of scrapes. In order to save him from indulging this partiality, Algardi would keep him busy, even on feast-days, making some little models which he would claim to need urgently for a current project; but Algardi shared his pupil's weakness, and once he had set Perone to work he would be off himself after some woman of his own, and, naturally, Perone was quick to follow his example.[36] Here again our source, Passeri, is weak on detail: we are not concerned with the sex-life of the baroque sculptor, and it would be more valuable to know what sort of models a sculptor of Algardi's genius would want from a not very able apprentice; from what Passeri had already written of Perone's activity, they would most likely have been studies for restoration, or perhaps neater versions of rough *bozzetti*. Nothing that we know of Perone's later independent work suggests an inventive mind (Fig. 7), and when, with the accession of Pope Innocent X in 1644, Algardi was genuinely busy, he lost little in finally dismissing an assistant who was constantly sloping off after his latest *inamorata*.

Perhaps sculptors did better when they studied under their own fathers. The most notable example of this is Gianlorenzo Bernini, who showed a truly precocious talent, even if not quite so precocious as he was later to claim.[37] At all events, he started young enough to have mastered more of his art than most other sculptors achieved in a lifetime before the age when he too was sometimes distracted by his hot blood.[38]

He had also an advantage in that Pietro Bernini (1562–1629) was not only a sculptor of considerable merit, but an extremely loyal and devoted father. Gianlorenzo was later to tell how Cardinal Maffeo Barberini, subsequently Pope Urban VIII, visited his father's studio and, seeing the young sculptor at work, remarked to Pietro 'watch out, or he will soon surpass his master', to which Pietro replied 'that doesn't worry me, for, as you know, in that case the loser wins'.[39]

With such ideal harmony, the only loser is the poor art historian, who takes it upon himself to try to unravel just who did what. Not only will the young sculptor set out by imitating his father's manner, but he will be working under close supervision, and his father will always be around to help. We do not know what happened in Pietro's studio, but we do know something of the relationship between Gianlorenzo and his own son, Paolo Valentino, whom Gianlorenzo took with him to France in 1665. Admittedly Paolo, then aged 17,[40] was not the genius his father had been, but when we read of Bernini going over 'to give a touch or two to M. Paolo's bas-relief'

Fig. 7 Giuseppe Perone, *St Eugenia*, marble. Rome, SS. Apostoli.

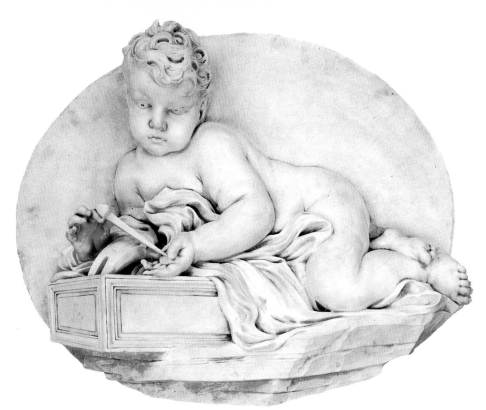

Fig. 8 Paolo Bernini, *The Infant Christ*, marble. Paris, Musée du Louvre.

(Fig. 8), saying that 'he was trying to show that the cloth which the Christ Child holds in front of him was the Virgin's',[41] it is hard not to imagine that the same sort of collaboration would have existed between Pietro and the young Gianlorenzo. Later Gianlorenzo was to find employment for his father as his assistant, and in vetting accounts for work in St Peter's,[42] and to ensure that his relatively incompetent brother Luigi never lacked for work, for example on a putto for the tomb of the Countess Matilda (Fig. 10).[43]

Collaboration means just that, and in a family workshop the relationship of father and son would leave no place for clear demarcation lines. Within such a family workshop it makes little sense to speak of training. The young Gianlorenzo would have learnt to sculpt much as he learnt to walk and talk, though just as that is not the same as mastering gymnastics or rhetoric, so Bernini would later tell of the hours he had spent in the Vatican copying antique statues, as generations of artists, like Taddeo Zuccaro, had done before him (Fig. 9).

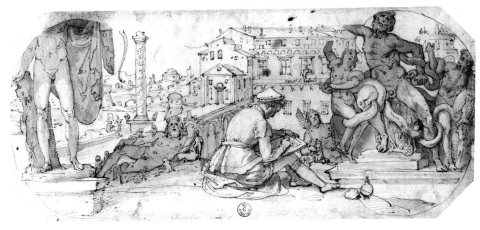

Fig. 9 Federico Zuccaro, *Taddeo Zuccaro Drawing the Laocoon*, drawing. Florence, Uffizi.

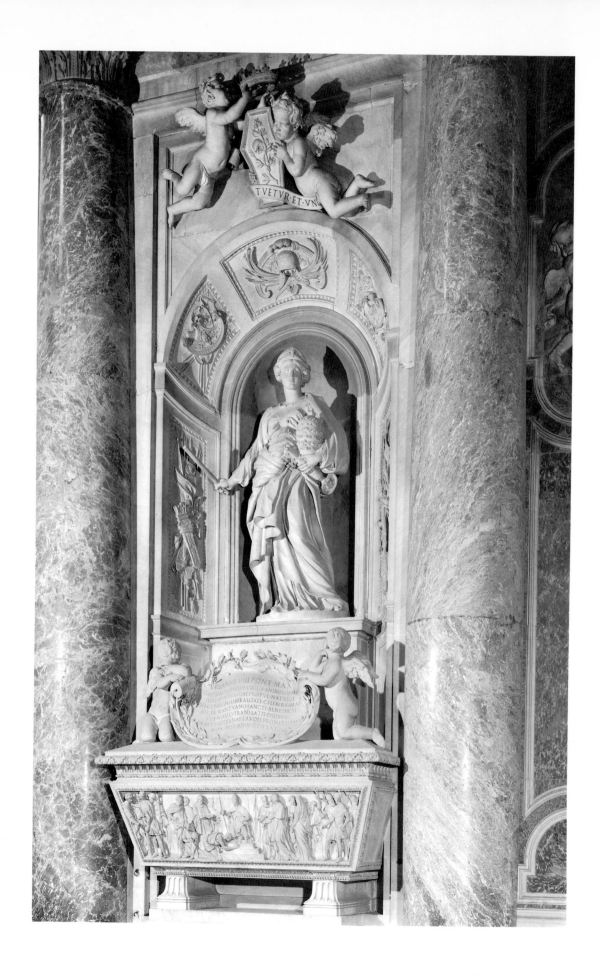

For historical evidence we must rely primarily on biographies and letters; but the biographers tell us nothing, firstly because seventeenth-century biographers were not, for the most part, much interested in the childhood of the artists they were discussing, and secondly because the methods of instruction were traditional, unchanged for many centuries, and not expected to change for many more, so there seemed little point in writing about what any interested reader could easily find out. Obviously, the nearer one is, the fewer letters one needs to write, so there would hardly be the equivalent of correspondence courses within the Roman workshops.

There are, however, two sources of letters that provide at least some information about the sort of things sculptors might be expected to learn: the correspondence concerning the academies established in Rome in the second half of the century by the French, and the Florentines. As academies, formal schools for the training of young artists, they no doubt differed from the more informal instruction that would have been given to an apprentice in the studio, but there would still have been many similarities.

When Bernini was in Paris in 1665 he criticised the way in the past young artists went to Rome at the age of 15 and did nothing but draw for ten years.[44] The French academy in Rome, however, was to be a post-graduate institution, for those who had completed their normal training and won what was later to be called a *Prix de Rome* in the regular competitions. None the less, Bernini's preferred method, of drawing one day (Fig. 11) and painting or sculpting the next, does at least show the equal importance he ascribed to each of these parts of the artist's training.

Fig. 12 Domenico Guidi, *History*, marble. Versailles, park.

The French academy (unlike the later Florentine institution) had formal statutes. While their main emphasis is on good behaviour, on meals with the Rector, who would read to them from the sort of narrative literature they might one day be expected to illustrate, and on prayers in the evening, they specify that the students should spend two hours a day on arithmetic, geometry, perspective, or architecture, while the rest of the day should be spent as directed by the Rector. They also lay down that a body should be dissected during the winter months so that the students could further their knowledge of anatomy, and that the Rector should have moulds taken from it.[45] This stress on the theoretical aspects of their training is thoroughly Colbertian, but it is a little surprising that nothing should have been said about drawing. Much, obviously, depended on the Rector, originally Charles Errard. It had been hoped that Poussin might have instructed the students, but his death coincided with the foundation of the academy. While Bernini was in Paris preparing his plans for the Louvre it had been suggested that the sculptors might work in his studio and under his instruction, and to this he had readily agreed, cannily proposing that they should work on statues for the Louvre for which he should make the models and oversee their work;[46] it could scarcely have escaped him that such a proposal might help to persuade the French of the advantage of executing his designs, rather than discarding them in favour of a French plan, as actually happened. Still, even after the failure of his Louvre project, he continued to receive a pension from the French king during the time he was supposed to be working on the equestrian portrait of Louis XIV, and it was expected that he should

10

look in at the academy from time to time and encourage the students.[47] By 1680 Colbert was writing to the Director that 'it would be particularly desirable that you invite the Cavalier Bernini to come and see the students at work, and also Carlo Marati [sic] and Domenico Guidy [sic], to whom the King has done the honour of appointing them his Painters and Sculptors'.[48]

This honour appears to have been unpaid, and was presumably tacitly included in the commissions Maratti and Guidi had been given to paint a picture and carve a statue (Fig. 12).[49] Guidi, who was hardly used to working on designs provided by painters, had accepted to follow the drawings sent from Charles Le Brun in Paris, but he does not seem to have made more than a very occasional appearance at the academy.

The Florentine academy, founded by Grand Duke Cosimo III of Tuscany, was a much less formal institution, but rather more effort was devoted to arranging for the instruction of the students, perhaps because they were younger.[50] This was not to be a 'course of perfection', but was a deliberate attempt to alter the style of Florentine art which, at least in sculpture, had not been able to free itself from the stale imitation of Giambologna, and to enter fully into the mainstream of baroque art then flourishing in Rome.[51] So, while the French were to complain of how the pure art of the ancients and of Raphael had been contaminated by the contemporary artists of Rome, and castigate their students for falling under its influence,[52] Cosimo III selected two artists of the modern baroque tendency to instruct his pensioners: Ciro Ferri (1634–89), the pupil of Pietro da Cortona (1596–1669), to teach drawing and oil painting, and Ercole Ferrata to teach modelling and stone-carving,[53] though Ferrata, as a former pupil of Algardi, belonged to the less extreme wing of the baroque movement. Carlo Marcellini (1646–1713), the first sculptor to be sent, in 1671, lived for the first two years in Ferrata's house;[54] when Cosimo was planning to send more young sculptors Ferri wrote that, despite the danger that while one student alone studied well, several together might get up to no good, it was on the whole desirable that they should live together where Ferrata could keep an eye on them, and they might spur one another to better work.[55]

Like the French, they had a life-class, with a male model (Ferri's suggestion that a suitable female model might be introduced into the academy scandalised the Grand Duke by its indecency),[56] but only in winter. They were less well-off, and smaller than the French academy, which could afford to pay the model all year round, and the Florentine students were expected to spend the summer carving (or, in the case of the painters, going out to make copies), so they had to make do with calling on an occasional model should they need to make a study from nature during the summer.[57] There was some disagreement between the Grand Duke and Ferri over the best course of study for the sculptors: Cosimo was anxious that they should learn to carve marble, and not just make models which were useful only for 'galanterie' and 'bagatelle',[58] a clear reference to the Florentine tradition of making small bronze statuettes that had flourished since the days of Giambologna; Ferri, however, held that 'good modellers can become perfect sculptors within a year',[59] and on the whole this was accepted, though the sculptors also did some carving.

This primary rôle of Ciro Ferri stamped its mark on the academy, and it is not only the fact that no letters from him are preserved that makes Ferrata a much more shadowy figure. It was Ferri who gave designs and 'concetti' for

11

Fig. 15 Jean Joly, *Ganymede*, marble. Versailles, Park.

the sculptors to execute,[60] and who set them to modelling reliefs after his own and others' paintings (Figs. 13, 14);[61] he also advised Foggini to draw after the chiaroscuros of Polidoro da Caravaggio, an interesting example of a sculptor studying paintings that had been made in imitation of ancient sculptures.[62] Ferri himself was no mean modeller,[63] but he was first and foremost a painter, and the Florentine school of baroque sculpture was to be characterised by its painterly quality.

While the French students were sent by the academy (though that institution was indirectly under royal control, and they were left in no doubt as to who was paying their stipend), the Florentines were sent by the Grand Duke, and for his own purposes. So one sculptor was maintained in Rome specifically to study wood-carving,[64] and Massimiliano Soldani (1656–1740), who was to become a medallist and die-engraver for the mint, was set to work under Travani,[65] while also practising drawing under Ciro Ferri to enable him to compose the reverses of his medals, and studying the antique to acquire a good taste.[66]

Where both academies agreed was on the importance of copying, which was long to remain the standard and most widely accepted method of learning to become an artist. For the French it was doubly important, for as well as training the artists who made the copies, these were to be sent back to France to decorate the royal parks and palaces, and to serve as models for future generations of artists who might not themselves make the journey to Rome (Fig. 15). The Florentines too worked on the Campidoglio, in the Forum, the Campo Marzio and the gardens of the Trinità dei Monti,[67] and

Fig. 13 (*facing, top*) After Massimiliano Soldani, *Crucifixion*, wax. Doccia, Museo della Porcellana.

Fig. 14 (*facing, below*) Nicolas Poussin, *Crucifixion*. Hartford (Conn.), Wadsworth Atheneum, the Ella Gallup Sumner and Mary Catlin Sumner Collection.

13

when the Grand Duke took it into his head to have an equestrian statue made, they were sent to copy all the best sculptures of horses in Rome.[68]

Copying to the French meant, above all, copying the antique. Colbert was very dubious about releasing them from this tutelage: 'I doubt very much', he wrote to the Rector Noël Coypel in 1673, 'that it would be advantageous for the advancement of their studies to let them make figures after their own designs, and it would be much more valuable that they should continue to work after the antique. None the less I leave it to you to judge according to their ability; but', he added with typical French *dirigisme*, 'if you judge that they might be able to make something out of their own heads, you should send me their drawings, so that I should be able to see them and give you my opinion.'[69]

Whether they were working on their own designs, or copying, they could expect to be strictly and severely criticised. But, while the painter Daniel Sarrabat was condemned for having followed the modern Italians rather than the antique in his painting of *Io and her Father*,[70] the sculptor Pierre Le Gros (1666–1719) was accused of following the ancients too exactly, and including even their faults in the copy he made.[71]

The Florentines were, on the whole, more liberal, and the authorities had less rigid precepts of art. When the sculptor Giovanni Battista Foggini sent back his first substantial work in marble, the *Adoration of the Shepherds* (Fig. 16), the Grand Duke declared himself 'entirely satisfied', and the shepherd in the foreground earned particular praise.[72] None the less, there were criticisms levelled at the excessive use of the drill, especially since the holes were left unconnected, and not smoothed away; the hand of the shepherd in low relief was condemned as badly drawn, and while the backs and heads of the cherubs above the crib were judged very beautiful, their thighs and legs were considered to be feebly done. It is hardly surprising that the comments concerned merely the technical faults of a young sculptor, and that no criticism was made of the design, for this must have been supplied by Ciro Ferri. And, indeed, the general approbation was well deserved, for it is a highly competent relief, and in the Hermitage it had passed under the name of Ercole Ferrata.

If the sculptures produced by the Florentine students in Rome show more evidence of the style of Ferri than of that of Ferrata, it would be wrong to underestimate the importance of the latter as a teacher. Quite apart from the Florentines, most of the best sculptors of the later seventeenth and early eighteenth centuries passed through his studio. And one word keeps re-curring in every account of their training there: models – both the models which they made, and those which they copied. A typical example of this is provided by Camillo Rusconi (1658–1728), who was to become the greatest sculptor of eighteenth-century Rome, and was set by Ferrata to modelling various heads after the statues of Algardi and Bernini, which Ferrata wanted for his own studies; but these turned out so well that plaster copies of them were made which painters and sculptors scrambled to obtain.[73]

Casts of this type, after both antique and modern sculpture, were un-doubtedly collected by both painters and sculptors. There is a fascinating list of the models that one professional plaster-maker, Carlo Andrea Carioli, sold to another, Francesco Arnaldi, in 1714. This includes many of the subjects one might expect to find in an artist's studio, such as the heads of Algardi's *St Philip Neri*, or his busts of *Sts Peter* and *Paul*, and a number of

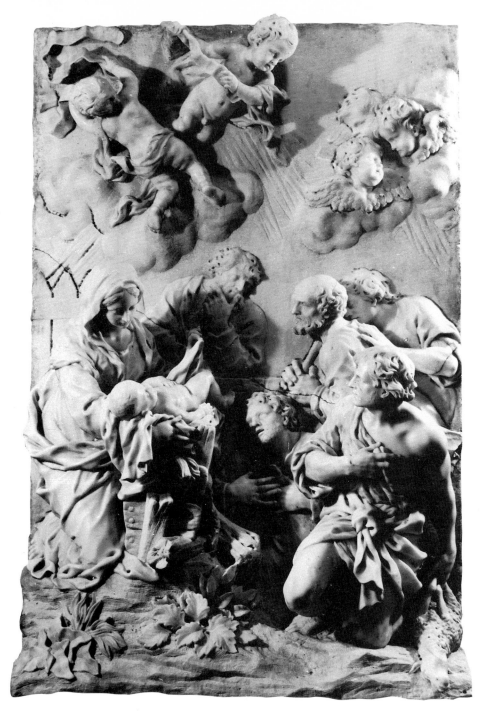

Fig. 16 Giovanni Battista Foggini, *Adoration of the Shepherds*, marble. Leningrad, State Hermitage Museum.

works, particularly putti, by du Quesnoy, which might also have found favour with collectors who could not afford marbles or bronzes, but also other objects such as the legs of Bernini's *Habakuk*, and of his *Putto* on the tomb of Urban VIII, the feet, arm and foot and half a leg of the *Venus de' Medici*, and three feet from the *Laocoon* group, fragments that could have been of use only as artists' models.[74] Another list of the models left by Innocenzo Spinazzi (1718–1798) in the care of his friend Giovachino Falcioni when he returned to Florence includes, as well as original models by himself and his teacher Giovanni Battista Maini, many of the same casts of seventeenth-century works that might well have been bought from Carioli.[75]

Fig. 17 Ercole Ferrata, *Cherubs Supporting the Emblem of St Andrew*, marble. Rome, S. Andrea della Valle.

Fig. 18 Anonymous draughtsman, *Cherub*, drawing. Leipzig, Museum der Bildenden Künste.

One of the most extensive lists to survive is that of Ercole Ferrata's studio, filling more than thirty pages of the inventory taken after his death.[76] This contained, besides many works of his own, and original models by du Quesnoy and by his teacher Algardi (who at his death had divided the models in his studio between Ferrata and his three other assistants),[77] a large collection of casts, and models that must have been made by his own students, primarily as exercises. Such models were valued properties, and just as Algardi's collection had been handed on to his assistants, and the painter Carlo Maratti was to direct in his will of 1711 that his 'studies in plaster' were to be divided between his twelve disciples,[78] so it was no doubt in accord with Ferrata's wishes that his executor divided the master's models between the assistants working in his studio at the time of his death, the academy founded by Cardinal Federico Borromeo in the Biblioteca Ambrosiana in Milan, and the Accademia di S. Luca in Rome, so that they would serve for the benefit of young students.[79]

Ferrata's biographer writes of one of his students who 'became so expert in modelling, that in a few months he modelled all the works of his master scattered through the city of Rome, and not only those, but also all the *bozzetti* and models in his studio'.[80] It must have been a pupil such as this who made a sketch-book now in Leipzig, for the choice of works shows a sculptor closely connected with Ferrata's studio, and the quality of the drawings would be more pardonable in a young artist, particularly one more practised in modelling than in drawing.[81] He copied such admired statues as the *Magnificence* on Algardi's tomb of Leo XI, and the Bernini/Finelli *Angels* on the high altar of S. Agostino, as well as works a little more off the beaten track, such as the stucco *Angels* by Cosimo Fancelli in Sta Maria in Vallicella, or the *Putti* carved by Ferrata for the façade of S. Andrea della Valle (Figs. 17, 18),[82] and he shows a particular liking for Melchiorre Cafà, the brilliant Maltese sculptor who worked with Ferrata until his untimely death in 1667.[83] Other drawings might be thought to be after the *Angels* above the altar of St Thomas of Villanova in S. Agostino (Figs. 19, 20), but, in fact, not only would it have been difficult to make such accurate copies at such a distance, but it would have been impossible to see them from this angle, and, moreover, there are differences in the way they fit on to the

16

Fig. 19 Anonymous draughtsman, *Angel*, drawing. Leipzig, Museum der Bildenden Künste.

Fig. 20 Ercole Ferrata, *Angel*, altar of St Thomas of Villanova, marble. Rome, S. Agostino.

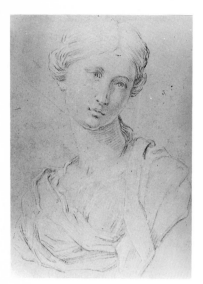

Fig. 21 Anonymous draughtsman, *Bust of St Susanna*. Leipzig, Museum der Bildenden Künste.

Fig. 22 Pierre-Jérome Lordon, *The Studio of Francesco Albani*, painting. Dunkerque, Musée des Beaux-Arts.

pediment, so that here at least he must have been copying models.[84] The altar was designed by Giovanni Maria Baratta, but the models as well as the marbles of these angels were to be made by Giuseppe Perone, whom we have met as the student of Algardi whose mind was on things other than sculpture; these distractions may have hastened Perone's early death, after which the commission was carried out by Ercole Ferrata, possibly using models by his pupil Cafà.

The pupil who made this sketch-book had graduated beyond the drawing of isolated limbs, and now, by copying the works of his teacher and other respected members of the previous generation, he would absorb their manner and sense of style, learning to recognise and select the beautiful in order to correct the defects of nature, to pose his figures gracefully, and to dispose the draperies on them, as well as assembling a repertory of models. Not, of course, that he would often incorporate whole figures into his own work, but the fall of a piece of drapery, the turn of a wrist, the flow of the locks of hair or the curls of a beard might reappear more or less exactly in his own sculpture.

Nor was it only students who made use of such copies. Orfeo Boselli (1597–1668) stresses how artists need friends, whether painters or sculptors, as he himself had benefited from the friendship of the sculptor François du Quesnoy, as of the painters Andrea Sacchi and Pierre Mignard; for they can lend each other, when needed, drawings, casts, models, prints, and so

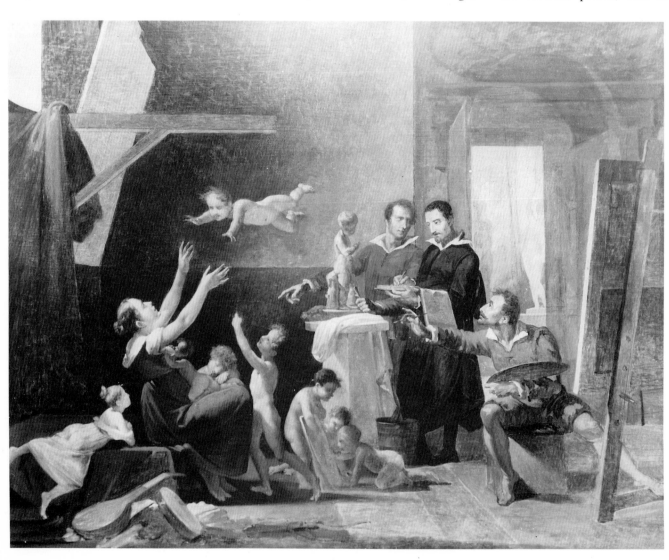

forth.[85] There is an interesting example of such a loan, of a head of an angel by Algardi, together with some books, made by the painter Francesco Grimaldi to the sculptor Antonio Giorgetti, in a list of such loans scribbled on the back of one of Grimaldi's drawings.[86]

It is rather surprising that there should be only one copy after du Quesnoy in the Leipzig sketch-book, and that this should have been after his bust of *Sta Susanna* (Fig. 21).[87] For it was his putti which brought him the greatest renown,[88] and they were collected not only by sculptors such as Ferrata and the Frenchman François Girardon (1628–1715),[89] but also by painters such as Carlo Maratti.[90]

Francesco Albani (1578–1660) was another painter who collected casts of putti by both du Quesnoy and Algardi to serve as models for the many infant cherubs and angels in his paintings, though it might seem that he hardly needed them, for his second wife provided him with more than twelve children, whom his biographer Malvasia describes as supplementing the plaster casts.[91] It was Malvasia's account, or a later embroidery on it, which inspired the absurd painting of Albani's studio by the nineteenth-century painter Pierre-Jérome Lordon (Fig. 22),[92] for Malvasia tells how Albani's wife would follow his instructions in posing the children (surely not all so much of an age) not only on the ground but also suspended in the air; despite the painter's expression of furious concentration, he is not trying to draw a child who has been tossed into the air, but it must be hanging suspended from a beam.[93] Yet the painter has not omitted to show a plaster cast of a putto, for these models were an indispensable aid, not only in the training of young painters and sculptors, but throughout the rest of their working lives.

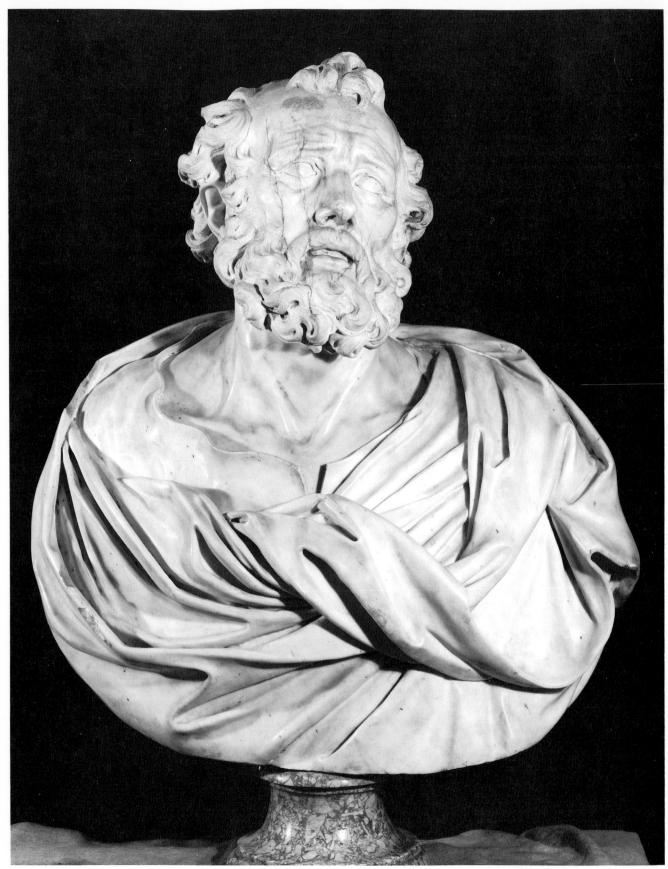

Fig. 23 Alessandro Algardi, *Bust of St Peter*, marble. Private collection.

II

FROM THE QUARRY TO THE CHURCH

'White marble', wrote Orfeo Boselli in the 1650s, 'is, and always will be, the most suitable material one could possibly find for making statues, and I am convinced that it was for this purpose that Nature created it, pure, shining, workable and enduring.'[1]

But if this was the ideal that nature intended, in practice she did not always achieve it. Boselli himself admitted that, if the greatest delight of a sculptor was to have a good piece of marble, the worst trouble that could befall him was to have a bad piece, and in comparing the sculptor to the painter he pointed to the hard lot of the former, who so often had to contend with marble in which nature had placed stains, cracks, faults, impurities, iron veins and other disasters that would try the patience of a saint.[2] Often, indeed, the effect of a sculptor's achievement can be gravely diminished by defects in the material.[3]

What this means in a sculpture can be judged from Algardi's bust of *St Peter* (Fig. 23), one of a pair of over-life-size busts of *St Peter* and *St Paul* which he carved for Cardinal Giacomo Franzone.[4] Here it is probable that the stains were already evident before the sculptor began to work the block, for he has put the faults to good effect to suggest the tear-stains on the face of the penitent saint.

There are, however, well-known cases of disasters, of which the most famous must be Bernini's bust of Cardinal Scipione Borghese (Fig. 24), which revealed a crack while the artist was working on the block. Never at a loss to turn such catastrophes to his own advantage, he took another block and, working feverishly, completed a second version in two weeks. Consummate showman that he was, he kept this secret, and when the Cardinal was shown the first marble, finished and polished so that the crack across the forehead was even more evident, Scipione had to struggle to hide his disappointment to avoid distressing the sculptor. Bernini pretended not to notice the Cardinal's agitation, and knowing full well that the greater the suffering the greater the relief, he went on talking to him as if nothing were amiss, before finally uncovering the second portrait (Fig. 25). The joy Scipione showed at the sight of this perfect bust made clear how unhappy he had been about the first. At least this is the story Bernini's biographer Baldinucci tells.[5] In fact, the second block was not entirely free from faults either: there is a crack in the body of the bust, not nearly so deep or grievous as the first, and most skilfully disguised by Bernini, who has carefully followed its line in the fold of the mozzetta.

When in France, Bernini undertook to carve the bust of Louis XIV (Fig. 26), and, having no time to order a block of marble from Carrara, he was faced with the unknown hazards of working French marble. Unsure of the quality of the stone, he started on two blocks at the same time to see which

Fig. 24 Gianlorenzo Bernini, *Bust of Scipione Borghese*, marble. Rome, Galleria Borghese.

Fig. 25 Gianlorenzo Bernini, *Bust of Scipione Borghese*, marble. Rome, Galleria Borghese.

Fig. 26 Gianlorenzo Bernini, *Bust of Louis XIV*, marble. Versailles, Palace.

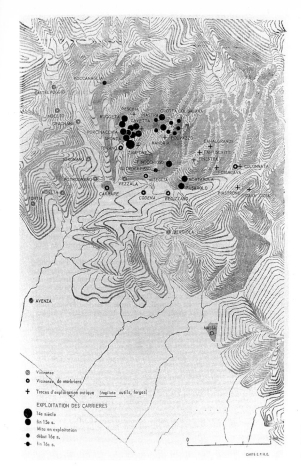

Fig. 27 Map of the marble quarries of Carrara, (from C. Klapisch-Zuber, *Les Maîtres du marbre*).

would turn out the most satisfactory,[6] and having settled on one to complete the sculpture, he none the less complained that, because of the inferior quality of the marble, he had had to make extensive use of the drill.[7]. While this was no doubt true, he could hardly have been unaware that such an explanation would also call the attention of Chantelou (and through him, it might be hoped, the Sun King and his courtiers) to the quite extraordinary virtuosity of the carving.

The marble to which Bernini was accustomed would·have been quarried at Carrara, and in the seventeenth century the best and most expensive statuary marble came from the quarries of Polvaccio (Fig. 27).[8] Occasionally it was ordered direct, and we shall examine such a negotiation more closely below, but by the seventeenth century it was more usual to make use of a marble merchant,[9] of which there were several in Rome, the most prominent being Domenico Marcone, followed by his son Giovanni Battista, and Filippo Frugone, who formed an association with the stone-mason Luca Berretini, the cousin of the painter and architect Pietro da Cortona.[10] Most of these merchants were, like Frugone, emigrants from Carrara, with strong family connections to the quarries. Several of the sculptors living in Rome, such as Giuliano Finelli,[11] Andrea Bolgi,[12] or Domenico Guidi, maintained and used their family links with Carrara to act from time to time as marble-dealers, and most sculptors had quantities of marble in their studios which they would sell as occasion arose.[13] It was by no means uncommon to reuse a partly worked and abandoned block; for example, in 1615 Pietro Bernini accepted a block that had been partially worked by Nicolas Cordier in place

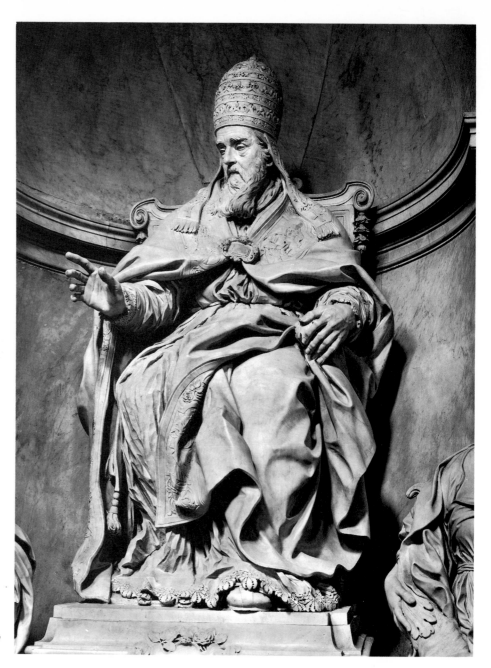

Fig. 28 Alessandro Algardi, *Pope Leo XI*, marble. Vatican, St Peter's.

of the sixty *scudi* owed to him by the Barberini,[14] and the great families might have large storehouses containing marble of this kind.[15] While one might expect sculptors to have reused antique blocks, '*marmo di scavo*', this does not seem to have happened;[16] more usually, it was employed for the restoration of damaged antiques. Large blocks for major statues usually had to be ordered specially from the quarries, or from the dealers who acted for them.

Michelangelo had passed a considerable part of his life in Carrara; his particularly close, almost mystical feeling for stone required him to choose the block himself and supervise the quarrying, and to work the statue from the first with his own hands. In the seventeenth century this was much rarer,

and I have found only two cases of an artist being obliged to go to Carrara to select the stone.[17] One was Francesco Mochi, who accompanied Tomasso Brandi in May 1603 to choose the stones for five statues to be carved for the Cathedral of Orvieto.[18] The other was Alessandro Algardi, for the statue of Pope Leo XI for his tomb in St Peter's (Fig. 28):[19] the contract of Cardinal Aldobrandini with Carlo Pellegrini and his brother Scipione demanded that the Pellegrini show a sample of the marble (as was quite normal), but added:

> such marble must be not only from the quarry of Polvazzo and of the best grain, and the whitest that can be found, but to the taste and satisfaction of Signor Alessandro Algardi, sculptor, who for that purpose shall travel to the said mine on behalf of the Cardinal, otherwise if the said marble is not quarried at his arrival in Carrara, Signor Alessandro can do it as he wishes, of the above measure, quality and soundness, and if it is not to the liking of the said Signor Alessandro the Cardinal will not be held to the contract.[20]

The accounts of the payments made to Algardi for the tomb include a sum for the expense of his journey to Carrara and back.[21]

The more usual way of specifying the quality desired was to quote some comparable work, and the same method was used to ensure the quality of the carving, or the casting of a bronze.[22] So the marble for Bernini's tomb of Alexander VII was to equal or surpass that supplied for his equestrian statue of Louis XIV,[23] and that for Algardi's group of *The Beheading of St Paul* (Fig. 29) was to equal or surpass that supplied to Bernini for the statue he was to make in St Peter's.[24]

The marble for *The Beheading of St Paul* was ordered from the dealers Giovanni Alessandrino, Giovanni Manescalchi and Michele Agnesini in April 1635, and was to be of white statuary marble of Polvaccio, from the quarry of Diana, of Francione, or of Lucarelli,[25] and, as was also usual, it was to be delivered to the sculptor's studio in Rome at the dealers' expense and at their risk,[26] an important point when one considers that, apart from the natural hazards of the sea journey from Carrara, the waters were infested with pirates.[27] To this we must add the risk of breakage, a constant fear from the moment the block was quarried and slid down the mountain, through the loading, transport and unloading.

The contract specified the height of the two blocks as twelve *palmi* and eight *palmi*, but for the width and other measurements it referred to drawings (Fig. 30). The history of this altar for S. Paolo in Bologna is long and complicated, and this was not in fact the first attempt to negotiate the acquisition of the marble for the statues. Earlier in 1634 the General of the Barnabite Order that owned the church was going to Pisa and offered to arrange for a priest there to purchase the marble at Carrara, but he forgot to take with him the *legnette*, or small wooden models for the measurement of the blocks.

These *legnette* were certainly not like the wooden *bozzette* habitually made by Northern sculptors,[28] for most Italian sculptors did not carve naturally, if at all, in wood. Although none survive today, we do have some drawings which must indicate what they looked like, both for Bernini's kneeling figure of Alexander VII for his tomb in St Peter's,[29] and for these two figures by Algardi.[30] It was the responsibility of the quarriers or of the marble-merchants to have the block *abbozzato*, that is, rough-hewn; in fact, even for

Fig. 29 Alessandro Algardi, *The Beheading of St Paul*, marble. Bologna, S. Paolo.

Fig. 30 Studio of Alessandro Algardi, drawing for a block for the executioner in *The Beheading of St Paul*. Rome, Archivio dello Stato.

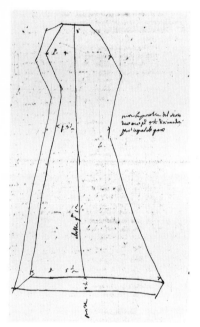

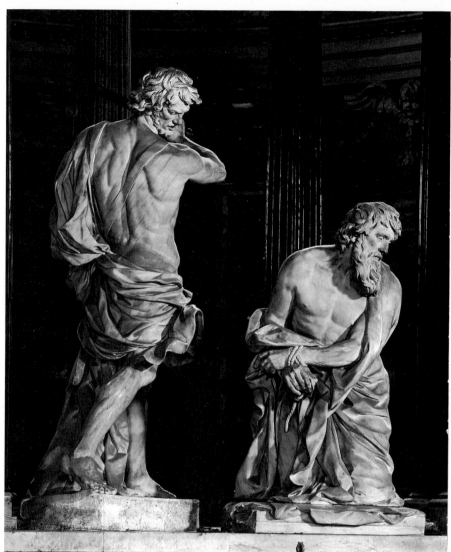

the statue of Leo XI, when Algardi himself was to be in Carrara, it was made quite clear in the contract that it was for Carlo and Scipione Pellegrini 'to have the marble reduced according to the model which the said Signor Alessandro will bring, and this shall be done straight away, and without any interval of time'.[31] The word used in that particular contract, '*sgrossare*', shows why this was to be done before the block was sent to Rome, for the more the weight of the block could be reduced, the cheaper and easier its transport.[32] On the other hand, this work could not be carried too far, not only because the quarrier and his assistants might not be competent for such work, approaching actual sculpture, but also because the blocks had to be left in solid shapes if they were to survive the long journey to Rome.

A contract would always specify who was to pay for the stone; in cases where the sculptor was repaid for the value of the marble, as when Nicolas Cordier was paid 215 *scudi* for his fountain group in the Vatican, specified as for 'the work and value of the marble of Carrara', we are probably justified in assuming that he had made use of a piece that he already had by him.[33]

26

Most often, as we have seen, this stone was ordered via an agent, but when Innocent X put Virgilio Spada in charge of the restoration and virtual re-building of S. Giovanni in Laterano before the Holy Year of 1650,[34] and Spada planned to set statues in the niches which Borromini was building along the nave, he decided to order the marble himself direct from Carrara. The result was some very revealing letters, but no statues; these had to await the early eighteenth century, and the initiative of Pope Clement XI (Fig. 31).[35]

For two larger statues, each to be of 18 *palmi* high, 8 wide, and 6 deep, he investigated various quarries, receiving estimates from two at Panello (which was at Sponda) and one at Finochia (Finochioso) among others, before settling on that of Bonanni which was at Polvaccio, though not one of the four leading quarries there. He drew up a contract with Bonanni for the supply of four blocks for these two statues at the rate of 22 *scudi* for each *carrata* of 30 *palmi* (Roman measurement), including the cost of rough-hewing them according to models that would be sent, and of de-livering them to Rome.[36] What happened after that we do not know: the money was never paid, nor were the statues carved.

But it was over the smaller statues of one block each that he became in-volved in a long correspondence with Carlo Cybo Malaspina, Marquis of Carrara.[37] Unfortunately the Spada archives contain only the letters received from the Marquis, and I have been unable to find those which Virgilio Spada

Fig. 31 Nave of S. Giovanni in Laterano, Rome.

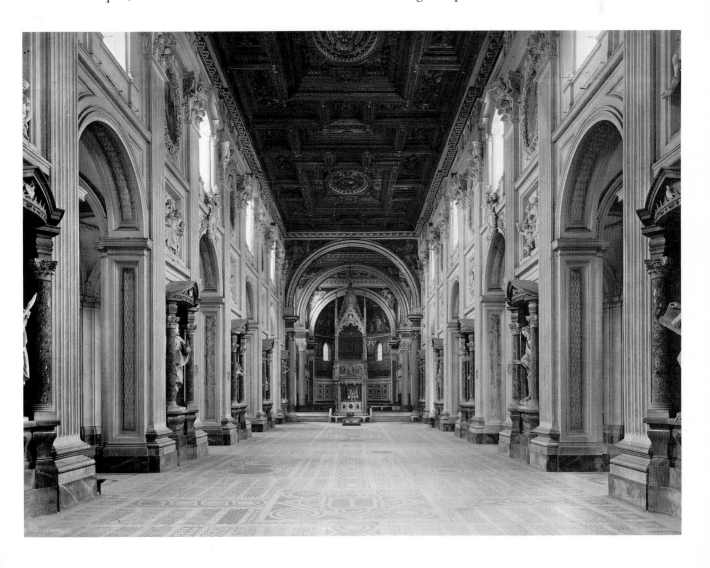

sent to Carrara; but we get a fair idea of their purpose, which was to complain about the prices he had been quoted.

The standard method, whether considering the cost of materials or the price charged by an artist, was to cite a comparison, and Virgilio had written to point out that Bernini and Algardi had had their marble for 25 *scudi* per *carrata*, to which the Marquis replied that the price of Bernini's block had not included the transport, labour, or insurance, that the marble had been of inferior quality, and not of a comparable size; moreover, there appears to have been some dispute about it. As for the blocks sold for Algardi's *Beheading of St Paul*, these had been sold at a discount because the merchants hoped to get further work for the chapel the Spada were building in Bologna.[38]

The *carrata* mentioned here was the standard measurement for marble, being the weight that could be drawn in a cart by a pair of oxen (Fig. 32); the ox was the normal source of energy for transporting both unworked blocks and finished statues.[39] They were used at Carrara right through to the present century, though the weight of the *carrata* changed, rising slightly between the fifteenth and seventeenth centuries, perhaps because the breed of oxen improved, or because a better cart was constructed, or because the roads were better built. By the end of the sixteenth century it was a little over a ton, or between 28 and 30 cubic Genoese *palmi*.[40]

Two fundamental points emerge from these letters: the Marquis disagreed with Spada over the dimensions of the blocks that would be required to carve the statues indicated in the drawings, and he attempted to explain that the size of the block affected the price, which, for a number of reasons, did not rise proportionately.

On the first point, the Marquis asserted that his experience had taught him that sculptors, such as those who had supplied the measurements, were often

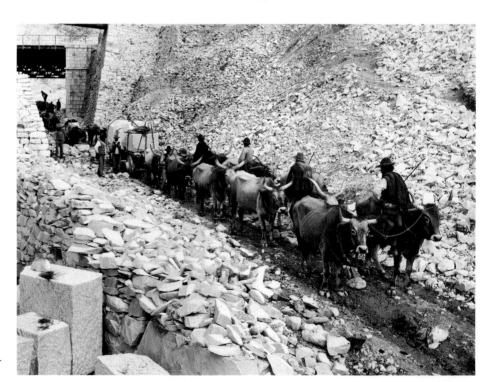

Fig. 32 Ox-cart drawing blocks of marble at Carrara.

28

either genuinely mistaken, or they deliberately miscalculated in order to make the costs appear smaller, and thus secure the commission.[41] Moreover, he had to point out that the marble merchants worked on the basis of the quarried block, 'vuoto pieno', that is, before it had been rough-hewn; thus a block that would be reduced to 20 carrate might be of 34 carrate when it was quarried.[42]

Throughout the correspondence the Marquis insisted on the importance of the size of the block; thus the blocks of about seven carrate needed for Algardi's statues could not be compared with those of some twenty-five carrate which were now under discussion. He explains this under three headings: first, to find such large blocks one may have to quarry for months, when found they may break in the quarrying, and even if they are successfully quarried in one piece they may be found to have some fault which renders the whole effort vain. Secondly, the cost of carrying them from the quarry to the quay rises incomparably, because such large blocks cannot be put on carts drawn by oxen, but must be put on rollers and pulled by winches (Fig. 33), the difficulty of which only those with experience can appreciate, because the road is long and bad. Lastly, the cost of shipping also rises, because they have to use large boats which do not like to come close to the shore, so that there is great difficulty in loading them, and this also raises the cost of insurance.[43] So, as he explains, there is no comparison between a block of 15 carrate and one of 30, and if, for example, the first can be sold for 20 scudi, this does not mean that the latter will cost 30.[44]

We do not know which sculptors had provided the models discussed in these letters (in fact, they seem to have been drawings), but foremost among the sculptors he intended to employ on the Lateran statues were Bernini, Bolgi, Mochi and Algardi,[45] that is, the artists who had carved the great statues in the piers supporting the dome above the crossing of St Peter's,[46]

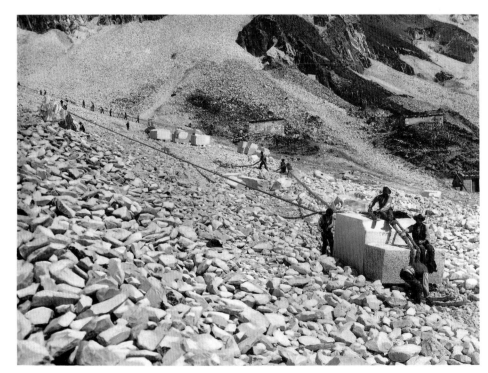

Fig. 33 Rollers and winches used to slide marble blocks down the mountains at Carrara.

29

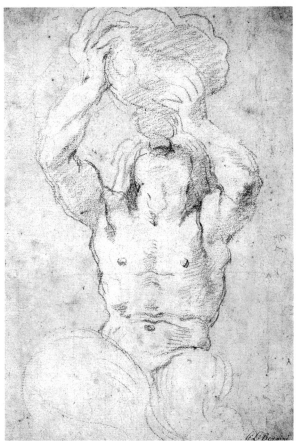

Fig. 34 Gianlorenzo Bernini, *The Triton Fountain*, marble. Rome.

Fig. 35 Gianlorenzo Bernini, drawing for the *Triton*. New York, Metropolitan Museum of Art. Harry G. Sperling Fund, 1973, Inv. 1973. 265.

with Algardi, who had so successfully fulfilled Spada's commission for the group of *St Paul*, replacing François du Quesnoy, who had died in 1643.

These four statues stood in St Peter's in niches Bernini had cut into the piers, so, it was said, causing cracks to open in the dome above.[47] Of the four, three were made substantially from two blocks each, and the fourth, Mochi's *St Veronica* (Fig. 37), from three blocks.[48] · Considering the explanation given by Malaspina of the rise in cost according to the size of the block, we may well understand why it was preferred to make such colossi from several blocks. We should also bear in mind that the blocks were quarried in regular shapes, columnar or rectangular, and, remembering also how large a proportion of the block would be wasted in cutting it to the desired shape, the extended limbs and drapery of Bernini's *St Longinus* (Fig. 38) in particular would make it more economic to use three blocks, just as, for his fountain figure of a *Triton* (Fig. 34), where the elbows and conch in the upper half project forwards and the fish-tail legs in the lower half sideways, it had been more economical to use two blocks, as can be clearly seen both in the marble and in a preliminary drawing where the outlines of the blocks required have been lightly drawn in (Fig. 35).[49]

Mochi, a rather prickly character, emphasised the extra amount of work required in his statue of three blocks (Fig. 37), but its pose undoubtedly did create problems, and after it was set up he wrote complaining about the base, which he feared might not support it.[50] One can never disentangle the possible strands of motivation in past disputes, and, as well as a genuine and

30

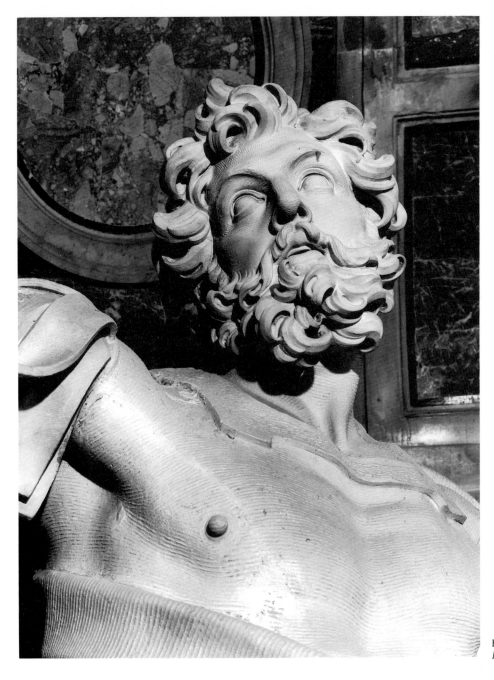

Fig. 36 Gianlorenzo Bernini, detail of *St Longinus*, marble. Vatican, St Peter's.

understandable nervousness about the stability of his figure, Mochi was no doubt also expressing his discontent with Bernini, who had designed the niches and their pedestals and was responsible for the whole scheme into which these four figures had to fit, for their enmity was of long standing. This was certainly the motive for his insistence that his *St Veronica* would not require weekly dusting, with the risk that a ladder or other implement might fall and break off a limb,[51] because, as he pointed out, it was completely finished and there was nowhere for the dust to lodge;[52] one has only to look at Bernini's *St Longinus* (Fig. 36) to see at whom this remark was aimed. This dig at Bernini continued an acrimonious exchange that had begun when the

Fig. 37 (*p. 32*) Francesco Mochi, *St Veronica*, marble. Vatican, St Peter's.

Fig. 38 (*p. 33*) Gianlorenzo Bernini, *St Longinus*, marble. Vatican, St Peter's.

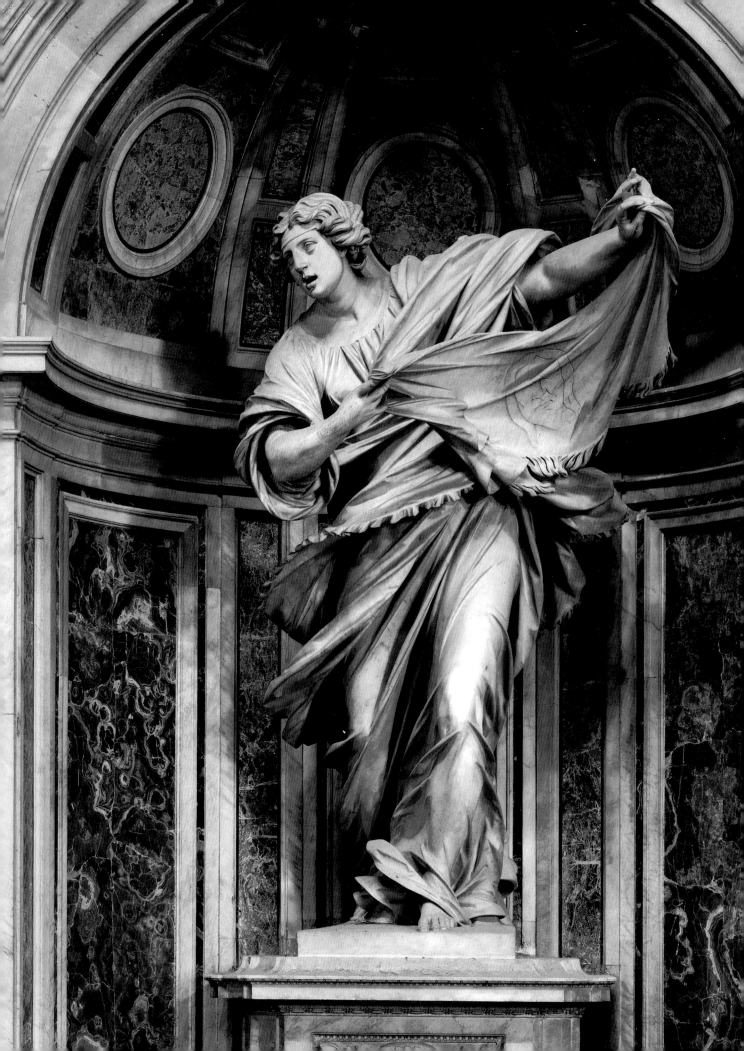

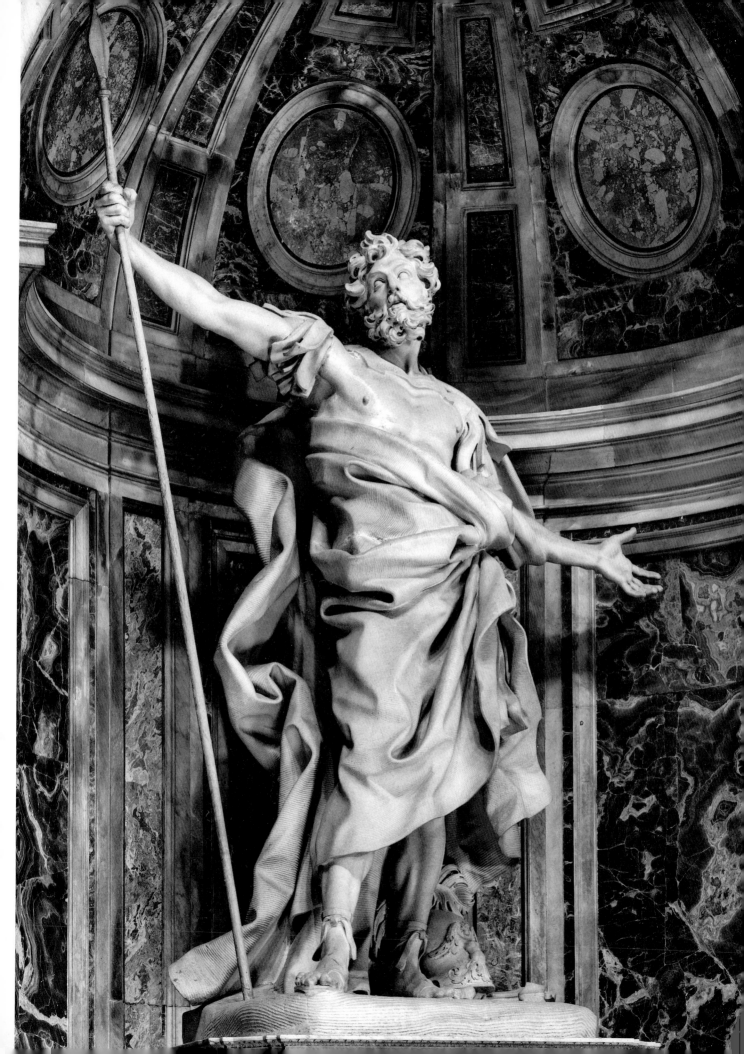

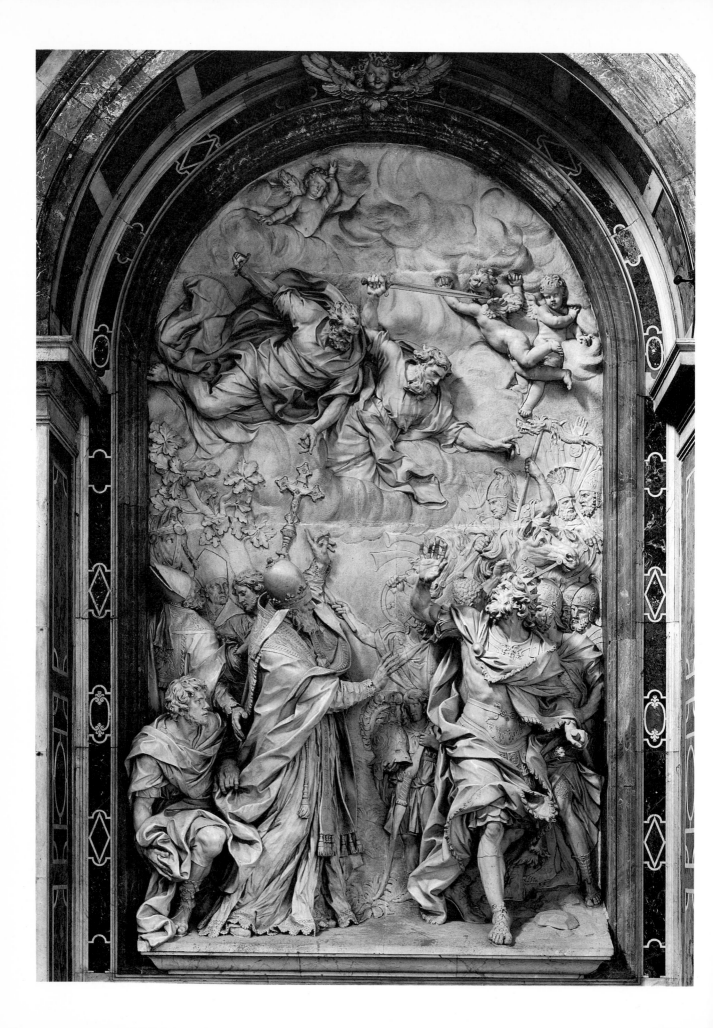

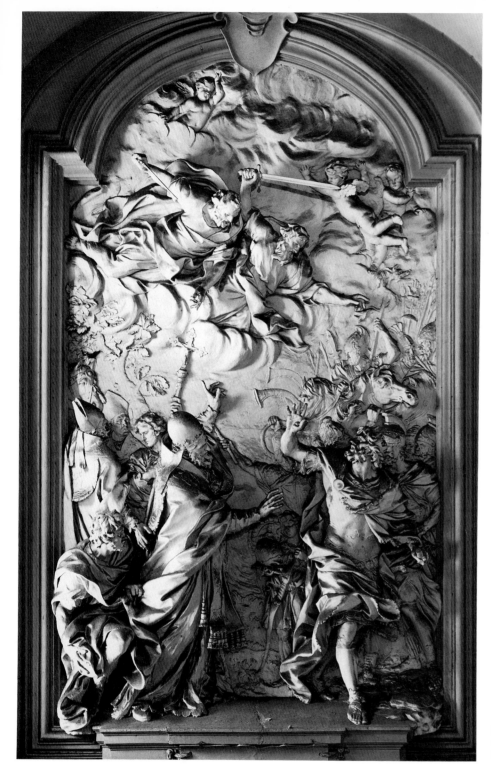

Fig. 39 (*facing*) Alessandro Algardi, *The Encounter of Pope Leo the Great and Attila*, marble. Vatican, St Peter's.

Fig. 40 Alessandro Algardi, *The Encounter of Pope Leo the Great and Attila*, stucco. Rome, Oratorio dei Filippini.

St Veronica was set up, and Bernini had asked contemptuously where the wind was coming from which was blowing the draperies against her body, to which Mochi tartly retorted 'from the cracks you have made in the dome'.[53]

It is hardly surprising that so vast a relief as Algardi's *Encounter of Pope Leo the Great and Attila* in St Peter's (Fig. 39) should have had to be made from

Fig. 41 Attributed to Melchiorre Cafà, *Angel*, terracotta. Rome, Museo di Roma.

five blocks of marble.[54] More remarkable is the decision to make the altar-piece of a marble relief rather than a painting. Originally a painting had been commissioned for this altar from Guido Reni, and, after difficulties had arisen, from the Cavalier d'Arpino; when this too failed to produce any result, Giovanni Lanfranco attempted without success to secure the commission for himself,[55] but finally, by 27 January 1646, it was decided to commission a marble relief. There may have been many reasons for this, such as the growing status of sculpture, or the artistic development of the relief medium in the middle years of the seventeenth century, but the decisive factor was, as is so often the case, very much simpler and more practical. St Peter's has always been excessively damp and humid; the canvases that hung in the church were rotting from their frames, and even the recently executed mosaics were showing a distressing tendency to fall from the walls. For this reason (and this is the only reason stated in any contemporary source), the authorities thought of trying out a relief instead, since marble is relatively damp-proof.[56]

When Algardi set about preparing this relief, he must certainly have made drawings, and a small terracotta *bozzetto* is known.[57] But before starting on the marble blocks he produced a full-scale model in stucco (Fig. 40) which was set up in St Peter's so that its effect could be judged on the site, and in the lighting of the basilica.[58] These stucco models, like the more desirably 'artistic' *bozzetti*, seem to have acquired a value of their own, and so we find in the contract between Prince Giovanni Battista Pamphilj and Domenico Guidi for the High Altar of S. Agnese that Guidi was obliged 'to make the model in clay, or stucco, of the same size as the said relief must be, in conformity with the above-mentioned small model, which, together with the small model, when the work is finished is to remain with the said Most Excellent Prince....'.[59]

The making of such models was so much an accepted part of the sculptor's preparatory work that Pascoli could write of Jacopantonio Fancelli making 'the usual models, both small and large',[60] and it is only very rarely that one finds a scale model specified, such as the clay models in proportion of 1:8 that each of the sculptors had to provide for the reliefs on the tomb of Paul V.[61] Scales are sometimes marked on terracotta models, such as that for the *Angel* (Fig. 41) to go above the pediment of the altar of S. Tommaso di Villanova in S. Agostino;[62] in this case we know that the artist was obliged by his contract to make both small and large models, and such a scale would have assisted in the process of enlargement.[63]

Nor was it only for marble sculpture that full-size models would be set up on the site; the models from which moulds would be taken to cast Pietro Tacca's bronze statues of the Medici for the Cappella dei Principi in S. Lorenzo were to be first set up in the niches of the chapel,[64] and in 1585 a mock-up of the statue of *St Peter* was set up on Trajan's column 'to see the effect that the bronze statue will have, that is to be set up in that position' (Fig. 42), and the pope went specially to see it.[65]

In the case of the model for Guidi's high altar of S. Agnese (Fig. 43), we may assume that it was left where it stood, for the same contract specifies that he was to carve the marble 'already placed in that site' and that he was obliged 'to make it in the same site, where at present is the marble destined for the said work, that is to say on the site of the high altar itself';[66] this, however, seems to be most unusual. It could be that a patron would provide

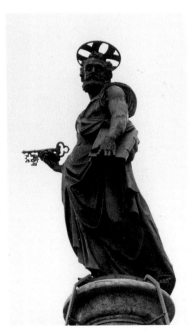

Fig. 42 Sebastiano Torrigiani, *St Peter* on top of Trajan's Column, bronze. Rome, Forum of Trajan.

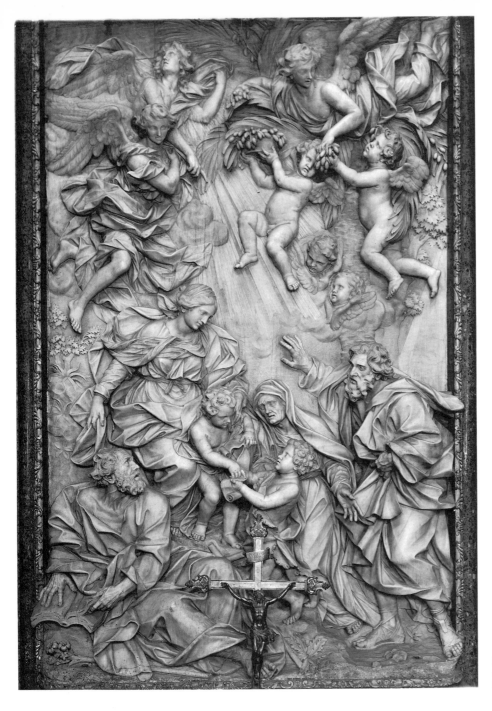

Fig. 43 Domenico Guidi, *Holy Family with St Elizabeth and St John the Baptist*, marble. Rome, S. Agnese, high altar.

a place for the sculptor to work, as the Duke of Parma ensured that Pierre Le Gros and Angelo De Rossi (1671–1715) obtained studios in the Palazzo Farnese from January 1696 while they worked on the altar of S. Ignazio for the Gesù,[67] but most sculptors would expect to provide their own studios, often in their own houses.[68] So once the full-scale model had been approved, it would be taken down from the site, a process that might necessitate cutting it into sections, and carried to the studio where the marble was to be carved, as when the stucco model of the *Death of St Cecilia* had to be cut into five pieces to be taken to the studio of the sculptor, Antonio Raggi (1624–86).[69]

On the practice of marble carving, as on so much else, we are best in-

formed where the circumstances required that letters be exchanged, and one of the most revealing series of letters concerns the only piece of Roman seicento sculpture that was created to stand in an English church: the tomb of Lady Jane Cheyne in Chelsea Old Church (Fig. 44), commissioned by her widowed husband Charles Cheyne.[70]. The letters from his agents in Rome throw a vivid light on the methods, as well as the vicissitudes of such an undertaking.[71]

It was Cheyne's relative Edward Chaloner who, in October 1670, sent him three 'Modells', by which he apparently meant drawings, to choose from.[72] Unfortunately, there is no unambiguous statement as to the identity of the architect who had made them. Later letters describe him as 'kinsman to the famous Cavaliere Bernini and his heir besides,' and as 'following his uncle's way of architecture', which should suggest that he was a nephew of Gianlorenzo Bernini; but there is no nephew who is known to have practised as an architect, and the most likely candidate, as Davies suggested, is Bernini's son Paolo, who had been born in 1648. These 'Modells' were accompanied by their prices, but these must have been very approximate, for by January 1671, when the wooden model of the selected design had been made, Chaloner wrote that 'ye Acct of ye several prices & quantity of ye stones wch I promised you in my last is not yett made'.[73] This wooden model would have been of the architecture, and, if normal practice were followed, the figurative parts would have been indicated, if at all, only very summarily in wax or clay. Indeed, it seems that the sculpture was not included, for, as will be seen later, the appearance and pose of Lady Jane Cheyne was still undecided.

At this point Chaloner left for Venice, and the negotiations were henceforth conducted by Edward Altham.[74]

On March 11/21[75] Altham wrote to say that the carving of the white marble base and capitals was going well, since he had 'had good fortune to meete with two excellent white marble stones of a likenes and of the best sort that comes from Massa di Carara.' The columns were 'to be made of an excellent speckled stone tending to red and white, which is called Breccia di Francia. Ittis costly, but much better than an inferior sort of the like stone that is used in Rome.' However, there were snags, the first of which, as Altham explained,

> partly proceeded from the Architect whose computation made of the expense was writt you, but he (afterwards 'twas found) was noe competent judge, it belonging to the Capo-Maestro of the stone cutters to understand the exact form, and the true expense of the designe, whoe would have eight hundered crownes for the making of it as the Architect had designed it, but wee brought him to seven Hundered crownes and lower he would not falle. Wee did make a tryal to prove more Capo Maestros than one, but all were about that price, some above it. In conclusion I hope to have made a good election of not only two able men but honest likewise as I perceive from the marble they have made choice of.

And there was worse:

> I perceive by what you writt Mr Chaloner that you thought the statue entered into the same account but ittis not so; for that belongs to the Sculptore which is here another profession, and if I take one of the best

Fig. 44 Antonio Raggi and others, tomb of Lady Jane Cheyne, marbles. London, Chelsea Old Church.

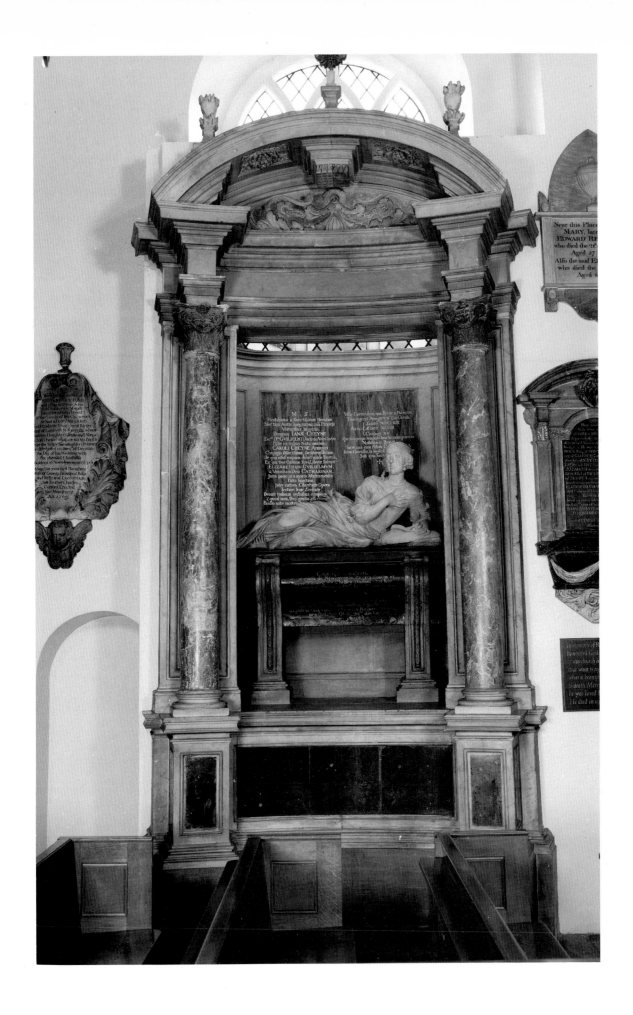

Workmen as I perswade my selfe you will not disapprove of, Hee will not undertake to doe it for lesse than fifty pistols, or there abouts.

So we see that the design was made by an architect, and the patron then looked round for a suitable *capo maestro scarpellino* who would execute the design for a reasonable price, and a sculptor who would undertake the figurative parts. Perhaps, however, this strangely disjointed method was more apparent than real, for, as will be seen, the sculptor whom Altham selected was Antonio Raggi, Bernini's favoured assistant, who was very likely recommended by the architect.

Altham continued his letter with what seems a rather odd request that Cheyne 'send the Lineaments of the face, whether long or round, and the proportion of the nose, lips, forehead, fat, or leane, of which in part I am somewhat already informed of by Mr Sanderson whoe was both the Lady's kinsman and acquaintance, but shall expect more to that purpose from your selfe.' One wonders what he expected; it sounds very much as if this should be merely a written description, from which he could surely not hope that the sculptor would be able to produce a recognisable likeness. In fact, Cheyne did send him a picture, 'or draught of the face' of his deceased wife, which Altham was to assure him was 'well liked by such as have skill to understand things of that nature'.[76]

Finally, he has to advise Cheyne of a serious misunderstanding: he had just received a letter from Chaloner (by then in Venice), telling him that there had been a mistake, and that the chancel of the church where the monument was to be erected was only 14 foot high, when they had been told it was 20. They might just be able to squeeze it in by omitting the cross, or perhaps that could go into the window space. As the stones had been bought and the workmen were already cutting them a change in the design at this stage would be very expensive.[77] Rather desperately Altham suggests that 'some part of the frontispice being most for ornament of Architecture may bee omitted, and without any preiudice to the monument bee rendered capable to stand in the compass of 14 foote,' and he begs that Cheyne 'be pleased therefore to send the string or thread in a letter which measures the space.' Altham explained that, 'instead of the English way of counting by feete the Italian counts by palmes and wee find ten thumbs breadthe compleate an Italian palme and twelve thumbs breadth constitute an English foote'. This was hardly a very precise way of expressing their relationship,[78] and he enclosed 'the precise measure of an Italian palme', reiterating his request for a thread measuring the height of the chancel, as he was to do in several later letters, for this mistake seriously held up the completion of the monument, on which they did not dare proceed further without secure and accurate knowledge.

By his next letter of 1/11 April he had been able to persuade himself that if the tomb intruded by a few *palmi* into the light of the window it would not seriously prejudice the appearance of the chancel, 'and to the monument it must bee beneficiall, whoes Cupola has an open Ovall figure in the top of it on purpose to receive the light which is to render the statue (in a reposing posture upon the Urne) better visible to spectators.'[79] It is hard to know quite how Altham visualised the church, for the tomb in fact covers a great deal of the window area, but it is true that the pediment hides the section of the window behind it. One might assume that most visitors to the church,

particularly knowing that the tomb was generally ascribed to Bernini, would have thought that this was yet another case of a Berninesque use of directed light from a partially hidden source, and never doubted that it was intended to extend into the window in this way.

The work on the structure was going ahead well, with seven persons employed on it, 'two of which are masters, all very active in forewarding the designe, some sawing some cutting, some polishing', and, as they were asking for more money if it were to be finished by August, Altham assumed that they were to put more men to work on it. Meanwhile he was negotiating with the sculptor, 'one of the best in Rome at his art and consequently the dearest, a quondam scholler of that famous Vangardy whoe has immortalized him selfe in describing the History of Attila when he came to destroy Rome. . . . This Artificer is called Antonio Raggi'. As yet he had not agreed on a price with him, as it was not decided whether to include the figure of Lady Jane's daughter, who had died a few months after her mother; if she were to be included, the price would rise from 50 pistols to 180 crownes.[80] The sculptor, he continued,

is of the opinion to follow the style of this country in the habiliments of the figure, and as they are represented in the draught so to forme them with necklesse, pendents, et ca: as if alive, without which ornaments very difficultly can bee represented the likenes to acquaintance. against which conception of his I braught this my opinion that the reposing posture of the figure on the Urne did not require such a lively representation of the persone as being dead or supposed to bee upon the bed of languishing: To which he made no reply, but the custome of this place was to make the figure as like as may bee. [Fig. 45].

Fig. 45 Antonio Raggi, *Lady Jane Cheyne*, marble. London, Chelsea Old Church.

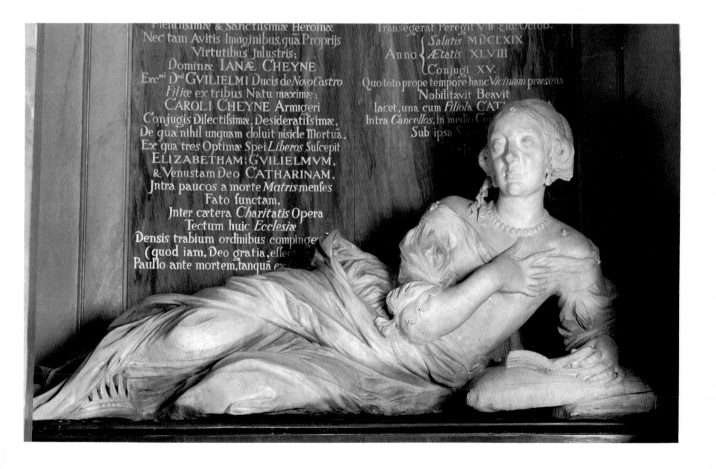

Obviously this worried him greatly, for he reverted to it in his letter 3/13 June, saying that 'the dresse or drapery of the statue will bee such as the best judgements of Artists shall think fitt for I am not content to have the opinione of one Sculptor, but doe take advice of Painters concerning this particular whoe will have the panegiatura as ittis called here done as much as may bee to the life'.[81] A request from Cheyne that the statue should wear the crown to which Lady Jane was entitled as the eldest daughter of a Duke also showed up the differences between the two countries for 'the custome of this Church is, not to crowne any of the Saints though canonized, and have lamps at their shrines, it being an honour onely above the rest due to the Regina Sanctorum Omnium as Mother of God, and Queene of Heaven'. Altham thought it might be added when the statue arrived in England, but 'the Artists have thought fitt to place a Crowne at her feete as neglected and not esteemed in her life time; which if I mistake not is part of your designe mentioned in your letter and may prove conformeable to your conception if not altogether yet in some measure'.

By 17/27 June Altham had received the measurements, and so could proceed with the monument, and the statue was well advanced. Altham described the pose, with the 'uper part of the body some what upright', the left hand on an open book, and 'the right hand and arme bent towards the breasts in a pious posture, the visage looking upwards, from whence the devoute soule may be conjectured (by the specators) was full of expectation and highly concerned in the thoughts of another life.' He enumerated the colours of the stones, and assured Cheyne that he 'will see something that is not of this nature to be paralelled in England', which may be just as well, because he was more than a little worried about the price:

> I hope I am not mistaken in making election of the best workemen this City affords, supposing you to bee a persone of that quality as has beene represented to mee, and will not think much to pay well to bee better served. I can assure you, were it not that this present Pope [Clement X] is noe wayes enclined to building, nor sculpture, both statue and monument would have cost a greate deale more than now it will.[82]

By August this had changed. It was not just that one of the best polishers had fallen sick, and they had difficulty in finding a replacement 'for those of this profession are Neapolitans and come in the winter to Rome, and in the summer returne to their country', but 'a great monument to bee made for Pope Clement the ninth at Sᵗ Maria Magiore [Fig. 46], which all of a sudden is to bee finished with great haste' was a magnet to draw all sorts of workmen to it, so that the number of men sawing for the Cheyne tomb was reduced from three to one. But this, he said, was the last bit of stone to be cut, the rest being either finished, or ready for polishing.[83]

However, on 8/18 September Altham had to report that the summer heat had brought on an indisposition, of which the workmen had taken advantage and had 'not followed their business as they ought', so that the tomb was not yet ready for dispatch: 'True ittis; the words of Artists are not to bee valewed much.'[84] Altham further explained his failure to visit the workmen 'so constantly as otherwise I should': 'one was the Sculptor and he lived at Sᵗᵃ Maria Magiore, the other was the Carver or Intagliatore and he lived a mile distant alli Pantani. The third was the stone cutters which have their shops at the Chiesa Nova: more than a good English mile distant one from

Fig. 46 Carlo Rainaldi, Domenico Guidi, Cosimo Fancelli, and others, tomb of Pope Clement IX, marbles. Rome, Sta Maria Maggiore.

the other.' Now, however, the tomb was cased; he might, he says, 'please my selfe with a high degree of flattery in telling you the opinion of the Romans, concerning the statue, and monument', but instead he merely assures him that 'Romes Artists in this nature can doe noe more'.

There were, however, problems concerning their payment: not only had the workmen deliberately understated the expense, 'to engage us in the designe', which he had estimated as totalling about three hundred pounds, but there were further charges he had not allowed for, such as the additions the architect had made to the design (the letter of 9/19 March 1772 specifies 'something in the frontispice which was not designed in the Modell' as well as other parts of the monument),[85] a mistake in the measurements and cutting of one stone, the cost of which the masons were unwilling to bear, and the speed with which the work was to be done, which required them to give some of the work to others, so that they now refused to stand by their original agreement. The architect also deserved to be paid in full, for he

43

Fig. 47 Giovanni Antonio Peracca, called il Valsoldo, or Pompeo Ferrucci, detail of the frieze of the Cappella Paolina, marble. Rome, Sta Maria Maggiore.

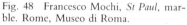

Fig. 48 Francesco Mochi, *St Paul*, marble. Rome, Museo di Roma.

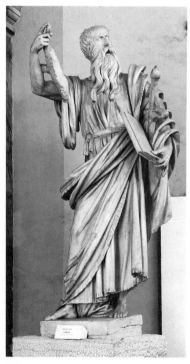

had been 'very sedulous and has followed in this designe his Uncles way of Architecture, which is to have the stones cutt sloping and not in a right line, which is very difficult', and, finally, there was the customs charge of three or four per cent.

The monument was shipped in thirty cases from Rome to Leghorn on 9/19 October 1671, and thence to London on 11 November.[86] By 11 January 1672 Cheyne could write of its safe arrival and his satisfaction.[87] Only after all this labour, however, did Cheyne discover the distressing fact that Lady Jane was lying the wrong way, with her feet to the West, which meant that she was looking away from the altar. After some delay for thought, the ingenious (and Catholic) Mr Altham found a manner to justify this:

The truth is, if in England that custome is not observed, it may seeme somewhat indecent to bring in a contrary custome; but seeing the situation would not permitt it, it may be excused, and such a smalle errour in a reformed Church will bee the easier pardoned, being a step out of the way from antiquity in this nature, will appeare noething in respect of those large strides which the reformists have taken in things of great importance from ancient Church ceremonies. Mr Challoner whoe has beene at Geneva, will bee of my Opinion ...[88]

So the tomb was set up in Chelsea Old Church in London, where it remains today, not exactly as its patron had wanted, not quite as the architect had intended, but as fine an example of a genuine Italian seventeenth-century church monument as one will find in this country.

Well could Altham write that 'in things of this nature there intervenes such variety of Accidents and so many uncertaintyes ...'.[89] Some of them were peculiar to the circumstances of a monument that was made at a distance from both the man who was commissioning it and the site where it was to be set up, but others, one may well imagine, could, and probably did, occur with works commissioned in and for Rome itself.

In one respect, at least, the fact that it was to be shipped to England did affect the way it was made: since it was to be set up by workmen unfamiliar with Italian sculpture it was necessary that the whole monument be completely finished,[90] and detailed instructions had to be sent concerning only the manner in which it was to be set up, including the reminder that the lime or mortar must be kept at a distance of at least two inches from the marble, otherwise it will stain the stone.[91]

In Italy, however, it was by no means uncommon to put the finishing touches on a sculpture after it had been set in place, and in the accounts for the Cappella Paolina in Sta Maria Maggiore, one of the great enterprises of the first–second decade of the seventeenth century, is an item for fixing the scaffolding so that the sculptors could retouch the marble putti between the capitals (Fig. 47).[92] In 1644 Francesco Mochi went to Orvieto to put the last touches on his statue of *St Thaddeus*, which was no doubt just as well as it had fallen twice on the journey as it was pulled by its nine pairs of oxen, and the book he is holding had been broken.[93] We may assume that he had sent it with marble struts still left in place, as they are to this day on the figure of *St Paul* (Fig. 48), one of a pair of statues of the Princes of the Apostles rejected by the patrons, the Benedictine fathers of Montecassino, who had commissioned them for S. Paolo fuori le Mura; only after the sculptor's death were they acquired by Pope Alexander VII, and presumably, still hoping to

sell them and unsure where they would go, he had not cut away these reinforcements.[94]

There are unfinished areas left on Nicolas Cordier's figure of *Charity* (Fig. 49), which adorns the tomb of Lesa Deti in the Aldobrandini Chapel in Sta Maria sopra Minerva: her right foot is merely sketched in and the left only slightly more worked, the brooch on her left shoulder is only sketched, and the hair of the two children at her left is unfinished.[95] On his statue of *St Sebastian* in the same chapel (Fig. 50) the hair, beard, and right foot are unfinished, and the struts have been left in between the fingers of his raised hand.[96] The otherwise completely finished and polished appearance of these two marbles shows that this was not an aesthetic choice, but we know that after the death of Clement VIII in 1605 the work on his family chapel came to a halt, and the artists were compelled to accept lower fees than had been promised; no doubt Cordier felt no obligation to put the finishing touches on his sculptures, and, again, the struts would have been left until this fragile figure was securely set in place.

Fig. 49 Nicolas Cordier, *Charity*, marble. Rome, Sta Maria sopra Minerva, Aldobrandini chapel.

Fig. 50 Nicolas Cordier, *St Sebastian*, marble. Rome, Sta Maria sopra Minerva, Aldobrandini chapel.

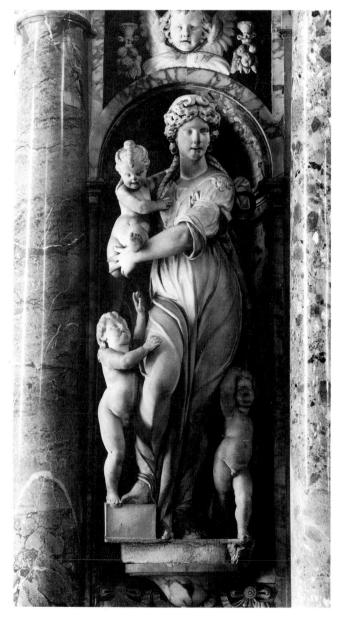

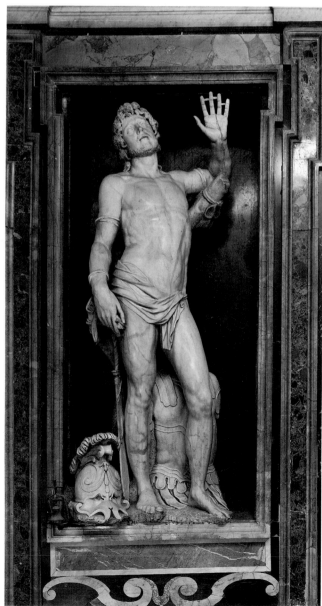

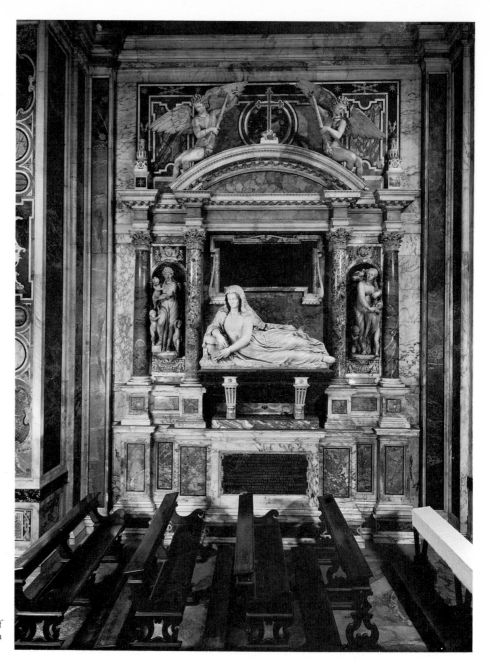

Fig. 51 Aldobrandini Chapel (tomb of Lesa Deti), marbles. Rome, Sta Maria sopra Minerva.

The Aldobrandini Chapel (Fig. 51) makes an interesting comparison with the tomb of Lady Jane Cheyne: not only does it show Silvestro Aldobrandini and Lesa Deti reclining on their tombs in the manner that had so disturbed Edward Altham, but, like the Cappella Paolina, it is an outstanding example of the use of of multi-coloured marble inlay, the sort of work that justified Altham's assurance to Cheyne that 'you neede not feare but there will bee an excellent concordance of colour, for in this kinde Rome has such a variety of different obiects as that noe nation is more exact in its reflexions then this.'[97]

Certainly such polychrome architecture was produced for its aesthetic effect. But, as we have had occasion to note in the course of this chapter, much of what one might assume to be due to aesthetic choice derives at least as much from practical considerations, whether it be the decision to erect a marble relief altarpiece in St Peter's, or to incorporate the window into the

46

Fig. 52 Pier Leone Ghezzi, detail of *The Lateran Council of 1725 Meeting in S. Giovanni in Laterano*, painting. Raleigh, North Carolina Museum of Art.

structure of Lady Jane Cheyne's tomb. There is another example of this in no less a place than the basilica of S. Giovanni in Laterano.

Originally it had been planned to make the bases of the pillars along the nave in the same white marble as the pillars themselves, but this plan was subsequently changed, and it was decided instead to use dark *bardiglio*. Undoubtedly this harmonises with the tabernacles, but it was not for this reason alone that the decision was taken, but also because it would not show knocks and scuff-marks as would the pure white stone, and because, as Virgilio Spada wrote, 'If some dog cocks his leg against them to make water they will not stain as the white would do'. (Fig. 52)[98]

It may be well to remember that incontinent dogs have more to do with the history of art than art historians usually give them credit for.

III

FOUNDERS AND SCULPTORS

Giovanni Baglione's *Lives of the Painters, Sculptors and Architects from the Pontificate of Gregory XIII to the Time of Urban VIII*, first published in Rome in 1642, and one of the basic collections of biographies of contemporary artists, includes among the Lives of the painters, sculptors and architects those of a number of bronze-founders. In this his book is, I believe, unique. In Florence, of course, since the time of Ghiberti and particularly during this same period (from the last quarter of the sixteenth century through the first quarter of the seventeenth), when the sculptural scene was dominated by men trained in the workshop and tradition of Giambologna, it is common enough to find biographies of sculptors who worked primarily in bronze, and many of these were themselves highly skilled bronze-founders; but that is something different. Rome in the early baroque age evidently prided itself on its bronze-founders, craftsmen first and foremost, but men whose skills were essential to the production of the finest art. And Baglione's lead was followed by many of the guidebooks, which, again far more frequently than is normally found in guidebooks to other cities, tell us not only who modelled a sculpture, but also who cast it.

It is worth looking at the metal sculpture of baroque Rome from the point of view of these men, once so justly admired,[1] but now largely forgotten in our celebration of inventive genius; and not only to look at what they produced and how they made it, but also to investigate their relationship to the sculptors, for this was less simple than is usually suggested; and, by raising the question of responsibility, we may be able to increase our understanding of the final appearance of the sculpture, as well as of the often highly complex processes of production.

Who were these men? Like the marble workers, they tended to form dynasties, ranging from brass-workers through bronze-founders to medallists, and the occasional all-round sculptor. Giacomo Laurentiani (died 1650) was the son of a founder, and a member of a family of metal-workers which included Giovanni Andrea Lorenzani (1637–1712), who was both a brass-worker and a medallist, and whose extensive collection suggests that he was one of the most active suppliers of small religious reliefs in bronze.[2] Ambrogio Lucenti (died 1656) was a founder, his son Girolamo (c.1625–98) was an assistant to Algardi who also carved marble, made guns for the papal armoury and was Master of the Papal Mint;[3] the name of Lucenti was still associated with bells cast in the nineteenth century, and the Lucenti foundry, claiming over five hundred years of existence, was active in Rome till 1988.[4] Bells and guns, those symbols of the two poles of the church and state, provide a constant background for the occasional work of art. And as one looks through the payments for the production of a statue, they are likely to be interrupted by a payment to the same founder for a drain pipe or a tap.[5]

At the close of the sixteenth century one encounters the names of a number of old-established workers, such as Bastiano Torrigiani (died 1596), Orazio Censore (died 1622), Domenico Ferrerio (died 1630) or Lodovico del Duca, later joined by men such as Giacomo Laurentiani, Ambrogio Lucenti, Francuccio Francucci, Angelo Pellegrini and Sebastiano Sebastiani. Like many craftsmen's families through the ages, they intermarried: so Bastiano Torrigiano's daughter Caterina was the mother of Francuccio Francucci, and another daughter married Orazio Censore; their daughter married Angelo Pellegrini, who was the nephew of Domenico Ferrerio.[6] As Baglione puts it, 'So all these founders were united by blood ties, and under a variety of surnames they have demonstrated an inseparable union of artistic skill, and have perpetuated their names in metal.'[7]

That family relationship of which Baglione wrote is reflected in a class of work that seems to have been specific to Rome: a series of pairs of large bronze candlesticks standing some one and a half metres high, which can be seen in a number of Roman churches and only very rarely elsewhere.[8] One, no different from the others, has been attributed to Benvenuto Cellini (1500–71),[9] a label which, in the field of Italian metalwork, is no more than a seal of excellence. Others, such as those with the Barberini, Peretti, and Strozzi arms (Fig. 53), all in S. Andrea della Valle, have always remained anonymous.[10] All of them are of the same essential form, a long baluster rising from a squat vase supported on a triangular base decorated with cherub heads, the deeply carved scrolls at the corners supported on a lion (or, following the principle *ex ungue leonem*, a lion's paw). These appealing beasts have a single head but a divided body, so that they appear complete from each of the three sides. In the church of the Trinità dei Pellegrini is a slightly more elaborate pair given to the church by the Comune of Rome in 1616, and resting appropriately on the Roman wolf (Fig. 54); these are the only ones to have a documented attribution, to the founder Orazio Censore.[11]

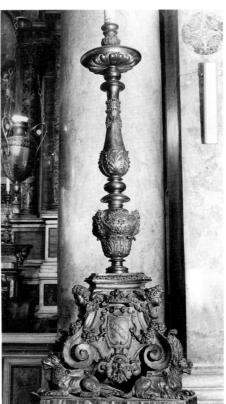

Fig. 53 Strozzi candlestick, bronze. Rome, S. Andrea della Valle.

Fig. 54 Orazio Censore, candlestick, bronze. Rome, Sta Trinità dei Pellegrini.

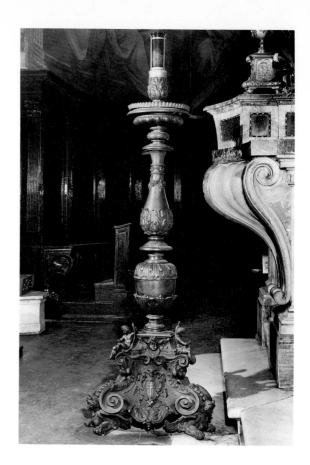

Fig. 55 Candlestick, bronze. Rome, Sto Spirito in Sassia.

Another pair in the church of Sto Spirito in Sassia (Fig. 55) bears the arms of the Order, and those of Cardinal Girolamo Agucchi who died in 1605.[12] With their unusual supporting harpy figures, and the incorporation of seated putti, they appear to be related to a series of drawings in Windsor Castle by Domenichino (1581–1641) (Figs. 56, 57, 58), a friend and protégé of Girolamo's brother, Monsignor Giovanni Battista Agucchi;[13] none of these drawings corresponds exactly, but they display the harpies and seated putti, both unique elements which recur on no other candlesticks of this type. Perhaps the final design, handed to the founder, is lost, or perhaps the founder was content to incorporate these specific features, while for the rest reverting to what was a more or less standard formula.

For most of these candlesticks are surely not artist-designed objects, but works of high craftsmanship. It is no coincidence that both Baglione and the accounts of the Comune record the name of the founder, but not of a designer, for the Trinità de' Pellegrini pair. The basic forms were carved in wood, in various interchangeable sections, and inventories of founders' workshops include such wooden models of balusters and vases, to which appropriate decorations could be applied in wax.[14] And I do not think it is entirely fanciful to imagine an apprentice sent scurrying from the workshop of his master to that of a cousin to borrow a model of a baluster or a drip-pan.

If one can regard these candlesticks as an autonomous product of the bronze-founding industry, the same applies to mortars and bells. The decoration was mainly composed of standard elements, for which the founder could use stamps of wood or lead, though just as Domenichino was brought in for the Agucchi candlesticks, so sculptors might be paid for relief models

50

Fig. 56 Domenichino, drawing for the base of a candlestick. Windsor, Royal Library.

Fig. 57 Domenichino, drawing for the base of a candlestick. Windsor, Royal Library.

Fig. 58 Domenichino, drawing for the base of a candlestick. Windor, Royal Library.

Fig. 59 Ambrogio Lucenti, mortar, bronze. London, Victoria and Albert Museum.

Fig. 60 Giacomo Laurentiani and Gregorio de Rossi, detail of the grille of the Cappella Paolina, bronze. Rome, Sta Maria Maggiore.

of saints venerated in a particular church whose images were to be applied to the bell.[15] Another method of decorating simple shapes was to cast from nature. This technique was used on a large mortar (Fig. 59) signed by Ambrogio Lucenti and dated 1642,[16] and on the main posts of the grilles of the Sistine and Pauline chapels in Sta Maria Maggiore, the former by Bastiano Torrigiani,[17] the latter (Fig. 60) by Giacomo Laurentiani and Gregorio de Rossi.[18] On these the vine leaves, enlivened by small lizards and other beasts, are not modelled, but cast from nature by a technique which was much used during the earlier mannerist period in the so-called rustic style.[19]

This same method was used on no less a monument of baroque sculpture than the great *Baldacchino* in St Peter's (Fig. 82). We shall return to this work later, because it is indubitably the major bronze structure of the Roman seventeenth century, but here I want just to point to the use of real olive branches wrapped around the columns to make the model.[20] Of course, the leaves had to be arranged, and supported by wax behind them to make them stand proud. A highly critical contemporary account of the making of these columns, which attempts to show that their cost was exorbitant, and in particular that Bernini was paid too much, emphasises that they were the work of carpenters and that the decoration of the shafts was provided by nature, with the exception of only a few of the larger leaves.[21] Such a technical short cut does not, of course, in any way diminish the value of the work, any more than it detracts from its ultimate splendour, or from Bernini's glory. But it is the sort of process that is likely to have been suggested by someone brought up, as Bernini was not, in the tradition of a bronze-worker's shop, such as those that had provided the grilles for Sta

Fig. 61 François Desjardins, model for an equestrian statue of *Louis XIV*. Copenhagen, Statens Museum for Kunst.

Maria Maggiore, and we may note that two of the founders involved in casting the columns were the same Giacomo Laurentiani and Gregorio de Rossi who cast the grille of the Pauline chapel, and a third was Ambrogio Lucenti, who made the mortar in the Victoria and Albert Museum.

As for the actual casting process involved, this was fundamentally similar, whether it was the lost-wax process most commonly employed in the seventeenth century for bronze, or what has been termed the 'lost-lizard process'.[22] This began, of course, with a model; in the cases we have considered so far it would have been made of wood, but for more 'artistic' objects it would have been of terracotta,[23] or, for large statues, built up in plaster. It was important to keep this model intact, both as an insurance against the failure of the casting, and as a guide for the repair and finishing of the rough casts when they emerged from the mould. So from this positive model a negative piece-mould would be taken, in as many sections as were required by the complexity of the original. By means of this mould a positive wax replica of the original would be made, not in solid wax, but a thin layer of wax that would be set round a core of friable clay. This wax cast would have to be repaired, that is to say that any excess wax that had oozed

between the sections of the mould would be cleaned off, any faults made good, and the details sharpened. It is at this stage that stamped relief decoration or any natural objects, branches or dead lizards, would be applied. To this wax would be attached a wax pouring funnel and a series of wax rods running from it which would serve to distribute the bronze to every part of the figure, while other wax rods would be placed to carry off the air and gasses released during casting so as to prevent air getting trapped in the under-cuts. The whole would then be encased in a solid covering of clay (in large figures reinforced by metal bands), and metal rods or nails passed through this covering into the core. Now it was ready for firing, and it would be subjected to intense heat so that all the wax would melt out, the branches and dead beasts would be reduced to ashes and float out with the wax, and the core and mould hardened and dried. Where the wax had been is now a void, with the core held suspended within it by the rods or nails, and the wax rods have become tubes. Through these tubes and into the void the molten metal was poured, and if the tubes had been correctly placed it would flow into even the most extended limbs. A model of an equestrian figure (Fig. 61), which was in fact created as a demonstration of how to attach these tubes to distribute the bronze for the casting of a full-size equestrian statue, serves as a convenient example of what a bronze sculpture looks like as it emerges from the mould, after the metal has cooled and hardened and the mould has been broken.[24]

At that stage the tubes would have been at least partly filled with bronze, and must be cut away; although not visible here, the rods too must be cut off flush with the surface, or, more often, removed, and their holes plugged, usually with screws. There might very likely be some parts that had not filled with bronze, which would have to be recast and attached, and a number of air-bubbles which would show as pits or holes in the surface, and these too would have to be made good. The surface of the metal was very seldom clean and smooth, and it would be carefully worked over with chisels and files, the details sharpened with engraving tools, and often a variety of textures obtained by the use of punches. After all this work, the raw bronze would be given a pleasing patina, either by the use of chemicals or a coat of lacquer, or it would be gilded, in whole or in part.[25]

This very summary account gives, perhaps, some idea of the many stages involved. There were less complex methods that could be used for small and relatively simple objects, and there were further complications on this basic method for really large statues. And there were short cuts, such as piece casts, particularly for objects such as crucifixes, where it was easier to cast the arms separately than to induce the bronze to flow into such widely spread extremities. I have used terms like clay, plaster and bronze, but in fact the mixtures were much more complex, and different sculptors would pride themselves on special formulæ, both for the moulds and for the core.[26] For example, although none of the treatises on bronze-casting mentions such a possibility, there is no question but that the core of the statue of Urban VIII on his tomb (Fig. 124) was built up, not with the usual sort of clay mixture, but in brick (Fig. 62), small fire-bricks which are quite soft and could be carved to the approximate shape of the body and head,[27] though the raised arm was presumably modelled, for a thick iron bar that must have served as an armature remains inside the cast.[28] Perhaps it was this use of bricks to which Bernini was referring when he claimed that he had had the statue of

Fig. 62 Gianlorenzo Bernini, *Urban VIII*, detail of the back of the statue, bronze. Vatican, St Peter's.

Urban VIII cast 'all by his orders, invention, and method, and with his personal assistance'.[29]

There were also a number of different alloys that could be used to encourage the metal to flow more freely,[30] though not much control could be exercised over large casts since they nearly always included a good deal of second-hand metal.[31] Everyone knows that the *Baldacchino* made by the Barberini pope, Urban VIII, incorporated bronze beams from the portico of the Pantheon, giving rise to the jibe that '*Quod non fecerunt barbari, fecerunt Barberini*'; it is not so often recalled that to make the statues of *St Peter* (Fig. 42) and *St Paul* on top of the columns of Trajan and Antoninus at the end of the sixteenth century the bronze had been taken from the doors of S. Agnese and the Scala Santa at the Lateran, a piece of an antique pilaster from the Pantheon, and the doors of the old ciborium of St Peter's.[32]

There is one point in this casting process which should be stressed, and that is the importance of the intermediary wax; this, as has been said, always needed to be repaired, cleaned, and freshened up. At this stage, obviously, the artist could make a number of fairly substantial changes, from adding a signature or changing a coat of arms, to changes in the model itself (provided always that they did not affect the core); he could alter the shape of a relief, add or remove subsidiary figures or attributes, or rework the base of a model. By such changes quite noticeable differences can exist between casts taken from the same model by means of the same piece-mould, apart from the different appearances that can be given to casts by the afterwork done on the cold bronze.[33]

This lost-wax method was used not only for making bronzes, but, in fact, most of the artistic figurative silver of the Roman baroque was also cast, by exactly the same lost wax process, and, naturally, the same figure could be found cast in bronze or silver. The same moulds could also be used for casting in other cheaper materials, such as wax, terracotta, plaster or papier mâché. These last were popular in the seventeenth century, and not only in poorer households,[34] and still today many of the crucifixes attached to pulpits in churches are made of plaster.

I have throughout been using the passive voice, rather than saying that the founder would perform an action, because all this work was not necessarily done by the same man.[35] The profession of *formatore*, or mould-maker, might be distinct from that of *gettatore*, or founder, and silversmiths in particular frequently sent models to have moulds taken and waxes cast from them, which they would then cast in silver.[36] A model of the *Descent from the Cross* by Guglielmo della Porta (1515–77) (Fig. 63), which had been stolen in the sixteenth century from his son and heir Teodoro (1567–1638), found its way to the silversmith Antonio Gentile (1561–1609), who, as he said in evidence at the trial, had a cast made by a certain 'Baldo *formatore*'; from it he made a silver cast, and also two waxes, one of which he sold to a Frenchman and the other to a German. When Teodoro della Porta attempted to sell a silver cast from his father's composition, he found to his dismay that other artists were offering for sale the same composition, which should have been his exclusive property.[37] We may note in passing that to do so was quite legitimate: there was no copyright on such artistic products, and the trial was concerned only with the criminal theft of the model from Teodoro's house, not with its reproduction.

A specialist *formatore* was also employed in the making of a small silver

replica of Algardi's marble relief of *The Encounter of Pope Leo the Great and Attila* (Fig. 64): the reduced model was made by Ercole Ferrata, and the silver was cast by the silversmith Santi Loti, but the mould had been prepared by a separate craftsman, in all probability the same founder Giovanni Artusi who was responsible for the bronze frame.[38] It was Ercole Ferrata who made and cleaned the wax cast from this mould, or rather the two waxes, for the first turned out to be too thick. This seems to have been quite a frequent occurence: it will be remembered that in lost-wax casting the metal will fill the area previously occupied by the wax, so the thickness of the wax will have a substantial bearing on the ultimate cost, and all the more so if the metal is the more precious silver.[39]

These two reliefs exemplify two different ways of commissioning sculpture – both, incidentally, using compositions created by other artists.

In the first case, it was the artist, Teodoro della Porta, who took the initative in offering the work for sale, showing the model of the *Deposition* made by his father to the prospective customer, and offering to make him a cast in silver.

In the case of the reduction of the *Leo and Attila*, it was Cardinal Francesco Barberini who took the initiative: wanting to send a special gift to Spain he commissioned Ercole Ferrata to make the reduction of his former master's marble, which symbolised for the Cardinal his growing fear of the Turks and his desire to see unity among the Christian powers, particularly the rival great powers of France and Spain, in the face of the Infidel. He paid the modeller and the founder, not to mention the others involved in its produc-

Fig. 63 Guglielmo della Porta, *Descent from the Cross*, bronze. Ann Arbor, University of Michigan Museum of Art.

Fig. 64 After Alessandro Algardi, *The Encounter of Pope Leo the Great and Attila*, silver, gilt bronze and decorative marbles. Madrid, Palacio Real, treasury.

tion, such as those who cut the stones for the frame or made the letters for the inscription formerly below the relief, and those who in 1659 wrapped it up and dispatched it to Spain, each according to the itemized accounts he submitted.

Sometimes the founder, or silversmith, would do the whole thing himself; this is not, of course, to say that one man would do it all, but that it would be done in one studio, with the aid of the founder's own assistants. This may have been the case with the candlesticks examined earlier, since those in the Trinità dei Pellegrini were attributed to the founder Orazio Censore and no sculptor is mentioned, and indeed the sculptural parts, the cherub heads and wolves, might possibly have been within his compass.[40] The same would apply to much silver-work, flatware, salvers and cutlery with standardised decoration, or simple church altar furniture and reliquaries. Both silver-smiths and bronze founders used model books and moulds which, like the basic wooden models, were standard studio possessions.[41]

But on occasion a silversmith would have to call on the assistance of a professional sculptor. Frequently their accounts for the making of an object such as a silver salver include payments both to an engraver for adding a coat of arms, and a sculptor for modelling, for example, the supporting putti.[42] This was indeed one of the ways in which sculptors, particularly young sculptors at the outset of their careers, could most easily earn a living. In his biography of Alessandro Algardi, Bellori records that when the sculptor first arrived in Rome he kept himself alive by restoring antique statues and by making models which were cast in silver and bronze.[43] These would not be models made on their own initiative so much as works commissioned from them by the silversmiths or bronze-founders. Similarly, the first work that Antonio Giorgetti made for his future patron Cardinal Francesco Barberini was not paid for directly by the Cardinal, but by the silversmith Michele Sprinati, who needed figures to decorate an aventurine casket, and he included the payment that he made to Giorgetti in the list of his own expenses that he submitted to the Cardinal in 1658.[44] When six years later the founder Giovanni Artusi presented Cardinal Francesco with his account for casting the olive swags above Bernini's tomb of Urban VIII (Fig. 65), he said that they had been made 'with the assistance of' Antonio Giorgetti, which must mean that the sculptor had prepared the models.[45] It is not clear whether he himself paid the sculptor, or whether such relatively simple work was perhaps covered by the regular salary Giorgetti was by then receiving from the Cardinal, but it seems evident that it was the founder who was responsible for the swags, and that the sculptor was working for him.

Certainly this was the case also with the elaborately decorated silver hammer that Antonio Pellicani (*c*.1611–77) provided for Innocent X when he opened the Porta Santa in 1650. Pellicani records 20 *scudi* paid 'to the sculptor and carver for the model of the said hammer', a small proportion of the hundred *scudi* he claimed for the work, exclusive of the silver and gilding.[46]

We might today describe the urn containing the body of St Ignatius (Fig. 66) as the work of Algardi. This would not be quite correct, as the design of the casket itself was made by the Jesuit Father Orazio Grassi, an architect and mathematician, better known perhaps for his part in the prosecution of Galileo. Algardi certainly was involved, modelling the relief of the Jesuit martyrs grouped around St Ingatius, and probably also the herms. The

Fig. 65 Gianlorenzo Bernini and assistants, arms and swags above the tomb of Pope Urban VIII, bronze and marbles. Vatican, St Peter's.

Fig. 66 Alessandro Algardi and others, urn of St Ignatius Loyola, gilt bronze. Rome, Gesù.

Fig. 67 Guillaume Berthelot, *Virgin and Child*, bronze. Rome, Piazza Sta Maria Maggiore.

contract, however, was drawn up not with him, but between Grassi, acting for the Company of Jesus, and the founders Angelo Pellegrini and Francuccio Francucci, and all it says about the decoration is that the models should be made by the person selected by Grassi, and that it was the responsibility of the founders to have them made, an expense that was included in the round sum of 1,000 *scudi* that they were to receive.[47]

This sort of contract seems to have been common for comparatively minor works, such as small bronze statuettes to decorate tabernacles, reliquaries or other ornate pieces of metalwork. I have never come across a major sculptural monument commissioned in this way direct from the founder.

Nevertheless, it might be that the founder, rather than the modeller, was considered as the principal creator of a major monument. For the modern historian, accustomed to thinking of the sculptor as the true creator, and the founder as a mere artisan who casts the sculptor's work in bronze, it comes as rather a shock to read the records of the payments to Guillaume Berthelot (died 1648), to whom we normally attribute the *Virgin and Child* on top of the column in the piazza of Sta Maria Maggiore (Fig. 67), and see that they are for 'the model he is making of the statue',[48] whereas those to the founder Domenico Ferrerio were according to the contract 'to make the bronze statue'.[49] If we take the wording literally, it is Ferrerio who made the statue, and Berthelot merely supplied the model for him; this does not change our perception of the work, but it does suggest that the men of the early seventeenth century looked at their respective rôles rather differently.

There is, however, one case (and, so far as I know, only one) where a statue was commissioned from the sculptor and founder together. This is the over-life-size figure of *Henri IV* (Fig. 68), commissioned in 1606 by the Chapter of S. Giovanni in Laterano from 'Nicolas Cordier of Lorraine, sculptor, and Gregorio de Rossi, founder, of Rome'.[50] Admittedly, Gregorio de Rossi, without Cordier, was involved in a contract for the acquisition of bronze,[51] and Nicolas Cordier seems to have been responsible for providing the marble base,[52] but the contract for the bronze statue was drawn up with both of them conjointly, and after the work was completed both of them signed a single letter begging for payment.[53]

Also rather unusual, though certainly not unique, were the founders who could model, or the sculptors who could cast their own bronzes. Of Francesco Perone, one of the leading workers of both silver and base metal in seventeenth-century Rome, we know that he could model, for his brother, the sculptor Giuseppe Perone, learnt to model by watching him;[54] and if the founder Angelo Pellegrini (one of the two founders who made the *Urn of St Ignatius*) was the same person as the Angelo Pellegrini paid for making figures on the catafalque of Carlo Barberini and the Triumphal Arches of Gregory XV and Innocent X,[55] then he could certainly have modelled bronzes for himself without the aid of anyone we should normally list as a sculptor. Nor should we forget Girolamo Lucenti, marble sculptor, coin engraver, silversmith, gun-maker and artillery expert, as well as a bronze founder who executed many of the later bronzes by Bernini.[56] But then Lucenti was a rather exceptional character, who straddled the line between founders and sculptors. Another who broke from the usual limitations of the craftsman–founder was Matteo Bonarelli, rather better known as the cuckolded husband of Bernini's mistress Costanza Piccolomini.[57] He

Fig. 68 Nicolas Cordier, *Henri IV*, bronze. Rome. S. Giovanni in Laterano.

Fig. 69 Alessandro Algardi, *Apostle*, partly gilt bronze. Rome, Gesù.

Fig. 70 Domenico Guidi, *Apostle*, bronze. Rome, Gesù.

Fig. 71 Domenico Guidi, *Bust of Alexander VIII*, bronze. Rome, Collection Principe Ottoboni.

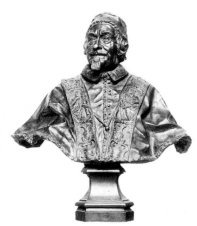

worked for Bernini in St Peter's, on the relief over the balcony of *St Longinus*, and made a putto for the tomb of Countess Matilda (Fig. 10),[58] and was later employed on the incrustation of the nave pillars,[59] as well as restoring ancient sculpture for the Pamphilj;[60] but he was more active as a founder, casting on the orders of Velázquez not only replicas of antique marbles such as the *Hermaphrodite*,[61] but also the twelve *Lions* (some of which guard the throne in the Royal Palace, while others now support stone tables in the Prado) which were apparently made from his own models.[62]

While founders who could create their own models were rare, sculptors who cast their own models were even rarer. In fact, throughout the seventeenth century there were, to my knowledge, only two sculptors in Rome who were capable of casting their own statues in bronze. One of these was Domenico Guidi,[63] whose earliest known works were the bronzes modelled by his uncle Giuliano Finelli for the chapel of S. Gennaro in Naples, where Guidi was employed as a founder and no doubt trained by the far more experienced Roman founder Gregorio de Rossi.[64] After the revolt of Massaniello in 1647, Guidi found it prudent to leave Naples for Rome, and worked as a general assistant to Algardi, casting a number of his bronzes, such as the *St Michael* for Bologna,[65] and the two *Apostles* (Fig. 69) which Algardi had modelled for the Gesù.[66] These *Apostles* were actually cast after Algardi's death in 1654, and Guidi was then commissioned to make further *Apostle* statuettes of his own to add to the series, including, very probably, one rather florid variation on Algardi's invention (Fig. 70).[67] He also produced several bronze busts, such as that of Nicolao Cotoner for his tomb in Valletta,[68] or the portrait of Alexander VIII (Fig. 71), which he made in 1690 for the pope's great-nephew Cardinal Ottoboni, of which his accounts include the model, wax, bronze, casting, and the cleaning of both the wax and the metal.[69] But the only full-size bronze figure from his own model is the *Crucifix* in the Pantheon of the Escorial, a heavy and uninspired variant of that which Algardi had made for Cardinal Giacomo Franzone.[70] As a

sculptor, Domenico Guidi remains, as one might expect from his Carrarese origins, primarily a marble man.

The other sculptor was of a quite different calibre. Francesco Mochi was a Tuscan from Montevarchi, and it is probably no coincidence that he was brought up in Florence, where the tradition of Giambologna's workshop was very much alive.[71]

Just as Giambologna had lost patience with the founders who were casting his statue of *Neptune* in Bologna, and in 1566 took it over himself,[72] so Mochi in Piacenza quarrelled with the founders of his two great equestrian monuments of Alessandro and Ranuccio Farnese, and assumed the direction of the work.[73] It may be this direct feeling for the material that enabled him, when he recast the model of Alessandro Farnese with the head of Carlo Barberini, to produce the most exciting small bronze of the whole baroque era (Fig. 72).[74] By the time Nicodemus Tessin the Younger visited the Barberini Palace in the 1680s it had acquired the usual attribution to Bernini, but it was not for this that he listed it as one of the finest works in that rich collection, writing of the fiery action of the horse, and of the wind that catches the drapery and tosses the horse's mane and tail so that, as he says, it

Fig. 72 Francesco Mochi, *Carlo Barberini*, bronze. Rome, Collection Principe Barberini.

Fig. 73 Francesco Mochi, *St Veronica*, bronze. Private Collection.

Fig. 74 Nicolas Cordier, *Paul V*, bronze. Rimini.

would be hard to imagine such a subject better treated, and both horse and rider appear quite exceptionally 'bold, haughty and proud'.[75] These qualities, already present in the wax model now in the Bargello, and in the full-size equestrian statue in Piacenza, are given added force by the quality of the bronze-working, its crisp finish and the linear strength in the chiselled folds of the cloak, the strongly modelled sinews of the arms, and the whipping leather tabs of his armour.

Something of the same immediate urgency informs his cast of the model (Fig. 73) for the statue of *St Veronica* (Fig. 37), which is apparently one of two such preliminary models that he made, for another, also cast in bronze, was engraved in the collection of the French sculptor François Girardon.[76] It differs very considerably from the final marble in St Peter's, with the iconographic peculiarity that the image of Christ is imprinted not on a separate sudarium, but on the end of her own veil. The gusts of wind against the figure, that had seemed so absurd to Bernini,[77] are here blowing even more strongly, and the sense of rushing movement that Passeri maintained denied the essentially static nature of a statue,[78] is even more intense. But what this small bronze demostrates, like the statuette of Carlo Barberini, is that freshness and spontaneity of a model converted into a fully finished bronze, a combination that is very seldom achieved, and that can surely be attributed to the control which the artist himself exercised over every stage of its creation.

There was nothing to stop other artists casting their own bronzes, and only ignorance of the complexities of the casting process, or a preference for leaving such technical work to those with specialist knowledge and skills, kept the majority of sculptors from undertaking such a task. With silver it was rather different; for, while there was nothing in law that prevented a sculptor from making a silver cast, the guild of the goldsmiths and silversmiths held a monopoly, extended by their statutes, so that by the eighteenth century no one else was allowed to make or sell works in silver.[79] Effectively, silver-working was restricted to the members of the guild, and I know of no sculptor who actually cast in silver.

We have so far examined various methods of producing bronzes: the sculptor/founder who offers his own work for sale; the patron who pays individually for the model and the various processes of casting it;[80] the founders who accept commissions and themselves employ the sculptors to make the models they are to incorporate; the sculptors and founders who accept a commission together, as a team; the founders or silversmiths who make their own models; and the sculptors who cast their own bronzes. This leaves the last method, the one most people think of when they consider bronze sculpture: that by which the sculptor acccepts the commission and retains the responsibility for providing a completed bronze cast, employing the founder on his own initiative. By now it is hardly necessary to point out that this was only one of the possible ways of producing metal sculpture, and possibly not the most usual.

It was, however, the method by which Nicolas Cordier made his over-life-size bronze figure of the seated Paul V for Rimini (Fig. 74).[81] It was with the founder Sebastiano Sebastiani that Cordier signed a contract in 1611;[82] Sebastiani came from Recanati, which is not all that far from Rimini, so it is likely that it was the authorities in Rimini who selected the founder, rather than Cordier who, as we have seen, had extremely close connections with

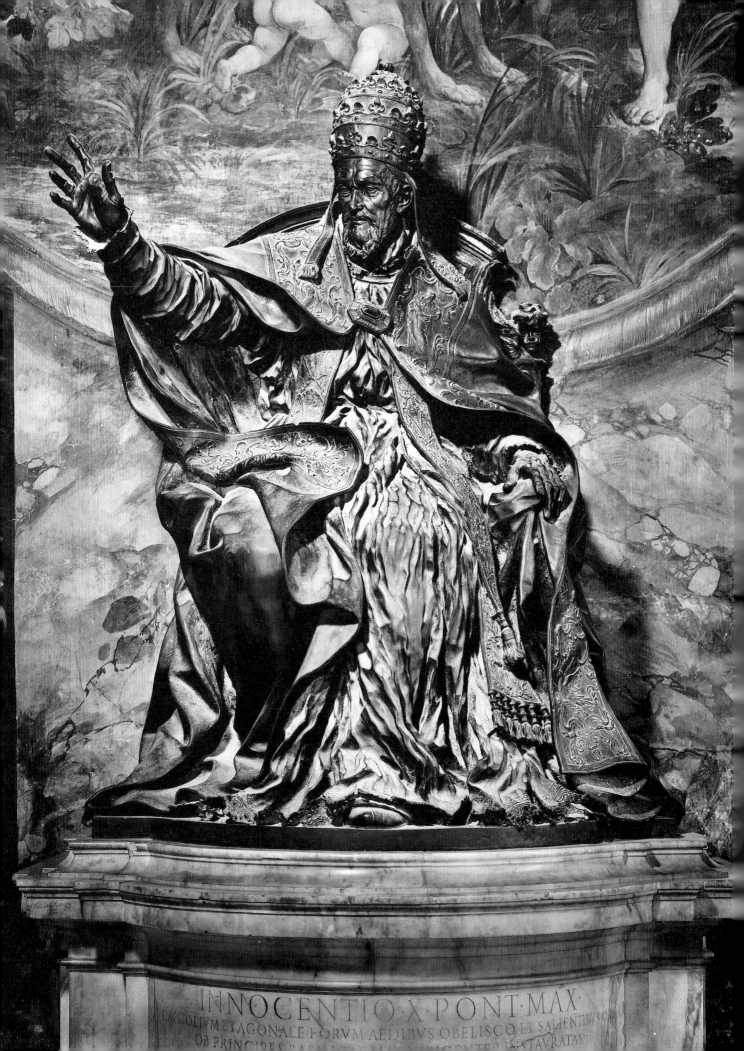

INNOCENTIO·X·PONT·MAX·
CAPITOLIVM·ET·AGONALE·FORVM·AEDIBVS·OBELISCO·ET·SALIENTIBVS·OR·
OB·PRINCIPES·BASILICAE·VATICANAE·MAGNIFICENTER·INSTAVRATAS·

other founders in Rome. Sebastiani journeyed to Rome for the express purpose of making this statue, which it was agreed should be cast in that city where Cordier was established, though, in the event, the model was shipped to Recanati and the bronze cast there. Cordier was paid a total of 2,800 *scudi* for the statue, of which he agreed to pay 2,000 to Sebastiani, so that he himself received 800 *scudi* for the model, and for the cleaned and repaired wax which he was to pass to Sebastiani; all other costs, for the material, casting, repairing, fitting together of the cast which was made in three pieces, and setting it up in Rimini, were to be borne by Sebastiani. So, even if Cordier had not died before the completion of the statue, he would have had no responsibility for the cleaning, chiselling, and filing of the bronze – all work that is so vital for the appearance of the surface of the statue – though had it been made in Rome he would at least have overseen it. Unfortunately the documentation is somewhat confused, and it is not clear whether the model sent to Recanati was Cordier's original, or the cleaned wax ready for casting that was promised to him; it seems more likely that it was the former, for without this original model he would have had no guidance for the repair of the bronze, and, more dangerous, no means of recasting the work should the first cast have failed.[83]

This was by no means an uncommon occurrence. It was to happen with the similar-sized statue of Innocent X (Fig. 75), made by Algardi for the Holy Year of 1650.[84] In this case we do not have the contract with the founder, but its terms were presumably rather different, for it seems to have been Algardi himself who bore not only the shame of this failure, but also the very considerable cost involved, which would have included at least a partial loss of the bronze, as well as the expense of preparing a new model and of casting it a second time. As for the shame, Algardi might have pointed out that the most directly comparable work of recent years, Bernini's statue of Urban VIII on his tomb (Fig. 124), had not been entirely successful: the stole over his left shoulder came out of the mould so defective that it had to be patched over in beaten metal,[85] but this had been done so skilfully that only if one stands on the tomb can one see the repair – and Bernini was certainly not a man to trumpet his failures abroad, or to attempt to console Algardi as others did. Friends such as Virgilio Spada came to his aid with sums of money, while the Pope, typically, chose a cheaper way of showing his continuing confidence by making the sculptor a Cavaliere di Cristo. Algardi proudly wore his cross, the insignia of the order, leaving his rival Francesco Mochi, who justly believed that the commission for the statue should have gone to him, to mutter that he had known the cross to be the reward of thieves, but had not thought to see them glorying in it.[86]

We know no more of the second casting than of the first, except that it succeeded perfectly. But, perhaps because of the earlier set-back and the need to get the work completed by a set date, the surface remains remarkably unfinished – bits of lace unrepaired, the undercutting hacked out of the cold bronze with great blows of the chisel, and many details, such as the cherub head on the back of the throne, scarcely finished at all (Fig. 76).

There are variations on this method that are often encountered. For example, the sculptor may accept full responsibility, but his payment will be determined according to the actual costs involved, and not set in advance. This seems to have been the case with the bronze relief of the *Beheading of St Paul* (Fig. 77) which Algardi made to set in the altar below his marble group

Fig. 75 Alessandro Algardi, *Innocent X*, bronze. Rome, Palazzo dei Conservatori.

Fig. 76 Alessandro Algardi, detail of the statue of *Innocent X*, bronze. Rome, Palazzo dei Conservatori.

Fig. 77 Alessandro Algardi, *The Beheading of St Paul*, bronze. Bologna, S. Paolo.

Fig. 78 Alessandro Algardi, *The Beheading of St Paul*, bronze. Rabat, Museum of St Paul's Collegiate Church.

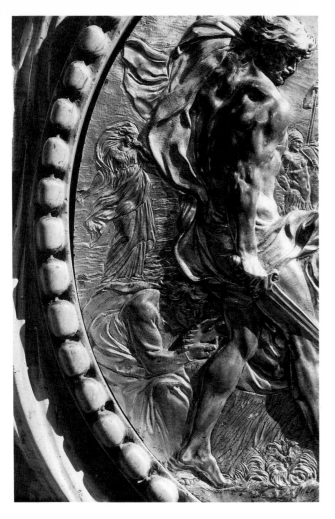

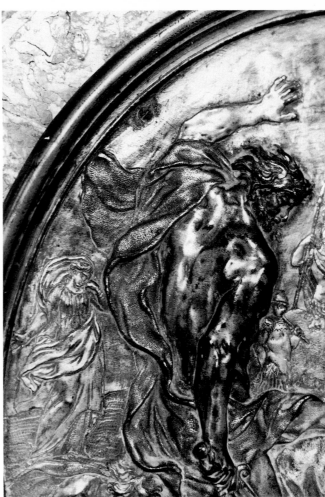

of the *Execution* in the Spada Chapel in Bologna.[87] It represents the moment when the head has been struck from the body, and, as it falls, it bounces three times on the ground; from each spot where it hits the ground a fountain springs up, to the astonishment of the executioner and the wonder of the bystanders. The payments include an entry dated 2 October 1648 of 80 *scudi* to Algardi 'for a medallion of gilt bronze for the chapel in Bologna'; the fact that it is for a medallion of bronze, not a clay model for a medallion, suggests that Algardi himself bore the costs itemized on a separate sheet, which include that for the casting, 10 *scudi* paid to 'Maestro Cesare *fonditore*' (presumably Cesare Sebastiani), for twenty days' work spent in making a plaster mould from the model, casting the wax, making a mould from that, and casting the bronze. This 10 *scudi* should be compared with the 15 *scudi* paid to a certain 'Monsù Pietro', whom I cannot further identify, for cleaning the medallion, that is to say the afterwork on the surface of the bronze.[88]

Just how important this work was we can judge by comparing the original cast in Bologna with one in Rabat in Malta (Fig. 78), which was sent there in 1681–2, so that it is the only one of the numerous replicas that we can be certain was made in the seventeenth century.[89] Monsù Pietro must have been working under Algardi's direct supervision, and to his skilled chasing we owe the light, quivering leaves on the tree at the right, and the delicate but firm indication of the hillocky landscape beyond it. Details of the executioner's cloak (Fig. 79), the sensitive preservation of the original

Fig. 79 Alessadro Algardi, detail of *The Beheading of St Paul*, bronze. Bologna, S. Paolo.

Fig. 80 Alessandro Algardi, detail of *The Beheading of St Paul*, bronze. Rabat, Museum of St Paul's Collegiate Church.

Fig. 81 Melchiorre Cafà, *Bust of Alexander VII*, bronze. Siena, Cathedral.

modelling and the softly filed texturing contrast with the coarser hammering of the Rabat version (Fig. 80), and the beautiful weeping woman has a swaying movement, and, even on this diminutive scale of some five inches, a solid structure, both of which are lost in the later cast.

A similar method was used by Melchiorre Cafà when he made the bust of Alexander VII (Fig. 81) for the pope's nephew Cardinal Flavio Chigi, submitting a list of expenses included in the making of the mould and the casting of the bronze by Giovanni Artusi, and the finishing and the gilding of the stole, leaving the payment for his own labours 'to the pleasure of His Excellency'.[90] This was only just before Cafà's untimely end in September 1667, when a plaster model prepared for the altar of the Co-Cathedral in Valletta fell and crushed him, and the terracotta remained in the Chigi palace, where, according to his biographer, it 'served to mould and cast many others'.[91]

None of these methods could be applied to what was the greatest bronze structure of the Roman baroque, the *Baldacchino* in St Peter's (Fig. 82).[92] At more than 28 metres high, its construction involved problems of architecture and engineering rather than sculpture, and the direction of the work was not unlike that of building a palace. Undoubtedly Bernini was in charge, doubly so for he was not only responsible for the design but he also held the post of architect of St Peter's, and he received a substantial salary as well as a princely honorarium, while each of the host of sculptors, carpenters, founders, brass-workers and gilders employed on the project was paid individually by the Fabbrica of St Peter's, at a rate approved by Bernini.

The columns were cast from wooden models, two models serving for the four columns; they were cast in five sections each, including the capitals. Each section of the columns fits by means of an internal collar into the one below, and wedges have been driven in, through the collar and into the core with which the columns are filled, to ensure that they fit plumb and to hold them secure (Fig. 83); in fact, in some places ungilt lead has been run in between the sections to adjust the angle. There are differences between the two pairs of capitals that do not seem to have any logical reason, for example, on one pair the suns are cast in one with the capitals, and the suns' rays are joined by a circular tube (Fig. 86), possibly used for the casting and retained for strength, whereas on the other pair the suns seem to have been cast separately and fixed with brackets running over the tops of the capitals (Fig. 84). As we shall see, different founders were responsible for the two pairs.

Vast as they are, the four columns were completed quite quickly, between 1624 and 1627 when they were set in place upon their pedestals. A statement presented on Bernini's behalf, outlining his work on the columns, claims that he had made the designs and the small and large models, that he had made the plaster moulds and cast the wax, that he had cleaned the wax casts and fitted them together to cast the metal, that he had attached the tubes for the metal to enter and the air to escape, that he had worked with the foreman to cover the wax in its final mould, to bind the moulds with metal, heat out the wax, bury the moulds in the ground for greater strength, melt the metal, and cast the twenty pieces. In sum, he had himself worked with his hands on the casting of the columns for three years, and, as the document emphasises, there was a considerable difference between working in his own house, and going to St Peter's through the hot sun and the pouring rain, even at night-time, and working at the furnace at great risk to his life.[93]

70

Fig. 82 Gianlorenzo Bernini, the *Baldacchino*, partly gilt bronze. Vatican, St Peter's.

Fig. 83 Gianlorenzo Bernini and assistants, detail of a column of the *Baldacchino*, partly gilt bronze. Vatican, St Peter's.

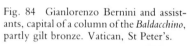

Fig. 84 Gianlorenzo Bernini and assistants, capital of a column of the *Baldacchino*, partly gilt bronze. Vatican, St Peter's.

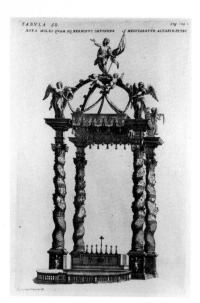

Fig. 85 Girolamo Frezza after Gianlorenzo Bernini, project for the *Baldacchino* with the *Risen Christ*, engraving (from F. Buonanni, *Numismata.... Templi Vaticani indicantia*, Rome, 1696).

After reading this it comes as a bit of a shock to find that Bernini drew up contracts with the most experienced founders of the day to cast each of the four columns.[94] One was made by Giacomo Laurentiani, the second by the same Laurentiani together with Orazio Albrici, and the last two by Gregorio de Rossi, Antonio Beltramelli, Ambrogio Lucenti and Innocenzo Albertino. According to these contracts, the founders were bound, as we might expect, not only to cast the bronze, but also to cast the waxes, make the moulds, and even to fit the sections together. Bernini, however, reserved to himself the task of cleaning and repairing the wax casts, and also the final cleaning and chasing of the bronze casts, both extremely important steps in the creation of the work, and particularly vital for its artistic effect, but not quite what the enumeration of his labours would have led us to expect. Nor, indeed, was even this done entirely with his own hands, for payments exist to other sculptors for the repair of the waxes.[95]

Once the columns were completed, with no evident hitches, the work came more or less to a halt. The major problem was that Bernini intended the columns to be joined by arched ribs, on the central crossing of which was to be placed a huge bronze statue of the *Risen Christ* (Fig. 85). Beneath this structure was the altar at which the pope was to say mass. It would be hardly surprising if the pope were hesitant about saying mass at the altar with several hundred pounds of bronze above his head, even in the form of the Saviour. Bernini had to think again. Even though the figure of Christ was not cast and finished until 1633, by 1631 work was already under way on a completely changed plan. Not only was a new, and more balanced shape evolved for the top of the *Baldacchino*, probably by the engineering genius Francesco Borromini, but the whole superstructure (Fig. 86) was created by a piece of brilliant theatrical illusion.

The great cornice is solid enough, cast in bronze (incidentally, like the statue of Urban VIII, over a core made partially of brick); there was no need to remove the large square nails that helped to hold the core suspended within the mould, though the square rods were withdrawn and their holes left unplugged. Even in photographs the difference between the laurel on the cornice and that on the columns is evident, and seen close to it is clear that the leaves on the cornice were carved in wooden moulds.[96] The four splendid *Angels* at the corners, which had been part of the first campaign, together with the columns on which they stand, are similarly cast in bronze, and their weight borne securely by the columns. But the garlands they hold are mere brass leaves attached to a thin wooden pole, and all the rest is made of light hammered brass over a wooden core; the pairs of putti seated on the cornice are of hollow beaten brass, and the top of the *Baldacchino* itself is of wood, for structural reasons rising in steps to form a shallow square dome and covered only on its underside with plaques of beaten metal. Even those great square-sectioned ribs are fake, for the real structural member is a third beam that rises up behind the *Angels*. Nor is the colour entirely genuine, for when the brass was gilded the firing altered the patina, and parts of this had to be retouched with varnish.[97] One could, on the other hand, describe the hanging tassels as more genuine than they appear, for they are attached by rings, and are actually mobile.

The difficulties Bernini had with this piece of bronze architecture emerge not only from the radical change of plan, but also from the accounts of the carpenter Giovanni Battista Soria (1581–1651) for the model of the super-

Fig. 86 Gianlorenzo Bernini and assistants, upper part of the *Baldacchino*, partly gilt bronze and copper. Vatican, St Peter's.

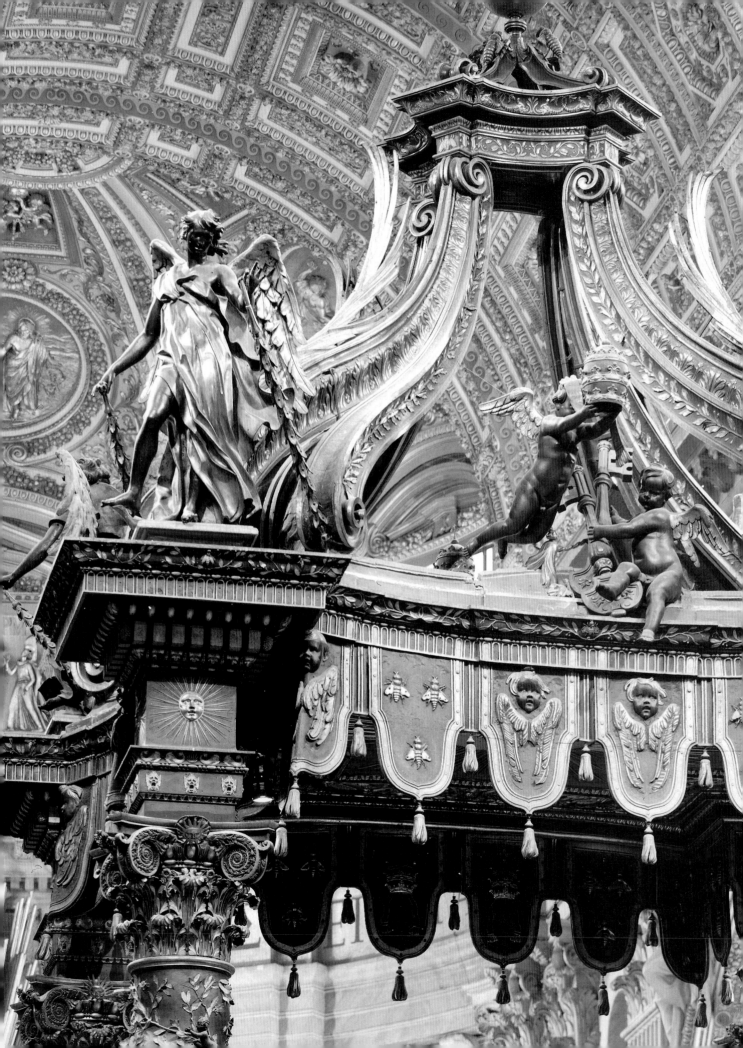

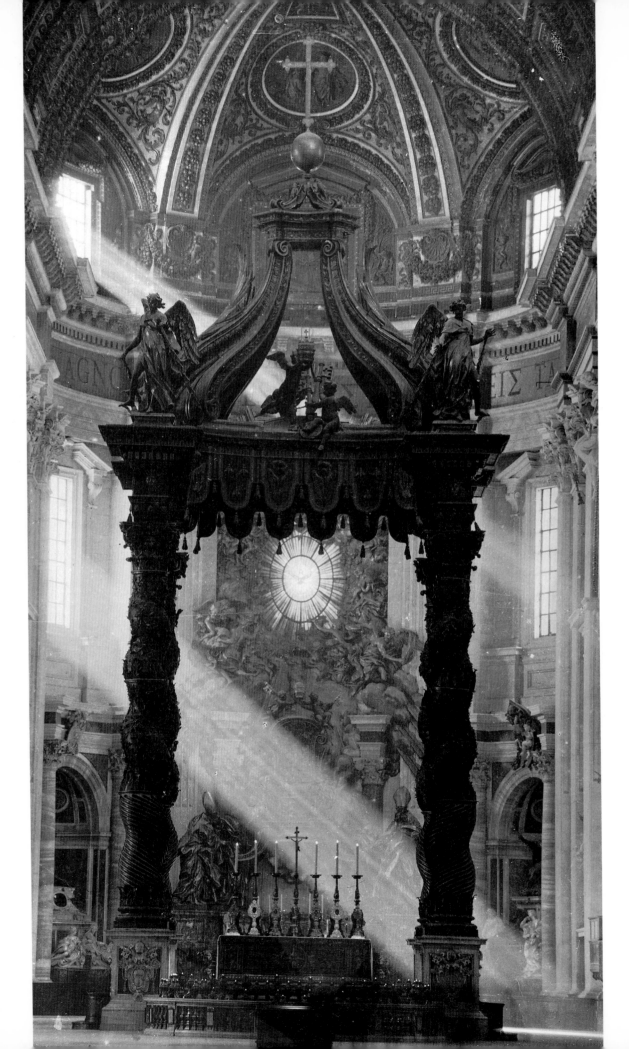

structure, with his repeated words 'adjusted according to need', 'moved several times to alter them according to need', 'moved more than once, that is, enlarged, and reduced, according to the needs of Signor Architetto', 'made and remade in more than two, or three manners, with great waste of wood', 'after having roughed them out in one manner, taken them down and again replaced the wood, and recut them as many times as was necessary', and so forth.[98]

Yet as we look at it today, it seems as if this was how it must always have been meant to be, just as, from the floor, all appears equally solid (Fig. 87). We are confronted with a masterpiece of architecture, sculpture, and theatrical illusion. To read the documents and to examine the structure is to realise the immense labour involved, a labour for which Bernini could not have overstated his own ultimate responsibility, but in which the part of the bronze-founders should never be underestimated.

Fig. 87 Gianlorenzo Bernini, the *Baldacchino*, partly gilt bronze. Vatican, St Peter's.

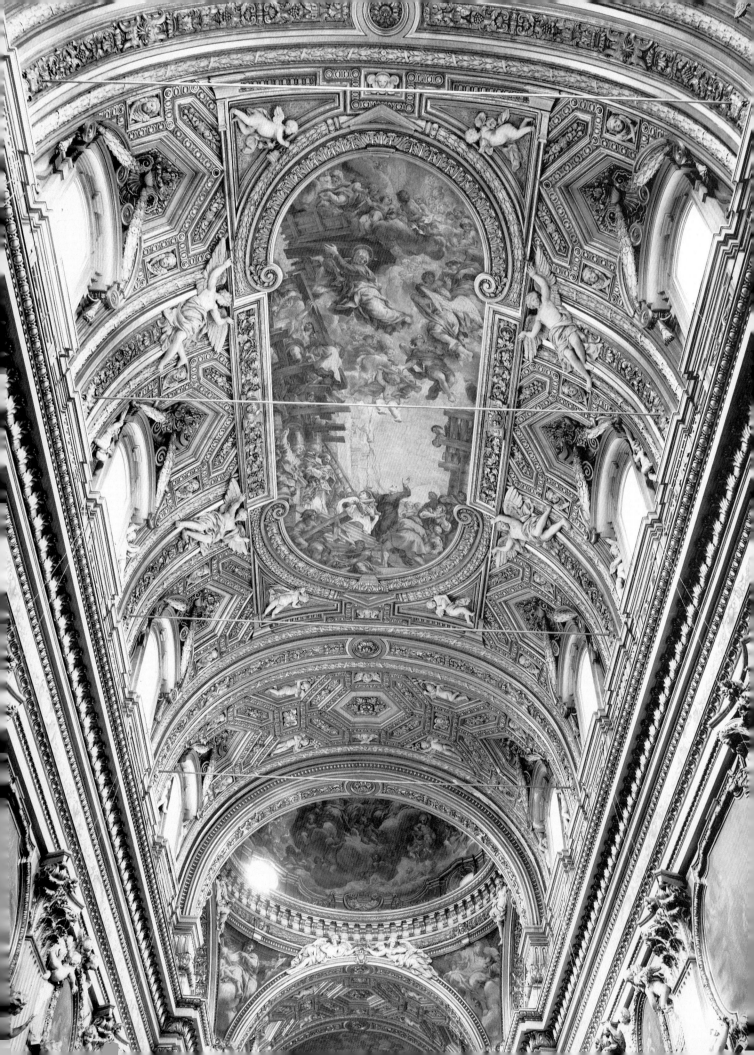

IV

THE SCULPTOR AS EXECUTANT[1]

If the history of seicento sculpture has attracted fewer students than that of
painting or architecture, and if it is rare to encounter a monographic study of
a baroque sculptor below the first rank, there are several very good reasons
for this, one of which will be examined in this chapter.

According to traditional theory, Painting, Sculpture and Architecture
were three sisters, all born of *Disegno*, a word which encompasses both
drawing in the limited sense, and design, in the sense of invention.[2] Ideally,
this might be so, but in practice very few sculptors appear to have been able
to draw,[3] and while this need not, of course, prevent them from designing,
working out their ideas in clay, or even in atrociously bad drawings, more
often it meant that they were content to work on designs provided for them
by other artists, whether painters or architects, or, as will be discussed in
the two following chapters, more inventive sculptors. Not surprisingly,
this dependence is a serious discouragement to anyone who might think of
undertaking a monographic study, for such sculptors cannot be looked at in
isolation, but only as part of an artistic milieu, and in relation to those
ultimately responsible for the projects on which they were employed.

Yet this is not to say that they are not of interest. The formation of such a
milieu, the relationship established between the sculptors and the architect in
charge of a building, or the painter creating a decorative ensemble, is of the
essence of baroque art. It is a commonplace to say that baroque art is one
which combines architecture, painting and sculpture within a unity, so the
question of who created this unity, and how this association actually
worked, is a subject that one cannot afford to overlook.[4] Nor can it be taken
for granted that the sculptor was always the docile or mechanical executant
of a fully worked-out design (Fig. 89).

Indeed, the word 'executant', used in the title of this chapter, may be
misleading; the designs given to the sculptors were not always precise, and,
even when they were, and were followed with a fair degree of accuracy, it
was left to the sculptor's skill to convert them into satisfying three-
dimensional works of art. And there are a number of sculptures designed by
painters which, through the addition of that feeling for three-dimensional

Fig. 88 Pietro da Cortona and others,
vault of Sta Maria in Vallicella, fresco and
stucco. Rome.

Fig. 89 Pierre Brebiette, *The Sculptor
Working under Instruction from the Painter*,
engraving (from Charles Patin, *Imper-
atorum romanorum numismata*, 1671).

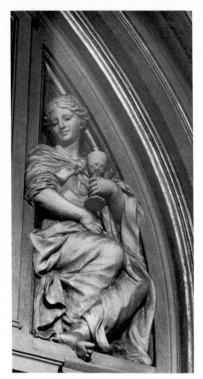

Fig. 90 Attributed to Cosimo Fancelli, *Faith*, stucco. Rome, Sta Maria in Vallicella.

Fig. 91 Attributed to Ercole Ferrata, *Religion*, stucco. Rome, Sta Maria in Vallicella.

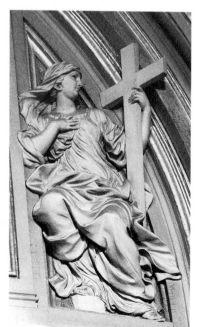

form, for the play of one plane against another, the contrast of solid and void, the interaction of line and mass, are more sculpturally exciting than many of the autonomous works produced by lesser sculptors.[5]

A number of the less inventive sculptors continued throughout their lives to receive commissions through painters or architects, some of them forming what might be called stable relationships. Thereby the sulptor might learn from the painter, as Pascoli says that Rusconi learnt from his friend Carlo Maratti a skill in handling drapery and disposing the folds, a nobility in the heads, and a grace in the gestures of the hands.[6] For the painter there was also an advantage, for he would often be called upon to design sculptures, and he would know that he could rely upon his chosen sculptor to execute them in the manner required, and the sculptor, by a mixture of natural inclination and constant practice, would come to work in a three-dimensional equivalent of the painter's style.[7]

The best example of such a relationship is that which developed between Pietro da Cortona and Cosimo Fancelli, one of mutual friendship, in which the painter protected and fostered the career of the sculptor. It was through Pietro da Cortona that Fancelli was employed on the stuccoes of the vault of Sta Maria in Vallicella (Fig. 88), executing those of the lantern and 'a putto of ten *palmi* made as a demonstration on the arch of the cupola'.[8] He continued this work under the aegis of Cortona, with various collaborators, of whom the foremost was Ercole Ferrata.[9] No drawings by Cortona for this project are known,[10] but many of the payments were specifically made 'on the orders of Signor Pietro', and it was certainly he who designed the ceiling, with its rich harmonies of white and gold around his own painting of *St Philip Neri's Vision of the Virgin*,[11] into which the stucco putti and angels are inserted, and he must also have provided drawings for the angels who recline on the arches of the crossing, as for the pairs of personifications in the window lunettes (Fig. 90). But well before the nave was completed, Fancelli had adopted as his own this style of broad, round heads, sleepy eyes with deeply hollowed pupils, and softly sweeping draperies, which make his figures look like the inventions of Pietro da Cortona even when he was working on the designs of another artist. This style is less noticeable in the personification of Religion holding the Cross (Fig. 91), who wears a floating veil reminiscent of that to be found on many of Algardi's sculptures, so that it seems safe to attribute her to Ercole Ferrata.[12]

It was Cosimo Fancelli who modelled the stuccoes in Sta Maria della Pace (Fig. 93), when Pietro da Cortona renovated the church for Alexander VII during the 1650s,[13] and in this case there is a drawing (Fig. 92) which can be compared with the finished work.[14] On it, Cortona indicates two graceful Virtues reclining on the arch, as yet unidentified by any attributes. One can be sure that the decision to characterise them as Fortitude and Prudence was made neither by the architect nor the sculptor, but by some theological adviser who must have determined the general iconographic programme for the church, with Peace and Justice opposite them on the entrance wall, but for the other changes there is no such certainty.

Between the drawing and the execution there has been a switch towards greater simplicity and logic. The fancy background to the figures has wisely been abandoned, so that they stand out more clearly (though the drapery of Prudence fans out almost like a memory of this shell-like fluting), and the Virtues no longer loll nonchalantly on the arch producing a slightly uncom-

Fig. 92 Pietro da Cortona, drawing for the chancel arch of Sta Maria della Pace. Windsor, Royal Library.

Fig. 93 Cosimo Fancelli, chancel arch, stucco. Rome, Sta Maria della Pace.

fortable feeling that there is nothing to stop them sliding down it. They have now been provided with seats, hidden, but at the same time indicated by the folds of their cloaks, and even Fortitude's column has a ledge to rest upon. Not only are they enlarged, but they overlap the framework more defiantly. They have become more sculptural, not just fillings for an otherwise empty space, but features of the church which demand our attention.

So who decided on the changes? There is, of course, no correspondence between people all of whom were present in Rome, still less any record of the discussions that might have taken place; rash though it may be to speculate in such cases, I believe that one may, none the less, suggest an answer. While the patron may have made some suggestions, and Alexander VII did take a great personal interest in all his artistic commissions,[15] the precise solution would most likely have been worked out between the architect and the sculptor, and, while it would certainly have required Cortona's approval, it seems safe to conclude that Fancelli would have had a decisive say in the matter. If one looks at the drawing, it appears, as indeed it is, the work of an architect/painter, and, were these Virtues to have been painted by Cortona himself, they would have served well enough; but in white stucco something firmer and more emphatic was required, and it is not unreasonable to suppose that the sculptor would have been better placed than the painter to recognise this need, and to demand for his figures a more prominent place in the decorative scheme.

Within this church of Sta Maria della Pace is an altar designed by Pietro da Cortona. It has received less attention than it merits, because above the entrance arch is one of Raphael's most inspiring masterpieces, the fresco of the *Four Sibyls*;[16] in the area of the altarpiece beneath the fresco, where Raphael had intended to paint the *Resurrection*, Cortona has sensibly refrained from attempting to compete with him, providing not a painted altarpiece by his own hand, but a bronze relief modelled from his drawing by Cosimo Fancelli (Fig. 94).[17] To comment on the differences between the drawing (Fig. 95)[18] and the relief would, again, be to offer hostages to fortune, for one can never be certain that another drawing may not emerge, enlarging the composition and setting Christ in a more upright position. In any case, the compositional differences are too obvious to need any commentary.

But there are differences which concern specifically the transfer of the design from one medium to another. In his drawing Cortona has himself clearly taken the limitations of sculpture into account, keeping his design within a strictly limited depth; even so, Fancelli has had to change the representation of the cross, presenting the front plane almost directly towards the spectator, and giving no indication of the thickness of the wood. The drawing provides no hint of the unusual decision to treat the background of the relief as a solid plane, and to thrust the figures of the Trinity forward from it into our space, with the dead Christ borne out towards us, emerging from the frame as if the angels were about to place Him upon the altar. Although the subject is, strictly speaking, the Trinity,[19] the theme of the image is the transubstantiation of the eucharist, and even the care the angels take not to touch the naked flesh of Christ, but to hold it within the shroud, symbolises the mystery and sanctity surrounding the host.

Whether or not Cortona made further studies, I suspect it was he, rather than the sculptor, who took this decision to model the relief projecting, rather than receding, and overlapping the confines of the bronze frame. It is

Fig. 94 (*p. 80*) Cosimo Fancelli, *The Trinity*, bronze. Rome, Sta Maria della Pace, Chigi chapel.

Fig. 95 (*previous page*) Pietro da Cortona, drawing of *The Trinity*. Hobhouse Collection?

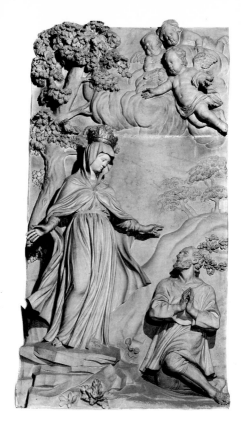

not unknown for sculptors to get slightly confused about the spatial depth of their reliefs (relief is a very sophisticated and difficult medium in which to compose a spatially complex image), but here it appears to have been the additional problem of translating a graphic design into three dimensions which left Fancelli somewhat uncertain as to where the lower part of God the Father should be. Similarly, the composition as a whole, with its myriad reflections on the surface of the dark bronze, is more crowded and difficult to read than the graphic model provided by Cortona, especially in the dark recess of the rounded chapel niche; it is to compensate for this that Fancelli has deliberately contrasted the smooth flesh of Christ's body with the highly worked, almost worried drapery of the figures surrounding Him, in an attempt to ensure that the central motif, the eucharistic body of the Saviour, remains clear and distinct.

It is uncertain whether the altar of the Gavotti chapel in S. Nicola da Tolentino (Fig. 96) was designed by Pietro da Cortona, who was responsible for the architecture of the chapel, or by Ciro Ferri who carried it to completion in 1679, ten years after Cortona's death.[20] Once again, it was Cosimo Fancelli who executed the marble relief, most probably on the design of Cortona.[21] A rather coarse terracotta model (Fig. 97) establishes the relationship of the figures and the disposition of the landscape, which fills quite a large proportion of this image of the Virgin's miraculous appearance to a peasant above the hills of Savona. Behind this solution it is possible to discern the thinking of a painter, accustomed to use atmospheric perspective to facilitate the distinction between foreground and distance, and whose brush could play among the leaves of the tree and the ripples of the stream. Such effects could be imitated to some extent in terracotta, but much less easily in marble; between the terracotta sketch and the marble

Fig. 98 Cosimo Fancelli, medallion on the urn beneath the altar of the Gavotti Chapel, gilt bronze. Rome, S. Nicola da Tolentino.

Fig. 99 Ciro Ferri, drawing for the altar of the Gavotti chapel. Rome, Istituto Nazionale per la Grafica.

altarpiece the sculptor has enlarged and simplified the image of the Virgin, who now corresponds to the traditional cult image, rather than a living woman, and has reduced the rôle of the landscape to accommodate the limitations of his chisel.

One detail of the chapel that can be incontrovertibly ascribed to Ferri is the gilt medallion of two martyr saints (Fig. 98) on the sarcophagus below the altar. Here it is more than likely that the slight sketch by Ciro Ferri (Fig. 99)[22] was succeeded by a more finished drawing establishing the actual proportions of the sarcophagus, but the awkward crowding of the two busts within the oval frame, which had worked well enough in the sketch, is further evidence of the difficulty of transferring a design from a drawing to sculpture.

Ciro Ferri was an artist even more involved in the design of sculpture than was his teacher Cortona. Like Cortona, he was both a painter and an architect, but he was particularly renowned for his ornamental designs, in which a contemporary described him as richly inventive, ready, and 'bizzar',[23] that term of high praise which might be rather inadequately translated as 'original'. It must have been these qualities which particularly appealed to Cardinal Francesco Barberini Senior, who, it is clear, made greater use of his talents than even the numerous references to him in the Cardinal's account books would suggest.

Among the most extensive of his commissions was the chapel of St Sebastian in S. Sebastiano fuori le Mura (Fig. 101), which the Cardinal decided to redecorate in the form of a confessional after the discovery in 1672 of the saint's relics beneath the floor.[24] It was Ciro Ferri who designed the chapel with its colourful inlay of various marbles, and the altar with its large slab of amethyst and gilt bronze embellishments.[25] The bronzes on this altar were made by the silversmith Carlo Spagna, and it was he who cast the formerly gilded bronze lamps (Fig. 100), from wooden models that had been carved by Giovanni Maria Giorgetti on the designs of Ciro Ferri.[26] With such elaborate pieces of metalwork as these one is in an area where ornamental bronzes merge into sculpture proper, but perhaps even on the strictest interpretation one would be justified in classing the Barberini bees on them as sculpture.[27]

Below the altar lies the body of the saint (Fig. 102), carved in marble by Giovanni Maria Giorgetti's son Giuseppe. In all probability the model had

Fig. 100 Carlo Spagna, lamp, bronze. Rome, S. Sebastiano fuori le Mura, chapel of St Sebastian.

Fig. 101 (facing) Chapel of St Sebastian. Rome, S. Sebastiano fuori le Mura.

been made by Giuseppe's brother Antonio, before his early death in 1669. But the style of the figure is not that of Antonio's other works, and I have no doubt that for this too Ferri provided the design, for the graceful torsion of the pose and the small flickering folds of the drapery fit exactly into his vocabulary. Neither of the Giorgetti brothers can claim a very extensive *oeuvre*, and Giuseppe in particular appears to have been a third-rate sculptor. In the figure of *St Sebastian*, an image of the repose of death with no memory of its agony, on whose lips hovers a sweet smile of beatitude, Giuseppe Giorgetti rises to a height which he could never have achieved unaided, to create one of the most justly admired of those images of dead saints that lie beneath the altars of Rome.

The bronze arrows that pierce his body were cast by Carlo Spagna,[28] and it was the same founder who cast the cover for the font in S. Giovanni in Fonte (Fig. 103), the baptistery of S. Giovanni in Laterano.[29] Here Ciro Ferri's undocumented responsibility can be proved by a succession of surviving drawings.[30] Beginning with the roughest of sketches (Fig. 104), he indicated the fronds of palm, or lily leaves, with which he planned to contrast the flame-like dome, and the oval of the image of the *Baptism*; as he defined this idea, he was able to visualise the seraphic consoles from the side (Fig. 105). It was this idea that he worked up into a very finished drawing (Fig. 106) complete with the arms of the reigning pope, Innocent XI Odescalchi, though the Barberini bees appear on the summit, both in homage to Pope Urban VIII who had restored the baptistery many years before, and in reference to his nephew, Cardinal Francesco, who paid for this imposing bronze structure. This large and precise drawing, which has all the characteristics of a presentation sheet, does not record the final design;[31] either the patron or the artist decided to revise the project, and another rapid sketch (Fig. 107) indicates a much more architectonic invention, the relief enclosed within a firmly structured frame, the dome reduced in scale and placed above a typically Cortonesque voluted pediment, and the

Fig. 102 Giuseppe Giorgetti, *St Sebastian*, marble. Rome, S. Sebastiano fuori le Mura, chapel of St Sebastian.

Fig. 103 (*top left*) Carlo Spagna, font, bronze. Rome, S. Giovanni in Fonte.

Fig. 104 (*top right*) Ciro Ferri, drawing for the cover of the Lateran font. Rome, Istituto Nazionale per la Grafica.

Fig. 105 Ciro Ferri, drawing for a console of the cover of the Lateran font. Rome, Istituto Nazionale per la Grafica.

Fig. 106 Ciro Ferri, finished drawing for the cover of the Lateran font. Rome, Istituto Nazionale per la Grafica.

Fig. 107 Ciro Ferri, drawing for the cover of the Lateran font. Rome, Istituto Nazionale per la Grafica.

scrolled brackets below the cherub heads rolled under to provide a more stable support. It was this sketch, with even greater simplification, which was finally executed in partially gilt bronze.

But by whom? Certainly Carlo Spagna cast the bronze, but as he did so for the round sum of a thousand *scudi*, a sum agreed in advance, leaving him with the responsibility for providing the models and everything else required, there was no need to give any justification of his expenses, nor for the accounts to include a payment by the patron to the sculptor.[32] While Spagna was a highly competent founder, there is no suggestion that he was also capable of modelling even the decorative parts, let alone the two oval reliefs of the *Baptism of Christ* and the *Baptism of Constantine* (Fig. 108). There is another possibility which should at least be seriously considered: that they are by Ciro Ferri himself. The Swedish architect Nicodemus Tessin the Younger, who knew and admired him, was to write that 'he also knew how to work out his ideas very skilfully and swiftly in clay, which is of great assistance to him',[33] and a number of sculptures are known which can be ascribed to him.[34] The matter cannot be decided one way or the other, but it is certain that whoever did produce the models was working very exactly on Ferri's designs, with those constantly moving folds of heavy drapery which we know from his other work; in the *Baptism of Constantine* the solidly

Fig. 108 Carlo Spagna, *The Baptism of Constantine*, bronze. Rome, S. Giovanni in Fonte.

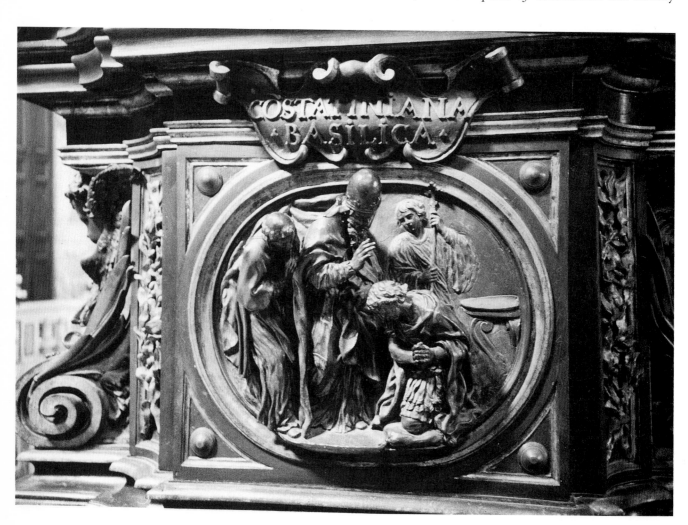

modelled figures are set before the back plane in a manner reminiscent of the bronze *Trinity* relief in Sta Maria della Pace by Ferri's teacher, while those of the *Baptism of Christ* are framed by trees like those in the sketch model for the *Madonna of Savona*.

At least when it came to large-scale figures Ferri would rely on professional sculptors to execute his designs, as in the case of the tabernacle for Sta Maria in Vallicella (Fig. 109).[35] Ferri's intentions are known from a rough sketch in the Farnesina and a finished drawing at Windsor (Fig. 110);[36] the voluted superstructure is a later addition, though it too was designed by Ferri,[37] and it certainly serves a practical function in hiding the supporting rods for the cherubim. The main difficulty, however, concerned the angels either side, and at one time the patrons even contemplated abandoning altogether this original and beautiful invention. Finally they were successfully completed and cast, and set in place rather further from the central tabernacle, but still combining with it to assert the divine mystery of the eucharist.

If the artist who made the models for these angels on Ferri's design was professional, he was hardly expert, for Ferri entrusted them to a young student at the Florentine academy in Rome, Carlo Marcellini.[38] According to Ferri, this would be an opportunity for Marcellini to make himself known in Rome, 'to the glory of the Most Serene Grand Duke [of Tuscany], the reviver of these most noble professions', but it did not quite work out that way, for until Lankheit published the correspondence in 1962, no one, so far as I know, was aware of Marcellini's participation.

Perhaps that was just as well; if one compares the finished work with the preliminary drawing in Windsor, there is less of the easy grace that Ferri had intended, and the draperies have become heavier and more angular. But

Marcellini was still a student, and Ferri, as his teacher, and as the man ultimately responsible for the success of the work, must be held to blame for any failure of the sculpture to live up fully to the delicacy of his graphic design.

It will be remembered that Ferri was not, in fact, supposed to be teaching sculpture to the young Florentines, as this was the responsibility of Ercole Ferrata;[39] yet this tabernacle exemplifies the dominance that Ferri exerted in the Florentine academy, and serves to explain why, when they returned to their native city, the Florentine sculptors continued to produce work characterised by this marked pictorialism. Ferrata was not known for his inventive facility, and throughout his life he relied on others to provide designs for his major works, either his more talented pupils, such as the Maltese Melchiorre Cafà, or Bernini, or a painter or architect. As has been seen, he worked together with Cosimo Fancelli on Cortona's design for the stuccoes of the Vallicella, and he also collaborated with him on the marble parts of the altar of the Trinity in Sta Maria della Pace. For the stucco lunettes above the marble altars in S. Agnese (Fig. 112) he depended on drawings by Ciro Ferri, who is better known for having painted the dome of the church, but whose responsibility for at least three of the lunettes over the side altars is confirmed by the existence of drawings (Fig. 111).[40]

If one compares the drawing for the lunette above the altar of St Alexis with the stucco produced by Ferrata, it is apparent that the freedom with which he has treated it is rather more apparent than real: apart from the reduction in the scale of the figures, this is limited to the greater prominence accorded to St Alexis's attribute, his pilgrim's staff – and even that is to a large extent a result of the greater space of the relief. This in turn is something that works better in sculpture than in painting, where the clouds that almost fill the sky in the drawing would look rather artificial in stucco. For the rest, almost everything in Ferri's drawing is there, but the figures at the edges are now seen from the side, taking advantage of the shallow curve of the niche, and increasing its apparent depth.[41] Here, as in Fancelli's execution of Cortona's drawings, one can see how a sculptor adapts a two-dimensional composition to the different requirements of his own medium. Unlike Fancelli, who exhibited such a close rapport with Cortona, Ferrata was a more independent character, and he has not hesitated to adapt Ferri's physiognomies to his personal manner.

The sort of relationship examined here is essentially one of a sculptor following another man's invention, and not necessarily reproducing his design in all its details and stylistic characteristics. Invention was for the seventeenth century a powerful and treasured faculty, but it was not one which was equally distributed among all artists. The word 'invention', like 'disegno', was used to signify two different capacities, or perhaps one should say two very different degrees of capacity.[42] It could mean that mental faculty which enabled a great artist to conceive a new idea, a formula whose power emanated from both its aptness, and its novelty;[43] or it could mean little more than drawing, in our sense of the term, the way in which the conventional elements of a traditional formula were shifted and redisposed to create a new, but essentially uninventive, image. It would be quite wrong to think that true invention in the first sense was the exclusive preserve of painters, for there are several paintings produced on the designs of Bernini,[44] and Bernini, Algardi and Cafà all provided designs for engravings.[45] If the

Fig. 111 Studio of Ciro Ferri, drawing for the *Attributes of St Alexis*. London, The Witt Collection.

Fig. 112 Ercole Ferrata, *Attributes of St Alexis*, stucco. Rome, S. Agnese.

reverse is more frequent, and it is more usual to see painters furnishing designs for sculptors, this was certainly not because all painters were by nature inventive (indeed painters too might use drawings provided by their colleagues), and it is not by chance that I have concentrated on only two, Pietro da Cortona and Ciro Ferri. In fact, except for Carlo Maratti and, to a lesser extent, Padre Andrea Pozzo (1642–1709), both of whom were more active at the end of the century, it would be hard to think of other painters who made designs for sculpture with any regularity.[46] For the most part the painters were little more inventive than the sculptors: they did usually work on their own drawings, but these were often inventions only in the second sense of the word, and one has only to look around the churches of Rome to see how uninventive the inventions of their innumerable painted altarpieces may be.

Where the sculptors differed was in the greater difficulty of their craft. It required sufficient application to learn to carve in marble or model in terra-cotta or stucco, and, once mastered, these skills should enable the practitioner to earn a living, at least as a mason, or a carver; additional skills in three-dimensional conception, in anatomy, or the disposition of drapery in satisfying sculptural forms would enable the carver to rise to the rank of a sculptor, without necessarily guaranteeing that high degree of inventive capacity which singles out the creative master from the ordinary sculptor. Yet these humbler workmen in the industry of art were far from mere mechanical executants.

When a painter gave a design, it was likely to be a complete pictorial image, even though it still left plenty of scope for the sculptor to fill in, or adapt, the details, to incorporate his own ideas, and to demonstrate his skill in his own branch of art.

With architects, the situation was usually very different.[47] There were some, of whom Carlo Fontana (1638–1714) is the leading example, who were skilled pictorial draftsmen whose designs might be as complete as those of a painter. But most architects were not figure draftsmen, nor capable of inventing figurative compositions such as those presented by painters. They were, however, in charge of the total complex in which the figures were to stand, be it a façade, a church interior, a tomb, or an altar. For this reason, the number of sculptural works designed by architects far exceeds that designed by painters (one might, in fact, argue that the activity of Cortona and Ferri in this respect came about precisely because both were architects as well as painters, and almost all the examples looked at so far have, indeed, been linked to architectural projects),[48] but for the historian of sculpture these designs made by architects are of far less interest.

Which is not to say that the sculptures themselves are not worthy of examination, but the relationship of the finished sculpture to the given design is usually much less revealing.

So it is probably no great loss that the surviving drawings for the façade of S. Andrea della Valle (Fig. 113) do not include the sculpture, though the contracts with the stonemasons and with each of the sculptors who carved the statues state specifically that they were to work according to the designs of the architect Cavaliere Carlo Rainaldi (1611–91).[49] Perhaps the result of this can be seen in the distinction between the two pairs of putti holding the medallions above the niches: the two in full relief were carved by Ercole Ferrata (Fig. 18), the two flatter, cruder, and less sculptural ones by the

Fig. 113 Façade of S. Andrea della Valle. Rome.

Fig. 114 Ercole Ferrata, *St Andrew*, marble. Rome, S. Andrea della Valle, façade.

Fig. 115 Domenico Guidi, *St Sebastian*, marble. Rome, S. Andrea della Valle, façade.

stonemasons, whom we may assume to have followed the designs more closely, having less of their own to contribute to the work; obviously the difference was in part willed by the architect, or why use a sculptor for two of them? But he can hardly have intended the blatant difference in quality. Similarly, although the pair of Virtues over the door are rather lumpy, and hardly to be classed among the major works of Roman baroque sculpture, they have, none the less, a distinct personality, that of Jacopantonio Fancelli (Cosimo's elder brother), and are several degrees better than the confused and messy pair of angels supporting the coat of arms, which were again commissioned from the masons.

With the saints below we move on to a different plane, and I cannot believe that Rainaldi's drawings would have contributed more than the most general idea. Whatever they may have been, they left Ferrata free to create in his *St Andrew* (Fig. 114) one of his finer pieces of sculpture, full of movement, exploiting the light and shadow within the niche,[50] while failing to prevent Domenico Guidi from producing a typically insensitive *St Sebastian* (Fig. 115), stiff and basically flat, and devoid of any sculptural interest.[51]

We are slightly better informed about the high altar of Sta Maria in Campitelli (Fig. 117).[52] This splendid structure of gilded wood contains the miraculous image of the Virgin from Sta Maria in Portico, framed within a symbolic representation of the portico (the Portico d'Ottavia, whence the original church took its name) in a form derived from Bernini's *Baldacchino* of St Peter's (Fig. 82), supported by a glory of angels, clouds, and gilded rays again derived from Bernini, from the glory surrounding the *Cattedra Petri* (Fig. 149). The earliest guidebooks attribute the invention and design to Melchiorre Cafà,[53] and there is no doubt that he made the clay model, for which he was paid 18.90 *scudi* on 5 January 1667, and, although he was killed in an accident on 10 September that same year, only six weeks before the precious painting of the Virgin was transported to its new altar, there are no further payments to him, and in 1667 Ercole Ferrata received a payment of two hundred and fifty *scudi*;[54] however, there seems little doubt that his model was followed very closely, for the angels are entirely in Cafà's manner. But the basic invention cannot have been his, since the profile of the altar is visible on Carlo Rainaldi's sectional drawing for the church (Fig. 116).[55] From this view one can tell very little beyond the fact that he planned a *baldacchino*-type structure supported by angels, but no doubt he also made a frontal drawing for Cafà, in which his ideas would have been clearer. It is to the architect that we owe the splendour of this invention, in which the sculptural part consists of no more than two angels, two and a half cherubim, and a number of cherub heads, and which yet strikes the viewer as a work of tremendous sculptural force. But this power, the sensation of life and movement, the variety of textures, and the quality of detail in this glorious hymn to the Virgin, indeed everything that makes this altar remarkable, and more than simply a pastiche of motifs from Bernini, is justly attributable to Cafà.

This can be said with some confidence, because the same drawing includes a much clearer view of the side altar (Fig. 118). It is true that all the elements are there in the drawing, the altar frame supported by two kneeling angels, and held at the sides by flying cherubs, but the drawing provides little more than is contained in this verbal description, and when one looks at the two

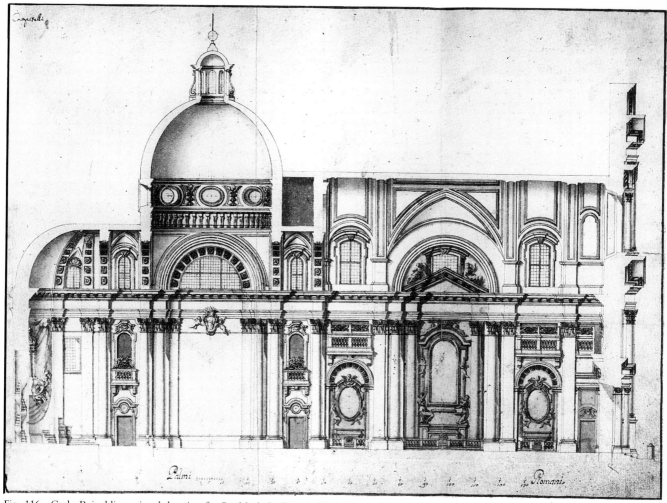

Fig. 116 Carlo Rainaldi, sectional drawing for Sta Maria in Campitelli. Rome, archive of Sta Maria in Campitelli.

Fig. 117 (*below left*) Melchiorre Cafà, high altar, gilt wood. Rome, Sta Maria in Campitelli.

Fig. 118 (*below right*) Luca Giordano, Michele Maglia, Lorenzo Ottone, and others, side altar of Sta Maria in Campitelli, canvas, marble and stucco. Rome.

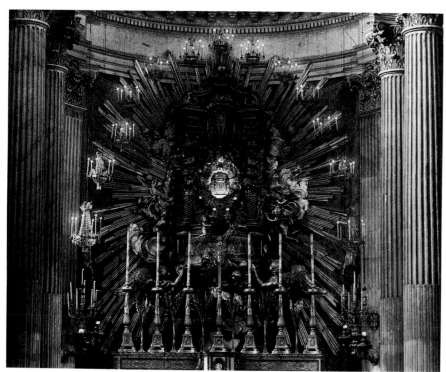

angels carved by Michele Maglia[56] and Lorenzo Ottone[57] one can see that all that is of interest in these marbles was contributed by the sculptors.[58] It is they who have fleshed out these vague indications with form and life, who have varied the poses and the turn of their heads, who have invented the draperies and given conviction to their function. It is not known whether the same sculptors were responsible for the Cherubim at the sides, but again the same judgement holds good: within the schema invented by the architect, it is the team of sculptors who created the figures.

The conception of this side altar is very close to that of the high altar in Sta Maria in Montesanto (Fig. 119) of 1677, which was also designed by Carlo Rainaldi (Fig. 120), though his original drawing for it was subsequently considerably altered by Mattia de' Rossi.[59] None the less, it is evident that the stucco parts were carried out according to Rainaldi's designs, by the stucco-worker Filippo Carcani. Carcani is an even lesser figure in the history of sculpture than Maglia or Ottone, and yet he was able to convert these scribbled indications into convincing and not uninteresting figures, balanced on the predella of the altar and supporting the frame of the image. Such an altar cannot bear comparison with Cafà's in Sta Maria in Campitelli, but it is, none the less, a respectable work, one in which the architect's project is given perfectly adequate sculptural life.

Fig. 119 Filippo Carcani, high altar, stucco. Rome, Sta Maria in Montesanto.

Fig. 120 Carlo Rainaldi, drawing for the high altar of Sta Maria in Montesanto. Vatican, Archivio Segreto, Fondo dell'Ospizio Apostolico dei Convertendi, 99.

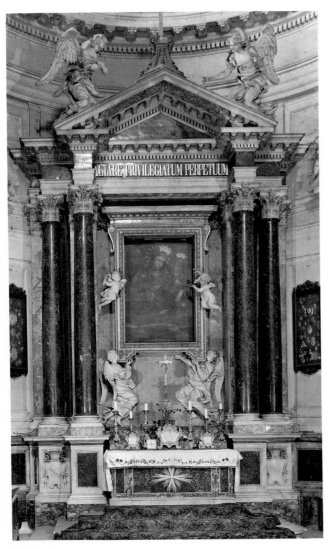

There are several drawings for the façades of both Sta Maria in Monte Santo (Fig. 121) and Sta Maria dei Miracoli, the two churches (Fig. 122) built over twenty years from 1658 to stand at either side of the Corso as it enters the Piazza del Popolo, where they fulfil a vital scenographic function in the Piazza, opposite the Porta del Popolo through which so many ambassadors and princes made their ceremonial entries into Rome. On all the drawings for both of the churches, whether those by Carlo Rainaldi or those by the younger Carlo Fontana, who eventually replaced him after the newly created Cardinal Gastaldi interested himself in the project in 1671, the sculptural decoration is indicated in only the most summary way.[60] How far the disposition of the sculptures as actually executed is due to Bernini's intervention, and, more important for our concern, how far he may have controlled their design, is a matter for conjecture, but it is certainly true that in the choice of sculptors, as in the general types of the statues, the decoration of the façades of these churches was a virtual continuation of St Peter's Colonnade.[61] Lists exist of the sculptors involved, and, apart from Ercole Ferrata and Lazzaro Morelli who each made one statue for the Miracoli, and Carcani who made two, they are a very shadowy lot.[62] Morelli and Carcani were also paid for statues on the Monte Santo, but the rest of the figures on this church were due to a group of sculptors of the next generation, and here one is clearly encountering members of the lower rungs of the profession.[63] There is a sociological interest in seeing how these sculptors move from one project to another, but as individuals their names arouse no interest, and scarcely any recognition even among specialist art historians.

However, it is still worth looking at what they produced. Not because it is

Fig. 121 Carlo Fontana, drawing for the façade of Sta Maria in Monte Santo. Vatican, Archivio Segreto, Fondo dell'Ospizio Apostolico dei Convertendi, 99.

Fig. 122 Façade of Sta Maria in Monte Santo. Rome.

in any way exceptional, but precisely because it is not. The altars produced on the designs of architects exhibit angels and cherubim which, were they torn from their contexts, would not disgrace the world's better museums; similarly, standing nuns could be produced almost, but not quite, in series. Many of them reflect the statues which Bernini had designed for the Colonnade of St Peter's (Figs. 195, 197, etc.), and in fact most of the sculptors employed on these two churches in the Piazza del Popolo had already worked on the Colonnade statues;[64] clearly, they had absorbed enough of Bernini's manner to be able to work out their own minor variations on his types, sufficient to create a varied skyline round the dome of a church, and, in some cases, before the travertine had weathered, of considerable distinction. And this with no real assistance from the architect, the nominal designer.

Just as Pietro da Cortona could rely on Fancelli to interpret his designs in a way that was fully in accord with his more precise demands and stronger artistic personality, so the architects, Rainaldi, Fontana, and many lesser men, could indicate the pose of an angel, or the scale and general movement of a group of saints, secure in the knowledge that they would be carried out with proficiency, not merely as an adornment, but as an essential part of their design. Baroque Rome, as we know it, depends upon this sculptural proletariat, this pool of competent workmen, whose sculpture seldom receives a second glance, but, should we sit at a café in the piazza and let our eyes wander over it, will not disappoint us. Who such men were, and how they worked, we shall examine more thoroughly in Chapter VI.

V

THE SCULPTOR AS DESIGNER

In 1634 a contract was drawn up between the sculptor Alessandro Algardi and Cardinal Roberto Ubaldini for a tomb to commemorate the Cardinal's uncle, Alessandro de' Medici, a member of a minor branch of that illustrious family who had been elected pope as Leo XI in 1605, and died twenty-seven days later (Fig. 123).[1] The first clause states that Algardi 'binds himself to make with his own hand [*di sua propria mano*] all the figures that must be placed on the said tomb', which it then proceeds to enumerate.[2] He is further bound 'to make with his hand [*di sua mano*] a wooden model of the whole work', including the figures which may be of clay. He must also make the niche, the urn, and the coat of arms. Then follows a clause stating:

> He is further bound to undertake with his hand [*di sua mano*] all those operations which may appertain to him, not only as sculptor, but also as the head and promoter of the whole of this work, and to take particular care that nothing be done that is not ordered by him himself, and also authorised by his signature, and in those things where it is necessary he shall be bound, for the information and better instruction of those who will have to do the work, to model with his hand [*di sua mano*], and make every other demonstration of all the work for this monument as shall be necessary for the stone-carvers, stone-masons, builders and others, and to choose the most excellent workmen.

This contract envisages three different degrees of personal involvement: the figurative parts, which should be autograph in the fullest sense of the term, the wooden model and the detailed drawings and models, which should be made by him, but not necessarily by his own hand, and the architectural parts (including the coat of arms) which are to be made by workmen under his direction, and following his detailed instructions. Of course, it would be recognised that even the figure sculptures would have been blocked out at the quarry, and that, when they had reached the studio, assistants would certainly do the rough work to reduce the blocks to shapes closer to the actual statues; this went without saying, and a sculptor who was contracted to carve a statue with his own hand was no more expected to do so without this assistance than without a chisel and mallet.

It is in no way surprising that he did not have to make the wooden model with his own hand; the clay figures on it are a different matter, but we may imagine that he had already produced a full drawing of the whole, and very probably also sketch-models for the statues, so that, assuming this was to be quite small, the figures would provide indications of their proportions and general movement, and could be safely left to an assistant. As for the models and 'other demonstrations' to be given to the carvers and stonemasons, these must concern details of the mouldings of the framework, the ornamental top

Fig. 123 (*p. 100*) Alessandro Algardi, tomb of Pope Leo XI, marble. Vatican, St Peter's.

Fig. 124 (*p. 101*) Gianlorenzo Bernini, tomb of Pope Urban VIII, marbles and partly gilt bronze. Vatican, St Peter's.

99

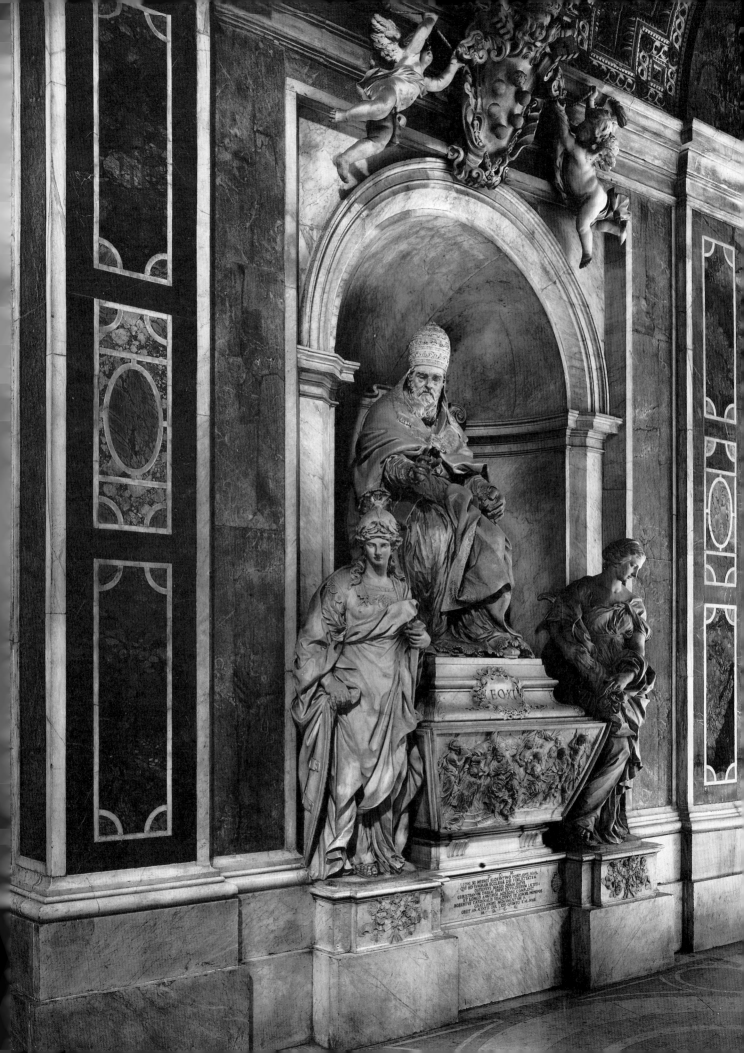

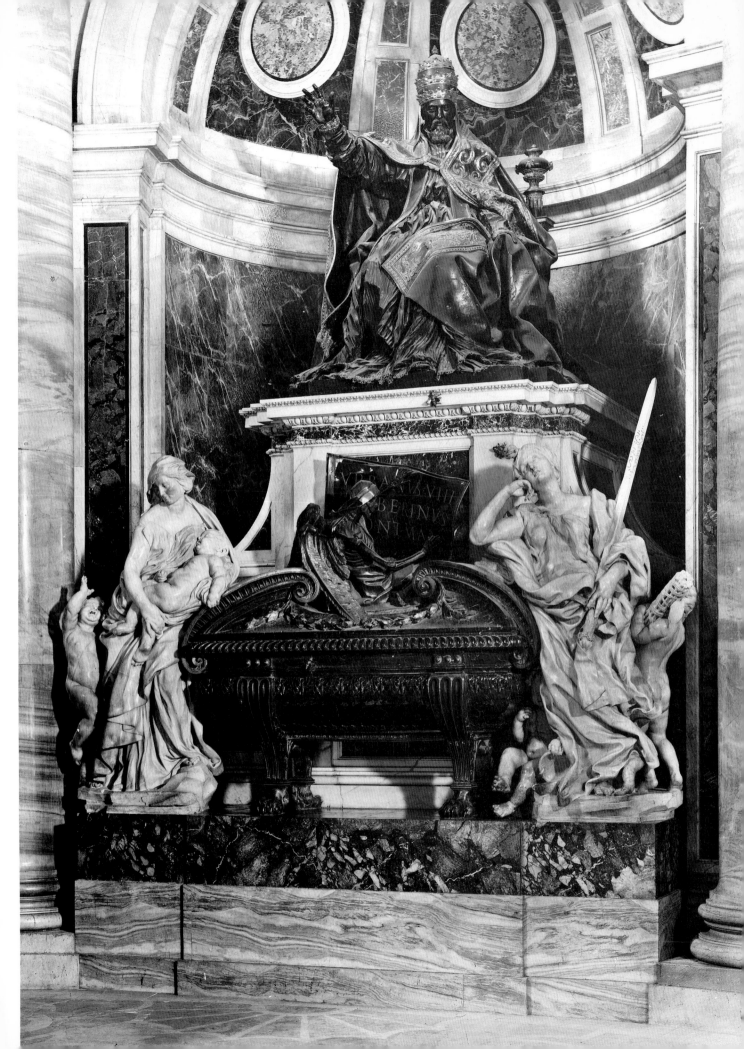

of the sarcophagus, the triglyphs below and the pedestals above, and so forth. They are so important to the overall effect of the tomb that one might have expected Algardi to provide them himself, and if he was not obliged to make them 'with his own hand' this is probably because those who drew up the contract expected them to be full-size models or drawings, which would have been made by an assistant from the sculptor's smaller and rougher sketches.

The contract for the tomb of Leo XI is, so far as I know, unique in introducing such a three-level division, and, by doing so, it reminds us that the standard phrase '*di sua mano*' did not, in practice, mean literally what it said, for it was normal for the two levels indicated by '*di sua propria mano*' and '*di sua mano*' to be amalgamated and covered by the single phrase '*di sua mano*', indicating both the work the sculptor did with his own hand, and the designs he produced for others. No doubt it had once been different,[3] but evidently in this contract it was thought necessary to strengthen the conventional wording, in the hope that the more emphatic phrase would restore its literal meaning.

In fact, however, Algardi did not carve all the figures 'with his own hand', for it was commonly recognised that the two lateral figures of *Magnanimity* and *Liberality* were carved by his assistants Ercole Ferrata and Giuseppe Perone, even if there was some disagreement as to which did which.[4] Since it is rare to find contracts specifying what was to be done by the sculptor's own hand, it is difficult to say whether or not such demands were expected to be taken literally; in any case, no objection was raised, and the tomb met with general satisfaction, the authorities of the Propaganda Fide, who were the legatees of Cardinal Ubaldini, paying the sculptor an extra one thousand *scudi*.

None the less, the distinction between the master and his shop remained a matter of considerable importance, just as this division of labour remained a standard practice, particularly in large undertakings such as elaborate tombs, and a sculptor seeking to enhance his reputation, or justify his wages, would emphasise just how much he had done 'with his own hand'. For example, Bernini listed the work that he had done 'with his own hand [*di sua mano*]' for the tomb of Urban VIII in St Peter's (Fig. 124):[5] The drawings, both small and large, and also the details of the mouldings, profiles, and so forth, needed by the various workmen such as stone-cutters, carvers, and carpenters; the models, small and large, for casting the bronze ornaments of the sarcophagus; the model, first in clay and then in wax, for the statue of the pope, which was 20 *palmi* high; the casting of the statue of the pope, done 'with his orders, invention, manner, and personal assistance'; the small model of the figure of Death, and the retouching of the large wax for casting; the casting of this figure (described in the same terms as that of the pope), which had still to be done; the marble figure of Charity, and the marble figure of Justice, which, too, had still to be done.[6] Here we can compare this with the accounts submitted by other workmen. Particularly interesting is the 'Note of large clay models made for casting in metal by Master Lorenzo Flori according to the designs and small models made by Signor Cavaliere Bernino, and also retouched': these included the cover of the sarcophagus, the clay and wax models of the garlands on it, the lion-feet, the clay model for the book held by Death, and the assembling of the wax of this model, and the retouching of the wax wings of the figure of Death, and his drapery.[7] In fact,

therefore, Bernini had certainly not made the large models for the ornaments of the tomb with his own hand, in the normal sense of the words.

For works of rather less importance than a papal tomb in St Peter's, the sculptor might undertake even less of the actual labour himself, while still furnishing the designs which ensure that the final structure conforms to his ideas, and justify us in regarding it as his creation. On 16 March 1637, Algardi contracted to make the tomb of Cardinal Giovanni Garzia Mellini (Fig. 125), and on the very same day he himself drew up a contract with the stonemason for everything except the bust, and even then the stonemason was free to sub-contract the work, binding himself 'to make, and have made [*fare, e far fare*] the tomb'.[8] Similarly, for the memorial to Innocent X in the Hospice of the Trinità dei Pellegrini (Fig. 126), apart from the design of the whole and the inscription, cherubim and arms, Algardi himself did no more than make the models for the bronzes (the bust of the pope and the two putti, all of which are now missing), and we know that the actual carving of the cherub heads which serve as brackets was left to a stonemason, Daniele Guidotti.[9]

Just how important were such designs, and the control the artist exercised over their execution, can be demonstrated by comparing the heraldic 'M' of the Mellini arms on the tomb of Giovanni Garzia Mellini in Sta Maria del Popolo (Fig. 127), with that on the tomb of Urbano Mellini (Fig. 128) in the

Fig. 125 Alessandro Algardi, tomb of Giovanni Garzia Mellini, marble. Rome, Sta Maria del Popolo.

Fig. 126 Alessandro Algardi, with later restorations, memorial to Pope Innocent X, marble. Rome, Hospice of Sta Trinità dei Pellegrini.

103

Fig. 127 Alessandro Algardi, heraldic 'M' on the tomb of Giovanni Garzia Mellini, marble. Rome, Sta Maria del Popolo

Fig. 128 Unknown stonemason, heraldic 'M' on the tomb of Urbano Mellini, marble. Rome, Sta Maria del Popolo.

same chapel, incorporating a bust undoubtedly carved by Algardi, but set up in 1660, some six years after Algardi's death.[10] The former is so beautifully designed and so sensitively carved that, despite the contract which left everything but the bust to the stonemason, it is hard to believe that Algardi did not carve it himself:[11] its graceful lines have a lively springing rhythm, and the acanthus-type foliage opens to reveal round seeds, suggestive of the renewal of life after death. The 'M' on the tomb of Urbano Mellini is relatively squat, and appears even more so as the receding front of the sarcophagus is set below eye-level; the seeds are reduced to decorative crescents, and the carver has made far more extensive use of the drill, so that the lobes of the leaves are awkwardly divided. If Algardi did not actually carve the 'M' on the tomb of Giovanni Garzia Mellini, he must have provided a clear and detailed model, and ensured that it was followed exactly, and that the work was done predominately with chisels; on the much simpler tomb it is probable that the stone-carver was merely told to imitate the 'M' on the tomb of Urbano's uncle, and, with no control over how he did it, he took little trouble, and used the tools which would produce the quickest and least laborious results.[12]

The contract for the tomb of Leo XI is remarkable, therefore, only in specifying so precisely what was to be done by the sculptor, and the precise degree of his involvement in each category of work. Seldom, indeed, is the sculptor obliged, however optimistically, to take so large a share in the work himself. Sculpture, unlike painting, is an art that involves a great deal of physical labour, and very frequently, as in these memorials, the work as a whole includes much that is hardly sculpture in the ordinary sense of the term, but for which the sculptor, as designer, remains ultimately responsible.

But even when the sculpture was in every normal and accepted sense by the sculptor himself, it was by no means unusual to make use of specialist marble carvers for specific details. Bernini was highly skilled in carving marble from his earliest youth, and yet he employed the younger Giuliano Finelli for some of the most spectacularly virtuoso effects in the statues he made in the 1620s.

No one questions that it was Bernini who conceived the brilliantly convincing image of metamorphosis, as, pursued by Apollo, Daphne changes

Fig. 129 Gianlorenzo Bernini, *Apollo and Daphne*, marble. Rome, Galleria Borghese.

Fig. 130 Giuseppe Giorgetti,
Bust of Maria Barberini Duglioli,
marble. Bologna, Certosa.

into a laurel tree (Fig. 129): bark encases the girl's thighs, roots stitch the fleet toes to the ground, and leaves burst forth from her upstretched hands. But the most astounding metamorphosis of all, the transformation of the hard and brittle marble into roots, twigs and windswept hair, was largely achieved by Giuliano Finelli.[13] He too was responsible for the bust of Maria Barberini Duglioli, not the copy by Giuseppe Giorgetti which is now on her tomb in Bologna (Fig. 130), but the lost original which remained in the Barberini Palace in Rome, where it was protected by a wire cage or a glass case, for the collar was so finely worked and pierced that one could look through it, and so delicate that it seemed inconceivable that it could have been carved without breaking.[14] It was for drill-work of this kind that Bernini made use of Finelli's expertise, and for the delicate embroidery, jewellery, and decorative buttons on the dress (this, after all, was why a sculptor such as Bernini employed an assistant); but the bust was paid for as a work 'coming from Bernini', and it was under his name that it was shown to visitors to the Palace.[15]

Finelli was not merely a craftsman, but a young man with the makings of a very considerable sculptor in his own right, with an ego to match, and he could not bear to remain in this subordinate position, nor tolerate this anonymity while Bernini received the fame and glory for his work. He was particularly angry that Bernini had promised that, on completion of this bust, he would take him and introduce him to the Pope, and instead had taken Andrea Bolgi, another young sculptor from Carrara whom Finelli

106

regarded as a rival, but whom Bernini evidently considered more docile and less of a threat to his own position.[16] The breaking-point came while both Finelli and Bolgi were employed on making models for the *Baldacchino* in St Peter's, for the putti on the columns and the angels who stand upon them well above eye-level, and it was Bolgi who received the commission for the marble statue of *St Helena* to stand in one of the niches in the piers of the crossing.[17] As the final straw, Finelli, through his Carrara connections, had had a share in the provision of the white marble for the bases of the *Baldacchino* columns, and when Bernini learnt of Finelli's involvement he reduced the agreed price.[18] So Finelli left his service, and set up in his own studio to seek work that would enable him to prove to the world that it was he who had carved the statues from which Bernini had acquired such fame.[19]

All the evidence[20] suggests that Bernini's flourishing workshop approached the sophisticated division of labour familiar to us from the painting-studio practice of Rubens. If it is difficult to say how common this extensive use of specialised assistants was among the less heavily patronised marble sculptors, it appears that even the young and relatively unprosperous might call upon outside workmen to help them with particular tasks.

Jean-Baptiste Théodon[21] had been a pupil at the French Academy in Rome, whose Director, La Teulière, lost no occasion to denigrate his work.[22] So, when Théodon was working on his statue of *Phaetusa* (Fig. 131), the sister of Phaeton who turned into a poplar tree for grief at the death of her brother, La Teulière wrote back to Paris not only ridiculing the treatment of the subject, but pointing out that Théodon had had much help with the carving, and that 'the two best sculptors in Rome for ornaments' had been paid 7 *giuli* a day to carve the bark, the ivy and the swan.[23]

These would not, of course, have been sculptors as we should use the term, that is to say creative artists, but highly skilled stone-carvers, the sort of men who were habitually employed on the carving of architectural mouldings and capitals which were the staple of the *scarpellino*'s or *intagliatore*'s trade, and the decoration of fireplaces and marble tables. No doubt Théodon was not the only sculptor to make use of their skills in producing such special effects as bark or feathers. These men were members of distinct professions, whether that of the specialised *intagliatori* or the more general *scarpellini*,[24] though such stone-carvers might work their way up to become sculptors,[25] or, as in the distinguished case of Francesco Borromini, architects.

We may here digress from sculpture, in the strict sense of the word, to note the various levels of expertise in marble carving envisaged in the decoration of the Gessi chapel in Sta Maria della Vittoria, for which Algardi provided the designs, and was to oversee the work, while some of the additions to the contract are in his hand, including the names of the *scarpellini*, Pietro Lambruzzi and Francesco Orsolani.[26] Yet the contract laid down that the Corinthian capitals and the coats of arms were to be 'made by the hand of someone skilled in the art',[27] and further on it states specifically that 'for that which touches the art of *intagli* the *scarpellini* must, in all such things, employ Master Gaspare Casella at the expense of the said *scarpellini*, if they do not want to do it with their own hands'.[28] While the contract states that the predella and the altar frontal were to be of coloured marbles, a clause was added to allow for the use of semi-precious stones, to be inserted by a jeweller.[29]

Fig. 131 Jean Baptiste Théodon, *Phaetusa*, marble. Versailles, Orangerie.

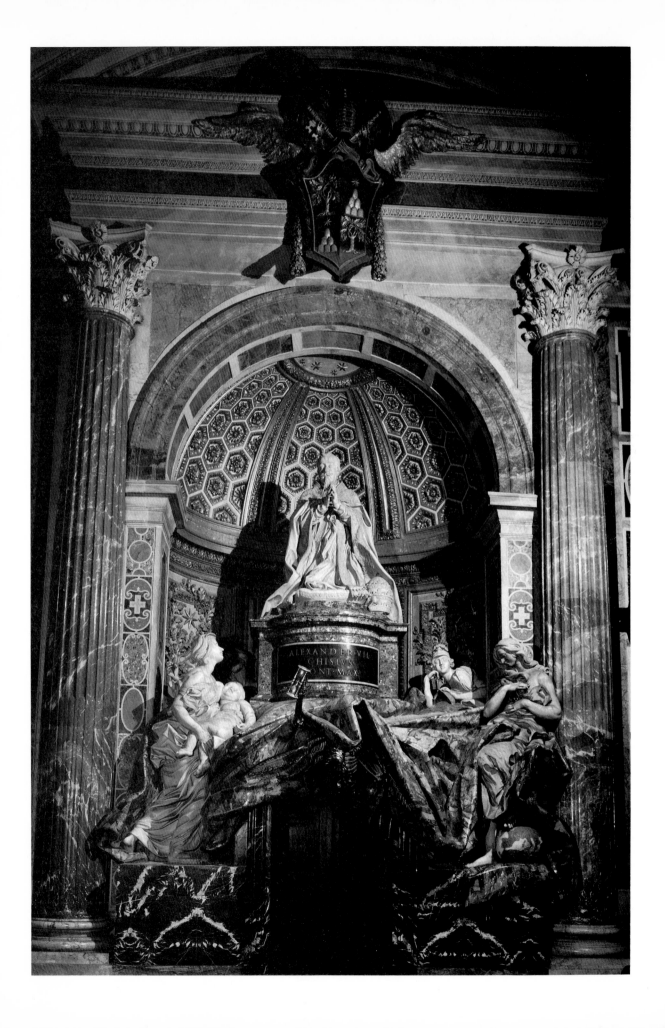

Fig. 132 (*facing page*) Gianlorenzo Bernini and assistants, tomb of Pope Alexander VII, marble, gilt bronze, and Sicilian jasper. Vatican, St Peter's.

Fig. 133 Gianlorenzo Bernini, drawing for the tomb of Pope Alexander VII. Philadelphia Museum of Art. The Muriel and Philip Berman Gift; acquired from the John S. Philips bequest of 1876 to the Pennsylvania Academy of Fine Arts, with funds contributed by Muriel and Philip Berman with the Edgar Viguers and Seeler Fund by exchange.

For sculpture proper, there was also the separate profession of *lustratori*, or stone-polishers, who would be called in when the carving of the statue was complete;[30] this form of assistance seems to have been so generally accepted as to be closer to the use of studio hands to block out a carving, and we may note that the same French Academy that had despised Théodon for using a specialist carver had, a few years earlier, with apparent unconcern, paid for 'Antonio et Pietrouche, *lustrateurs*' for their work '*à lustrer et polir et lustrer*' Joly's marble copy of *Ganymede* (Fig. 15), and a copy of the Medici Vase.[31]

If the relatively youthful Bernini of the 1620s made use of Finelli's specialised skills as a marble carver, at the height of his career as papal sculptor in the 1670s he might scarcely touch the marble himself, even for so important a work as the tomb of Pope Alexander VII in St Peter's (Fig. 132), where only the finishing touches of the pope's face are generally agreed to be due to Bernini himself.

The tomb was originally commissioned during the lifetime of the pope, but it was not till long after his death, and after various changes of plan, that it was actually begun, on the orders and at the expense of his nephew, Cardinal Flavio Chigi.[32] The three known drawings for this tomb[33] all show it incorporating a door, as in the actual monument, and can be presumed to be related to the final project, after the abortive idea of building it in Sta Maria Maggiore. In what must be the first drawing (Fig. 133),[34] showing the pope enthroned, Bernini is clearly embarrassed by this door, and, despite his attempt to incorporate it into the design by making one of the Virtues lean upon the lintel, it still remains as a gaping hole in the composition.

109

Fig. 134 Gianlorenzo Bernini, drawing for the tomb of Pope Alexander VII. Windsor, Royal Library.

Fig. 135 Gianlorenzo Bernini, drawing for the tomb of Pope Alexander VII. Private collection.

Yet the idea of the door of Death is an old one, going back to the iconography of classical sarcophagi,[35] so the briliant invention of the figure of Death himself emerging through this door to brandish his hourglass before the imperturbable faith of Alexander should not seem so surprising. However, in two workshop drawings which chart the development of the sculptor's ideas, that in which the Virtues are closest to their final form lacks any reference to Death (Fig. 134);[36] the other (Fig. 135),[37] however, incorporates two images of this personification, one, emerging from the door with his hourglass, the other flying above the arch of the tomb, attempting to snatch at the coat of arms which Fame bears up beyond his reach. In both these drawings the niche is eliminated in favour of a perspective arch, the illusionism of which would work much better for someone standing on the ground, whose head would scarcely reach the globe beneath the foot of *Truth*. Neither drawing, both of which must be far from Bernini's own studies, indicates clearly how the background was to be treated, but in both of them the effect of a free-standing structure is even more deliberately stressed than in the final version.

This is not the place to examine at length the development of Bernini's designs, nor to analyse the concepts they embody, still less to attempt to place them in chronological order.[38] But, in a chapter devoted to the sculptor as designer, it is necessary to give some idea of the thought that went into such projects before the other workmen were assembled to carry them out.

Having decided on his final design, and even before, Bernini would elabo-

110

Fig. 136 Gianlorenzo Bernini, *bozzetto* for *Alexander VII*, terracotta. London, Victoria and Albert Museum.

rate the individual figures in drawings and clay models. One of the finest of the *bozzetti* for this tomb is that for the pope himself (Fig. 136);[39] as Bruce Boucher noted, the head was modelled separately, not just for technical convenience, but so that the sculptor could experiment with its angle before finally squashing the neck with his thumb into the soft clay of the body to hold it firmly in its chosen position.[40] This very summary *bozzetto* is close to the actual design, but it should not be confused with the small model of the entire tomb which he made, and from which his assistants constructed a full-size wooden model with clay figures.

While this large model was under construction, the first two blocks of marble were ordered from Giovanni Battista Marcone; for this purpose measured plaster models were handed to the marble merchant, corresponding to the drawings kept with the contract.[41]

Fully preserved records of the payments for this tomb enable us to follow every stage of its manufacture, and to identify the sculptors involved. From these documents it is evident that, on the one hand, Bernini took almost no

Fig. 137 Gianlorenzo Bernini, Lazzaro Morelli and Giulio Cartari, *Truth*, detail of the tomb of Pope Alexander VII, marble. Vatican, St Peter's.

part in its actual making, and, on the other hand, that the sculptors took no personal responsibility for their work, but merely followed the designs they were given. This is not just a matter of the usual workshop division of labour, with a *scarpellino* roughing out the blocks before the sculptors started work, another sculptor going over the completed figures with a rasp and file, and a *lustratore* giving the final polish,[42] nor the complex practices of casting the figure of *Death*, involving the founder casting it and others repairing the rough cast, another being paid to set it in place and yet another to drill the holes for the screws, nor the production of the great shroud, carved from a block of travertine, while a stone-carver was employed to cut and fit the veneer of rare and valuable Sicilian jasper which covers it. All this, as has been seen in previous chapters, was standard practice.

Two things, however, stand out as rather extraordinary. One is that the final payment to Bernini of one thousand *scudi*, specifically for the design and model of the tomb, and apparently the last he received, was made in 1672,[43]

112

Fig. 138 Gianlorenzo Bernini, Michele
Maglia and Domenico Bassadonna, detail
of *Alexander VII*, marble. Vatican, St
Peter's.

when the model was indeed complete, but the carving of the marble had not
yet begun, and was not to be finished till six years later, in 1678 (including
the casting of a piece of white-painted bronze to cover the naked *Truth*,
considered too starkly nude for a Christian church). All the payments during
the intervening years were countersigned by Bernini, but his responsibility
was for the design, and after that it was for his assistants to get on with the
task of producing the actual tomb.[44]

This they did, but in a way which is quite unexpected, and, at the same
time, very revealing. It is expected, and was indeed normal, that sculptors
should assume some degree of personal responsibility for the figures they
carved,[45] but here one finds Lazzaro Morelli starting to work the statue of
Truth (Fig. 137), and part way through another assistant of Bernini's, Giulio
Cartari, takes over. Their payments divide roughly three to two, which is
quite a different proportion to that which is found when the marble-carver
Domenico Bassadonna was called in to do the embroidery on the cloak and

113

Fig. 139 Gianlorenzo Bernini, Paolo Naldini and Giacomo and Carlo Beccheria, detail of the cupola of Sta Maria Assunta, stucco. Ariccia.

stole of the statue of Alexander VII (Fig. 138), which had otherwise been carved by Michele Maglia, or when the same Giulio Cartari was paid for doing the lace, which was, again, a typical workshop use of men with specialised skills for special jobs; in such cases the specialist received only a very small sum relative to that paid to the sculptor who did the major share of the work. It could be that Morelli was too busy elsewhere to finish his statue (and he was working at this time on the churches of the Piazza del Popolo),[46] for he was undoubtedly a typical example of the independent sculptor who was frequently employed to produce the statues for Bernini's vast undertakings, whereas Cartari, whose known independent *oeuvre* is remarkably small, was evidently particularly favoured by Bernini, carving a copy of the master's own statue for the Ponte Sant'Angelo.[47] None the less, whatever the reasons, this division of work on the statue of *Truth* indicates that those employed on the tomb were simply following Bernini's models, with so little latitude for personal invention or idiosyncracies that it was perfectly easy to switch workmen mid-statue.

Although such an extreme form of this practice may not have been common, the employment of assistants to execute precise drawings or models, without deviation, was, and always had been, perfectly normal. An

114

example is provided by the decoration of the dome of the collegiate church of the Assumption in Ariccia (Fig. 139).[48] Paolo Naldini made the models, certainly from Bernini's drawings (Fig. 140)[49] and presumably under his direct supervision, of the twelve putti and four angels, as well as the cherub heads on the inscription tablet. These figures he then executed in the church, but his part was confined to the figure sculpture, since the professional stucco-workers, Giacomo and Carlo Beccheria, did all the rest, including the garlands between the figures, the ribbons holding the garlands, and even the bunches of flowers in the hands of the putti.[50] Again, this division of labour, in a situation where it is imperative that the various parts fit together, makes it clear that the sculptor, as well as the comparatively minor *stuccatori*, were following very precisely the drawings that had been established by the master.[51]

Fig. 140 Gianlorenzo Bernini, drawing for the decoration of the cupola of Sta Maria Assunta. Windsor, Royal Library.

If the use of assistants in this way was necessary in large works, such as elaborate monuments, for different reasons it was equally commonplace in minor works. Domenico Bernini claimed of his father that 'in every work, of whatever kind, that he was asked to do, no matter how small it was, he would devote to it all his application, and in its own way a design for a lamp would receive as much study as a noble building, because he held that in their perfection all arts are equal, and that whoever could achieve beauty in a minor or little object, would achieve equal beauty in a major or large undertaking'.[52] Allowing for a little exaggeration, this statement is no doubt true, but we should note that Domenico Bernini writes of designs, and Gianlorenzo would no more have executed these minor works with his own hand than he would have laid the stones in the noble building.

The division between 'fine' and 'applied' arts with which we are familiar today had not yet taken root, and throughout the renaissance, as in the middle ages, artists were prepared to work in both sectors; indeed, it would be truer to say that they were unaware that there were two sectors. Yet already there were the beginnings of change, and Bernini's boast makes it clear that not everyone shared his view. It is this sense that there was something degrading about the minor arts, as much as a preference for marble statues, and the natural belief that the bigger the work, the more important it must be, which underlies the words of Bellori, that protagonist of classicism, when he wrote of the Bolognese sculptor Algardi's difficulty in establishing himself in Rome, and described him as having 'wasted his best years and the prime of his life . . . in making little models of clay and wax',[53] by which he meant 'models of putti, little figures, heads, crucifixes and ornaments for silversmiths'.[54] In fact, Algardi continued to make such models throughout his life, the main difference from Bernini being that, because he had a smaller workshop, and, perhaps, because he had a particular skill in modelling, he was more likely to make the model himself, whereas Bernini, with his great facility in making sketch-models, might provide such a sketch, or merely a drawing, for an assistant to work up. For the finished object, both would rely on the expertise of a bronze-founder, silver-smith, or wood-carver. But, in any discussion of the sculptor as designer, it is important to remember that the leading figures in the profession devoted a great deal of their time to the design of minor, even minimal, objects.

Just how minimal they might be emerges from the correspondence between Francesco d'Este, Duke of Modena, and his brother, Cardinal Rinaldo, in Rome, which provides clear evidence that at the time of his death

Algardi was supervising the production of ornamental nails for the Duke's coach, from which it is to be assumed that he must have designed them.[55]

Such nails would be quite sizeable, and we know that they were decorated with the heraldic eagles of the Este arms;[56] none the less, they must rank well below the lamps of which Domenico Bernini wrote. However, if it seems somewhat improbable that Algardi, at the height of his career, would have designed upholstery nails, even for the Duke of Modena, it should be borne in mind that the Duke also required finials, four large ones to decorate the corners of the coach roof, and four smaller ones for the seats within, and the commissions for the nails and the finials evidently went together. Seventeenth-century finials could be extremely elaborate, and also very costly. One brass pair designed by Algardi for the chair of Pope Innocent XI (Fig. 141) was described by the artisan who made it as having 'six little brackets on each vase and three small putti ... each with his dove on his head with a sprig of olive in its beak and three shells with harpies' heads below the shells, and three flowering lilies on top of the vase ...'[57], and cost the very considerable sum of ninety *scudi*. Should we be tempted to underestimate the importance of such work, it should be remembered that this is the same sum that Giuliano Finelli received for a marble bust of Cardinal Scipione Borghese, which is now displayed in the Metropolitan Museum of Art in New York.[58]

Costly though they may have been, such things were not generally considered sufficiently valuable to survive the change of pope,[59] or the change of taste that consigned the chair they adorned to the scrap-heap. More often, it was the value of the object, or rather of its material, which led to its destruction. It is remarkable that in 1643, when Urban VIII was involved in the war of Castro and the papal treasury was depleted, an edict went out that everyone having silver with figurative decoration (*argentaria historiata*) was to show it, but not to consign it to the mint, because the value of the work was greater than that of the material.[60] However, such an exception was extremely rare; moreover, the workmanship itself, as it came to appear old-fashioned and out of date, would be a reason for melting down sculpture in precious materials. So it is useless to search for the reliquary of St Helena, of gold and silver set with rubies, which Cardinal Francesco Barberini commissioned for the Queen of England from Francesco Spagna in 1636 on the designs of Bernini;[61] for the great silver bowl designed by Bernini and executed by Francesco Perone in 1643 for Cardinal Antonio Barberini;[62] for the silver fountain, set in a bowl which could be used in winter as a brazier, executed by Fantino Taglietti in 1636 on the models of Algardi for Prince Marcantonio Borghese;[63] or for the magnificent silver-gilt cradle with an embroidered satin coverlet and encrusted with jewels, designed by Bernini, and worth around four thousand *scudi*, which Olimpia Maidalchini presented in May 1653 to her daughter-in-law, the Princess of Rossano.[64]

One might expect the survival of wooden objects to be more secure, but a wooden frame designed by Algardi (Fig. 142) and made in 1649 for Giovanni Domenico Cerrini's painting of *David* in the Galleria Spada has also been destroyed.[65] More fortunate was a silver frame (Fig. 143) which Algardi designed for a small painting on copper of the *Annunciation* by Luigi Gentile, and which was executed by Francesco Perone in 1648;[66] yet this is the only known survivor of some twenty-eight such works listed in the accounts.

116

Fig. 141 Alessandro Algardi, drawing for a finial. Windsor, Royal Library.

Fig. 142 Alessandro Algardi, drawing for a frame. Biblioteca Apostolica Vaticana, MS. Vat. Lat. 11257, f. 225.

Fig. 143 Francesco Perone, frame for a painting of *The Annunciation* by Luigi Gentile, silver. London, Museum of the Order of Malta.

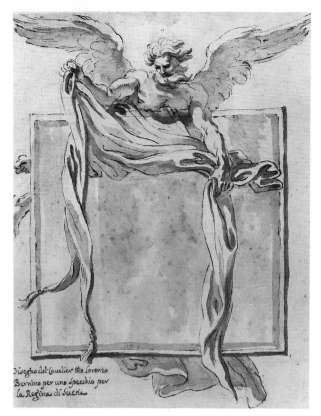

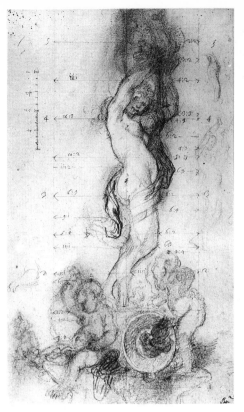

Fig. 144 Gianlorenzo Bernini, drawing for a mirror frame for Queen Christina. Windsor, Royal Library.

Fig. 145 Gianlorenzo Bernini, drawing of *Venus*. Leipzig, Museum der Bildenden Künste.

Fig. 146 Gianlorenzo Bernini, drawing for a mirror frame for Queen Christina. Stockholm, Nationalmuseum.

Fig. 147 Gianlorenzo Bernini, drawing of *Vulcan*. Leipzig, Museum der Bildenden Künste.

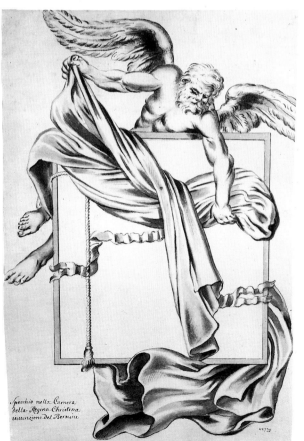

Again, it may have been the value of the silver which condemned them, while it is much more likely that the paintings still survive, for not only is copper much less valuable than silver, but paintings have always been regarded as fine art, whereas frames are merely decorative art, and there can be no objection to melting them down for their silver and replacing them with plain wood.

It was not always so, and, in fact, we know that in this series of small copper devotional paintings in silver frames, presumably intended as papal gifts to distinguished visitors, it was the frames which were made first, and the paintings were then produced to go inside them. It is also significant that the frames might cost anything from sixty to a hundred *scudi*, not including the engraved and gilded back, whereas the painter received only thirty *scudi* for each picture. The value that might be set on a frame is indicated by examples of paintings made specifically to go inside old frames, such as the copper painting of the *Virgin and Child with an Angel* made by Bartolomeo Colombo in 1640 'to put within an ornament where was an octagonal mirror', though who had made this frame is, unfortunately, not known.[67]

If it was worth saving, the frame was probably quite elaborate, but if it could be reused for a religious painting it is unlikely to have been figurative, in contrast to the two frames by Algardi, one of which incorporated the symbols of David, and the other the heraldic devices of Pope Innocent X. It is typical of Bernini's inventiveness, and his belief in the necessity of an appropriate 'concetto', that when he designed a mirror for Queen Christina (Fig. 144) he should have invented a figure of Time, drawing his veil from the mirror, to create the emblematic image of Time revealing Truth. The drawing in Windsor is certainly the autograph design,[68] but a drawing in Stockholm (Fig. 146) no doubt represents the mirror as it was actually made.[69] Why the design was altered (and whether or not Bernini was responsible for the change) is not known, but the reason for the veil, cords, and so forth cutting across the mirror was entirely practical, at a time when floating large sheets of flat glass was not yet a technical possibility in Italy, and it was necessary to break the area into smaller portions. It might be thought that the *concetto*, however appropriate, was in this case a little tactless: Christina had never been beautiful, and the process of ageing was something she was extremely reluctant to acknowledge. Was this a Truth she would wish to see? Philipp Fehl has suggested that it was not, but rather that, as the sun was one of Christina's emblems, and as the sun was, like the mirror, an attribute of Truth, it was Christina, the radiant personification of shining Truth, who should be revealed in the mirror.[70] What Bernini had in mind we shall never know, and it is one of the characteristics of such conceits that they may be read in several different ways. If the idea of Christina as Truth seems far-fetched, we may imagine that, were the ex-Queen to be enraged or dispirited by the more obvious interpretation, there would be some courtier at hand to show his wit (and earn his keep) by elaborating this more comforting interpretation.[71]

Equally appropriate in their different way are the images of Vulcan (Fig. 147) and his wife Venus (Fig. 145) which Bernini designed for firedogs, those necessary supports which allow the air to circulate through the burning logs, but which developed into elaborate works of sculpture. Vulcan, as the smith of the gods, was an obvious choice, and he stands proudly displaying a helmet he has just forged, while suits of armour come

Fig. 148 (*facing page*) Gianlorenzo Bernini, *Cattedra Petri*, gilt bronze and gilded stucco. Vatican, St Peter's.

Fig. 149 Silvio Calci, vase with serpent handles, black marble. Rome, Galleria Borghese.

Fig. 150 Gaspare Morone, medal of Pope Alexander VII, bronze. British Museum.

Fig. 151 Gianlorenzo Bernini, drawing for the reverse of a medal, showing the *Cattedra Petri*. London, British Museum.

to life and sit on the anvil to support the base, which is formed of a cannon and other military products of his craft, such as shields and mortars.[72] On a similar anvil, Venus represents the fire of love, presumably the occupation of peace, while one Cupid forges his arrows on a flaming cannon, and another holds a flaming torch upon it.[73]

It was when a sculptor was closely linked to a particular patron that he was most likely to produce a number of relatively menial designs – or perhaps it would be truer to say that this is when art historians are most likely to find documentary references to such work. It was, for instance, when Algardi was the only sculptor known to have been working for Prince Marcantonio Borghese that he designed the *pietra del paragone* vases and urns which were executed by Silvio Calci, not in true touchstone but in the softer black Flemish marble which usually passed under the same name in seventeenth-century Rome. Only one pair, large decorative vases with serpent handles (Fig. 149), is actually documented as designed by him,[74] but another pair of vases and a pair of urns, also made by Calci, can be plausibly ascribed to his designs.[75]

A very different relationship existed between Bernini and the Chigi pope, Alexander VII: one of mutual respect and even friendship. The pope kept a diary, actually more of an annotated appointments book, in which are recorded his meetings and discussions with various artists, but most frequently with Bernini, who appears to have visited him at least once a week.[76] They discussed everything from the *Cattedra Petri* (Fig. 148), the vast structure Bernini created to incorporate the relic of the chair of St Peter, to the design for the reverse of the annual medal (Figs. 150, 151), and this too, for several years, was designed by Bernini.[77] The former cost more, and was larger, but the latter clearly occupied the pope's mind just as much, for each year he had to decide on a subject which summed up the achievements of his office, and find an inscription in correct and succinct Latin, and if the execution of the *Cattedra*, once its form was established, remained a matter for the sculptor, the erudite Pope could exercise his own learning on the medal.

Fig. 152 Gianlorenzo Bernini, drawing for a golden rose. Paris, École des Beaux-Arts.

Fig. 153 Gianlorenzo Bernini and assistants, *Four Rivers Fountain*, travertine and marble. Rome, Piazza Navona.

It was for Alexander VII that Bernini designed a golden rose (Fig. 152),[78] which was a regular gift from the pope to honour a favoured ruler. Within the standard formula there was room for some variation, though perhaps not so much as Bernini attempted here, with the roots raising the plant (the Chigi oak tree, on which the roses bloom) above the base with exactly the same daring that he had used in the rocky support for the obelisk in his *Four Rivers Fountain* in the Piazza Navona (Fig. 153). There an extremely stable structure had amazed everyone by its apparent fragility; in the rose the fragility would have been all too actual, and most likely it was never made, or, if it was, it is hardly likely to have survived.[79]

It was also under Alexander VII that Bernini designed the altar furniture for St Peter's (Fig. 154), though he did so in his capacity as Architect of the Basilica, rather than as Architect of the Palace, a position which he held under this pope.[80] Unlike so many of the objects discussed in this chapter, these survive, though not the designs that Bernini must have made for them, and, indeed, the degree of his direct involvement is a matter of some debate.[81] The only surviving drawing related to them is a neat project from Bernini's studio for the candlesticks (Fig. 155),[82] which were carved in wood and then cast, as were the crosses. It is to be presumed that Bernini took a more personal interest in the two figures of Christ, one living (Fig. 156) and the other dead, which were to hang upon them, but the actual models were made by Ercole Ferrata[83] and executed by a number of other workmen.

122

Fig. 154 (*top left*) Gianlorenzo Bernini and assistants, altar furniture, partly gilt bronze. Vatican, St Peter's.

Fig. 155 (*above*) Studio of Gianlorenzo Bernini, drawing for a candlestick. Windsor, Royal Library.

Fig. 156 (*left*) Gianlorenzo Bernini and Ercole Ferrata, *The Living Christ*, gilt bronze. Vatican, St Peter's.

The same design for the candlestick was cast in a larger format for the Chigi family chapel in Sta Maria del Popolo,[84] where, on the pope's orders, Bernini designed the tombs, and the figures, of *Habakuk* and *Daniel*, for the two remaining empty niches in the wall, as well as being in charge of the remodelling of the whole church.[85] Hanging in this chapel is a lamp (Fig. 157), modelled by the Flemish sculptor Peter Verpoorten.[86] It was cast by Francuccio Francucci, and gilded by Francesco Perone, both of whom were also engaged in the casting of more substantial, if less directly artistic, frames for the chapel,[87] but Bernini's responsibility is not mentioned in the documents. It could, of course, be inferred from his general involvement with the chapel, but it is confirmed by an entry in the Pope's diary for 16 July 1657: 'Yesterday we saw the bronze lamp made for the chapel in the Popolo by Bernini.'[88]

That Bernini was responsible for the design of this lamp is equally evident from its style. It is hardly feasible to compare a lamp and a palace, but it is possible to compare the pose of the foremost flying cherub with that of the marble *Daniel* (Fig. 158), and to accept that Bernini was not unjustified in his claim, and that some of the same attention, the same thought, the same care for twisting movement, went into both the bronze lamp and his justly admired marble figures. If the latter were made by his own hand, the hanging lamp was modelled by an artist virtually unknown to the history of art; such a man was able to create a work of this high aesthetic quality because a sculptor such as Bernini was responsible not only for his autograph marbles, but also for the design of a small bronze lamp.

Fig. 158 Gianlorenzo Bernini, *Daniel*, marble. Rome, Sta Maria del Popolo.

Fig. 157 (*facing page*) Gianlorenzo Bernini and Peter Verpoorten, hanging lamp, bronze. Rome, Sta Maria del Popolo.

125

VI

THE 'BOYS'[1]

In 1656 Virgilio Spada wrote to Monsignor Rasponi, then polishing his Latin volume on S. Giovanni in Laterano, to correct certain commonly held misapprehensions; mainly these concerned the architecture of the rebuilt church, but Spada mentioned also the reliefs along the nave (Fig. 31): 'Algardi', he wrote, 'did not work on these, but rather the best boys [*i megliori giovani*] who were to be found in Rome, just as is now being done in the church of S. Maria del Popolo.'[2] In the past two chapters we have looked at sculptors who executed designs provided for them by others; in this chapter I shall examine a more complex situation: those sculptors who worked, often in teams, following the general direction of some more prominent member of their profession, but at least to some degree free to interpret these directions according to their own abilities and their own temperament.

The word '*giovani*' used by Virgilio Spada has many meanings in Italian – young man, of course, but also apprentice, office-boy, or bachelor; none of them quite fits Spada's use of the the term, which was common enough in seventeenth-century parlance. He was writing in 1656 of events of 1648–9, and when he compares the artists who had worked in the Lateran with those working eight years later in Sta Maria del Popolo the comparison was indeed valid, for several of them were the same sculptors; they were seven or eight years older by then, and some of them had been far from young in 1648, and one at least, Domenico de Rossi, had been active at the end of the 1620s when he carved a marble statue from his own design in Sta Maria di Loreto.[3] So they were not necessarily young, and neither were all of them apprentices.[4] What they had in common was that, for one reason or another, they had not made good; they were 'boys' in the sense that we may refer to a 'gardener's boy', who might be an eager youngster who would rise to greater things, or he could be a mumbling greybeard, a man of little talent, or someone who had once shown promise but had failed to maintain it, slipping ever further down the field in the rat race. In other words, they were all men who were prepared to work in a subordinate position, taking orders, fulfilling a scheme devised by someone else, and they made up the 'lump', the pool of available sculptural talent which men like Virgilio Spada, Gianlorenzo Bernini, or some other architect, could draw on to execute the major works of baroque decoration which required many hands, and which all too often had to be completed in a hurry.

The restoration, or rather the transformation, of the Lateran was just such an enterprise, and one about which we are extremely well informed because Pope Innocent X put Virgilio Spada in charge, and it was he who had to deal with the highly neurotic and temperamental architect Francesco Borromini, and to find the sculptors. His family documents are preserved in the Archivio di Stato in Rome, and the relevant papers have recently been

published.[5] But documents never really answer the questions one needs to ask. They tell us of the Pope's determination to preserve the old Constantinian walls (so important to him that, where the oval prophets were painted in the eighteenth century, the ancient brickwork was formerly left bare, set off like a jewel in a ring);[6] they tell us of the supreme technical achievement of Borromini in forcing these walls upright, and preserving the old wooden ceiling, while building what is virtually a new church round them,[7] and they tell us of his tantrums, and the long periods when he refused to appear on the site,[8] so that we can better understand the rush to get some sort of decoration up by the Holy Year of 1650. They tell us that these reliefs were not intended to remain in stucco, but that, after contemplating casting them in bronze, Spada decided that this would be too laborious, and that the colour contrast with the white plastered walls would be too crude, so he planned to change them for mosaics.[9] They tell us that Annibale Albani, the learned librarian of the Vatican, worked out the programme, with the Old Testament types down the right wall and the New Testament antitypes down the left, and why they start with the *Expulsion of Adam and Eve from Paradise* and *The Soul of the Good Thief Entering Paradise* (which is the real subject of the *Crucifixion* relief) in imitation of the lost decoration of the Constantinian basilica.[10]

But they do not tell us the full meaning of the programme, because the list of subjects Annibale Albani provided for Spada is scribbled down on a rough piece of paper,[11] and if he provided a fuller explanation for the Pope this has since been lost; they do not provide the names of the sculptors for all the reliefs, because, mysteriously, thirteen artists received full payments for what are only twelve reliefs, and even the categorical statement that Algardi did not work there must be taken with a large grain of salt, because Spada had a rather cavalier way of regarding designs, demanding them from all and sundry and never paying for them, and it seems inconceivable that Algardi did not design at least some of the stuccoes.[12]

For some, however, we do know the artists. *The Crucifixion* (Fig. 159), for example, was one of three modelled by the young Frenchman Michel Anguier, who was to return to his own country in 1651 after ten years in Rome, and to become one of the leading sculpors in mid-seventeenth-century Paris.[13] In Rome he certainly worked for Algardi, but here, if he were given designs, he must have followed them with a freedom that destroyed all trace of Algardi's style. Spada seems to have liked young foreigners, and as well as Anguier we find Alexandre Jacquet, another Frenchman,[14] and the mysterious Gervase Derouet, of whom almost nothing more is known.[15]

Another young artist was Antonio Raggi,[16] who had already worked for Algardi as a restorer in the Villa Pamphilj, and, who, in contrast to Anguier, seems here to be following designs provided by the master. Yet Raggi was still stylistically unformed, and at the very time he executed these reliefs he was carving an altarpiece on the designs of Bernini;[17] finally he was to opt for the manner of Bernini, and to become his most trusted assistant.

Domenico de Rossi has already been mentioned as something of an anomaly among these youngsters, but one look at his *Sacrifice of Isaac* (Fig. 160) is enough to explain why a sculptor who was once so promising had come to rely on this sort of work. His son Giovanni Francesco, however, who modelled the *Descent into Limbo* (Fig. 161), was to become Virgilio Spada's most patronised sculptor. This would be hard to understand if one looks at his works in marble, which are usually hard and insensitive, and

Fig. 159 Michel Anguier, *The Crucifixion*, stucco. Rome, S. Giovanni in Laterano.

Fig. 160 Domenico de Rossi, *Sacrifice of Isaac*, stucco. Rome, S. Giovanni in Laterano.

Fig. 161 Giovanni Francesco de Rossi, *Christ's Descent into Limbo*, stucco. Rome, S. Giovanni in Laterano.

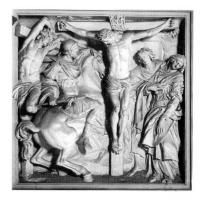

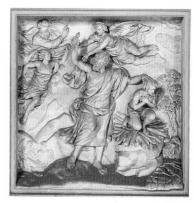

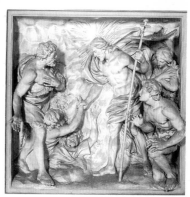

Fig. 162 Giovanni Francesco de Rossi, ceiling of the Spada Chapel, stucco. Rome, Sta Maria in Vallicella.

often defective in proportion,[18] but he was a competent stuccoist, and could produce satisfactory results from someone else's designs, as he did on the ceiling of the Spada Chapel in the Vallicella (Fig. 162).[19] The younger de Rossi's undoubted success in the less competitive milieu of Poland[20] was paralleled by the blossoming of Giovanni Battista Morelli,[21] another of the sculptors of the Lateran, who shortly afterwards moved to Spain.[22]

The team of sculptors who executed these reliefs, in great haste, and as temporary mock-ups for what was intended to be a more permanent decoration, may seem a motley and heterogeneous group; but, in fact, they had been assembled for a far more prestigious and permanent undertaking, the decoration of the nave of St Peter's (Fig. 163), and Virgilio Spada, who was also a member of the Committee of the Fabbrica of St Peter's, just transferred them, along with the plasterers, for the rushed job in the Lateran – though that is not to say that the decoration of St Peter's was not also done at speed. There we find most of these same sculptors,[23] with many more, working on the marble incrustation, carving the putti who hold the medallions of early popes, the swords and books, mitres and keys. This immense enterprise, which took from the spring of 1647 through 1649, was subject to the same deadline of the Holy Year, and no less than thirty-nine sculptors in all laboured on these reliefs, while other marble-cutters sawed and polished the multicoloured stones for the incrustation. Just about every available sculptor was rounded up and set to work: the young Frenchmen; Bartolommeo Cennini from Florence who was more experienced as a bronze-

128

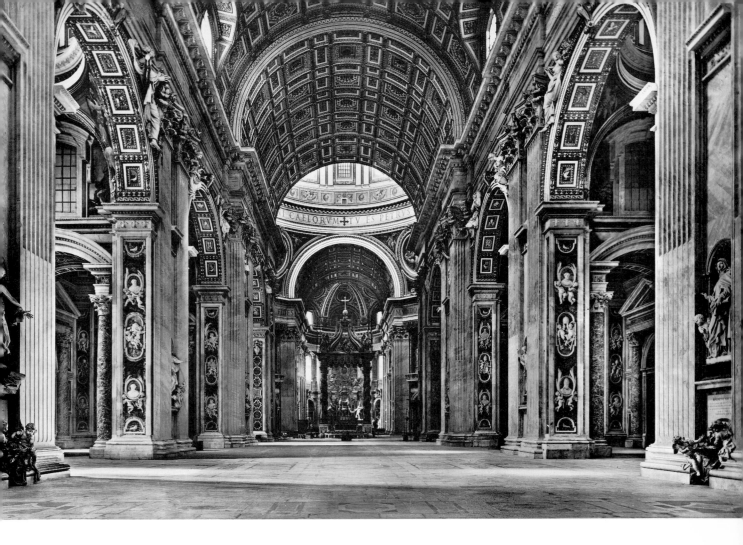

founder;[24] men who had seldom done more than make busts for antique heads such as Clemente Giovanozzi;[25] and, on the other hand, such established masters as Ercole Ferrata, and the architect and sculptor Cavaliere Cosimo Fanzago, briefly in Rome from his home in Naples.

Fig. 163 Nave of St Peter's. Vatican.

Virgilio Spada himself writes with pride of his achievement in completing the work so swiftly, his main worry having been how to find sufficient coloured marbles, those for the Pamphili doves with olive branches in their beaks proving particularly elusive, and difficult to carve.[26] But his words about the sculptors have a special significance in our context: such work, he claims, could not have been done in previous centuries, because never before had there been so many competent men available as now, when the leading sculptors of the century have produced students especially skilled in the sculpture of putti, so that not only was it possible to undertake such a labour without fear of failing to complete it with honour, but the whole nave was finished in an extremely short time, one could say about a year, although it involved fifty-six large medallions, and one hundred and ninety-two cherubs, each some four feet high, with one hundred and four doves considerably larger than life, thanks to the diligence of Cavaliere Lorenzo Bernini, the Architect of St Peter's, whose own excellence in both sculpture and architecture, and whose uninterrupted application, inspired the workmen to labour well and fast.[27]

This comment, taken together with what we know of the men involved, is extremely revealing. The assembling of this team of disparate talents was

possible because of the number of proficient sculptors around, and, we should note, the basic nature of the work, of which the most notable and varied part consisted of the putti, or cherubim, which had become the standard building-block of so much Roman baroque sculpture. Every artist learnt to produce them, and even men of very mediocre talents could be trusted to turn out something passable, and, perhaps more important, something that would fit harmoniously into this team effort, without, one may assume, requiring detailed guidance from Bernini himself. It is unlikely to be mere coincidence that, apart from a workshop drawing for one complete panel (Fig. 164),[28] which was not the design finally selected, only one rough sketch by Bernini for this enterprise has survived (Fig. 166),[29] and this for the cherubim holding the sword and book (Fig. 166), placed near the tomb of Benedict XV, which is something of an oddity, being the only relief to represent this motif.[30]

Fig. 164 Studio of Gianlorenzo Bernini, drawing for the incrustation of a pilaster. Biblioteca Apostolica Vaticana, Arch. Chigi, Cart. A, 24922.

I am not suggesting that this sketch was all the guidance he gave, but it seems more than likely that he provided only a few drawings for the sculptors, and told them to continue in the same way, secure in the knowledge that this would suffice to indicate what was required of them. The word 'workmen' (*operarij*), which Spada used, could be applied to these sculptors just as well as to the men who cut the coloured marble slabs. And when one looks at their work, for all its variation in quality, it is probably impossible to tell the difference between the contributions of the struggling artisan and the greatest sculptor of baroque Naples; I say 'probably' because, to be honest, I have never tried, but then I am sure that I was not meant to. It is sufficient to know that the medallions represent the sainted popes, that the mitre and keys refer to St Peter and the book and sword to St Paul, and that the doves refer to hopes for peace as well as to the current Pamphilj pope (whose arms contain a dove with an olive-branch in its beak; the other element, the fleur-de-lis, appears on the friezes on the pilasters).[31] Above all, it is the richness of the effect which overwhelms the visitor to St Peter's, to which the quality of the sculpture contributes, without inviting detailed critical appraisal.

From among this army of *operarij*, eleven were also employed to execute the stucco personifications over the arches of the nave.[32] In 1599 two arches at the far end had already been so decorated, and the pattern was to be followed in the six remaining bays down to the entrance.

For work of such comparative importance one might have expected Bernini to choose artists of some standing, but this was not the case. Those selected included men like Domenico Prestinari, author of the figure of *Patience* (Fig. 172), who had been around for some time during which he had produced no sculpture of merit,[33] and several, such as Bartolommeo Cennini, who had not entered Bernini's orbit before their work on the incrustation. Both the de Rossi's were employed here, Giovanni Francesco modelling the figure of *Strength* (Fig. 167), and helping his father on that of *Mercy* (Fig. 168). Andrea Bolgi, who had assisted in the modelling of the *Baldacchino* and carved the great marble statue of *St Helena* for one of the piers in the crossing, added the only note of distinction (Fig. 173). Although no drawings by Bernini survive, it is inconceivable that he did not provide at least rough sketches, if only to determine the iconography, yet the sculptors must have been left very free to interpret them in their own ways, as can be seen by comparing, for example, the calm stolidity of the Fancelli brothers'

Fig. 165 Jacomo Balsimelli, *Cherubs with the Sword and Book*. Vatican, St Peter's.

Fig. 166 Gianlorenzo Bernini, drawing for the *Cherubs with the Sword and Book*. Leipzig, Museum der Bildenden Künste.

Contemplation (Fig. 169) with the swinging movement and strong contrasts of light and shade in Giovanni Battista Morelli's *Innocence* (Fig. 170). Yet such discrepancies pale into insignificance against the blatant idiosyncracy of the two allegories by Bolgi (Fig. 171), the sculptor who had once been favoured above Finelli for his greater docility and comparative lack of ambition. Whatever direction the sculptors were given, Bolgi interpreted them with a liberty which was beyond the courage – and capacity – of his colleagues, and beyond the tolerance of the pope, who ordered these two

131

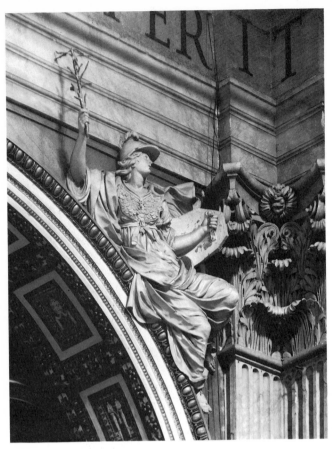

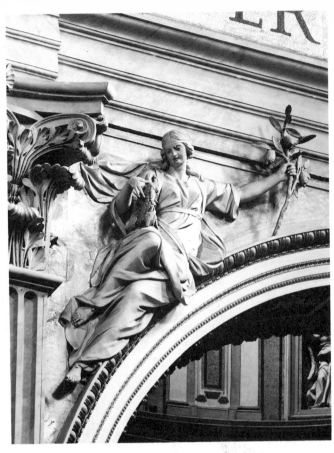

Fig. 167 Giovanni Francesco de Rossi, *Strength*, stucco. Vatican, St Peter's.

Fig. 168 Domenico and Giovanni Francesco de Rossi, *Mercy*, stucco. Vatican, St Peter's.

Fig. 169 Cosimo and Jacopantonio Fancelli, *Contemplation*, stucco. Vatican, St Peter's.

Fig. 170 Giovanni Battista Morelli, *Innocence*, stucco. Vatican, St Peter's.

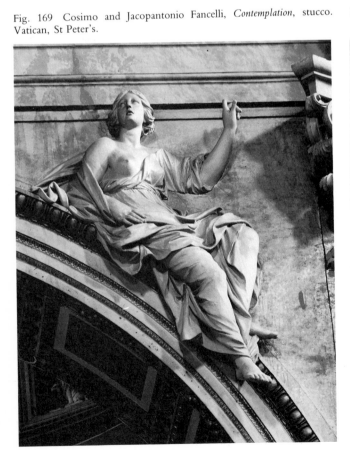

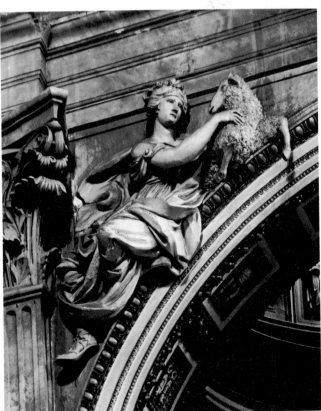

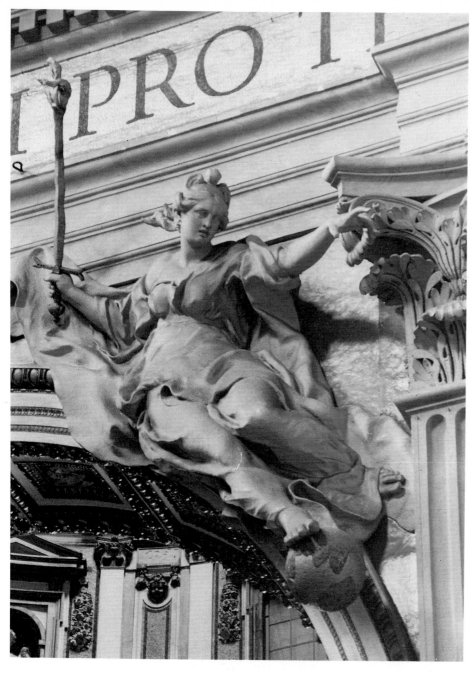

Fig. 171 Andrea Bolgi, *Divine Justice*, stucco. Vatican, St Peter's.

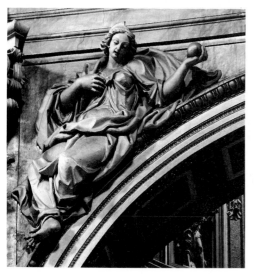

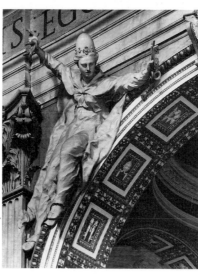

Fig. 172 Domenico Prestinari, *Patience*, stucco. Vatican, St Peter's.

Fig. 173 Andrea Bolgi, *The Church*, stucco. Vatican, St Peter's.

personifications to be taken down.[34] This order does not appear to have been followed, or at most very minor alterations can have been made to what remain the only really masterly figures of the series. Not altogether surprisingly, Bolgi was never to work for Bernini again, and shortly after this he left for Naples, where he gave free rein to his fascination with subtly swirling draperies and wide, soaring movement.

The stuccoes in the nave of St Peter's and the Lateran date from the end of the 1640s, but Virgilio Spada's letter of 1656 quoted at the beginning of this chapter compared the sculptors who had worked in the Lateran with those currently engaged in Sta Maria del Popolo (Fig. 174). Again, as in St Peter's, the artist in charge was Bernini, and again the commission came from the pope, for it was Alexander VII who decided on the modernisation of the old church that stood at the end of the Via Flaminia at the principal entry to the city of Rome, and in which his family, the Chigi, had built their chapel.[35] The task was to remodel the quattrocento interior, counteracting the clear division of the round-arched bays with a swinging cornice that runs the length of the nave, widening the gothic windows and linking them to this cornice by means of pairs of stucco figures, repeated along the length of the nave and related to a pair on the inner façade and another pair over the crossing.[36] But, in contrast to St Peter's, in this smaller space the rich polychrome effects were replaced by the sobriety of white stucco and marble.

Originally, as is shown by a workshop drawing (Fig. 175),[37] Bernini had planned to fill the spaces between the depressed arches of the bays with kneeling angels, and some models for them must have been made, presumably in the workshop of Ercole Ferrata, since they appear in several drawings preserved in the same sketchbook (Fig. 176).[38] This scheme of angelic decoration remains in the angels which Ferrata did indeed place on the entrance wall, the pair that Raggi made below the organ lofts, the four marble angels supporting the altarpieces in the transepts, and Raggi's so-called 'victories' over the crossing.[39] But presumably this decoration was judged too monotonous for the length of the nave, and by 1655 Bernini had evolved a new scheme of female saints,[40] creating a train of maids of honour to surround the sacred image of the Virgin on the high altar, who thus appears as the *Virgo inter Virgines*.

In Sta Maria del Popolo, it was once again team-work that was essential to provide the stylistic unity which was the purpose of the redecoration, and a common stylistic language. The payments do not always specify the sculptor who produced each figure, and, though confident attributions have been made, I cannot always share their assurance. The team was rather different from that which had worked on the earlier projects: in St Peter's the approaching Holy Year had necessitated the inclusion of just about anyone who could hold a chisel, and even for the stucco *Virtues* it seems that necessity, rather than choice, must have guided the employment of some of the sculptors; in the Lateran, Virgilio Spada's constant desire for economy, perhaps justified by his intention that the reliefs should be only temporary, seems to have outweighed his aesthetic sensitivity. Here, however, the Pope must have demanded a higher level of competence, and a more careful choice of sculptors, which ensured a more homogeneous approach.[41]

Three drawings survive, one a workshop drawing for the decoration of the round window on the entrance wall, for which the stucco angels were to be made by Ercole Ferrata, and two for the stuccoes in the nave.[42] One of

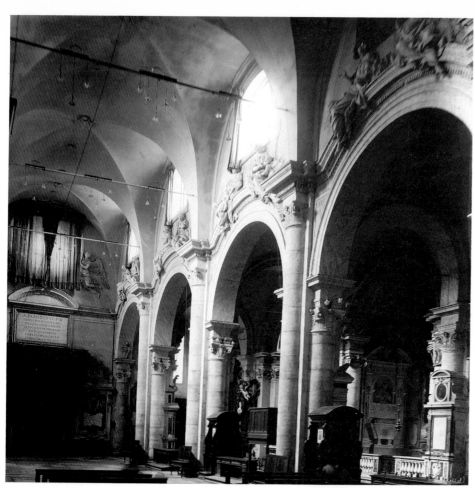

Fig. 174 Nave of Sta Maria del Popolo. Rome.

Fig. 175 Anonymous draughtsman, project for the nave of Sta Maria del Popolo, drawing. Leipzig, Museum der Bildenden Künste.

Fig. 176 Anonymous draughtsman, *Angel*, drawing. Leipzig, Museum der Bildenden Künste.

Fig. 177 Gianlorenzo Bernini, drawing for *St Ursula*. Leipzig, Museum der Bildenden Künste.

Fig. 178 Giovanni Antonio Mari, *St Ursula*, stucco. Rome, Sta Maria del Popolo.

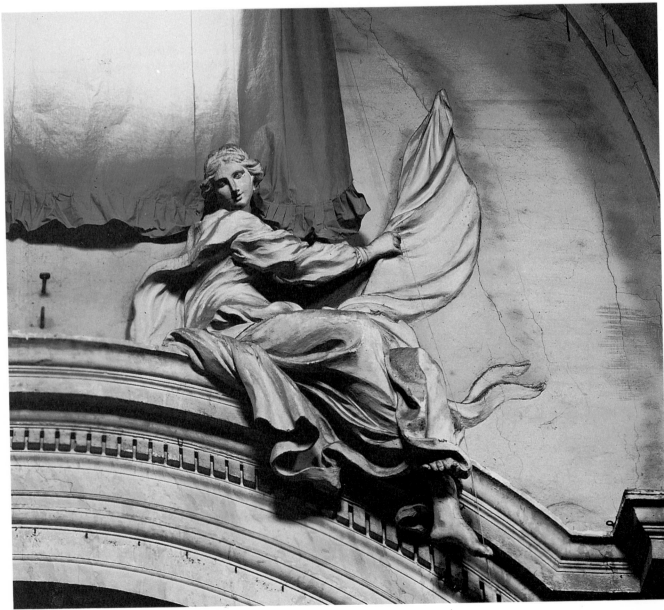

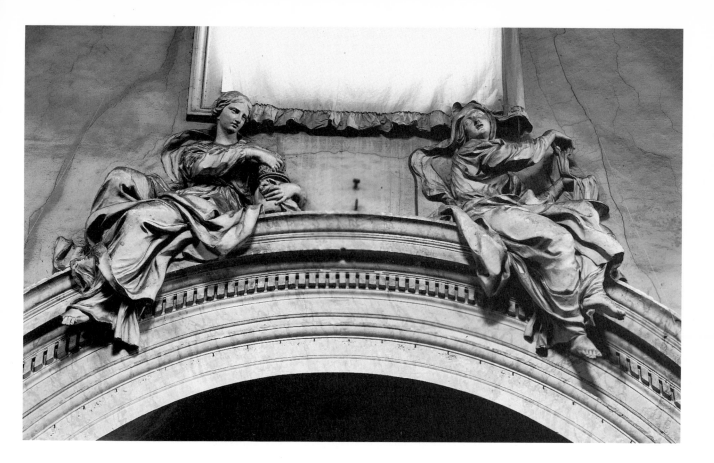

Fig. 179 Paolo Naldini, *Sta Prassede*, and
Lazzaro Morelli, *Sta Pudenziana*, stucco.
Rome, Sta Maria del Popolo.

these (Fig. 177), a lightly drawn but clearly defined study for the *St Ursula*,[43] is unquestionably autograph, and must record the design given to the sculptor, Giovanni Antonio Mari,[44] though most probably he would have been supplied with a neater workshop copy. It is revealing to compare it with the stucco (Fig. 178): the essential pose of the figure is identical, and the sweep of the drapery over her legs is retained, as is the line of the cloak over her lap; but the sculptor felt free to introduce a fall of drapery over the cornice, to increase the billowing folds behind her back, to alter the angle of the head, and to lengthen the sleeve, treating it in a way that harmonises with the easy grace of the general construction of the figure. Although one can never exclude the possibility that Bernini modified his design in another, lost, drawing, I should consider it more likely that such modifications were left to the judgement of the sculptors, for here, as in the nave of St Peter's, one can see how their different styles made themselves visible even within this much more rigidly unified scheme determined by Bernini. An example of this is found in another pair of saints (Fig. 179), the *Sta Prassede* of Paolo Naldini and the *Sta Pudenziana* of Lazzaro Morelli, companion figures seated over the same arch mopping up the blood of the martyrs. It was surely Naldini who chose to stress the solid construction of his figure, at the left, and Morelli who preferred to emphasise the floating draperies of his saint, at the right. Bernini must have decided on the angles of their heads, but the sculptors must have been responsible for the almost unemotional expression of *Sta Prassede*, and the ecstatic gaze of *Sta Pudenziana*, and, within their prescribed actions, the simple straightforward way that Santa Prassede wrings out her sponge, and the coquettishly arched hand of Sta Pudenziana delicately raising her cloth.

137

Fig. 180 Gianlorenzo Bernini, drawing for an organ loft. Biblioteca Apostolica Vaticana, MS. Chigi P. VII.10, f. 29r.

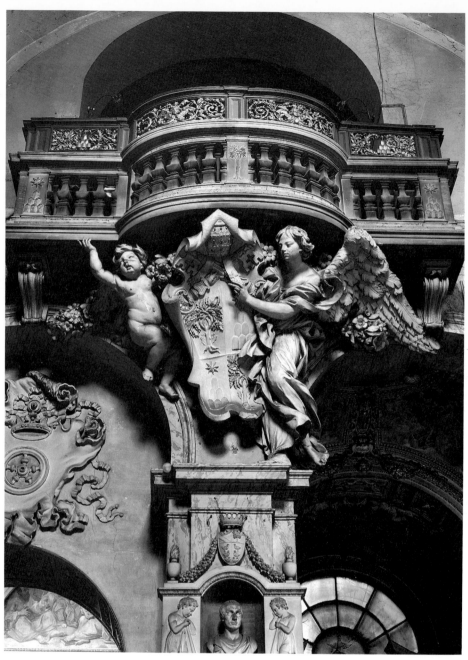

Fig. 181 Gianlorenzo Bernini and Antonio Raggi, organ loft, stucco. Rome, Sta Maria del Popolo.

The completion of the nave was followed by the construction of the two organ lofts, both executed by Antonio Raggi. There is a preliminary drawing for one of these (Fig. 180), from an anonymous draughtsman in Bernini's shop, which is close to the executed project, at least as regards the organ itself, the pipes appearing like some natural structure enmeshed in the branches of the oak tree, which is one of the elements of the Chigi arms, taken over from the della Rovere family, and therefore particularly appropriate in this church, which had been patronised by the della Rovere in the sixteenth century.[45] The angels and cherubs which support the two lofts differ, subtly but decisively, from each other. In these differences Mark Weil has seen the contrast between the balanced serenity of Bernini, who would have designed the vertical coat of arms held by the confidently flying angel

Fig. 182 Antonio Raggi, organ loft, stucco. Rome, Sta Maria del Popolo.

(Fig. 181), and the almost mischievous variation that Raggi has introduced (Fig. 182), his angel tripping as it alights on the impost-block and catches its foot in the edge of its robe, struggling to keep its balance, hampered by the sleeve which has slipped from its shoulder and almost dropping the coat of arms, a more elaborate and baroque cartouche with its scrolled edges and the top which folds over the papal tiara and a swathe of drapery which partially obscures the arms themselves.[46] Strange though it may seem that Bernini should have provided a precise drawing for one of these two organ lofts, while leaving Raggi free to produce his own variation for the other, there is no denying the gulf that separates the conception of the one from the other, and no reason why Bernini should have sought to distinguish so markedly between them.

With the marble angels supporting the frames of the altarpieces in the transepts we encounter a rather different process. Drawings exist for them in Berlin (Fig. 183), but, interestingly enough, they are not by Bernini's own hand, but by Giovanni Battista Gaulli, known as Baccicio,[47] a Genoese painter who came to Rome when scarcely more than a boy and entered Bernini's studio; later, as a painter, he was frequently to collaborate with the sculptor, but here he appears to have been employed to prepare rough ideas for the poses of these angels. They are considerably wilder and more active, though more normal in their proportions, than the final marbles (Fig. 184). Evidently Bernini must have set some less inventive, but more moderate member of his shop to tone down the designs before giving them to the sculptors, Raggi, Ferrata, Mari and Giardé,[48] who carved the stately figures between 1657 and 1658.

It was to Antonio Raggi that Bernini entrusted the largest share of this work. He had taken only a very minor part in the decoration of St Peter's, but in the Lateran he had been the only sculptor to model as many as three of the twelve reliefs, and in Sta Maria del Popolo he was assigned four of the female saints, the two victories, the organ lofts, and one of these marble angels, a share surpassing even that of the considerably older Ercole Ferrata. Ferrata, born in 1610 and some fourteen years older than Raggi, was an established artist; after Algardi's death, like almost every other sculptor in Rome he had been drawn into the orbit of Bernini, but he had his own style, owing much to the relatively unemotional manner of Algardi, and he had his own considerable independent practice, as well as being the most successful teacher of the next generation of sculptors. In other words, though he was included in the team at the Popolo, he was scarcely to be ranked among the *giovani*.

Not so Raggi. In 1652 Duke Francesco d'Este was looking for sculptors to work for him in Modena, particularly at his villa at Sassuolo,[49] and his agent in Rome, Geminiano Poggi, relayed back a fascinating report on the information Bernini had given him as to the best sculptors available in Rome at that time:[50] there were, he was told, many sculptors, but the number of good ones was limited to only four *giovani*, who could at present be called *mastri*; these were the Milanese Antonio Raggi, the brothers Giacomo Antonio and Cosimo Fancelli, and 'Monsù Claudio' (Claude Poussin) from Lorraine. Bernini named Raggi as the best, a young man (*giovane*) of the highest talent, who worked with great speed. Raggi was Bernini's pupil, and Bernini said he employed him on his best works. But the agent noted in their conversation that Bernini would be reluctant to see him leave Rome, although he had said that if it were for the Duke's service he would be very willing to send him. If Raggi were to work at Sassuolo, Bernini himself would also make the models for the statues, and it would be as if he had lent him.[51] At present, so Bernini said, Raggi was not engaged on any major work, but by making models and other things he was easily earning two ducats a day, implying that Raggi would ask something over sixty ducats a month to stay in Modena. Of the other three, Bernini said there was not much to choose between them. They all worked '*da maestro*' (by which he evidently meant from their own models); he praised Monsù Claudio as a very studious young man (*giovane*), but not yet very sure in larger works, though he modelled well and with a good style, and, since he was continually studying, one could hope for good results. The other two

Fig. 183 Giovanni Battista Gaulli, drawing of angels. Berlin, Staatliche Museen Preussischer Kulturbesitz, Kupferstichkabinett, KdZ 1284.

Fig. 184 Bernini workshop, angels supporting an altarpiece, marble. Rome, Sta Maria del Popolo.

140

brothers worked along the same lines, and the unmarried one, Cosimo, had more spirit than the other.

Here Bernini is using the words '*maestro*' and '*giovane*', words familiar from guild distinctions between masters and apprentices, in a very idiosyncratic manner: technically, they were all masters, and accepted as such by the Accademia di S. Luca,[52] and he admits that they were all capable of working as *maestri*, from their own inventions; yet he still regards them as *giovani*, in the same sense that Virgilio Spada used the term, as workmen who would realise the inventions which he gave to them.

The fluidity of these terms, or perhaps rather the different judgements that could be formed of a sculptor's capacities, is evident if one compares Bernini's rather patronising remarks about Claude Poussin with the view of another agent of the Duke of Modena, who reported at the same time that Claudio Poussino was a man of universal inventiveness, who could be compared to Algardi and Bernini; if he was overshadowed by them in Rome, were he to be employed by a great prince (such as the Duke of Modena) he would show himself to be a sculptor of real merit.[53] Alas, the only work of his which is known today, the *Ganges* (Fig. 153 at right) on Bernini's *Four Rivers Fountain*, is a statue of lifeless classicism which shows none of the spirit admired by this agent, and it was most probably this work that inspired Bernini's doubts. Indeed, it is evident both from the date, and the choice of artists, that this fountain was very much in Bernini's mind when he spoke to Poggi, for he had made use of both Raggi and Poussin to carve figures of *Rivers* for it, and, if Cosimo Fancelli had not been included there, Bernini could hardly have overlooked his superiority to his elder brother, who was. As for the fourth sculptor, Francesco Baratta, Bernini's silence need not necessarily have any significance, for he might well have been aware that Baratta himself had sent a small marble relief to Modena in 1651,[54] so that the Duke would have been able to form his own opinion.

Raggi was among the eight sculptors selected by Bernini to carve the ten angels bearing the instruments of Christ's Passion on the Ponte Sant'Angelo between 1667 and 1672. This series of statues is too important to be properly dealt with in a general discussion of the second-rank artists, and, indeed, by that time most of them had risen above this category, but the relationship between the statues as executed and Bernini's designs does illustrate the general point of this chapter.[55] Undoubtedly the finest of the series, always excepting Bernini's own, is the *Angel with the Column* by Raggi (Fig. 185), for the passionate drapery that swirls about the figure like a cry of anguish, billowing up to provide a support for the weight of the column, and flowing away in a dying moan, and the soft intensity of the angel's desolate gaze show Raggi's own febrile manner in perfect harmony with the drama of the action. Cosimo Fancelli, whom Bernini had praised in his letter of 1652, is also represented here, but by now he has become so imbued with the manner of Pietro da Cortona, with whom he had worked so often in the intervening years, that the thick woolly drapery, and the heavy, rather sleepy sweetness of the expression of his *Angel with the Sudarium* (Fig. 186) cannot sustain the intensity of emotion that Bernini's conception required.

One of the few *Angels* for which a drawing can reasonably be assumed to represent Bernini's final idea is that bearing the cross (Fig. 187). The drawing is not autograph, but comes from Bernini's workshop, and very likely re-

Fig. 185 Antonio Raggi, *Angel with the Column*, marble. Rome, Ponte Sant'-Angelo.

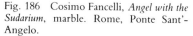

Fig. 186 Cosimo Fancelli, *Angel with the Sudarium*, marble. Rome, Ponte Sant'-Angelo.

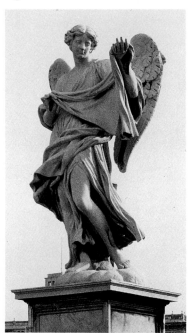

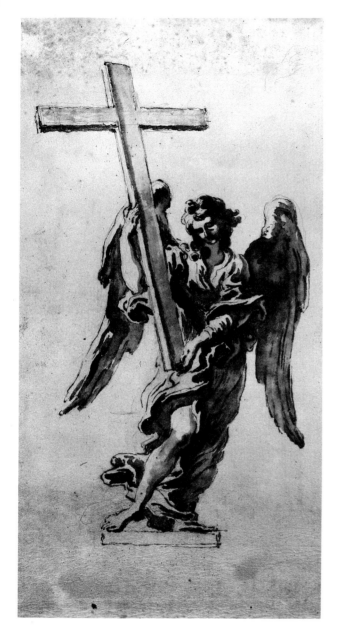

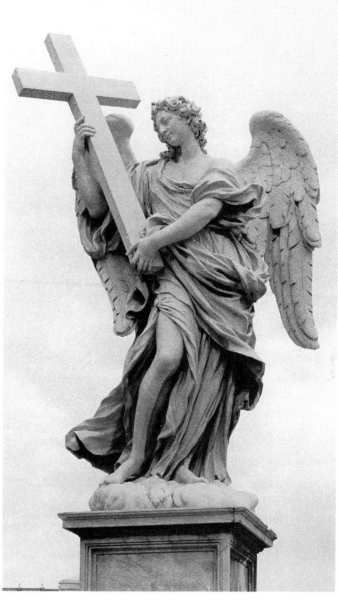

produces the design given to the sculptor, in this case Ercole Ferrata.[56] On the whole Ferrata has kept close to Bernini's intentions (Fig. 188), the additional folds of the drapery being required to support the weight of the huge marble cross. But if one looks at the drapery at the left, it is all too evident that the emotional flicks of Bernini's pen, the sense of cloth fluttering in the air, was foreign to the sculptor's heavier and more prosaic vocabulary. Unlike Fancelli, who translated his *Angel* completely into his own Cortonesque terms, Ferrata, a sound but uninventive artist, has sought to follow the drawing as closely as possible, and the result is neither the ethereal grief of the drawing, nor the delicate strength of Ferrata at his best.

The most revealing of the sculptors from our point of view is Paolo Naldini. Although his direct association with Bernini was much slighter than that of Raggi, Bernini evidently respected his capacity, and we find him

Fig. 187 Studio of Gianlorenzo Bernini, drawing for the *Angel with the Cross*. Rome, Palazzo Rospigliosi.

Fig. 188 Ercole Ferrata, *Angel with the Cross*, marble. Rome, Ponte Sant'Angelo.

143

Fig. 192 (*p. 145, top left*) Gianlorenzo Bernini, *Angel with the Superscription*, marble. Rome, St Andrea delle Fratte.

Fig. 193 (*p. 145, top right*) Gianlorenzo Bernini, *Angel with the Crown of Thorns*, marble. Rome, St Andrea delle Fratte.

carving two of the *Angels*.[57] One, the *Angel with the Robe and Dice* (Fig. 189), reflects his own close friendship with the painters Andrea Sacchi and Carlo Maratti, Sacchi's pupil: its square outline and calmly solid stance differentiate it from the other emotionally swaying *Angels* of the bridge, and the long, sorrowing head depends on antique portraits of Alexander the Great.[58] But it was Naldini whom Bernini chose to reproduce his own statue of the *Angel with the Crown of Thorns* (Fig. 190).

Originally Bernini had intended to carve two of the *Angels* on the bridge himself, but when they were finished the pope was so impressed by them that he refused to allow them to stand exposed to the weather, and they are now in the church of S. Andrea delle Fratte (Figs. 192, 193). None the less, Bernini was determined that some work by his own hand should be included in the series on the bridge, and, with the assistance of Giulio Cartari, he reproduced the *Angel with the Superscription* (Fig. 191), modifying the drapery swirling round the legs, and reducing the elaborate detail of the original in a manner more appropriate to a statue that was to be set out of doors, where both the attacks of the weather and the relatively fleeting observation by those traversing the bridge required a broader, less complicated structure.[59] There are a number of drawings and *bozzetti* for both the *Angel with the Superscription* and the *Angel with the Crown of Thorns*, the only ones of the series for which such *bozzetti* exist (and even the surviving drawings for the other *Angels* are all workshop elaborations of what were quite possibly no more than slight sketches); most of the models refer to Bernini's first versions in S. Andrea delle Fratte, but one, a *bozzetto* in Leningrad (Fig. 194), certainly by Bernini himself, introduces just those changes which are visible in the second version of the *Angel with the Crown of Thorns*, modifying in particular the sweeping drapery which underlined the crown, though retaining, albeit in a different form, the curling fold at the left which echoes its circle.

The two *Angels* by Naldini demonstrate very clearly the meaning of the title of this chapter, and how the works discussed in it differ from those

Fig. 189 Paolo Naldini, *Angel with the Robe and Dice*, marble. Rome, Ponte Sant'Angelo.

Fig. 190 Paolo Naldini, *Angel with the Crown of Thorns*, marble. Rome, Ponte Sant'Angelo.

Fig. 191 Gianlorenzo Bernini, *Angel with the Superscription*, marble. Rome, Ponte Sant'Angelo.

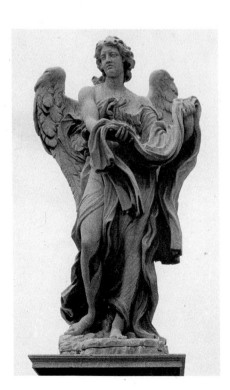
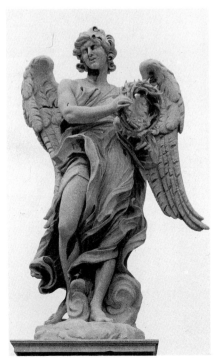
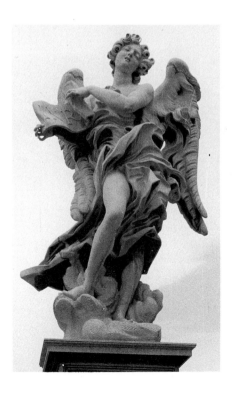

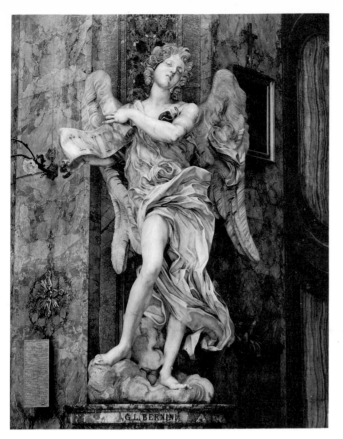

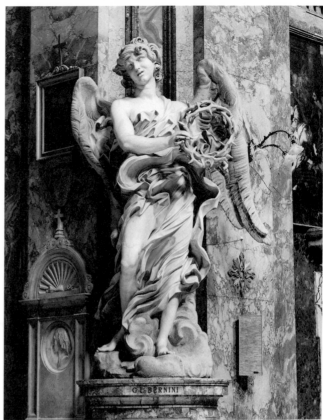

considered in the previous chapter. Without the documents one would have been unlikely to attribute these two *Angels* to the same artist, and, in fact, one would have been right to hesitate, for in *Angel with the Crown of Thorns* Naldini is acting as a simple executant, copying Bernini's model even to the curls on the head, above a face very different indeed from the physiognomy one finds in his own sculpture. In the *Angel with the Robe and Dice*, however, he is acting as a *giovane*, in the sense in which I am using the term here, as someone who is interpreting the idea, and no doubt a generalised sketch, provided by the master, but doing so in his own manner. This is still very different from working *da maestro*, as an independent sculptor executing his own invention, but, none the less, it leaves plenty of scope for the expression of the artist's own personality.

Although it would, perhaps, be unfair to describe any of the artists who worked on the Ponte Sant'Angelo around 1670 as *giovani*, in any sense of the term, it is, none the less, one of the most important and revealing examples of the particular kind of work with which we are here concerned, where the designer in charge would rely on the high level of ability among the sculptors of Rome to translate his sketches into statues fit to stand in this prominent position, on what was the processional way towards the centre of Christendom, the high altar of St Peter's.

The pilgrim who had passed this way, across the bridge with its symbols of Christ's Passion, would continue through the old narrow streets of the Borgo till he entered the piazza before St Peter's. Here, at the very time that these marble *Angels* were being carved for the bridge, a team of fourteen sculptors was actively at work on the ninety statues above the curved arms of the colonnade.[60]

Fig. 194 Gianlorenzo Bernini, *bozzetto* for the *Angel with the Crown of Thorns*, terracotta. Leningrad, State Hermitage Museum.

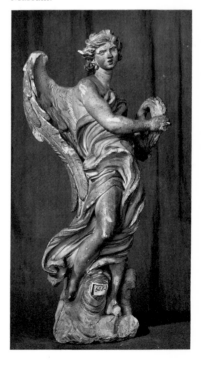

Fig. 195 Colonnade of St Peter's. Vatican City.

There is no question but that the colonnade (Fig. 195), and the piazza it surrounds, is a major work of Bernini the architect. It is hard today to think of St Peter's without it, and, indeed, the long façade of the church would look ill-proportioned without this prolongation which, by contrast, increases the apparent height of the wide, low building, and the need for such a modifying effect would have been all the greater before the nineteenth-century addition of the two clock-towers.[61] Usually it is regarded simply as architecture, and the host of saints who crown it are disregarded, much as one tends to dismiss the statues, so often just botched imitations of the antique, that break the skyline of so many palace façades.

We know that three wooden models for the colonnade were prepared. The first, of 1657, a full-size mock-up of a section of the colonnade constructed of wood and canvas, included grisaille paintings of four figures,[62] but it did not satisfy the pope, and was succeeded in the same year by another partial mock-up, for which no statues were made, though possibly the paintings from the previous model were incorporated.[63] The third, made in 1659–60, was a smaller version of the whole structure about five and a half metres wide, finely carved in walnut wood and surmounted by fifty wax statuettes, each of about 8 centimetres,[64] and Lazzaro Morelli, who was

146

paid for making them, cannot have provided anything more than summary indications of their proportions (which had been a matter of some uncertainty) and their general poses.

Yet Bernini clearly regarded the actual statues (Fig. 196) as more than mere decoration, and no less than three autograph drawings exist for *Sta Fabiola*,[65] showing the care he took over the definition of her pose, and the fall of her cloak; two other very similar drawings (Fig. 197) sketch in with summary but brilliant clarity the essential form of *St Mary of Egypt* (Fig. 196, second from left),[66] and another, originally intended for a female saint,[67] was evidently adapted for the statue of *S. Nilamon*. There is also a pen study from his workshop for *St Mark*, with a smaller sketch on the same sheet which is very close, in reverse, to the statue of *Sant'Appolonia*.[68] It must have been on the basis of such drawings that the sculptors worked, and made their own models. There is one surviving terracotta, and two such models are preserved in bronze casts.[69]

In 1666 the work began in earnest, with Lazzaro Morelli producing the lion's share – thirteen out of the first twenty-five statues – and other sculptors, including Naldini, Jacopantonio Fancelli, Bartolommeo Cennini, and Andrea Baratta, carving one or two each. It is also significant that all the surviving drawings and models refer to these statues of what we may call the first campaign. By the middle of February 1667 the authorities of the Fabbrica of St Peter's began to get worried: only twenty-six had been completed and sixty-four had still to be produced, at a minimum of two months each; they recorded in their deliberations the not very original conclusion that the more sculptors were employed on the job, the faster it would be done. Rather more interesting is the list they drew up of other artists who might be called in.[70] Not surprisingly, it includes the sculptors who were to work on the bridge, Ferrata, Raggi, Guidi and Lucenti;[71] also included were Ferrata's brilliant pupil, the Maltese Melchiorre Cafà, who was to die in an accident later that same year, Baldassare Mari, two of whose sons were already active on the Colonnade, and Orfeo Boselli, though Boselli, despite having worked on the incrustation of the nave, detested Bernini and all he stood for.

None of these were in fact to be employed, but rather those who were *giovane* in the primary sense of the word: Filippo Carcani, Francesco Antonio Fontana[72] and Michele Maglia, whom we have encountered working on the churches of Sta Maria di Montesanto and Sta Maria dei Miracoli, and Giuseppe Mazzuoli[73] and Lorenzo Ottoni, sculptors who bridge the gap between Bernini and the new generation of the next century, both surviving to contribute statues to the greatest enterprise of the early eighteenth-century, the series of *Apostles* for the nave of the Lateran. Together with these newcomers, Lazzaro Morelli, alone amongst those originally employed on the colonnade, worked doggedly on to carve the last statue in 1673.

If, even in the flourishing school of baroque Rome, they had to scrape the barrel of available sculptors for so vast an undertaking, it is little wonder that Bernini's incredible inventive genius was stretched to its limits, and beyond. The sharp-eyed Carlo Cartari noted that the *S. Ephrem* (Fig. 196, second from right) was copied from the *St Paul* by Paolo Taccone (Fig. 198), one of the two quattrocento statues that stood before the Ponte Sant'Angelo.[74] According to this well-informed observer, this was judged to be much better

147

Fig. 196 Workshop of Gianlorenzo Bernini, *Saints*, travertine. Vatican, colonnade of St Peter's.

Fig. 197 Gianlorenzo Bernini, drawing for *St Mary of Egypt*. Leipzig, Museum der Bildenden Künste.

Fig. 198 Paolo Taccone, *St Paul*, marble. Rome, Ponte Sant'-Angelo.

than the companion statue of *St Peter*, and this was why Bernini had chosen it to be reproduced on the colonnade. But why reproduce either? And why copy the *St Benedict* (Fig. 199) from that which Orfeo Boselli had carved from du Quesnoy's design for S. Ambrogio alla Massima (Fig. 200)? These copies, together with the lack of any surviving drawings, seem to indicate Bernini's dwindling interest in what he must have realised would never be regarded as much more than a decorative finish for his architecture. And this same realisation of the unimportance of these travertine statues may also have dictated the choice of such relatively inferior sculptors. There could be little glory for them, and their names emerge only from an attentive perusal

Fig. 199 Workshop of Gianlorenzo Bernini, *St Benedict*, travertine. Vatican, colonnade of St Peter's.

Fig. 200 Orfeo Boselli, *St Benedict*, marble. Rome, Sant'Ambrogio.

149

Fig. 201 Visitors to the Piazza S. Pietro. Vatican.

of the account books, and then seldom attached to a particular statue. For the pilgrim passing to St Peter's even the saints are for the most part anonymous, their names recorded only on a series of eighteenth-century prints,[75] and only a few are identifiable by their attributes. For the tourist they are part of the magnificence of Rome, splendid *en masse* but scarcely receiving a second glance as individual statues. For the art historian they are mostly anonymous works of the school of Bernini. For those who have read this chapter, however, they merit a little more attention, as proof of the quality that Bernini could extract from the pool of secondary sculptors, the 'boys', without whom the supreme genius of seventeenth-century sculpture could never have created the baroque Rome which today is so much admired.

In the eighteenth century, Charles de Brosses was to write that the population of Rome was composed of one quarter priests, one quarter statues, one quarter those who do scarcely any work, and one quarter those who do nothing at all.[76] Looking at the colonnade, and those who fill it (Fig. 201), one can well see what he meant; but we should also remember that the statues were not self-creating, and spare a thought for that small but forgotten proportion, the 'boys' who carved them.

VII

THE INFLUENCE OF THE BAROQUE
ON CLASSICAL ANTIQUITY

In an otherwise unremarkable inventory of 1690 appears a reference to an antique statuette '*rimodernata*', or, as we might say, 'modernised'.[1] It would be a mistake to put too much emphasis on what was probably no more than the chance use of an unusual word, but, rare though it may be, it is a just way of describing a very characterisitic activity, far more apt, in fact, than the more common '*ristaurata*', or 'restored'.

In the seventeenth century the antique was valued, but not as a fragment. High prices were paid for ancient sculptures, and princes and cardinals would quarrel over finds, and farmers struggle to maintain their rights over territory under which such treasures might be found. Camillo Pamphilj wrested a relief of *Perseus and Andromeda* from Marchese Muti to adorn his new villa,[2] while a contract for the rent of land might include provisions reserving the right to any objects found beneath it.[3] Broken and fragmentary marbles were avidly hunted, collected, and then, more often than not, kept in store-rooms; for in a sculpture gallery, on a staircase, in a loggia or in the garden, only complete statues were judged fit for display.[4] And so developed the profession of the restorer, the man who converted the former into the latter.

This was by far the steadiest and most reliable profession the sculptor could adopt. Since the best times are always in the past, Orfeo Boselli writing in the 1650s laments that in former times, that is in the 1620s and 1630s, the greatest masters had been employed for such work (men such as Bernini, Algardi and du Quesnoy) whereas in his own day the owners of antiques economised by employing the feeblest of sculptors, who produced hybrid abominations.[5] This was by no means true: restoration had always been one way in which a young sculptor could keep body and soul together; a few blossomed into successful sculptors, but most did not, and those who did would abandon such tasks,[6] or leave them to the assistants in their workshops.[7] While the leading families always could, and occasionally did, employ the best sculptors available, others had to make do with lesser men, some of whom were little more than incompetent hacks, whereas others, like Boselli himself, who never rose to eminence as original artists, were still able and conscientious technicians, and sometimes rather more than mere technicians when it came to restoration.

Boselli held strong and rigid views on the subject of restoration. It was not, as many believed, a job for mediocre talents, but one that required such high and sublime invention that it was the equal of the greatest of arts.[8] So the restorer had to study the iconography of ancient art in order to recognise the Virtue, god or person represented so as to complete its pose correctly, and give it the appropriate attributes and the right proportions, and, most important of all, he had to execute it in the antique style, in so far as anyone

Fig. 202 *Dying Gaul*, antique statue restored by Ipolito Buzzi, marble. Rome, Museo Capitolino.

could hope to emulate or equal antiquity.[9] He goes on to praise certain notable restorations carried out in the past, such as the legs of the Farnese *Hercules*, particularly renowned because the original legs turned up later, but, supposedly on Michelangelo's advice, it was preferred to retain those made for the figure by Guglielmo della Porta,[10] and he adds three restorations of his own day, by Bernini, Algardi and du Quesnoy, which will be discussed below.

This is still the way in which restoration is usually conceived: as an attempt to recreate the original as nearly as lay within the restorer's power. One has only to look at some of the restorations made by the best professional restorers, such as Ippolito Buzzi (1562–1632) (Fig. 202), to feel reasonably confident that, give or take the turn of a wrist, this was much the way the antique originally looked, and to have no doubt that this was what Buzzi intended us to think. In this spirit, he would seek out marble which matched that of the original, often reusing antique fragments, and take the utmost care in masking the joins and adjusting the polish.[11]

But this was not the only way in which one could treat an antique fragment, and I want in this chapter to concentrate on two other approaches, a concentration which may be rather misleading, for it would be wrong to underestimate the number of what we may call 'straight' restorations produced in the seventeenth century, but which is none the less necessary because such work has usually been forgotten, or misunderstood.

No one looking at the *Gypsy* (Fig. 203) restored by Nicolas Cordier for the Borghese would mistake it for an antique.[12] And yet the dark grey *bigio* marble body is indeed a fragment of an antique statue, the upper border round the neck recut with the heraldic dragon and eagle of the Borghese arms, and combined with shining white Carrara marble and bronze, the details of which have been gilded.

Another *Gypsy* (Fig. 204), also from the Borghese collection but now in Versailles, was constructed in a similar way, from a body which was recognised already by Aldrovandi in the sixteenth century as that of a Diana, but with simpler bronze additions.[13] While Bohemians and fortune-tellers

152

have always been popular subjects of genre painting, there was a particular vogue for them in the wake of Caravaggio, characters who add a touch of exoticism, and a spice of crime, to the scenes of low life which he inspired,[14] but just why the Borghese should have set up this gypsy encampment in their villa has yet to be discovered, or why they should both have been constructed in this way from such improbable originals.

What is clear is that here, as in the Roman *Gypsy*, it was not ignorance that guided the choice of subject, but a deliberate act of will, which had as little in common with Boselli's precepts regarding the preservation of the original iconography as the mixture of materials had with his instructions about selecting marble to match, disguising the joints, and tinting the new stone to harmonise with the old.[15]

Nicolas Cordier, whose colourful *Gipsy* alone remained in the Villa when so many of the other Borghese antiques were sold to the French, undertook a number of restorations for the Borghese, and even if he himself is not

153

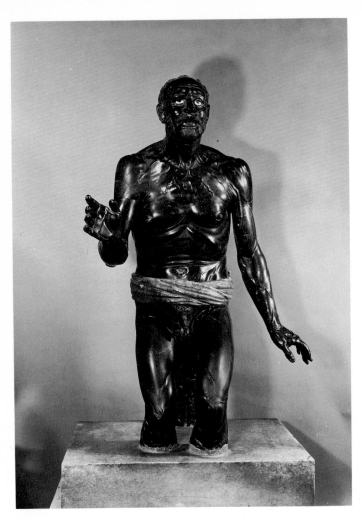

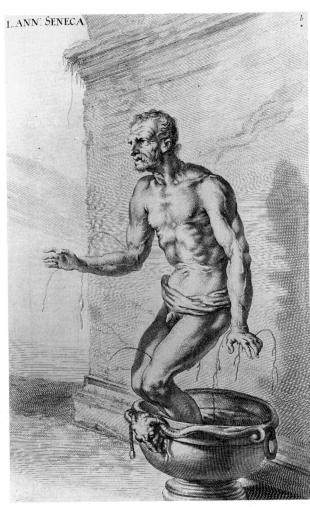

Fig. 205 Antique statue restored as *The Dying Seneca*, marbles. Paris, Musée du Louvre.

Fig. 206 Joachim von Sandart, *The Dying Seneca*, engraving by Richard Collin (from J. von Sandrart, *Der Teutschen Academie*).

responsible for the restoration of the *Dying Seneca* (Fig. 205), it is inspired by the same taste:[16] by the addition of the arms, one thigh, an alabaster loincloth and a fine basin of violet *breccia*,[17] the *bigio moretto* torso has been converted into the image of the ancient stoic philosopher who killed himself on the orders of Nero by opening his veins in the bath. As in the statues of the gypsies, coloured marbles have been used for their naturalistic effect, and at the same time with an obvious enjoyment of the bright beauty of the coloured stones for their own sakes.

The fame of the *Seneca* was enormous; it was copied by Peter Paul Rubens (1577–1640) in many drawings and in a painting,[18] while Joachim von Sandrart (1608–88) even reproduced the modern basin in both his engraving of the antique (Fig. 206) and his own painting of the same subject, almost as if it were a holy relic of this saint of stoicism.[19] The history of its influence could fill a chapter: for Charles Le Brun (1619–90) its proportions established the type of a venerable old man of ingenious intelligence,[20] and the same idea was in the mind of Pigalle (1714–85) when he represented the elderly and appropriately skinny philosopher Voltaire in obvious imitation of this admired prototype.[21] The Abbé Raguenet in 1700 expatiated on the expressive power of this statue of Seneca, in which everyone can see that he has arrived at his last moment, that his soul is reaching its immortal state, and that he is wholly concerned with the other life he is about to enter; 'if only our sculptors knew how to make a Christ with a similar expression, it is

certain that He would draw tears from the eyes of all Christians without the aid of any words, for that dying Pagan, by his expression alone, arouses sympathetic sorrow in those who look at him.'[22] So deeply engrained was it in the consciousness of cultured Europe that the discovery in 1813 of a bust of a totally different man firmly labelled as Seneca came as a nasty shock;[23] but gradually the realisation sunk in that this underfed and underdressed figure, so far from being a noble-minded philosopher, was a peasant of the lowest kind, a fisherman, accustomed to standing up to his knees not in his sacrificial bath-tub, but in a muddy river.[24]

Admittedly, the head did resemble busts that had been accepted as representing Seneca, and the restorer had been less fanciful than in the case of the *Gypsies*. But still the pose, with its wide-spreading arms and the sagging knees, was a thoroughly modern invention, owing nothing to ancient images of death.

In these statues the antique was incorporated into a new creation, one whose status between ancient and modern remained ill-defined. The *Seneca* was regarded as an antique, however much restored; the remaining *Gipsy* is not mentioned in the standard list of ancient sculptures in Rome.[25] Yet in both cases there is no doubt that the antique fragment was valued as something more than a convenient lump of stone, and treasured as much for its ancient origin as for the beauty of the material.

But there was another class of restoration, identical in its technique, but quite distinct in its meaning.[26] It was Cordier, again, who created the statue of *St Agnes* (Fig. 207) in the church of S. Agnese fuori le Mura, again incorporating an ancient torso of oriental alabaster, completed below the knees, with head, hands and sandals of gilt bronze, and a little lamb of silver.[27] The gilt-bronze edge of the tunic is treated in just the same way as that of the *Gypsy*, but here the restricted pose conditioned by the ancient torso, and above all the hieratic head, give a dignity to the fragment, which was venerated as a relic of that same antiquity in which the young virgin had suffered martyrdom. But surely there was more to it. These gods and goddesses of the pagans, transformed into Christian martyrs, were in a sense baptised, converted to Christianity, and at the same time they also represent a victory of Christianity over pagan antiquity, a reversal of the martyrdom St Agnes had suffered so many centuries before, as is seen far more blatantly in the ancient columns and obelisks, re-erected but surmounted now by symbols of the triumphant Church.[28] The idols were broken, but they are now restored – as Christian saints. Yet the overtones extend further, for the torso retains something of the numinous, and this in turn is transferred to the new image. To play with such numina is not without its dangers, and a later seventeenth-century Protestant visitor to Rome, believing rather oddly that this female torso had been that of Bacchus, used it as further evidence to demonstrate the conformity of 'popery' and paganism.[29]

This continuity of the spirit, as well as the form, contained in classical fragments, is not confined to religious statues. When in 1630 the Conservatori of Rome decided to set up a commemorative statue to Carlo Barberini, who had held the position of General of the Holy Church, and who was, rather more effectively, brother of the reigning pope Urban VIII, they sought out an ancient torso of an emperor to form the basis of the statue (Fig. 208).[30] The restoration work, in the ordinary sense of the term, was performed by Algardi, who had previously restored a relief for the Con-

Fig. 207 Nicolas Cordier, antique torso restored as *St Agnes*, alabaster and gilt bronze. Rome, S. Agnese.

Fig. 208 Gianlorenzo Bernini and Alessandro Algardi, antique torso restored as *Carlo Barberini*, marble. Rome, Palazzo dei Conservatóri.

155

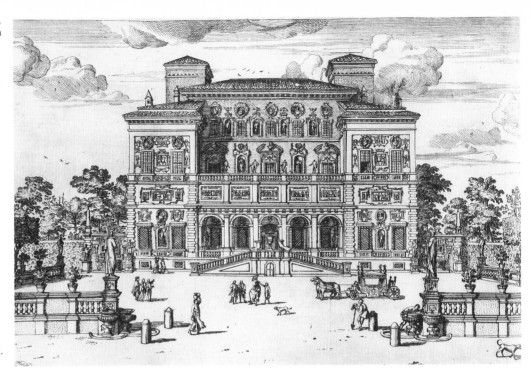

Fig. 209 Dominique Barrière,
Villa Borghese, engraving (from
J. Manilli, *Villa Borghese*).

Fig. 210 Villa Doria Pamphilj.
Rome.

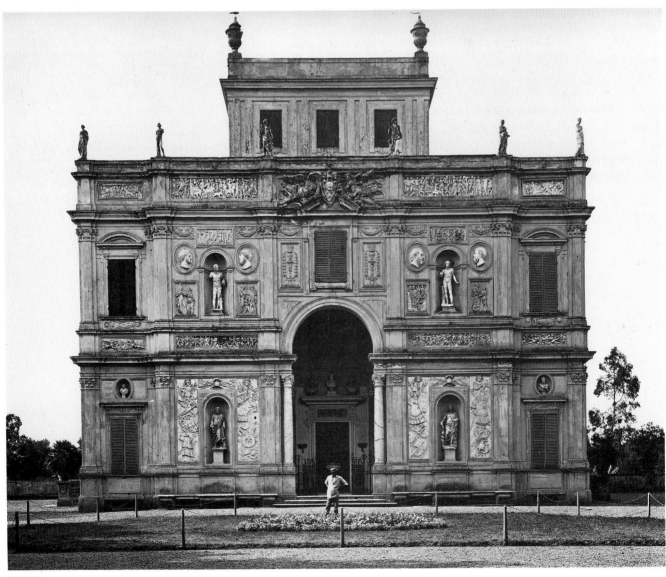

servatori,[31] while the head was commissioned from Bernini, the recognised sculptor of the papal family. This was not the first time the Conservatori had had a statue constructed in this way to commemorate an eminent commander and adorn their palace on the Capitol; but why, when it would have cost no more in cash and not much more in effort to create an original statue? Surely such statues represent an assimilation of the modern hero to his ancient prototype, an incorporation of the glory and valour of these Roman generals and emperors into their later descendants, quite as effectively, if rather more literally than those paintings glorifying contemporary rulers in the guise of an ancient hero or god.

Nor was this practice confined to human beings; buildings too could be turned into ancient palaces by covering them with fragments of antique sculpture (Fig. 209). The precise concept behind this is elusive, and I can find no evidence from archaeological studies, either of the seventeenth century or of later times, to suggest that Roman buildings had been so decorated, or were believed to have been so. None the less, it is clear that this practice, which began in the early sixteenth century, was inspired by something more than a simple desire for adornment.[32] The reliefs that once covered the Villa Borghese are gone,[33] but those on the Villa Doria Pamphilj still remain (Fig. 210),[34] and we know how avidly they were sought out during the construction of the building, with agents scouring the site of Hadrian's Villa at Tivoli, and others sent to Nettuno,[35] while Poussin wrote back to Chantelou in France to say that there was no possibility of getting some antique heads out of Rome, since all works of this kind were being pre-empted by Camillo Pamphilj for his villa.[36] The fragments were restored, that is to say completed in stucco or combined with each other, with only minimal concern for iconographic or stylistic coherence, and constructions which Boselli might well have described as monstrosities jostle on the wall against some of the finest of ancient sarcophagus fronts. If two sarcophaghi of Bacchic processions are joined to another representing Diana and Endymion to create a single frieze,[37] this will look impressive enough from a distance, and serve to guarantee the classical character of the building, and to manifest the ancient origins of the family who owned it; but there was no pretence that this was a single ancient frieze, any more than *Carlo Barberini* or *St Agnes* were to be taken for antique statues.

It was not conversions such as these that Boselli had in mind when recommending the sculptor to study and emulate antiquity. Yet, given his strong advocacy of 'straight' restorations, the modern achievements that he singles out for praise[38] may strike one today as rather odd: Algardi's *Hermes Logios* and Bernini's *Ares*, both in the Ludovisi collection,[39] and du Quesnoy's *Rondinini Faun*.

The choice of the *Hermes* of 1631 (Fig. 211) from among Algardi's antique restorations may not be fortuitous, for it was this statue which was engraved by François Perrier, and which was to be singled out for special praise by Bellori as 'conforming to the good ancient manner'.[40]

Undoubtedly the *Hermes* introduces a new, perhaps more mature, sobriety into Algardi's work as a restorer, but still hardly what one could call accuracy. For this statue, so admired by the classically-minded Boselli and Bellori, has been roundly condemned by modern archaeologists because here, unlike his earlier restorations of the minor and unidentified torso of the *Torchbearer* or the correctly identified *Athena*, Algardi was given a torso of a

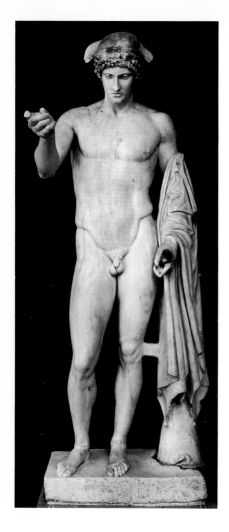 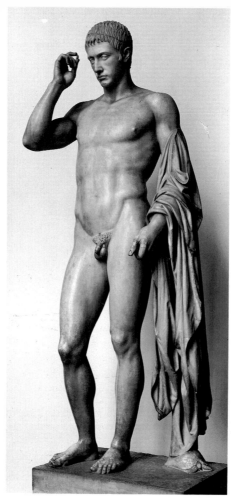 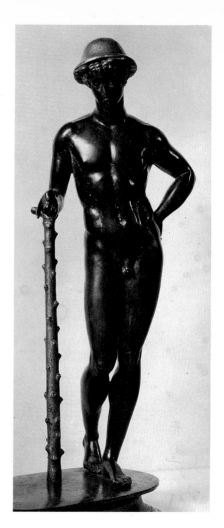

Fig. 211 Alessandro Algardi, antique statue restored as *Hermes*, marble. Rome, Museo Nazionale delle Terme.

Fig. 212 Antique statue of *Germanicus in the Pose of an Orator*, marble. Paris, Musée du Louvre.

Fig. 213 Antico, *Mercury*, bronze. Vienna, Kunsthistorisches Museum.

statue which can be recognised as of the same type as the Louvre *Germanicus in the Pose of an Ancient Orator* (Fig. 212), but which he chose to restore in a very different form.[41] The figure as it is known today is not quite as Algardi restored it: it should hold a caduceus, not a purse, in the raised hand, and the purse in the other where there are the remains of a later caduceus, but this makes little difference to the essential iniquity of the outstretched arm, except that the caduceus and the index finger supporting it would have extended the arm even further from its intended position and out into space. All the righteous wrath of the archaeological purists has fallen on Algardi, but always on the assumption that he must, of course, have wished to restore the figure correctly,[42] and this, particularly in view of the evidence of the two preceding works, seems most unlikely. In fact, it appears that he was most probably inspired by Antico's bronze statuette of *Mercury* (Fig. 213), now in Vienna, but in Algardi's day still in Mantua.[43]

With the second of Boselli's three exemplary modern restorations, Bernini's seated *Ares* of 1622 (Fig. 214), one encounters a rather different approach.[44] Apart from minor chips and breakages, the *Ares* was substantially complete except for his right foot, which needed to be replaced, and the infant Cupid behind it, of which the left arm, much of the right foot, and the head, were remade by Bernini. Contrary to the precepts of Boselli, there is no attempt to match the marbles in this little figure, or even to polish the

158

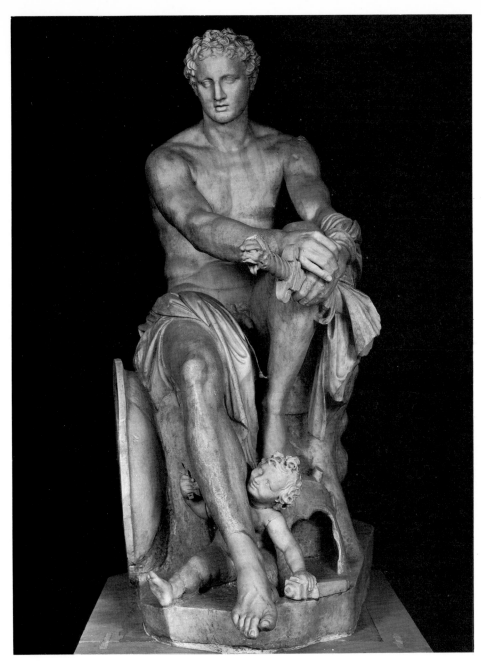

Fig. 214 *Ares*, antique statue restored by Gianlorenzo Bernini, marble. Rome, Museo Nazionale delle Terme.

Fig. 215 Gianlorenzo Bernini, sword pommel, detail of the *Ares*, marble. Rome, Museo Nazionale delle Terme.

Fig. 216 Gianlorenzo Bernini, head of Cupid, detail of the *Ares*, marble. Rome, Museo Nazionale delle Terme.

surface to the same finish as the original (itself much reworked by Bernini), for the hair has been intentionally left rough. As for the type of the head (Fig. 216), this can be compared only to Bernini's own sculptures of children, such as the young *Ascanius*;[45] there is not the slightest pretence that this impish son of the baroque could be an original antique. The pommel of the sword (Fig. 217) presents a more interesting case, for, as Beatrice Palma has pointed out, this is inspired by that of the commander on the 'Great Battle Sarcophagus' in the same collection;[46] but, while the ancient sculptor was content to show a naturalistic feline head, Bernini has substituted a grimacing human mask, an invention completely of his own time; the very fact that such a decorative pommel was justified by antiquity shows how completely he could depart from antique conventions and allow free play to his own baroque imagination in such details.[47]

Fig. 217 Gianlorenzo Bernini, restored antique statue of the *Hermaphrodite on a Mattress*, marble. Paris, Musée du Louvre.

Fig. 218 The *Hermaphrodite*, formerly on a base, marble and wood. Florence, Museo degli Uffizi.

Another, even more extraordinary, flight of fancy, is the mattress which he placed in 1620 beneath the sleeping *Hermaphrodite* (Fig. 217), formerly in the Borghese collection, and now in Paris.[48] Again, the restorations of the statue itself were minimal, but it was the amazing realism of the mattress that filled the President de Brosses with admiration: 'to see it, and to pass one's hand over it, it is no longer marble, is is a real mattress of white leather or of satin which has lost its sheen'.[49] In 1700 it was remarked that no one could look at this statue without pressing his finger on this so soft-looking mattress,[50] and, indeed, this remains true of the visitors to the Louvre today.[51] However Milizia, for whom this baroque addition was an affront to the ancient marble, regarded it quite differently, as filled not with feathers, nor even wool, but with stones.[52] Whichever view one takes, it is equally un-antique, and one has only to compare it with the more prosaic restoration of another *Hermaphrodite* from the Ludovisi collection attributable to Ipolito Buzzi,[53] undertaken only one or two years later and now in the Uffizi, to see how far it departs from what it was assumed the antique had looked like. Yet, strangely, it was this Ludovisi *Hermaphrodite*, lying on a sheet over a tiger skin thrown down on the rocky ground, who was placed upon a wooden bed, surely a more suitable support for a mattress. In 1622 the carpenter Giovanni Volpetta and the gilder Simone Lagi were paid by the Ludovisi for work on two beds, 'made and placed in the Casino of our Villa . . . one as a base for the Hermaphrodite, and the other to rest on in the summer'.[54] This is presumably the wooden base of the *Hermaphrodite* sent to Florence with the statue (Fig. 218), originally decorated with masks and columns, and ten gilt statuettes of gods and goddesses;[55] as for the other, we have no evidence as to its appearance, but the temptation is irresistible to visualise Cardinal Ludovico Ludovisi taking his summer ease on a twin bed with the *Hermaphrodite*.

Startling though Bernini's restorations may be in their frank disregard for the original appearance of the antique, it is significant that the liberties he took were all marginal. The mattress may bother purists who look at the *Hermaphrodite*, but it leaves the original figure intact, and his additions to the *Ares* are equally inessential to the figure of the seated nude. This is an interesting approach to the art of restoration, combining ancient and modern, setting the classical statue with baroque embellishments, but it is an approach which should not surprise us in an artist to whom the classical past was not just something to be revered, but a living influence, and, as Wittkower has shown, the basis for much of his own most personal sculpture.[56]

It is rather more surprising that this approach should have been praised by Boselli, so far is it from his own theories, and so antagonistic was he to most of what Bernini stood for. It is more to be expected that he should praise du Quesnoy, not only because he had been one of Boselli's teachers and is the often cited hero of his *Treatise*, but also because du Quesnoy's restorations appeared to his contemporaries to be so much more correct; indeed, his early biographer, Giovanni Battista Passeri, wrote that in restoration he was 'absolutely perfect, because he added the missing parts with such accuracy and similitude, that one was left in doubt whether they were part of the original antique, or modern additions'.[57]

Today one would hardly share this doubt, and the *Rondinini Faun* (Fig. 219), having languished for decades in the store-rooms of the British Museum because so little of it met the criteria of the Department of Greek

Fig. 219 *Faun*, antique statue restored by François du Quesnoy, marble. London, British Museum.

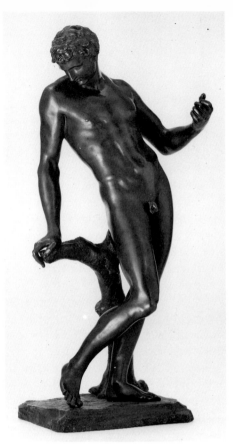
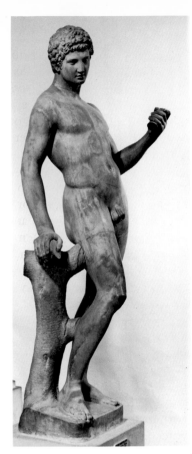

Fig. 220 *Bacchus*, restored antique statue, marble. Paris, Musée du Louvre.

Fig. 221 François du Quesnoy, *Mercury*, bronze. Vaduz, Collections of the Prince of Liechtenstein.

Fig. 222 *Mercury*, restored antique statue, marble. Paris, Musée du Louvre.

and Roman Antiquities, is now, by a most enlightened exchange, the centre-piece of the baroque primary gallery at the Victoria and Albert Museum.[58] Jacob Hess has suggested that the restoration of the head, ams and legs was based on a similar *Faun* in the Giustiniani collection,[59] and, though it is questionable how much of that marble is original, or when its restoration was undertaken, the comparison is illuminating, for the free movement and wide-flung arms of du Quesnoy's *Faun* surely owe more to the baroque than to any classical statue.

In this case, in contrast to Algardi, who did not hesitate to introduce very personal stylistic features into the *Athena*, and who consciously restored the *Hermes* on the basis of a renaissance prototype (albeit one by an artist who had earned the name of 'Antico'), and to Bernini, who clearly never intended his additions to look like antiques, du Quesnoy evidently viewed the classi-cal past through the eyes of his own time. This is not to say that he was, even in his restorations, a 'baroque' sculptor, but rather that the seventeenth-century view of the past was not the same as ours. The same, no doubt, could be said of Passeri when he admired the correctness of the restoration, a judgement which might well appear perverse to the modern critic. This phenomenon is well enough known in the history of fakes, where a forger working in the style which appears correct to his contemporaries, gives himself away to later generations. In judging the intentions of restorers, or the extent of an artist's 'classicism', one should be careful to bear in mind that, for an artist of the seventeenth century, the choice of sculptures on which he formed his image of the antique, and consequently his notion of the classical past, was very different to that of a twentieth-century historian.

162

Another restoration, attributed to du Quesnoy at least since the time of Mariette in the eighteenth century, is the *Bacchus* from Girardon's collection (Fig. 220), now in the Louvre.[60] The head, although it probably does not belong, is ancient, but the pose of the body and arms owe more to du Quesnoy's own invention of a small bronze *Mercury* (Fig. 221)[61] than to anything conceived in ancient times. This same *Mercury* is closely imitated in another restored antique in the Louvre from the collection of Mazarin (Fig. 222).[62] This is hardly proof of du Quesnoy's authorship, since the bronze was well known from many casts and often imitated,[63] but again, like the praise of his restorations, it proves the readiness of men of the seventeenth century to see ancient sculpture through the forms of their own classically orientated contemporaries, and demonstrates the way in which contemporary sculpture can reflect back on to antiquity.[64]

One of the most glaring examples of such an approach is provided by a group of *Apollo and Marsyas* in Dresden (Fig. 223).[65] Wilhelm Gottlieb Becker, who described the group with the utmost distaste, accepted the Marsyas as predominantly antique, but, of course, quite unconnected with the Apollo, of which only the torso was original, and even that had been given a modern air: 'probably it was the trunk of a statue of Apollo, represented at the moment he caught up with Daphne'.[66] Whether or not this was the subject of the antique marble, it was clearly in the mind of the restorer, for both the details of the figure of Apollo and the whole structure of the group are directly dependent on Bernini's famous carving of this subject (Fig. 129). Unfortunately we do not know who the restorer was: it would be ironic were it to have been Orfeo Boselli's son, Ercole, who did undertake many restorations for the Chigi family from whose collection the piece was acquired for Dresden, but it seems to have been restored before he started to work for them,[67] and perhaps before it was bought by the Chigi.[68]

The most regular bread and butter of the restorer's trade was the completion of antique busts. References to the restoration of busts abound, as do references to the making of further busts to complete or extend a series of at least partially genuine originals.[69] In antiquity, heads and busts were frequently carved separately, and it is hardly surprising that they were even more frequently found separately by later excavators. Sometimes ancient busts could be found to fit more or less plausibly below ancient heads, but more often they would have to be made. In 1627 the Barberini paid Bernini for an antique marble bust attached to an antique marble head, two originally quite separate works,[70] but when in 1652 a head of Severus, complete with its neck, was offered to the Grand Duke of Tuscany, his Roman agent was prepared to send it with or without 'a most beautiful alabaster bust which I have had made for it'.[71] Rather more intriguing than these typical examples is a case known from a letter from his Roman agent to Cardinal Leopoldo de' Medici in Florence concerning a statue and head from the Orsini collection: in this it was suggested that the head of the statue should be removed and replaced by a modern restoration, and, if no suitable ancient busts could be found, new ones should be carved for both the bustless head and the head taken from the statue, so that the Cardinal would, as his agent said, 'have three antique pieces for the price of two'.[72]

At the opposite end of the scale of importance was the so-called *Barberini Faun* (Fig. 224).[73] This famous antique was found in the moat of the Castel Sant'Angelo, the old Mausoleum of Hadrian, and must be the torso carried

Fig. 223 Stölzel, after a drawing by Retzch, engraving of *Apollo and Marsyas* (from W. G. Becker, *Augusteum*).

163

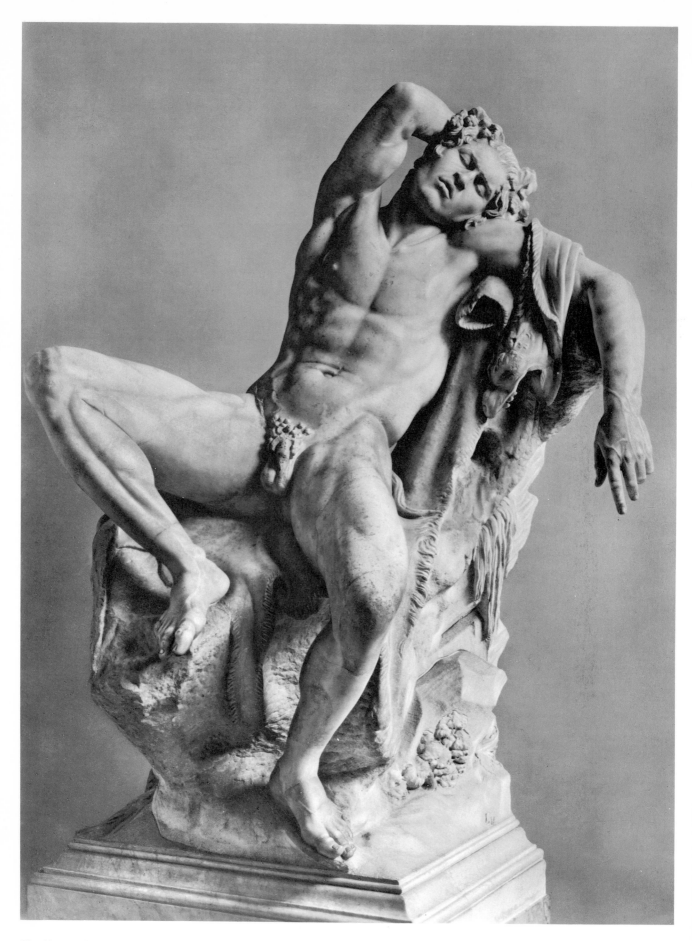

Fig. 224 *Barberini Faun*, antique statue restored by Pacetti, marble. Munich, Staatliche Antikensammlungen und Glyptothek.

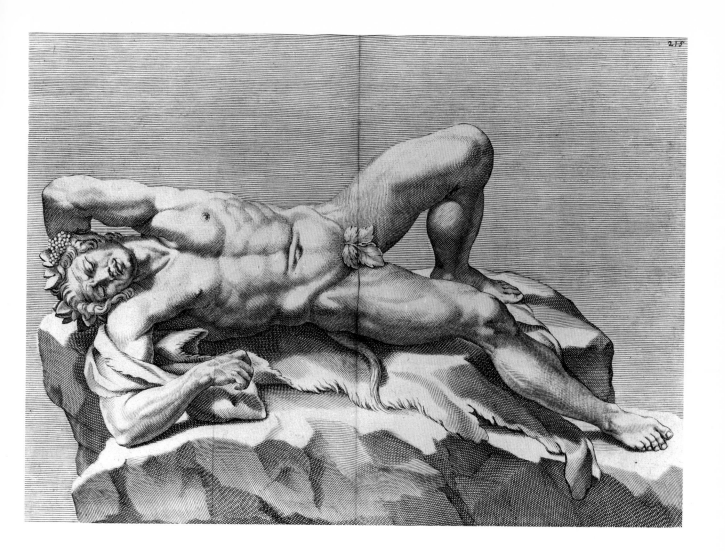

from the castle to the Palazzo Barberini on 15 May 1627.[74] It is next heard of in an account which Cardinal Francesco Barberini's sculptor, Arcangelo Gonelli, submitted on 6 June 1628, 'a torso of a figure found in the moat of the Castello on which I am working at present', and he promises to give a full account of his work on this and other antiques,[75] but, strangely, there is no further mention of it, though the marble for the restoration of a statue was acquired on 11 July.[76]

That Gonelli did indeed restore it we can be quite sure, and there is no need to regard the engraving in Girolamo Teti's *Ædes Barberinæ* of 1642 (Fig. 225) as a mere paper reconstruction, for it would be hardly conceivable that so admired an antique should have been allowed to remain unrestored for half a century. In 1644 Poussin wrote to his friend and patron Paul Fréart de Chantelou about the studies being pursued by Chantelou's young protégé, the sculptor Thibault Poissant (1605–88), and undertook to obtain permission for him to copy the *Sleeping Faun*, 'a statue truly of the best manner to be found among the remains of Greek antiquity'.[77] If one should not put too much emphasis on the use of the word '*statue*', at least one may note that he did use it, rather than 'torso'; moreover, Poussin's own painting of a *Bacchanal* of 1635–6, known through the copy in the National Gallery in London (Fig. 226),[78] includes a drunken youth in the centre who has a more than casual resemblance to Gonelli's restored *Faun*.

Fig. 225 Engraving after Archangelo Gonelli's restoration of the *Barberini Faun* (from H. Tetius, *Aedes Barberinae*).

Fig. 226 After Nicholas Poussin, detail of *Bacchanal*. London, National Gallery, reproduced by courtesy of the Trustees.

165

Fig. 227 Giorgio Ghisi, *The Drunken Silenus*, engraving. London, British Museum.

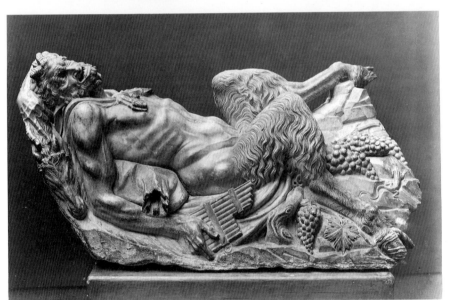

Fig. 228 Attributed to Giovanni Antonio Montorsoli, *Barberini Pan*, black marble. St Louis Museum of Art.

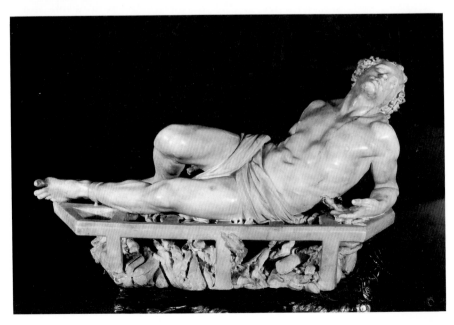

Fig. 229 Gianlorenzo Bernini, *St Lawrence*, marble. Florence, Palazzo Pitti.

Fig. 230 Gianlorenzo Bernini, *St Sebastian*, marble. Lugano, Thyssen collection.

That the pose is wrong, both on archaeological evidence and on the evidence of the torso itself, hardly invalidates the arguments for the existence of this horizontal restoration. The gesture of the arm bent over the head is a traditional formula for sleep, and figures similar to this restoration can be found on innumerable Endymion sarcophaghi;[79] but the specific suggestion of drunken slumber, manifest in the abandoned pose of the legs, is more commonly found in later art, such as paintings of the drunkenness of Noah[80] or of Silenus (Fig. 227).[81] But there was another source closer at hand: the *Barberini Pan* (Fig. 228), now generally agreed to be a later, probably sixteenth-century, pastiche of an antique, but accepted in the seventeenth century as genuine, and engraved as such by Sandrart in 1680.[82]

It has been suggested that this restoration of the *Faun*, attributed, of course, on no evidence whatever, to Bernini, was inspired by his own marble statuette of *St Lawrence* (Fig. 229).[83] This would fit neatly with my argument, if only there were any real resemblance between the two statues. It is tempting also because the later restoration of the *Faun* in a diagonal position, also attributed to Bernini, could then be associated with his sculpture of *St Sebastian* (Fig. 230),[84] but again I can see very little resemblance, and, moreover, it is now known that these two Bernini marbles were carved at about the same date, so there is no reason to assume that he would have used one model first, and then corrected his restoration in accordance with the other.

For a later re-restoration there certainly was, carried out by Giuseppe Giorgetti and his associate Lorenzo Ottone in 1679. What they did to the statue is described in three and a half pages of the long account of various restorations they had undertaken for Cardinal Francesco Barberini.[85] In this they write of making the two legs in stucco, and fitting into them two

167

Fig. 231 Giovanni Volpato, reduction of the *Barberini Faun*, biscuit porcelain. Rome, Palazzo dei Conservatori.

Fig. 232 Robert van Auden Aerd, engraving of the *Barberini Faun* (from D. de Rossi and P. A. Maffei, *Raccolta di statue antiche*, 1704).

fragments of marble, a very difficult process because there was no stable base to which they could be attached; the left arm too was made of stucco, as were some stones on which it rests, the elbow of the right arm, and many other pieces, including the fingers of the right hand. But the greater part of their work was in the carving of the rock on which the torso was now placed, consisting of three pieces of stone.[86] This rock was carved 'with grasses, flowers, twigs and tree trunks with a vine of ivy which twines around the said trunk' and also 'his musical instrument which the silvan creatures play with its ribbon'. These details, wantonly mutilated by the Bavarians in the nineteenth century, are visible in Giovanni Volpato's small biscuit reduction (Fig. 231),[87] and in the copy made by Edme Bouchardon (1698–1762) as a young student in Rome.[88]

The attention lavished on this rock was not simply for the sake of decoration: these naturalistic details serve a very deliberate purpose in luring the visitor round to what we might call the back of the statue, but which the restorers realised was a view which repaid study. This is not the place to follow the complicated later history of this statue,[89] but it is helpful to compare the effect of Giorgetti and Ottone's stucco limbs (Fig. 232) with those of marble made by Vincenzo Pacetti (1746?–1820) when he restored the statue yet again in 1799 (Fig. 224). Where the seventeenth-century legs with their open pose had complemented the form of the upper part of the body, Pacetti brought the right leg across, forming a closed, trapezoidal

168

shape, and creating an even more blatantly suggestive pose for this pagan child of nature. Significantly, the new position of the leg establishes the single viewpoint from which the sculpture has been considered ever since, and, although Pacetti left the base untouched, its original function was negated by the strong orientation of the statue, and the right side was allowed to slip into oblivion.

But to return to the Giorgetti/Ottone restoration: a belief has grown up, since the 1738 inventory attributed the restoration to Bernini,[90] that he was, indeed, responsible for it. The account books of Cardinal Francesco Barberini exclude absolutely the possibility that he actually restored the marble, yet there remains the possibility that he did at least design this new setting of the torso.[91] However, those who wrote in praise of the *Faun* would hardly have failed to mention Bernini had he been so deeply involved,[92] and, in fact, at this time he does not appear to have worked at all for the Cardinal, whose position was hardly what it had been while his uncle was pope.[93]

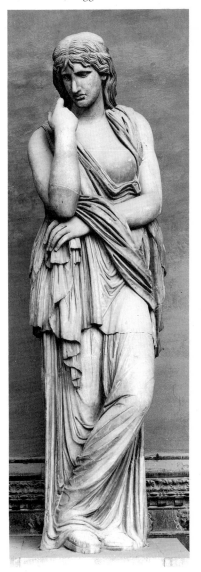

Fig. 233 *Vetturia*, antique statue, marble. Florence, Loggia dei Lanzi.

Whether or not Bernini was indirectly responsible, the fact remains that the restoration was carried out in a manner very similar to that which we have seen in his own authentic works in this genre. The statue itself was restored in a way that must have been close to its original form (modern experts judge the angle to have been out by a few degrees, and this has been corrected on the figure as it is now presented), while the sculptors gave free rein to their imagination in the marginal parts, treating the rocky base very much as Bernini had the mattress of the *Hermaphrodite*. Yet such a similarity proves nothing: it merely exemplifies one approach to the antique, in which a great respect for the actual fragment was combined with a freedom in the treatment of accessories, carried out in a fully baroque spirit to give the work as a whole a distinctly modern air.

So far we have considered a number of restorations carried out in the seventeenth century and attempted to deduce from the results the various aims and attitudes of the sculptors concerned. To find these aims spelled out, we must turn not to a restoration, but to a copy. The sculptors studying at the French Academy in Rome were obliged to make copies after the antique to be sent back to Paris, both as ornaments for the royal parks, and as objects of study for the artists in France; we have already noted how Bouchardon copied the *Barberini Faun*. In 1692 it was proposed that Pierre Le Gros should make a marble copy of the statue known at the time as Vetturia, the mother of Coriolanus who went to plead with her son not to attack Rome, and which was then in the Villa Medici (Fig. 233).[94] The copy (Fig. 237) was made under the supervision of the Director of the Academy, La Teulière, who was himself subject to the Directeur des Bâtiments in Paris, Colbert de Villacerf, who, in turn, was answerable to the king.[95]

For La Teulière in Rome, the problem was that the antique was not adequately worked at the back (Fig. 234),[96] and, moreover, he did not approve of various parts of the drapery, the feet, and other details, which he regarded as due to defective restoration.[97] For Villacerf in Paris, the objection was to any figure so covered in drapery, and, we may assume, particularly a figure in repose, where the drapery offered little variety.[98] This basic disagreement on what sort of statues should be copied by the students was compounded by the unfortunate fact that, as La Teulière attempted to explain, the drawings of Le Gros's model, made by a fellow student, Daniel Sarrabat, had been done in haste,[99] and produced a very unhappy effect, eliciting

169

Fig. 234 *Vetturia*, antique statue (back view), marble. Florence. Loggia dei Lanzi.

Fig. 235 Pierre Le Gros, copy after *Vetturia*, back view, marble. Paris, Tuileries Gardens.

Fig. 236 Marcantonio Raimondi, engraving after Raphael, *Charity*. London, British Museum.

highly critical comments on their arrival in Paris from the Surintendant: the figure had too much drapery, and, if placed free of a niche, would never look good from the back; the fold on the left was ugly when seen from the back but was unavoidable in relation to the front view; the attitude was exaggerated and unnatural, Villacerf had tried standing like that and had fallen over; the raised foot did not help to support the figure, and she was standing at too much of an angle to balance on the right foot alone. In short, Le Gros should use the block for another figure.[100]

La Teulière was piqued by this slur on his judgement, and, besides, the figure had already been blocked out, and there were few other antiques which could be fitted into such a block, that is, figures with their arms so close to their sides. He was sure that when the drapery was worked it would not appear excessive, and there was a pleasing variety in the materials; in fact, he had chosen this figure for the copy because it was right that students should study such subjects as ancient costume, and this was a particularly fine example. As for the pose, it was true that it would not do for someone who had to resist an attempt to push him over, but the position of the *Vetturia* was not his own invention, it was the choice of the ancients who, being just as well instructed in matters of balance as the moderns, could not have erred. The fold at the left must be judged in regard to the whole figure, seen as an entity from all sides, and, as for the back (Fig. 235), Le Gros had followed an engraving after Raphael (Fig. 236) which La Teulière had shown him, since the sculptor kept changing his mind about how best to treat it. Finally, La Teulière insisted on the soundness of his own judgement, and his understanding of the antique: studies such as he had undertaken were worth more than the opinions of practising artists, guided by no more than their

170

own genius, as had been seen in the state of art in Rome since the deaths of the students of Raphael and Michelangelo. Then, one might say, three men, Bernini, Pietro da Cortona and Borromini, had entirely ruined the fine arts by the liberties that they had taken in following their own tastes, or rather caprice, in their separate arts. He rashly referred to a similar dispute that he had had, and won, in the time of Louvois, when he had even bested the antiquarian, Pierre Rainssant.[101]

Villacerf made short work of that: he would not take the advice of just anyone as to what statues should be made, but had sought the opinions of Pierre Mignard (1612–95), François Girardon, and Martin Desjardins; one would never find him consulting men like Rainssant, who was an ass. La Teulière should not have allowed the sculptor to cut the block so close to the figure, but he should have left sufficient marble to make corrections; however, as that was now impossible, there was nothing for it but to continue. 'Take every care', he wrote,

> so that the King will be pleased with the result, which will hardly be easy with a statue draped like this one. What you must do is give the drapery an extremely fine finish. You should not stick so servilely to the antique as you do, that is to say copying it point for point, because that will lead to failure, as in the present case, and, if you find something defective in an antique figure, you should correct it according to logic, for it is a poor excuse for the workman to say that he has followed the antique.[102]

The clash of two opposed standpoints could hardly be clearer. For La Teulière, the standards had been set by the antique, to which Raphael was the heir; if there was something defective, it was to be seen as the result of restoration, and any departure from such standards was a sign of modern decadence. To the more modern Villacerf, the antique was no longer sacrosanct; it was capable of producing defective statues, and these should not be imitated, nor was it an absolute necessity that students should learn about ancient costume, if such drapery produced montonous effects. Admittedly, he may have exaggerated his position somewhat (no man who crosses his legs and falls over likes to be told that the ancients were better at keeping their balance than he), but, none the less, his standards of judgement were set by modern artists, Mignard, Girardon and Desjardins, none of them baroque artists in the Italian manner, but, still, practising artists who adapted their studies of the antique to produce recognisably seventeenth-century work. It might be going too far to see this dispute in terms of the Quarrel of the Ancients and Moderns, which had divided French literary critics during the seventeenth century and which had its repercussions on judgements of the visual arts, but certainly this helped to instil a freer, more critical attitude towards the previously axiomatic superiority of the ancients.

But what of poor Le Gros, caught between these two factions? There can be little doubt that, although the censure from Paris was levelled at his statue (Fig. 237), he shared the attitude of Villacerf. It is not just the back which he has changed, but those insistent, near-parallel folds of the antique have been reduced and varied, and given a new life which is that of his own age, not of antiquity. This is not the slavish copy after the antique which one might have expected from the letters of La Teulière and the objections of Villacerf,[103] but an interpretation of the antique motif, a correction made from the standpoint of his own age.

Fig. 237 Pierre Le Gros, copy after *Vetturia*, marble. Paris, Garden of the Tuileries (Photo author).

La Teulière may have intended not merely to train the students in his charge, but to send back to Paris copies of the antique that would serve as models for the young French artists to study, and nothing in his letters suggests otherwise: where the ancient statue was defective it was to be corrected by means of another, purer, antique fragment; where it was insufficiently worked, the example of Raphael was an almost equally revered model. Can he really have been unaware of what Le Gros was doing? Was it the need to justify what he believed to be his responsibility as the Director of the Academy that prevented him from admitting – or the inability to free his vision from the style of his own century, of the corruption introduced by modern masters, that prevented him from seeing – the strong and unmistakable influence of the baroque on this copy of classical antiquity?

172

VIII

FESTIVALS AND FEASTS

What did the inhabitants of Rome do for amusement? There were theatres, most notably that of the Barberini and, by the end of the century, that of the Ottoboni, but these were private, run by the nobility for the enjoyment of other nobles.[1] A public theatre was opened at the Tor di Nona in 1671, but it was closed by papal decree, and finally torn down by Innocent XII in 1697.[2]

If the Church was frightened of secular diversions, it was, none the less, the source of such festivities as were available to the people of Rome. The Church was also a court, and received ambassadors who entered with sumptuous processions, bringing colour, and often a touch of exoticism, to the common men and women who watched their progress.[3] But the religious life itself was full of incident, including miracles, which might rise to as many as two or three a year.[4] Most of these were connected with images, usually small and unconsidered pictures of the Virgin attached to walls, which would suddenly start to weep, speak, or cure the halt and the blind; this would bring crowds of people, causing a good deal of annoyance to the neighbours and opportunity to pickpockets, and often the Church authorities attempted to discourage these manifestations of popular piety, though there are also cases of two neighbouring churches squabbling over such an image that each wanted to detach from the wall and appropriate, for the greater decency of public worship before it, and for their own considerable financial profit.[5]

The advantages accruing to the possession of such a miraculous painting of the Virgin, or a Crucifix, were quite substantial.[6] Donations were made by those who believed themselves cured, or who hoped to be cured; masses were paid for to be said before the image, and the church gained in any number of ways from the throngs of the devout and curious who were attracted to it. So much so that there were not enough genuinely miraculous images to go round, and miracles would be manufactured. The diary of Giacinto Gigli, which runs from 1608 to 1670, but is fullest for the reigns of popes Urban VIII and Innocent X, from 1622 to 1655, provides a fascinating indication of what an average cultivated member of the upper bourgeoisie found of note in his life. He records a number of such miracles, at least one of which he himself doubted, when the lame man, on being cured, walked in too practised a way,[7] and several of which he recorded with pious conviction, only to admit later that they had been fabricated – miracles of the Devil, he called them, which can be distinguished from miracles of God because the latter were true.[8]

The frequency of such events should be noted as an expression of a genuine need, both for excitement and for a confirmation of faith. The former could be met in part by the standard fare of the tabloid press: murders, robberies, executions, fires, accidents, and the scandals of the

173

Fig. 238 Anonymous sculptor, float of the *Pietà*, painted wood. Rome, S. Marcello.

Fig. 239 Alessandro Algardi, drawing for a float of the *Pietà*. Zürich, Technische Hochshule.

monasteries; but religious festivals, processions, special Forty-Hours' Devotions,[9] and above all the Holy Years every quarter-century[10] provided both spectacle and religious renewal, and could, at least to some extent, be controlled by the authorities.

There were many confraternities in Rome and the towns of the Campagna that might be attached to some particular devotion, such as the Rosary,[11] or centred on a particular saint or image, and they would celebrate feast-days by processing with banners of their saint or their holy image; or the building or refurbishing of the chapel in which such an image was housed would give the occasion for a particularly grand procession.[12] These confraternities functioned as clubs, and, just as with later club outings, the festive nature of the occasion might overwhelm its religious pretext, or others less genuinely devout might join in, to the scandal of the Church, a particular risk if the procession took place at night. Gigli's diary gives the impression of a veritable mania for such processions, of almost Ulster proportions, and often almost equally disastrous consequences.

Holy Years were naturally a time when these multiplied out of all proportion, with not only the confraternities of Rome and the nearby towns, but

174

others from all over Italy pouring into the Eternal City, bearing their totem objects.[13] They would be welcomed by various Roman confraternities who made it their business to look after the pilgrims, such as that of the Trinità de' Pellegrini, or that of the Gonfalone. Emboldened by the sense of corporate importance, these marching confraternities would beat up a coachman who got in their way,[14] and the ordinary Roman such as Gigli, trying to go about his day-to-day business, would find his way blocked by a procession of rustics from Zagarolo with no hope of passing through.[15] Accounts of the Holy Years tend to degenerate into a series of such misadventures, two groups of pilgrims meeting at a crossroads and contesting the right of precedence, ending with fist-fights, stone-throwing, broken heads, and trampled standards,[16] or confraternities which, having constructed some particularly effective illuminated display and been refused permission to march at night, were reduced to holding their procession without it.[17]

But there was, of course, another side to it: admirable processions of the truly devout, attractive children dressed as angels,[18] or impressive bands of penitent flagellants.[19] Many of these processions carried not only specially venerated images, but also religious tableaux borne on floats; these might be tableaux vivants, but they might also be carved in wood or modelled in papier mâché. And it is here that the sculptor comes into this picture of the popular religious life of Rome.

The only such float to survive in Rome is that of the *Pietà* (Fig. 238), made for the Confraternity of the Madonna of the Seven Sorrows, attached to the church of S. Marcello; although it was carved in 1700, it incorporates pieces of an earlier group.[20] Now, as it stands in S. Marcello, there are no cherubim around the cross, but a few years ago some were still in place, and originally there were even more of them.

This *Pietà* is made of wood, which no doubt accounts, at least in part, for its survival. Others might have been made of papier mâché, which would have been more easily portable. There is no evidence as to the material of a very similar group made by Michel Anguier on the designs of Alessandro Algardi, but the original drawing still exists (Fig. 239), and documents and descriptions confirm that it was commissioned in 1650 for the Archconfraternity of the Gonfalone.[21] Comparison with the float in S. Marcello explains how the cherubim might have been supported around the cross (although, as there is no specific mention of them in the payments, they might have been omitted), and one can well understand why Ruggieri judged it to be 'the most beautiful "mystery" of this year'.[22]

Another drawing by Algardi (Fig. 240) must also have been made for a float, for the hangings below indicate that it was to have been carried.[23] It would have contained a holy image, supported on a rod passing up from the globe, though who it was made for is unknown, and it is possible that the difficulty of constructing it with the baldachin above proved to be too great, and that it was never actually executed. Another drawing of the *Resurrection* (Fig. 241) was also intended for such a float, though again nothing is known of its purpose, or even its author, who was certainly not Bernini.[24] The feast of Easter was a favourite time for these Holy Year processions, and not infrequently the tableaux dealt with the theme of Christ's Passion, often in a series of floats recounting the various events connected with Holy Week.[25] The drawing is, in any case, revealing in its inclusion of the poles used for

Fig. 240 Alessandro Algardi, drawing for a float. Oxford, Christ Church.

Fig. 241 Anonymous artist, drawing for a float of *The Resurrection*. Munich, Staatliche Graphische Sammlung.

Fig. 242 Stefano Speranza and Andrea Bolgi, *Christmas Crib*, travertine and marble. Albano, Capuchin Church.

Fig. 243 Anonymous artist, drawing for a *Sepolcro*. Düsseldorf, Kunstmuseum.

carrying the float, and the candles, which also appear on Algardi's drawing, are typical of the silver that so often adorned them.[26]

While Holy Years were infrequent, there were regular festivites connected with the church year such as Carnival,[27] Christmas and, more important to seventeenth-century Catholicism, Easter.

For Christmas it was customary to set up a crib;[28] this might be quite a simple affair of terracotta,[29] but it could also be much more sophisticated, like that provided by Cardinal Francesco Barberini in 1635 for the Capuchin monks at Albano, which still survives (Fig. 242). This was made by Stefano Speranza and Andrea Bolgi, and there are payments to the former for the Madonna and the Christ-Child of marble and travertine,[30] and to the latter for the figure of St Joseph, which was made of the same materials.[31].

At Easter the Sacrament would be removed from the ciborium on the altar and placed in an urn, or *Sepolcro*. Typical of the designs for such urns is a drawing (Fig. 243) attributed, probably wrongly, to Lucatelli, but in any case by a painter, from which a sculptor must have modelled the figures of Christ, the angels and cherubim.[32] Apart from the rather unfortunate similarity of the urn to a soup-tureen, it brings out the essential iconographic point, the burial of Christ's body, and the standard inclusion of many lamps.

Equally obvious was the incorporation of angels holding the instruments of Christ's Passion, and if the drawing for an urn illustrates the sort of apparatus that might be within the financial means of a fairly minor church, Andrea Pozzo created something much more elaborate for the church of S. Ignazio (Fig. 244), a veritable *tempietto* in which, were it not for the glory that surrounds it, the urn itself would be almost lost from view. The engraving illustrated comes from the later Augsburg edition of Pozzo's book on perspective and reverses the print in the original Rome edition,[33] thus restoring it to the direction of the drawing, so that one can compare it more easily with a drawing in the Witt Collection (Fig. 245).[34] This makes a point of some relevance in our context since, although the drawing is acceptable as

Figura 66.

Fig. 244 Andrea Pozzo, engraving for a *Sepolcro* (from A. Pozzo, *Perspectiva pictorum atque architectorum*).

Fig. 245 Attributed to Andrea Pozzo, drawing of *Angels with the Instruments of the Passion*. London, Courtauld Institute, Witt Collection.

a work from Pozzo's hand, it was certainly not prepared for the engraving, as the angels are not shown foreshortened as they appear in the print, but are seen from eye-level. They must, therefore, have been made for the sculptor who was to create these figures to decorate Pozzo's *tempietto*.[35] Who this sculptor was, and what material he worked in, is not known, though again wood or papier mâché, or perhaps stucco, seem the most likely.[36]

In fact, although much interest has been shown of late in these ephemeral decorations,[37] very little is known about their executants. This is because one can hardly apply stylistic criteria to works that no longer exist, and that are known only through engravings of doubtful stylistic accuracy. These engravings do usually give the name of the inventor, but not of the men who brought that invention to realisation, and the archives, in so far as they have been consulted, prove remarkably uninformative. This in itself, however, is revealing, for it was the inventor, usually an architect or sometimes a specialist in such work, who was in charge, and just whom he employed was of no interest to the men who were paying.

The same applies to the far more theatrical settings devised for the Forty-Hours' Devotion to the Holy Sacrament, a ceremony that came into use during the counter-reformation as a diversion from less edifying occupations during the time of carnival, and which was often employed at moments of crisis.[38] As these devotions developed during the seventeenth century, so the apparatus became more elaborate; almost invariably they involved setting the eucharist in the sky, surrounded by a glory of light from vast quantities of hidden lamps, and below it was usually a scene of typological significance, such as the salvation manifested in the crossing of the Red Sea paralleling that obtained through Christ's sacrifice as embodied in the eucharist (Fig. 246). These tableaux would be composed partly of painted flats, and partly of figures in terracotta, which might be moulded in papier mâché, presumably for the figures such as Cherubs, which had to be multiplied. Cardinal Francesco Barberini Senior, the Vice-Chancellor of Rome, was responsible for those held in the church of S. Lorenzo in Damaso in the Cancelleria, and we know that in several years it was his sculptor, Nicolò Menghini, who made the designs, modelled the figures, and directed the painters, gilders and artisans involved. As a sculptor, Menghini ranks as a very minor figure,[39] yet it was he who designed the *Crossing of the Red Sea* for the Gesù in 1646, an image worthy of any of the painters of the period,[40] while in that of 1640 for the same church, showing Moses and other figures of the Old Testament related to prefigurations of the eucharist, the complexity of the iconography is surpassed only by the elaborate combination of sculpture, painting and light; indeed, the conception appears so advanced that its invention has been attributed to Bernini, or Giovanni Francesco Grimaldi.[41] While the intervention of either is possible, and one is always tempted to ascribe to Bernini any revolutionary invention in the field of sculpture, and particularly of the use of light, the engraving would hardly have appeared with Menghini's name had he not played at least a substantial part in the creation of this tableau.

It has become a commonplace of art history to point out how the light effects of these ephemeral displays recur in the permanent art of baroque Rome. In particular, Bernini used light streaming from a hidden source on his altar of St Teresa in Sta Maria della Vittoria,[42] and it is therefore appropriate that the first record of such an illumination in a Forty-Hours'

Fig. 246 Dominique Barrière, engraving after Nicolò Menghini's *Quarant'Ore* decoration of *The Crossing of the Red Sea*. London, British Museum (Photo Warburg Institute).

178

DISEGNO DEL TEATRO, FATTO AL GIESV NELLA QVINQVAGESIMA, SOTTO GLI
AVSPICII DI PAPA INNOCENTIO X. QVEST'ANNO M.DC.XLVI.

IN EVCHARISTIA, DEVS MORS EST
SICVT OLIM MALIS.
IN COLVMNA NVBIS, VITA BONIS.

display was that devised by Bernini for the Pauline Chapel in the Vatican in 1628. This, alas, is not a visual record, but a description of the 'very beautiful apparatus representing the Glory of Paradise shining most splendidly though one could see no lights, because behind the clouds were more than 2,000 burning lamps'.[43] From then on these effects became a regular feature of most Forty-Hours' displays, just as they were used in Menghini's design, which itself is strongly suggestive of the *Cattedra Petri* which Bernini was to create in St Peter's some twenty years later (Fig. 149).

Other events, such as beatifications or canonisations of saints, occurred rather less frequently. Here again it was the architect, or a specialist, who was in charge of the decoration, and even if he wanted to include reliefs they were more likely to have been imitations in chiaroscuro painting than actual sculptures. These ceremonies were a source of great excitement for the populace of Rome, and, particularly when the saint was a foreigner, or a member of a religious order, would justify extremely elaborate decorations not only in St Peter's, where the ceremony occurred, but also in the national church or the mother house of the order. Commemorative engravings, such as that of Paolo Guidotti's decoration for the canonisation in 1622 of Sts Isidore the Labourer, Ignatius Loyola, Francis Xavier, Philip Neri and Teresa of Avila (Fig. 248), suggest a highly decorous ceremony, whereas in fact it turned out to be rather chaotic. In one account of it the procession was not described because it was too confused and disordered; the pope commanded the doors to be closed and many could not get into the church, not only the ordinary people but even those 'of condition', and in this confusion the pope's household could enter only 'with great disorder'.[44]

These were the high points of religious life in Rome, but the institution of the papacy was much like that of any secular ruling house, and the death of a pope, or the election of a new one, deserved to be marked by an appropriate ceremony.

For the first anniversary of the death of Pope Paul V, in January 1622, a catafalque was erected by the architect Sergio Venturi (Fig. 249), with white stucco sculpture around it executed by the young Gianlorenzo Bernini.[45] The series of *Virtues* (Fig. 247), if exceptional in its quality, is traditional both in selection and representation, and differs little from similar series made by sculptors of the previous generation.[46] Gigli certainly looked at the statues, and admired them as 'very beautiful', but the overall effect was greatly enhanced by silvered wooden candelabra along the nave of the church, and yet more on the dome of the catafalque, with, between them, stucco angels holding yet more candles.[47] It is important to note that the catafalque was not made at the death of the pope, but for the translation of his body to the burial chapel in Sta Maria Maggiore almost a year later, for even such temporary monuments required a great deal of work, and time for their preparation.

Eight years later Bernini himself was to design a catafalque for Carlo Barberini, General of the Holy Church, and brother of the reigning pope, Urban VIII (Fig. 250). This was intended to commemorate Carlo Barberini's death in February 1630, but, not surprisingly, it could not be completed until August. In its general form it followed the same traditional type, with its oval dome supported by columns between which were placed a number of statues.[48] The surviving drawings do not record its final appearance, for we know that the sarcophagus was borne not by skeletons, but by 'captains', as

Fig. 247 Dietrich Krüger on a drawing by Lanfranco, engraving of *Providentia* by Gianlorenzo Bernini, from the catafalque of Pope Paul V (from L. Guidiccioni, *Breve racconto della trasportatione del corpo di papa Paolo V . . . , 1623*).

180

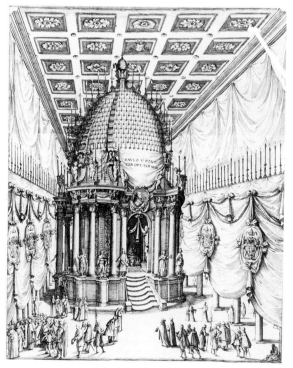

Fig. 248 Giovanni Tonini, engraving of Paolo Guidotti's decoration for the canonisation of five saints, 1622. British Library.

Fig. 249 Dietrich Krüger, engraving of the catafalque of Pope Paul V (from L. Guidiccioni, *Breve racconto della trasportatione del corpo di papa Paolo V . . . , 1623*).

Fig. 250 Studio of Gianlorenzo Bernini, drawing for the catafalque of Carlo Barberini. Windsor, Royal Library.

Fig. 251 Anonymous engraver, *Procession of Innocent X.* Rome, Gabinetto Comunale delle Stampe.

the documents name them, though the general design probably remained very much the same. Here Bernini called on the assistance of all the lesser sculptors of Rome, including Algardi, who was then still virtually unknown and struggling for a living, though he did make four of the statues, rather more than such men as Nicolas Cordier,[49] Jacopantonio Fancelli, Angelo Pellegrini or Domenico Prestinari; but the major share of the work was given to the far more experienced Domenico de Rossi. These names emerge not from the descriptions and comments of the time, but from the archives; so far as contemporaries were concerned, this was the work of Bernini, and probably they were right, for there is no reason to suppose that this miscellaneous band of sculptors would have been allowed any personal freedom in interpreting the drawings provided by Bernini, whose work on the catafalque, erected by the Conservatori of Rome in their church of the Aracoeli, was rewarded with a gold chain costing 304 *scudi*, specifically for having made the designs and having continually assisted in its construction, for having supervised the funeral ceremonies, and for his many other labours involved,[50] and his success with the catafalque also earned him the citizenship of Rome.[51]

The death of one pope is followed by the election of another, and shortly after his election he must take possession of his cathedral church of S. Giovanni in Laterano, in his capacity as Bishop of Rome (Fig. 251). The processions on such an occasion wound their way across the city, through streets decorated with borrowed tapestries, paintings and silver. Along the way were great triumphal arches; one was always constructed by the Conservatori of Rome at the top of the steps of the Campidoglio, where it would, of course, be flanked by the statues of the *Dioscuri* holding their horses (Fig. 254), but others would be built by representatives of the pope's native city, or even by private individuals, while the existing arches, such as that of Septimius Severus, were also covered with appropriate temporary decorations.[52] When Innocent X was elected in 1644, the arch on the Capitol was designed by the architect Carlo Rainaldi, and adorned with statues of *Nobility* and *Labour*, *Wisdom* and *Vigilance*, coats of arms, *Fames*, *Putti* and *Virtues*, and paintings of significant achievements of Innocent's earlier life.[53] Among the sculptors employed were four of the same artists who had worked on the catafalque of Carlo Barberini fourteen years previously: Domenico de Rossi, whom we have encountered in previous chapters sliding slowly down the scale of merit, Angello Pellegrini (who may be identical with the bronze-founder), the younger Nicolas Cordier, and Domenico Prestinari, an archetypal also-ran.[54] Absent, however, are Alessandro Algardi

182

and Jacopantonio Fancelli, both of whom had progressed to higher things, though the other names include that of Claudio Cusino, who might well be the Claude Poussin who was to be praised by Bernini in 1652 as an up-and-coming young man.[55] But for contemporaries, again, the only name publicised was that of the architect and designer, Carlo Rainaldi, which was no doubt fair enough, for as he was to say himself, 'I as Architect had the responsibility for the said arch, to give out and to distribute the work which was to be done on that arch'.[56]

If one looks at details of the arch as it appears in two different engravings of the procession (Figs. 252, 253), a curious fact emerges: they have nothing in common with each other, nor do either of them correspond to the written descriptions, or to the image that can be derived from the payments; for example, one of the few sure things about it was that its balustrade was surmounted by statues of the four Cardinal Virtues and at least four putti. Somewhat evasively Giacinto Gigli, who by then was prominent among the Conservatori, described the arch as not yet finished, nor was that which the Duke of Parma had erected for the same procession;[57] indeed, it was a common feature of such events that the workmen would still be hammering away as the procession approached, to duck out of sight as it reached the arch, leaving their work still unfinished.[58] Gigli complained angrily that there were several descriptions of the procession, both engraved and written, and that none of them was true, since they were all printed before the event; it was, he said, a disgrace that such things were allowed, though his principal grievance was that the costumes of himself and his fellow magistrates were wrongly described.[59]

All this effort may appear rather excessive for an arch that was to be used for a brief occasion and pulled down shortly afterwards.[60] In this case the Conservatori's arch was sold off, but for a mere one hundred *scudi*, which sounds as if it went for the value of the scrap-wood, though it is not impossible that bits of it may have been re-employed elsewhere.[61] Undoubtedly, some of the arches of successive *possessi* do have a family resemblance, which suggests that parts may have been stored and reused.

Fig. 252 Anonymous engraver, arch for the procession of Innocent X (detail of Fig. 251) Rome, Gabinetto Comunale delle Stampe .

Fig. 253 Anonymous engraver, arch for the procession of Innocent X. Rome, Gabinetto Comunale delle Stampe.

Fig. 254 Giovanni Battista Falda, engraving of the *Arch of Clement X*.

Fig. 255 Carlo Rainaldi and various sculptors, high altar. Rome, Gesù e Maria.

There is one case where this is known to have happened, with fortunate results. As the Holy Year of 1675 approached, the church of Gesù e Maria was still unfinished and lacked a high altar. Holy Years were times when decrees went out that all the churches should look their best: work in progress was hastened to completion, and general repainting and refurbishment undertaken,[62] so it was considered urgent that this deficiency should be remedied. The church authorities asked the Conservatori whether they could have the fragments of the arch that Carlo Rainaldi had set up four years previously for the *possesso* of Clement X in 1670 (Fig. 254), which were lying in a store-room. From them they took the four columns of painted cloth on a wooden framework, and the medallions, which were repainted with images of Sts Augustine and Monica, and other Augustinian saints. These 'rags' so impressed Monsignor Girolamo Bolognetti, who looked in one day as he was passing the church, that he undertook to pay for a real altar for it (Fig. 255), designed by the same Carlo Rainaldi.[63] The general form, with its prominent columns, may perhaps reflect some memory of the earlier arch, though the statues are now placed outside the paired columns.

The pope was not only the Pontifex Maximus, but also the secular ruler of Rome. As such, he had a political rôle to play, and the city of Rome reacted to events that passed on the world's stage. At times of crisis it might do so with a Forty-Hours' Devotion; at times of joy or triumph it would do so with fireworks. Pope Clement IX had been much exercised by the war between the two great Catholic powers of France and Spain, and instrumental in securing the peace of Aix-la-Chapelle in 1668. So this happy outcome was celebrated by the embassies of the two countries (in rivalry, of course), and for the French ambassador Bernini designed a firework display outside the ambassadorial residence, in the Piazza Farnese. There is a preliminary drawing from the master's studio, but Pierre-Paul Sevin's record of the event (Fig. 256), if less artistic, is more revealing of what actually took place.[64] There were candles and torches all round the Piazza, and in the centre was an immense construction of a globe, surmounted by stucco figures of the Papacy, to whom War presents her sword and and Victory her

Fig. 256 Pierre-Paul Sevin, drawing of Gianlorenzo Bernini's fireworks display. Stockholm, Nationalmuseum.

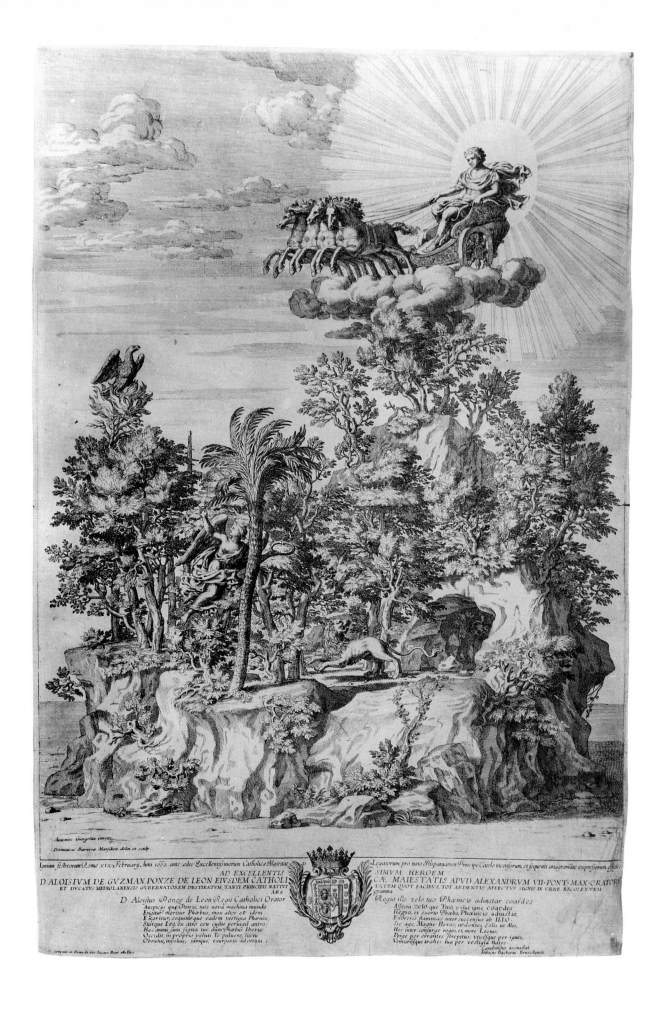

Antonius Georgetus INVENT.

Dominicus Barriere Marsilien delin et sculp.

Ignium festivorum Romæ xix Februarij, Anni 1662, ante ædes Excellentissimorum Catholicæ Majestatis Legatorum, pro nato Hispaniarum Principe Carolo incensorum, et sequenti anagrammate expressiorum glossis

AD EXCELLENTIS SIMVM HEROEM
D ALOISIVM DE GVZMAN PONZE DE LEON EIVSDEM CATHOLI CÆ MAIESTATIS APVD ALEXANDRVM VII PONT MAX ORATORE
ET DVCATVS MEDIOLANENSIS GVBERNATOREM DESTINATVM, TANTI PRINCIPIS NATIVI TATEM QVOT FACIBVS, TOT ARDENTIS AFFECTVS SIGNIS IN VRBE REGOLENTEM
 ABa gramma

D. Aloisius Ponze de Leon Regis Catholici Orator Regio illo zelo tuo Phœnicis adinstar coardes

Auspice quo, Ponze, tuis nova machina mundo Affectu zelo que Tuo, velut igne, coardes
Erigitur! moritur Phœbus, mox alter et idem Regio, et exorto Phœbo, Phœnicis adustar.
Exoritur, sequiturque eadem vestigia Phœnix; Exoreris flammas inter succensus ab ILLO
Statque Leo, ex atro ceu custos pervigil antro. Sic age, Magne Heros, ardentis Solis ut Ales,
Rex animi sunt signa tui dum Phœbus Iberus Hos inter conjurge rogos, et more Leonis,
Occidit, in proprio velut Te pulcere, lucu Perge per errantes strepitus, vivesque per ignes,
Obrutus, involutus, iamque, exurgentis adortum. Venturosque trahes tua per vestigia Natos,

 Cecabundus accinebat
Stampati in Roma da Gio. Iacomo Rossi alla Pace Lodovicus Bacherus Bruxellensis

palm; for more than a quarter of an hour the globe was engulfed in fire and fireworks which completely obscured the figures above, so that the on-lookers imagined that they must have been consumed in the conflagration, but as the fire died down and the smoke cleared they reappeared, unscathed and triumphant.

This was a relatively simple display, both in its structure and in its obvious and easily interpreted message. Far more complex was the firework display mounted by the Spanish ambassador in 1662 (Fig. 257), as part of the three-day celebration of the birth of a son, Don Carlos, to the king of Spain. It was erected in the Piazza di Spagna, designed by and presumably executed under the supervision of the sculptor Antonio Giorgetti.[65] At its summit, in a vast splendour, was the sun-god Apollo in his chariot, above a rock of precipices and caverns covered by trees; before the sun was a phoenix, symbol of rebirth, gazing fixedly at it, and below flew a woman holding the serpent of Eternity, and symbolising Immortality; the lion, prancing out of its cave, was the lion of the arms of Spain. As the invited cardinals, princes and noblemen were entertained, fed and given wine and iced water to the sound of music, there was a great burst of gunfire, and the firework display revealed the sun and his horses, and at the same time the mountain burst into stars, all of which continued for an hour with fireworks and noisy explo-sions; the phoenix burned up, and so did the lion, and eventually the sun, to be replaced by another in the midst of ever more fireworks and mortar fire, to symbolise that, if one Spanish prince dies, another is born. Finally, a rain-bow shot up into the air, and, if I understand the description correctly, the whole machine was burnt to ashes.

Nothing is harder to understand than the descriptions of seventeenth-century fireworks, and, naturally, nothing remains of this machine except, by good fortune, the engraving. Here, in contrast to the Forty-Hours' Devotions, a sculptor's design must have been executed in the round, and therefore by a sculptor, but just what it looked like at any one moment of the long display, and how it really worked, remain rather obscure, despite the written account. Although Giorgetti is stated on the print to be the inventor, this must mean the designer of the machine rather than the inventor of the complicated, and ultimately rather peculiar, allegory, which would have been thought up for him by some more learned adviser.

In any case, like Menghini's Forty-Hours' design, it reveals a talent that none of Giorgetti's surviving sculptures would have led one to expect;[66] and it is a reminder that one should not underestimate the inventive powers of even the lesser-known sculptors, or judge their creativity solely on the basis of their 'noble' works in marble and bronze. There was a whole alternative culture, which it would be wrong to describe as a subculture, of such ephemeral work, much of which will have left no trace behind for even the most diligent researcher to discover.[67]

If one reads the accounts of the great households of the time, whether of cardinals or of princes, it is striking that fine art was, with rare exceptions, quite a minor expense as compared to the provision of a banquet,[68] or the organisation of some ephemeral display such as the Forty-Hours' Devo-tion;[69] Even the monthly living expenses of a princely household might eclipse the price of a painting,[70] not to mention the heavy cost of the stables, for which new horses were bought, vast quantities of fodder consumed, and harnesses made and refurbished.[71]

Fig. 257 Dominique Barrière, engraving after Antonio Giorgetti's fireworks display. London, British Museum.

187

Fig. 258 Alessandro Algardi, drawing for a coach for Camillo Pamphilj. Vienna, Albertina.

Fig. 259 Giovanni Paolo Schor, drawing for a coach. Windsor, Royal Library.

Students of seventeenth-century sculpture cannot confine themselves exclusively to fine art; the horses and their hay might be provided by nature, but the coaches they drew were not, and here the sculptor had an important rôle to play. He might design the coach, and one can compare the relative calm and simple design by Algardi for a coach for Camillo Pamphilj (Fig. 258)[72] with another, far more florid, from later in the century, attributed to Giovanni Paolo Schor (Fig. 259), a draughtsman often employed by Bernini, and very active in the invention of such fantastic processional coaches.[73] Another even more prolific designer was Ciro Ferri, and many drawings for coaches formerly ascribed to Schor have now been convincingly shown to have been invented by this painter and occasional sculptor.[74] According to the note on Tessin's drawing, it was Bernini who designed the coach for the King of Spain (Fig. 260),[75] a conception in which grimacing masks feature prominently,[76] and the four bronze heads (Fig. 261) in the possession of Bernini's descendants are said to have been the *vasi*, or finials, of his own coach, which suggests that he found such motifs particularly suitable for the decoration of these carriages.[77] In 1639 'his' and 'hers' coaches were ordered for Prince Paolo Borghese and his wife Olimpia Aldobrandini, but there is no visual record of them, nor is it known who made the designs.[78] However, Paolo died very young, and his widow remarried Prince Camillo Pamphilj; it must have been for a coach designed for this couple that Algardi made the drawing of a finial (Fig. 262), incorporating the Pamphilj and Aldobrandini arms.[79]

When, after her abdication from the throne of Sweden, Queen Christina arrived in Rome in 1655, Pope Alexander VII presented her with a coach, a litter, a sedan chair and the harness for the horses and mules.[80] The decorative figures on the coach had been designed by Bernini, who was present when the ex-Queen came to the Belvedere garden to inspect them. With feigned modesty he told her that 'if anything is bad, that is my work',

188

Fig. 260 Nicodemus Tessin the Younger, after Gianlorenzo Bernini, coach for the King of Spain, drawing. Stockholm, Nationalmuseum.

Fig. 261 (*top right*) Gianlorenzo Bernini, *Grimacing Head*, bronze. Rome, private collection.

Fig. 262 (*below right*) Alessandro Algardi, drawing for a finial for Camillo Pamphilj and Olimpia Aldobrandini. New York, Metropolitan Museum of Art. Harry G. Sperling Fund, 1979. Inv. 1979. 131.

Fig. 263 Ercole Ferrata, cast by Francesco Perone, gilt bronze frame for a carriage window (from G. Incisa della Rocchetta).

Fig. 264 Ercole Ferrata, cast by Francesco Perone, gilt bronze frame for a carriage window (from G. Incisa della Rocchetta).

to which Christina replied 'then none of it is yours'.[81] This witty risposte is not so far from the truth, for the drawings had been prepared by Giovanni Paolo Schor, the models made by Ercole Ferrata, and the execution carried out by a host of workmen.[82]

Most of these were the same men who, both before and after, also worked on coaches for Pope Alexander's nephew, Cardinal Flavio Chigi. While no Roman coaches of the seventeenth century survive, we do still have two gilt-metal frames (Figs. 263, 264), elaborate and beautiful works of art created originally for the windows of such a carriage, designed by Schor (Fig. 265), modelled by Ercole Ferrata and cast by Francesco Perone; it is a stroke of rare good fortune that, when later in the century the coach was scrapped, they were preserved, and paintings were ordered to fit within them.[83]

Both Pope Alexander VII and his successor, Clement IX, invited Queen Christina to dinner. This was not such a simple matter as it may sound, for etiquette prevented them from sitting at the same table, and Queen Christina's was required to be lower, with a silk cloth instead of one of velvet.[84] No point of seventeenth-century protocol caused such problems as correct chairs: Pope Alexander, of course, sat on a throne; reigning princes were entitled to chairs with arms, but what of Christina, who had abdicated? She could hardly be asked to sit on a backless, armless stool, so Bernini, no less, designed a chair with a back somewhat lower than that appropriate to a ruler, and with rudimentary protruberances for the arms. No visual document survives of that meal, but Pierre-Paul Sevin did record her dinner with Pope Clement IX in 1668 (Fig. 266), for which it seems that she was allotted a rather higher back.[85] So far apart were they that they could converse only via a go-between, who may have been all the more necessary as a choir was singing throughout the meal which would have made ordinary conversation somewhat difficult.

On the table shown by Sevin was a quantity of ornaments, little putti holding up a tray, crowned globes, and trees. These were known as *'trionfi'*

190

Fig. 265 Giovanni Paolo Schor, drawing for the frame of a coach window. Rome, Istituto Nazionale per la Grafica.

Fig. 266 Pierre-Paul Sevin, drawing of the dinner of Pope Clement IX and Queen Christina. Stockholm.

Fig. 267 Giovanni Paolo Schor, drawing of a phoenix. Rome, Istituto Nazionale per la Grafica.

and were made of sugar. For the earlier banquet given by Alexander VII these had been designed by Schor and modelled by Ercole Ferrata, who had been paid the substantial sum of 49 *scudi*;[86] a drawing by Schor (Fig. 267), showing a phoenix which was one of Christina's emblems, was most probably made for the *trionfi* of that dinner.[87] Another banquet drawn by Sevin (Fig. 269)[88] shows a number of mythological *trionfi*, among them the figure of Mercury holding Pegasus, symbolising *Fama Chiara* which corresponds almost exactly, though in reverse, to a sketch by Schor for a dinner given for Queen Christina (Fig. 268), proving that once again he must have been the designer.[89] Those at the banquet of Clement IX look less sculptural, and in fact we know that after the table was cleared they were brought back filled with fruit and sweetmeats.

Seventeenth-century banquets were considerable works of art, and not just the cooking, though that was certainly elaborate enough, and the dishes themselves might be further decorated not only with marzipan flowers, but with little figures, such as sugar dogs pointing, and men throwing trapping-nets over the already roasted partridges, or hunters shooting at the game dishes.[90] Even the napkins were folded into the most complicated constructions.[91] But real sculpture would be moulded in butter, or cast in jelly, ice, or sugar;[92] we may note that the Germans also sculpted in turnips and beetroot, though the Italians seem to have drawn the line at this.[93] So important was the making of these objects that a plan of the Vatican kitchens shows a special room labelled 'Room in which the *trionfi* are prepared'.[94]

The art of sugar sculpture is one of the strangest of the seventeenth century, and this is not only because no examples have survived to show us what they were really like.[95] We know that they were usually gilded (with edible gilding), and, even if they were not actually eaten, they might be given away after the banquet.[96] Considering the amount of effort and expense that went into these great state banquets, it is rather comforting to realise that the table, laid out with its folded napkins and *trionfi*, might be displayed to the public for a couple of days before the meal was actually served.[97]

192

Fig. 268 Giovanni Paolo Schor, drawing for a *trionfo* and other studies. New York, Metropolitan Museum of Art. Purchase, David L. Klein Jr Memorial Foundation, Inc. Gift, Richard and Trude Krautheimer Gift, Van Day Truex Fund, 1985. Inv. 1985. 64.

Fig. 269 Pierre-Paul Sevin, drawing of a banquet table with *trionfi* of mythological subjects. Stockholm, National-museum.

Fig. 270 Pierre-Paul Sevin, drawing of a banquet with *trionfi* of the Passion of Christ. Stockholm, Nationalmuseum.

Fig. 271 Pierre-Paul Sevin, drawing of a banquet with *trionfi* of the instruments of the Passion. Stockholm, Nationalmuseum.

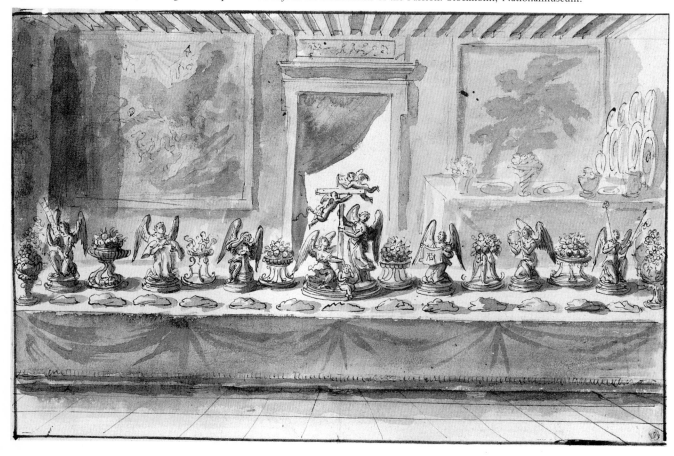

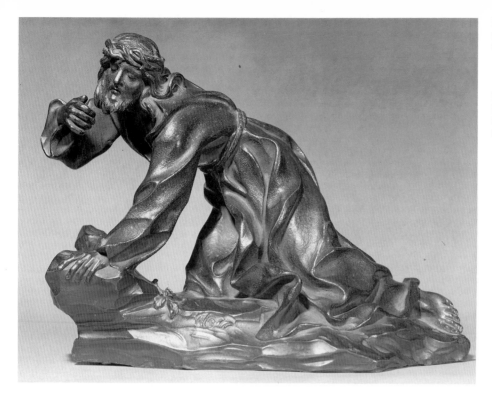

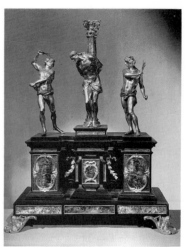

Fig. 272 Alessandro Algardi, *Christ Falling under His Cross*, bronze. New York, Collection Michael Hall.

Fig. 273 Alessandro Algardi, *The Flagellation of Christ*, bronze, ebony, gilt bronze and semiprecious stones. Vienna, Kunsthistorisches Museum.

Fig. 274 Roman seventeenth century, reliquary of St Feliciano, gilt bronze. Florence, S. Lorenzo, treasury.

One of the strangest aspects, at least to modern sensitivity, is the subjects depicted by these *trionfi*. One of drawings by Sevin in the same volume (Fig. 270) shows a table set with sugar *trionfi* with Clement IX's arms in the centre and scenes of Christ's Passion around it,[98] while another shows a crucifix, with angels holding the instruments of the Passion (Fig. 271);[99] in this irreligious age it is hard to reconcile the combination of scenes which we have been led to believe should inspire feelings of grief or penitence, if not actual tears, with the jollity and lavish over-indulgence in the pleasures of the flesh that we should expect to accompany a banquet. And we may find it hard to imagine the dinner-conversation when Cardinal Altieri entertained the cardinals during Holy Week of 1675, and the sugar *trionfi* represented scenes from the scriptures.[100] Perhaps art historians should bear these customs in mind, before assuming that men of the cloth must necessarily have been inspired to pious thoughts by the works of religious art with which they surrounded themselves.

Here, however, we are concerned with sculpture, and sculpture these small figures indubitably were. There are bronze crucifixes similarly upheld by angels,[101] and the cherubs flying round the cross are reminiscent of those Algardi designed for the float of the *Pietà* (Fig. 239). Algardi's bronze statuette of *Christ Falling under His Cross* (Fig. 272)[102] is not far from the sugar sculpture shown by Sevin (Fig. 270), and Algardi's *Flagellation Group* (Fig. 273),[103] which is also close to the sugar group in the same drawing, was certainly well known to Ferrata, who very possibly modelled these *trionfi*. Even the angels holding up the coat of arms are just like others in bronze or silver who support reliquaries in church treasuries (Fig. 274).[104] This may not be fortuitous, for it is not just that real sculptors were employed in making such sugar sculptures,[105] but the *trionfi* at the dinner given by Alexander to Queen Christina, as well as being modelled by Ferrata, were

195

Fig. 275 Pierre-Paul Sevin, drawing of a banquet with *trionfi* of scenes of the life of Christ. Stockholm, Nationalmuseum.

Fig. 276 Arnold van Westerhout on a drawing by Giovanni Battista Lenardi, engraving of *trionfi* of the *Birth of Adonis* and *Apollo and Daphne* (from J. M. Wright, *Ragguaglio*).

Fig. 277 Arnold van Westerhout on a drawing by Giovanni Battista Lenardi, engraving of a *trionfo* (from J. M. Wright, *Ragguaglio*).

cast by Girolamo Lucenti, one of the best bronze-founders of the day, and others who are familiar from the world of bronze-founding.[106] So the arts of casting in bronze and sugar were not far apart, and it could well be that the same models, or even moulds, were used for both media.[107]

But what makes sugar sculpture so particularly interesting is where it differs from the sculptural forms traditional in bronze or marble. Looking at the little figures enacting the washing of Peter's feet (Fig. 270), or what may be Christ taking leave of His mother, one must remember that, apart from groups of the Baptism or the Giving of the Keys, or various closely

entwined scenes of rape or attempted rape, free-standing sculptures of more than one figure are rare in Roman baroque art. The same would apply to the central motif of the Transfiguration in another of these banquet drawings by Sevin (Fig. 275),[108] which is far more elaborate and complex than anything attempted in contemporary 'noble' sculpture.

Even more remarkable are the *trionfi* made for the banquet given in 1687 by King James's envoy to Rome, the Earl of Castlemaine.[109] The mythological groups (Fig. 276) are extraordinary enough in the context of late seventeenth-century sculpture, but the centrepiece (Fig. 277) is a truly incredible construction of seven *palmi*, and, even allowing for an extensive armature, it is hard to believe that it could really have held together, or stood up through the length and heat of the banquet.

Undoubtedly, there were rules of decorum, and, if here experimentation was possible, bizarre effects appreciated, and a whole range of designers given their heads, the same would not have been acceptable in less ephemeral work. Indeed, one of the criticisms levelled at Bernini's great marble statue of *Constantine* (Fig. 278) was that 'the whole horse seems a *trionfo* of marzipan and meringue'.[110]

<p style="text-align:center">★ ★ ★</p>

In any discussion of baroque sculpture, it should be remembered that it included these table decorations, processional floats and firework displays, as well as the comparatively limited range of sculptural expression that has survived. For these too formed part of that sculptural industry that I have been examining in the past chapters. Names mentioned in this chapter, Bernini, Algardi, Ferrata, Ferri, Giorgetti, and many others, have been cited again and again in past chapters, for the same men were involved in many kinds of art, at many different levels; the industry of which they formed part was extensive and manifold, and ranged from the great monuments of St Peter's to a sugar bird on a dinner table or a pile of smouldering ashes in the Piazza di Spagna. In order to understand one part of it, it is essential to be aware of the others, and it is towards an understanding of this art in its entirety that I hope this book may have made some contribution.

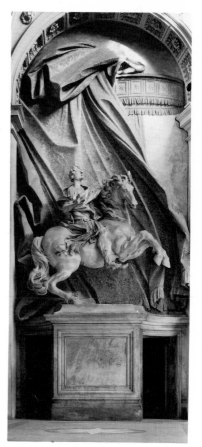

Fig. 278 Gianlorenzo Bernini, *Constantine*, marble. Vatican, St Peter's.

NOTES

PREFACE

1. Published by the Yale University Press, New Haven/London, 1985.
2. R. Enggass, 'Un problème du baroque romain tardif: Projets de sculptures par des artistes non sculpteurs', *Revue de l'art*, 31, 1976, pp. 21–32; M. Conforti, 'Pierre Legros and the Rôle of Sculptors as Designers in late Baroque Rome', *Burlington Magazine*, CXIX, 1977, pp. 556–61. In contrast to Enggass, Conforti disputes the frequency of sculptors working on designs of others (excluding the cases of sculpture tied into an architectural context, and major papal commissions), but, while either argument can be overstated, both contain large elements of truth.
3. This was not reflected in other publications, which have continued to ignore the problem.
4. Most notably Michelangelo Cagiano de Azevedo, in his *Il Gusto nel restauro delle opere d'arte antiche*, Rome, 1948.
5. Most particularly Maurizio Fagiolo Dell'Arco and Silvia Carrandini, in their *L'Effimero barocco*, Rome, 1977–8.
6. Martin Wackernagel, *Lebensräum des Künstlers in der florentinischen Renaissance*, Leipzig, 1938, translated by Alison Luchs as *The World of the Florentine Renaissance Artist*, Princeton, 1981. See also Bruce Cole, *The Renaissance Artist at Work, from Pisano to Titian*, London, 1984, and, for a more serious and scholarly study of a more limited aspect, Hannelore Glasser, *Artists' Contracts of the early Renaissance* (Columbia University Ph.D., 1965), Ann Arbor, 1973.
7. Most recently Rudolf Wittkower, *Sculpture: Processes and Principles*, London, 1977, and Marie-Thérèse Baudry and Dominique Bozo, *La Sculpture: méthode et vocabulaire*, Paris, 1978.
8. In particular, material from the original lectures was used in three colloquium papers, subsequently published, and has been incorporated in this book: 'Architects and Sculptors in Baroque Rome', *Bollettino del Centro Internazionale di Studi d'Architettura 'Andrea Palladio'*, XXIII, 1981, pp. 71–83; 'Bernini Sculptures Not by Bernini', *Gianlorenzo Bernini: New Aspects of his Art and Thought*, ed. Irving Lavin, University Park (Penn.)/London, 1985, pp. 25–61, and 'Disegni, Bozzetti, Legnetti and Modelli in Roman Seicento Sculpture', *Entwurf und Ausführung in der europäischen Barockplastik*, Munich, 1986,

pp. 9–30. I am grateful to the editors and publishers for their kind permission to reuse the material.
9. The complete series was given in Cambridge and repeated at University College, London; five were given at Duke University in 1987, and individual lectures have been repeated in many places in England and America.

CHAPTER I

1. On this series of paintings see, most recently Zygmunt Waźbiński, 'Lo Studio – la scuola fiorentina di Federico Zuccaro', *Mitteilungen des Kunsthistorischen Institutes in Florenz*, XXIX, 1985, pp. 275–346.
2. Leone Pascoli, *Vite de' pittori, scultori ed architetti moderni*, Rome, 1730, II, pp. 446–7. Morelli was born in 1619 and died in 1690. See Mark S. Weil, *The History and Decoration of the Ponte S. Angelo*, University Park/London, 1974, pp. 141–2; Laura Falaschi, in Valentino Martinelli, *Le Statue berniniane del Colonnato di San Pietro*, Rome, 1987, pp. 219–21.
3. There is no study of foreign sculptors in Rome, though much material can be found in the various books by Antonio Bertolotti. Some incidental information about sculptors is contained in books primarily about painters, such as Godefridus J. Hoogewerff, *Nederlandsche Kunstenaars te Rome, 1600–1725*, The Hague, 1942, and Jacques Bousquet, *Recherches sur le séjour des peintres français à Rome au XVIIème siècle*, Montpellier, 1980.
4. See Ascanio Condivi, *Vita di Michelangiolo*, ed. Emma Spina Barelli, Milan, 1964, p. 23.
5. On Jacopantonio (1606–74), with some information on Cosimo (1618–88) and their brother Francesco (1624–81), see L. Pascoli, *op. cit.*, II, pp. 467–77; on Cosimo see M. Weil, *op. cit.*, pp. 143–4. See also the entries on the family in Ulrich Thieme and Felix Becker, *Allgemeines Lexikon der bildenden Künstler*, XI, Leipzig, 1915, pp. 241 ff. I am grateful to Maria Teresa De Lotto for allowing me to quote the dates established in her unpublished thesis *L'Attività di Cosimo Fancelli fino al 1669*, and to Jörg Martin Merz for telling me of it; the information on Jacopantonio has since been published in Valentino Martinelli, *op. cit.*, 1987, pp. 209–10. Their father, Carlo Fancelli, carved various arms

of Urban VIII for the Castel Sant'Angelo (Cesare D'Onofrio, *Castel S. Angelo*, Rome, 1971, pp. 258–9, and fig. 198), and the fountain formerly at Scozzacavallo, and now, with some modification, before the church of S. Andrea della Valle (ASR, Camerale 1°, Fabbriche, Mandati Busta 1537, f. 310; 19 November 1614, payment on account).
6. Christiane Klapisch-Zuber, *Les Maîtres du marbre*, Paris, 1969, pp. 34–9.
7. *Ibid.*, pp. 172–9.
8. See Hugh Honour, in *Dizionario biografico degli italiani*, V, Rome, 1963, pp. 787–92, 793–4.
9. Giovanni Battista Passeri, *Die Kunstlerbiographien . . .*, ed. J. Hess, 1934, p. 333.
10. ASR, Corp. Relig. Masc., Agostiniani Scalzi, Busta 273, fasc. 711 (modern 237), pp. 281, 291, 324; he received seventy *scudi* in all. He also worked on the incrustation of the nave of St Peter's (AFP, Armadi, vol. 276, p. 151), as did Francesco Baratta (*loc. cit.*) Francesco (*c*.1600–66) is the only member of the family for whom even approximate dates can be given.
11. ASR, Corp. Relig. Masc., Agostiniani Scalzi, Busta 274, fasc. 716 (modern 235), f. 208 (14 June 1665); ADP, Scaff. 88, no. 5, int. 8. That Andrea (whose relationship to the other 'Barattas was unknown to Hugh Honour) was a brother is proved by a receipt of September 1665 (Busta 273, fasc. 711, p. 324): 'Io Andrea Baratta ò riceuto scudi trenta moneta a nome di Gio Maria mio fratello da Pro: Fulgentio della Beata Rita sotto Priore di S. Nicola di Tolentino quali sono per compito pagamento delle due pile di aque sante fatte nella loro chiesa . . .'. On Andrea Baratta see Paola S. M. Mannino, in V. Martinelli, *op. cit.*, p. 204.
12. G. B. Passeri, *op. cit.*, p. 206; J. Montagu, 'Alessandro Algardi's Altar of S. Nicola da Tolentino', *Burlington Magazine*, CXII, 1970, p. 285; Elena Bianca di Gioia in *Archeologia nel centro storico* (exhibition catalogue), Rome, 1986, cat. 13, pp. 180–84.
13. Rudolf Wittkower, *Gian Lorenzo Bernini*, 1966, cat. 46, pp 213–14; on this altarpiece see also I. Lavin, *Bernini and the Unity of the Visual Arts*, New York/ Oxford/ London, 1980, p. 33 ff.
14. See below, p. 223.
15. J. Montagu, 'Antonio and Giuseppe Giorgetti: Sculptors to Cardinal Francesco Barberini', *Art Bulletin*, LII, 1970, p. 279. Antonio died young in 1669; the dates of Giuseppe are unknown. The father of

Filippo Carcani was a carpenter, employed on St Peter's (see Rosella C. Taranto, in V. Martinelli, *op. cit.*, p. 206).

16. G. B. Passeri, *op. cit.*, p. 315. Giuseppe was born *c.*1626, and died in 1663.

17. *Ibid.*, p. 319. None of his drawings are known today.

18. *Ibid.*, p. 131. See also Ulrich Middeldorf, 'Camillo Mariani, Scultore-Pittore', *Burlington Magazine*, CXVIII, 1976, pp. 500–3 (reprinted in *idem*, *Raccolta di scritti: that is Collected Writings*, Florence, 1981, III, pp. 53–7); see, however, the letter from Marco Chiarini, *Burlington Magazine*, CXVIII, 1976, pp. 703–4.

19. L. Pascoli, *op. cit.*, II, pp. 457–67; Ursula Schlegel, 'Notizen zu italienischen Skulpturen des Barock', *Antologia di belle arti*, N.S. XXV/XXVI, 1985, pp. 39–44; for his work see also M. S. Weil, *op. cit.*, pp. 142–3; Rosella Carloni, in V. Martinelli, *op. cit.*, pp. 221–3. The busts are now in the Protomoteca Capitolina.

20. Filippo Baldinucci, *Notizie dei professori del disegno . . .*, ed. Ferdinando Ranalli, V, 1847, p. 392. On Carcani see Rosella C. Taranto, in V. Martinelli, *op. cit.*, pp. 206–207.

21. G. B. Passeri, *op. cit.*, p. 315.

22. Giovan Pietro Bellori, *Le Vite de' pittori, scultori e architetti moderni*, ed. Evelina Borea, Turin, 1976, p. 400; see also J. Montagu, *Alessandro Algardi*, New Haven/London, 1985, pp. 2–3.

23. L. Pascoli, *op. cit.*, II, p. 85; Orfeo Boselli, *Osservazioni della scoltura antica*, ed. Phoebe D. Weil, Florence, 1978, MS. Corsini f. 9v.

24. G. B. Passeri, *op. cit.*, p. 245–6.

25. See F. Baldinucci, *op. cit.*, V, p. 376.

26. Orsolino's dates are unknown, but he died between 1674 and 1677.

27. *Ibid.*, V, p. 377.

28. *Loc. cit.*

29. Orfeo Boselli says that the young sculptor should begin by copying plaster fragments from the antique: 'si principia a studiare da teste, mani, e piedi di gesso, formate sopra l'antico; si proseguisa a corpi, gambe, e braccia, tanto che si prevenga a fare le figure intere' (O. Boselli, *op. cit.*, MS. Corsini f. 12v).

30. F. Baldinucci, *op. cit.*, V, pp. 377–81.

31. For a stonemason, 16 August 1606 (ASR, 30 Not. Cap., Uff. 14, Marco Antonio Gazza, vol. 26, ff. 171r–v; the same volume contains several contracts for other trades).

32. On Caporale see Antonella Pampalone, in *Dizionario biografico degli italiani*, XVIII, 1975, pp. 671–2. The contract cited above provides the additional information that he was the son of Giacinto, and was born in Soncino in the diocese of Cremona; it is also unusual in specifying what should happen were Caporale to work outside Rome, which might suggest the prospect of such an engagement.

33. ASR, 30 Not. Cap., Uff. 14, M. A. Gazza, vol. 26, ff. 366–7v. The relevant paragaph, which I have translated freely, is on f. 367r: 'Item il detto Maestro Francesco Caporale si obliga et promette esercitar il detto Carlo nella professione del scultore con farli far

teste mano piedi disegni et fare di cera greta ossature ottomia et carnatione et carnatione pannegiato, et capricci et altre cose appartenenti al detto mestiero'.

34. G. B. Passeri, *op. cit.*, p. 334.

35. *Ibid.*, p. 316.

36. *Loc. cit.*

37. See Cesare D'Onofrio, *Roma vista da Roma*, Rome, 1967, pp. 89–97.

38. *Ibid.*, pp. 122–136.

39. Paul Fréart de Chantelou, *Journal de voyage du Cavalier Bernin en France*, ed. Ludovic Lalanne, Paris, 1981, 5 August, p. 96.

40. He was born on 14 February 1648, and died in 1728; Gianlorenzo said that he was 18 (*loc. cit.*).

41. 1 August, *ibid.*, p. 89; there was also the occasion on 6 September when Gianlorenzo 'called his valet to bring his working jacket and began to give a touch or two to the drapery of Signor Paolo's figure of the *Christ Child*' (*op. cit.*, p. 159); I have used the translation of Margery Corbett (Paul Fréart de Chantelou, *Diary of the Cavaliere Bernini's Visit to France*, Princeton, 1985, pp. 95, 169).

42. Oskar Pollak, *Die Kunsttätigkeit unter Urban VIII*, II, Vienna, 1931, *passim*. See Howard Hibbard, in *Dizionario biografico degli italiani*, IX, 1967, pp. 376–7. Might Gianlorenzo not also have let his father exercise his traditional skill in the carving of sheeps' fleece on what was meant to be a lion's pelt in the statue of *Aeneas and Anchises*?

43. On Luigi Bernini see H. Hibbard, in *Dizionario biografico degli italiani*, IX, 1967, pp. 375–6; he was appointed Soprastante alla fabbrica di S. Pietro in 1635, where he contributed several inventions, such as a moveable *castello*, and a weighing machine (Domenico Bernini, *Vita del Cavalier Gio: Lorenzo Bernino*, Rome, 1713, p. 153). In Carlo Fontana's 'Ristretto di quanto hà ricavato il Cavaliere Bernino dalla R. Fabrica', he includes the earnings of Luigi in the 'Casa Bernini' (BAV, MS. Vat. Lat. 8635, ff. 53v–56, published in *Bernini in Vaticano*, exhibition catalogue, Rome, 1981, p. 320; copies in the Getty Center for the History of Art and the Humanities, Archives of the History of Art, no. 850688, unpaginated, and BAV, MS. Chigi P.VII.9, f. 51ff).

44. P. Fréart de Chantelou, *op. cit.*, 1981, 5 July, p. 51; Anatole de Montaiglon, *Correspondence des directeurs de l'Académie de France à Rome*, I, Paris, 1887, letter 11, p. 7. This is an odd statement, and it is hard to imagine whom he might have had in mind, nor is it possible that the French could have intended the academy they were planning to set up to be run in this way. Possibly Bernini, who had had no experience of an academy as a teaching institution (for the Accademia di S. Luca in Rome was more of an aritsts' association, with occasional lectures and discussions), may have intended this as an indirect criticism of the Académie Royale de Peinture et de Sculpture in Paris, where the students were taught theoretical matters such as perspective and anatomy, and did indeed practise life-drawing, and he may

not have realised that they were at the same time learning the craft of painting or sculpture by the traditional methods of apprenticeship. However, he does not refer specifically to French artists, and he may be been thinking of foreigners in Rome in general, though the remark remains curious.

45. Statutes of 11 Feb. 1666 (A. de Montaiglon, *op. cit.*, I, pp. 8–11).

46. P. Fréart de Chantelou, *op. cit.*, 5 July, p. 51; A. de Montaiglon, *op. cit.*, I, letter 11, p. 7.

47. Letter from Colbert of 15 July 1667 (A. de Montaiglon, *op. cit.*, I, letter 21, p. 14.; Rudolf Wittkower, 'The Vicissitudes of a Dynastic Monument: Bernini's Equestrian Statue of Louis XIV', in *De Artibus opuscula XL*, New York, 1961, pp. 497–531, reprinted in R. Wittkower, *Studies in the Italian Baroque*, London, 1975, pp. 83–102.

48. A. de Montaiglon, *op. cit.*, letter 163 of 1 February 1680, p. 93.

49. On Maratti's *Apollo and Daphne* (1681), see Antoine Schnapper, *Tableaux pour le Trianon de Marbre 1688–1714*, Paris/The Hague, 1967, pp. 64, 71 note 34; on Guidi's *History* (1679–86), see Lorenz Seelig, 'Zu Domenico Guidis Gruppe "Die Geschichte Zeichnet die Taten Ludwigs XIV. Auf"', *Jahrbuch der Hamburger Kunstsammlungen*, XVII, 1972, pp. 81–104. Neither received any pension from the royal funds.

50. This impression may also be influenced by the fact that the correspondent in Rome who was responsible for the academy's affairs was not an artist, so less could be left to his discretion. See the letters published in K. Lankheit, *Florentinische Barockplastik*, Munich, 1962, pp. 245–67.

51. Ferdinando Tacca (1619–86) had introduced some baroque elements, and deliberately perverted some of the principles of Giambologna's art, but his artistic language remained inescapably conditioned by that of his illustrious predecessor (see A. Radcliffe, 'Ferdinando Tacca, the Missing Link in Florentine Baroque Bronzes', *Kunst des Barock in der Toskana*, Munich, 1976, pp. 14–23, and Anthea Brook, 'La Scultura fiorentina tra il Giambologna e il Foggini', in *Il Seicento fiorentino: arte a Firenze da Ferdinando I a Cosimo III* [exhibition catalogue], Florence, 1986, I [*Pittura*], pp. 71–6).

52. See below, note 70.

53. K. Lankheit, *op. cit.*, p. 32.

54. *Ibid.*, p. 162; doc. 53, p. 245.

55. *Ibid.*, doc. 55, pp. 245–6.

56. *Ibid.*, p. 32, and docs. 114–15, p. 254.

57. *Ibid.*, doc. 80, p. 250.

58. Mara Visonà, 'La Via Crucis del Convento di San Pietro d'Alcantara . . .', in *Kunst des Barock in der Toskana*, Munich, 1976, p. 62.

59. K. Lankheit, *op. cit.*, doc. 92, p. 251.

60. See M. Visonà, *loc. cit.*; J. Montagu, 'Il Primo rilievo in marmo del Foggini', *Arte illustrata*, LV/LVI, 1973, pp. 331–8. Ferri had a poor opinion of Ferrata's drawing (K. Lankheit, *op. cit.*, doc. 85, p. 250).

61. That the wax relief in the Doccia Museum is by Massimiliano Soldani is proved by

the eighteenth-century inventory (Klaus Lankheit, *Die Modellsam-mlung der Porzellanmanufaktur Doccia*, Munich, 1982, p. 134 [34.72]); for a terracotta version, see Charles Avery and K. Corey Keeble, *Florentine Baroque Bronzes and Other Objects of Art* (exhibition catalogue), Toronto, 1975, pp. 58–9. There is no certainty that this copy of Poussin's painting, now in the Wadsworth Atheneum, was in fact made while he was still a student in Rome; since the painting was sent to France, Soldani would in any case have had to copy an engraving, of which three were available (Anthony Blunt, *The Paintings of Nicolas Poussin: A Critical Catalogue*, London, 1966, cat. 79, p. 55).

62. Lucia Monaci, 'Alcuni disegni giovanili di Giovan Battista Foggini' in *Kunst des Barock in der Toskana*, 1976, p. 24. Foggini was born in 1652 and died in 1725.

63. See below, p. 88.

64. His name was Stefani (no first name is recorded by Klaus Lankheit, *op. cit.*, p. 31); he was sent to study in the Schor workshop (*ibid.*, p. 33).

65. K. Lankheit assumes this to have been Giovanni Pietro Travani (*op. cit.*, p. 33). The better medallist, Giovanni Hamerani, who was reluctant to train Soldani because he would thus loose the work he was currently getting from Florence, demanded too high a salary (*ibid.*, doc. 133, p. 256).

66. *Ibid.*, doc. 128, p. 255.

67. L. Monaci, *op. cit.*, pp. 24, 32 note 4.

68. K. Lankheit, *op. cit.*, p. 33, and doc. 105, p. 253.

69. A. de Montaiglon, *op. cit.*, I, letter 83, p. 48.

70. It was badly drawn, though the colour was '*pas mal*'; the drapery was unnatural and insufficiently varied, the views of the heads were too similar, the finish inadequate, the choice of subject bad, and decorum not observed, 'car l'on ne met jamais un Fleuve en pied que quand il court après Aréthuse'. In sum, 'l'on voit par ce tableau que le Peintre néglige les Anciens, trouvant apparamment trop de peine à les imiter, et qu'il n'imite que les Peintres vivans actuellement dans Rome. Il est certain qu'il s'écartera toujours du bien et de la perfection s'il n'imite les anciens.' (A. de Montaiglon, *op. cit.*, I, letter 446, pp. 435–6).

71. See below, pp. 169–172.

72. J. Montagu, 'Il Primo rilievo in marmo del Foggini', p. 332.

73. Giovanni Bottari and Stefano Ticozzi, *Raccolta di lettere*, II, Milan, 1822, letter XCVI, p. 312.

74. ASR, 30 Not. Cap., Uff. 4, vol. 335, ff. 263–6v, 301–302v; see J. Montagu, *Alessandro Algardi*, 1985, p. 239, note 30, etc. I am indebted to me of this list.

75. ASR, Camerale Diverse II, Antichità e Belle Arte, Busta 9, fasc. 226 (1807). I owe my knowledge of this list to the kindness of David Bershad.

76. Vincenzo Golzio, 'Lo "Studio" di Ercole Ferrata', *Archivi d'Italia e rassegna internazionale degli archivi*, ser. II, II, 1935, pp.

64–74.

77. J. Montagu, *op. cit.*, p. 231.

78. Romeo Galli, 'I Tesori d'arte di un pittore del Seicento (Carlo Maratta)', I, *L'Archiginnasio*, XXII, 1927, p. 227; David L. Bershad, 'The Newly Discovered Testament and Inventories of Carlo Maratti and his Wife Francesca', *Antologia di belle arti*, N.S. XXV–XXVI, 1985, p. 66. The cast of the Borghese *Gladiator* was left to the Accademia di S. Luca (*loc. cit.*).

79. Carlo Bartolomeo Piazza, *Eusevologio romano*, Rome, 1698, p. lxxvi; Ferrata's will has not been rediscovered, so we must accept the word of Piazza, who says that he himself undertook this division.

80. F. Baldinucci, *op. cit.*, V, p. 395. This sculptor he calls Giuseppe Nusman, and states that he was now ('oggi') one of the foremost sculptors in Milan; no one of that name is known, either in Ferrata's studio or in Milan, and it is possible that he meant Giuseppe Rusnati.

81. This volume, Rensi VI, also contains some drawings by other hands.

82. See below, p. 92.

83. Cafà's date of birth is given variously as 1631 or 1635. On some of the drawings after Cafà's models see J. Montagu, 'The Graphic Work of Melchior Cafà', *Paragone Arte*, 413, 1984, pp. 50–61.

84. E. Bianca di Gioia in *Archeologia nel centro storico*, 1986, cat. 16, pp. 195–200.

85. O. Boselli, *op. cit.*, MS. Corsini ff. 156v–157r.

86. Haarlem, Teylers Stichting, K.VI.122; Ann Sutherland Harris kindly told me of this example.

87. This bust, derived from his standing figure of the saint, was evidently a popular subject for copyists; for example, it serves as a model in a painting by Egon Hendrik van der Neer in the Wallace Collection showing a woman amateur drawing a reduction of the *Borghese Gladiator* (Wallace Collection, cat. 243). The bust was included by Sandrart in a print of various antiques (Joachim von Sandrart, *Der Teutschen Academie Zweyter und letzter Haupt-Teil von der edlen Bau- Bild- und Mahlerey-Knste . . .*, Nürnberg, 1679, 2nd part, pl. qq).

88. On the use of plaster casts after his models by both painters and sculptors see G. B. Passeri, *op. cit.*, cat. 92.

89. See René Charpentier, *Cabinet du Sr. Girardon*, *c.*1708; François Souchal, 'La Collection du sculpteur Girardon', *Gazette des beaux-arts*, pér. 6e, LXXXII, 1973, pp. 1–98.

90. Romeo Galli, *op. cit.* III, *L'Archiginnasio*, XXIII, 1928. pp. 60–61; D. L. Bershad, *op. cit.*, p. 76.

91. Carlo Cesare Malvasia, *Felsina pittrice*, ed. Giampietro Zanotti, Bologna, 1841, II, pp. 153–4; see also G. B. Passeri, *op. cit.*, pp. 267–8.

92. Dunkerque, Musée des Beaux-Arts, inv. 76.13; see *Revue du Louvre et des Musées de France*, XXVII, 1977, p. 48. It was exhibited in the Salon of 1834 (no. 1294).

93. Compare the plaster putto in *The Drawing Lesson* by Jan Steen in the J. Paul Getty Museum, Malibu (83.PB.388); see *The J.*

Paul Getty Museum, Handbook of the Collections, Malibu, 1986, p. 100.

CHAPTER II

1. 'Il Marmo Bianco fù, et sarà sempre la più proporzionata matteria che possa trovarsi per fare statue, et tengo per certo, che la Natura a questo effetto lo generasse, Candido, Lavòrabile, et Durevole' (Orfeo Boselli, *Osservazioni della scoltura antica*, ed. Phoebe Dent Weil, Florence, 1978, MS. Corsini f. 9).

2. O. Boselli, *op. cit.*, MS. Corsini, f. 154v.

3. This was not, of course, a peculiarly seventeenth-century problem: Michelangelo had abandoned his first version of the *Risen Christ* because of a dark vein that appeared in the area of the face (Sylvia Pressouyre, 'Sur la sculpture à Rome autour de 1600', *Revue de l'art*, 28, 1975, p. 69).

4. J. Montagu, *Alessandro Algardi*, New Haven/London, 1985, cats. 70, 71, pp. 376–7.

5. Filippo Baldinucci, *Vita di Gian Lorenzo Bernini*, ed. Sergio Samek Ludovici, Milan, 1948, p. 77. Domenico Bernini tells a somewhat different version of this story (*Vita del Cavalier Gio. Lorenzo Bernino*, Rome, 1713, pp. 10–11).

6. Paul Fréart de Chantelou, *Journal de voyage du Cavalier Bernin en France*, ed. Ludovic Lalanne, Paris, 1981, p. 42 (21 June). Domenico Bernini says that his father changed the blocks twice in order to find one that was suitable (*op. cit.*, p. 133), and that even while he was working on the final version, for fear that a vein or similar defect would appear, and that he would have to recarve the whole work, as had occurred before (no doubt this was a reference to the *Scipione Borghese*), he ordered his assistant Giulio Cartari 'che ne incominciasse lo sbozzo in altro Marmo, quale mancando il primo, haverebbe egli poi ridotto a perfezione' (*ibid.*, p. 135).

7. Chantelou p. 93 (4 August). The drill-holes are particularly evident in the hair, as well as in the cravat.

8. For the map, and for much of what follows, I am indebted to the fascinating and exemplary book by Christiane Klapisch-Zuber, *Les Maîtres du marbre*, Paris, 1969. By the seventeenth century there were four main quarries at Polvaccio producing the best marble.

9. C. Klapisch-Zuber points to the growth of this practice by the end of the sixteenth century, and to its effect in breaking the close relationship that had existed previously between the sculptor and the quarrier (*op. cit.*, p. 203).

10. ASR, Not. Trib. A.C., vol. 5422, S. Pasquettus, 1648, ff. 761r–v.

11. For his statue of *The Four Seasons* that he was to carve for Cardinal Giulio Sacchetti he ordered the marble block from his brother Giacomo, 'il quale insieme con il Padre faceva la professione di mercante da per tutto li marmi carrarini' (Giovanni Battista Passeri, *Die Kunstlerbiographien*,

ed. J. Hess, Leipzig, 1934, pp. 249–50. See also below, p. 107).

12. On 7 September 1637 Andrea Bolgi was paid for having supplied the marble for Bernini's statue of *Urban VIII* in the Palazzo dei Conservatori (Arch. Cap., Credenza IV, vol. 112, f. 139v).

13. Lanciani notes how, in the late sixteenth century, almost all the sculptors who worked on the Lateran ended by becoming marble suppliers, so that in the last folios of the account books one repeatedly finds the records 'a Flaminio Vacca per tanto marmo dato ... a Nicolò fiamengo per marmi dati ...' etc. (Rodolfo Lanciani, *Storia degli scavi di Roma*, IV, Rome, 1912, p. 193).

14. S. Pressouyre, *Nicolas Cordier*, Rome, 1984, p. 167, and doc. 276, p. 334. Cordier was born probably in 1567, and died in 1612. Tommaso della Porta (died 1618) owned 'una bozza di S. Giovanni a sedere di mano di Prospero Bresciano' and 'una bozza di un figurino moderno di Michel Agnolo' both of which passed after his death into the collection of Pope Paul V (*ibid.*, p. 167).

15. The Barberini had such a store of marble, including antiques, looked after by a series of sculptors: Lorenzo Ottone, Bernardino Cametti, and Agostino Cornacchini (see BAV, Arch. Barb., Indice II, 2449). The inventory of 1680 lists pieces of marble used to make the decorative parts of the memorial to Cardinal Francesco Barberini (in the Vatican), a broken capital given to the kitchen for a mortar, etc.; that of 1700 lists a 'troncone di colonna di bigio' used to make an eagle as a base for a medallion of Alexander VIII (visible on an old photograph of the Barberini collection, Musei e Gallerie Vaticani, negative XXIII, 9.29), a sarcophagus was taken to be placed below the figure of *Diana* which Cardinal Francesco Barberini 'prese del Sig.r Giuseppe Mazzuoli', and two pieces of an architrave of *porta santa* which were given to Cametti for the tomb of Cardinal Antonio Barberini at Palestrina, etc. They might also hold stocks of semiprecious stones, which were rare enough that they had to be bought when they were offered; so, when on 18 December 1638 the jeweller Curtio Bentornati was paid 55 *scudi* for a frame of about a *palmo*, made of 'pietra paragone', it was described as 'fatta del suo, e profilata di lapis lazzaro del nostro' (BAV, Arch. Barb., Card. Francesco Barberini Sr, mandati 1637–41, no. 6180).

16. There was the case of Giulio Cesare Conventi in Bologna, who began to carve a putto from an antique *cippus*, until the stone was seized from him (Carlo Cesare Malvasia, *Marmora felsinea*, Bologna, 1690, p. 46); this now forms part of the Lapidarium of the Museo Civico in Bologna (Giancarlo Susini and Rosanna Pincelli, *Le Collezioni del Museo Civico di Bologna: Il lapidario*, Bologna, 1960, no. 47, p. 57).

17. See, however, below, note 32, for a sculptor sent to the travertine quarries at Tivoli.

18. *Francesco Mochi, 1580–1654* (exhibition catalogue), Florence, 1981, p. 102 (29 May

1603).

19. J. Montagu, *Alessandro Algardi*, 1985, cat. 161, pp. 434–6.

20. ASR, 30 Not. Cap., Uff. 32, vol. 104, f. 936v.

21. Oskar Pollak, *Die Kunsttätigkeit unter Urban VIII*, II, Vienna, 1931, doc. 911, p. 287.

22. So Algardi's bronze statue of *Innocent X* for the Capitol was to be 'di altezza, forma e qualita di materia della statua di Sisto quinto [by Taddeo Landini (see Werner Hager, *Die Ehrenstatuen der Päpste*, Leipzig, 1929, cat. 36, pp. 52–3)]' (Arch. Capitolino, Credenza VI, vol. 37, p. 139). The coloured marble decoration of the altar of the Gessi chapel in Sta Maria della Vittoria was to be 'al paragone di qualsivoglia altro lavoro più bello, e meglio lavorato che sij stato fatto sino al p[rese]nte giorno in Roma come dire la Capella di Paolo V. in Sta Maria Magg[io]re, la confessione dell'Apostoli in S. Pietro, la Capella del Beato Luigi nell'Annunziatella, la Capella dei Signori Gaetani in S.a Pudentiana, e potendosi far meglio, megliorare ...' (ASR, 30 Not. Cap., Uff. 25, T. Raimundus, vol. 186, 24 Nov. 1639, f. 290v). Sometimes, however, this was left vague, as when by a contract of 21 Feb. 1668 the stonemason Luca Berrettini was to provide an altar for the Oratory of the Arciconfraternità dell' Santissimo Sacramento at the Scala Santa of the Lateran, which was to be 'ben fatte, ben lavorato ad ogni paragone' or 'à paragone d'altri lavori che si fanno in q[ues]ta Città' (The Getty Center for the History of Art and the Humanities, Archives of the History of Art, no. 850461, f. 12v).

23. Vincenzo Golzio, *Documenti artistici sul seicento nell'archivio Chigi*, Rome, 1939, p. 118.

24. See J. Montagu, *op. cit.*, p. 370. This presumably referred to the blocks ordered from Rafaelle Pisani for the four saints in the crossing, including Bernini's own *St Longinus* (see O. Pollak, *op. cit.*, docs. 1650, p. 431, and 1718–1728, pp. 443–6), negotiations in which Cardinal Bernardino Spada, Virgilio's brother, was involved. It is less likely to refer to the two blocks for the *Countess Matilda* supplied by Diana, since these were not paid for till 12 May 1635 (BAV, Arch. Barb., Index IV, 1615, f. 197).

25. Lucarelli was presumably identical with the 'Ducarelli' linked with Franzoni and Diana by Scamozzi as the leading three quarry owners in Carrara (Vincenzo Scamozzi, *L'Idea della architettura universale*, Venice, 1615, p. 187); see also Document I.6.

26. J. Montagu, *op. cit*, pp. 370–371.

27. It was reported that when this finished group was shipped from Rome to the church in Bologna it was seized by pirates and had to be ransomed; in this case the story is improbable (see J. Montagu, *op. cit.*, p. 371), but by no means all marble, worked or unworked, arrived safely at its destination.

28. See *Bayerische Rokokoplastik. Vom Entwurf zur Ausführung* (exhibition catalogue), Munich, 1985; J. Montagu, 'Disegni,

Bozzetti, Legnetti and Modelli in Roman Seicento Sculpture', in *Entwurf und Ausführung in der europäischen Barockplastik*, Munich, 1986, p. 12.

29. J. Montagu, *loc. cit.*, figs. 14–16. The payment for the marble for the statue of Urban VIII on the Campidoglio included a repayment for the money spent 'per l'abbozzatura del sud[ett]o marmo conform' al modello di legno ma[n]datoli dal Signor Cavalier Bernino à Carrara' (see above, note 12).

30. J. Montagu, *loc. cit.*, figs. 17 and 18. In a draft contract of the early eighteenth century, in which G. M. Frugone offered to supply the marble for the statues which it was proposed to make for the Lateran, he stated (article XI) 'Con patto però, che li scultori debbano dare li modelletti di Legno, o di Gesso, con sua scaletta smusciati à loro compiacimento ...' (Edward J. Olszewski, 'Giovanni Martino Frugone, marble merchant, and a contract for the apostle statues in the Nave of St John Lateran', *Burlington Magazine*, CXXVIII, 1986, p. 666. The same document was published by Helga N. Franz-Duhme, *Angelo De Rossi. Ein Bildhauer um 1700 in Rom*, doctoral dissertation for the Frei Universitt Berlin, Berlin, 1986, pp. 284–7).

31. J. Montagu, *Alessandro Algardi*, 1985, p. 434 (where the word '*sgrossare*', here translated as 'reduced', was mistranscribed '*sgrattare*'). What this model was to be made of is not specified; it might have been of plaster, or terracotta, and by no means necessarily of wood.

32. On 11 May 1672, Lazzaro Morelli was to be paid ten *scudi* 50 'per aver fatto di creta un modello della coltra [the 'shroud' for the tomb of Alexander VII] ... e questo portatolo alle cave di travertino di Tivoli et andato lui medemo a farlo abbozzare, acciò essendo allegierito possa condursi a Roma' (V. Golzio, *op. cit.*, p. 119). G. M. Frugone explains his need for measured models (see above, note 30) '... affinche li Marmi vengano più leggieri, per la qual smodellatura si facilitano li prezzi ...' (E. J. Olszewski, *loc. cit.*).

33. S. Pressouyre, *Nicolas Cordier*, 1984, doc. 163 of 5 September 1609, pp. 289–90.

34. On this undertaking see Minna Heimbürger Ravalli, *Architettura, scultura e arti minori nel barocco italiano: Ricerche nell'archivio Spada*, Florence, 1977, pp. 217–50, and Klaus Güthlein, 'Quellen aus dem Familienarchiv Spada zum römischen Barock. 1 Folge', *Römisches Jahrbuch für Kunstgeschichte*, XVIII, 1979, pp. 227–46; '2 Folge', *ibid.*, XIX, 1981, pp. 179–210.

35. For these later statues see Frederick den Broeder, 'The Lateran Apostles. The Major Sculpture Commission in eighteenth-century Rome', *Apollo*, LXXXV, 1967, pp. 360–65; Michael Conforti, *The Lateran Apostles*, Harvard University thesis, 1977 (unpublished); idem, 'Planning the Lateran Apostles', in *Studies in Italian Art and Architecture, 15th through 18th Centuries*, ed. Henry Millon, Cambridge (Mass.), 1980, pp. 243–55.

36. ASR, Arch. Spada Veralli, vol. 192, pp.

523–5 (2 June 1647).

37. He apparently wanted twelve in all, eight of one piece, and four of two blocks (Document I.6); it is not clear whether these numbers include the four blocks ordered from Bonanni.

38. See Document I.1.

39. For example, nine pairs of them were used to draw Francesco Mochi's *St Thaddeus* from Rome to Orvieto (*Francesco Mochi, 1580–1654*, 1981, cat. 24, p. 82).

40. C. Klapisch-Zuber, *op. cit.*, pp. 72–3.

41. Document I.6.

42. Document I.4; Malaspina also said that the blocks Spada wanted, and claimed to be of 20 *carrate*, would in fact be 40 as quarried, and over 30 even after rough-hewing (Document I.5).

43. When the project for Nicolò Menghini to make the statue of Urban VIII for Pesaro was under discussion, it was stated on 30 October 1646 not only that 'la statua sarà di tre pezzi e così nel prezzo del sasso si dovrà guadagnare', but also that it 'dovrà esser vota dentro e così si potrà condurre su i carri per terra' (Antonio Brancati, *Una Statua un busto e una fontana di Lorenzo Ottoni*, Pesaro, 1981, p. 109 note 36), implying that this would be cheaper than sending it by sea.

44. Document I.6. One might have expected him to quote prices of 20 and 40 *scudi*. We may note that this does not appear to work in reverse, and when Malaspina is apparently suggesting that the blocks might be divided in two, he quotes precisely half the price (Document I.6). When G. M. Frugone was offering to supply marble for making the Lateran *Apostles* (see above, note 30), and he raised the possibility that the marble might be ordered in two blocks, he offered them at 2500 *scudi* (instead of 2800 for single blocks), explaining that 'benche siano di minor peso, e misura nulladimeno vi và fatta doppia manipolazione oltre che quando si metteranno in opera puol'accadere di scagliare qualche panno quando s'uniscono li due pezzi assieme per qualsivoglia diligenza possibile' (E. J. Olszewski, *loc. cit.*, article 9); Frugone was offering not only to supply the marble, but also to set up the finished statues, and this article provides interesting evidence that, if a statue were carved from two large blocks, they would not be fixed together until the statue was set up.

45. K. Güthlein, *op. cit.*, 1979, pp. 227–8; see also J. Montagu, *Alessandro Algardi*, 1985, pp. 116–17.

46. On this commission, see Irving Lavin, *Bernini and the Crossing of Saint Peter's*, New York, 1968.

47. F. Baldinucci, *Vita di Gian Lorenzo Bernini*, p. 156.

48. On this statue see Maddalena De Luca Savelli, in *Francesco Mochi, 1580–1654*, 1981, pp. 75–6, with earlier bibliography. On the marble, see the statement of G. B. Pollina, Document I.6.

49. New York Metropolitan Museum of Art, Harry G. Sperling Fund, 1973.265; see J. Montagu, 'Disegni, Bozzetti, Legnetti and Modelli . . .', p. 11.

50. O. Pollak, *op. cit.*, p. 451, doc. 1754.

51. Such risks are very real; nor were they the only hazards to which a statue might be exposed. On 28 February 1657 Andrea Ghislandi wrote from Bologna to the Spada to say that he had seen a man climbing up the Executioner in Algardi's group of *The Beheading of St Paul* in their family chapel to light some lamps fixed above it, and on the last three days of carnival the sacristan had hung the altar 'with a thousand fripperies' ('*mille frascherie*') which not only encumbered the altar and hid the statues almost entirely, but involved further climbing on the statues to light lamps and pull some cloth over the figures from behind, which the workmen proceeded to fix in place with nails driven into the joints in the statues (ASR, Arch. Spada Veralli, vol. 490, unpaginated). The sacristan, a man described as '*capriccioso et ostinato*', was one of those all too familiar today, who 'si prenda piacere in coprire l'altare con mille frascherie nelle occasioni di maggior concorso quando più dovrebe esser esposta la sua belezza, ne è possibile persuaderlo al contrario' (*loc. cit.*).

52. O. Pollak, *loc. cit.* That dust was considered a problem is confirmed by the estimate that Nicolas Cordier, Ambrogio Bonvicino and Camillo Mariani made in December 1610 of Pietro Bernini's *Assumption* for Sta Maria Maggiore, qualifying their evaluation with the comment that 'esso signor Pietro Bernino la debbia allustrare con diligentia acciò che la polvere con il tempo non la innegrisca e non se gli attachi sopra' (S. Pressouyre, *op. cit.*, doc. 205, pp. 298–9).

53. Lione Pascoli, *Vite de' pittori, scultori ed architetti moderni*, Rome, 1730, II, p. 416.

54. J. Montagu, *Alessandro Algardi*, 1985, pp. 358–60, cat. 61.

55. On this prehistory of the altar see J. Montagu, *op. cit.*, p. 138, with the relevant notes.

56. As Virgilio Spada wrote in a report on the decoration of St Peter's, '. . . havendo Sua Santità avvertito, che i quadri delle Capelle, e sopraporti non solo di pitture, mà uno anco fatto di musaichi di marmo non po[sso]nno resistere al freddo, et humido di quel gran vaso, pensò di far prova di far fare un Quadro di basso rilievo . . .' (A.S.V., Arch. Spada Veralli, vol. 186, p. 38; see K. Güthlein, *op. cit.*, 1979, p. 186; cf. J. Montagu, *op. cit.*, p. 256, note 9).

57. J. Montagu, *op. cit.*, cat. 61.B.1, p. 360.

58. *Ibid.* cat. 61.B.5, pp. 361–2. The contract of 10 May 1733 for the monks of Monte Cassino for Antonio Montauti's statue of *St Benedict* in the Vatican, for which he had already presented a small model, specifies that before he starts to carve the marble a full-size model was to be set up in the niche 'à publica vista per qualche spazio di tempo, che i[l] d[etto] Padre Priore Generale piacerà' (David L. Bershad, 'The Contract for Antonio Montauti's St Benedict in St Peter's, Vatican', *Antologia di belle arti*, N.S. XXIII/XXIV, 1984, pp. 76–9; the author is in error in stating that the model was to remain in the niche till the marble

was finished). Unusually, this contract spells out the reason: 'affinche possa coreggersi, se vi fosse qualche errore o difetto' (ASR, Not. A.C., Salvator Paparotius, 5211, p. 370). Similarly, in the contract of 16 September 1734 for Giovanni Battista Maini's statue of *St Philip Neri*, also for St Peter's, even though the small-scale model was to be made in a wooden niche, the full-size model was to be set up in its niche in the nave 'con il suo steccato, e ponte per poter operare intorno a d[ett]o modello', and it was laid down that the representatives of the Oratory who commissioned the statue could 'far mutare il med[esi]mo [modello] in qualche parte, che non sara di suo compiacim[en]to' at Maini's expense (ASR, Congregazione dell'Oratorio, Busta 160, int. 16).

59. ASR, Not. Trib. A.C. J. Belletus, vol. 801, f. 257v, 27 November 1676. The contracts for the reliefs for S. Agnese by Giuseppe Perone and Ercole Ferrata include the same stipulations (ASR, Not. Trib. A.C. Simoncellus, vol. 6677, ff. 373r–v, 419, and 374–375v, 417). In the mid-1630s, when draft contracts were being drawn up for Algardi's *Beheading of St Paul*, Virgilio Spada added to the clause demanding that Algardi produce models (it is not spelt out that these should be both large and small, but this is highly probable), the phrase 'et detti modelli finita l'opera, rimanghino ad esso Padre Virgilio' (J. Montagu, *op. cit.*, p. 370).

60. 'Fatti dunque i soliti modelli, e in piccolo, e in grande . . .' (L. Pascoli, *op. cit.*, II, p. 470) These were for two statues to go on an unidentified altar, somewhere in the country.

61. The contract of 10 May 1613 is transcribed in Maria Cristina Dorati, 'Gli Scultori della Cappella Paolina di Santa Maria Maggiore', *Commentari*, XVIII, 1967, doc. 153, p. 255.

62. See Elena Bianca Di Gioia, in *Archeologia nel Centro Storico* (exhibition catalogue), Rome, 1986, cat. 16, pp. 195–200.

63. Scales were also required on the much more simplified models sent to the quarries, see above, note 30.

64. See the contract of 19 August 1626, in Simonetta Lo Vullo Bianchi, 'Note e documenti su Pietro e Ferdinando Tacca', *Rivista d'arte*, ser. II, anno III, XIII, 1931, p. 204.

65. R. Lanciani, *op. cit.*, IV, p. 153.

66. See above, note 59. Possibly this was the marble already ordered for Algardi's projected altarpiece, though it is not clear whether this was actually delivered (see J. Montagu, *Alessandro Algardi*, cat. 45.L.B.1, pp. 351–2).

67. Olivier Michel, 'L'Accademia', in *Le Palais Farnèse*, Rome, 1981, I, 2, pp. 572, 577; the Jesuits deducted De Rossi's rent from his pay. Algardi, who was given space in the Vatican foundry to carve his excessively large relief of *Leo and Attila*, apparently remained there even after the work had been finished, for the inventory of his possessions taken after his death includes works in his studio there (J. Montagu, *op. cit.* p. 234).

68. In 1728 Agostino Cornacchini, as 'Scultore di S. Pietro', had the right to the 'studio di S. Pietro à S. Marta molto lontano della d[etta] abitazione' which was at the 'casino detto di Carlo Maratta'; his father-in-law therefore requested that he be put in charge of the Barberini's marble store (see above, note 15), with which went a studio near where he lived, so that he could work there on his statue of *St John Nepomuk* (BAV, Arch. Barb., Indice II, 2449).

69. On 23–28 March 1665 a payment was made 'Ad Antonio Bruschetto Caporale di facchini di dogana scudi dieci in quali per haver portato con la sua compagnia il modello del Basso rilievo di Santa Cecilia in n[umer]o 5 pezzi dalla Fabbrica a casa del Signor Antonio Raggi scultore ...' (ADP, Scaf. 94, no. 13, transcribed in Robert Westin, 'Antonio Raggi's *Death of St Cecilia*', *Art Bulletin*, LVI, 1974, p. 429; the transcription is corrected in his Ph.D. thesis of 1978, *Antonio Raggi: A Documentary and Stylistic Investigation of His Life, Work and Significance in Seventeenth-Century Roman Baroque Sculpture*, Ann Arbor, 1978, p. 254); we may note that both the large and small models of this relief were to remain the property of Prince Pamphilj. Of the model for François du Quesnoy's statue of *St Andrew* Bellori records that 'avvenne che nel trasportarsi poi il modello alla fonderia dove si sogliono lavorare le statue per la fabbrica vaticana, mancando sotto le macchine precipitò e ruinosse tutto in pezzi' (Giovan Pietro Bellori *Le Vite de' pittori, scultori e architetti moderni*, ed. Evelina Borea, Turin, 1976, p. 292). Giovanni Martino Frugone, in his efforts to obtain the commission to supply the marble for the Lateran *Apostles*, offered to transport the models from the niches of the nave to the sculptors' studios (see above, note 30, article XVI; Olsewski is mistaken in stating on p. 665 that Frugone offered also to take the models to the Lateran). In the contract of 1734 for Giovanni Battista Maini's statue of *St Philip Neri* for St Peter's, where it was assumed that he would work on the fullscale model in the church (see above, note 58), it was specified that when this was finished Maini should 'farlo calare, e portare allo studio di esso Signor Giovanni Battista Maijni ben custodita', and that subsequently he should produce the marble (ASR, Congregazione dell'Oratorio, Busta 160, int. 16).

70. Charles Cheyne had been in Italy, as transpires from this correpondence.

71. These letters, forming only one side of the correspondence, are in the Bridgewater Collection, forming part of the Ellesmere Collection now in the Huntington Library (EL 11121–11140); I am grateful to the staff of that library for facilitating my consultation of the originals, and to S. R. Letman for telling me of their present location. The most essential parts were published by Randall R. H. Davies in *Chelsea Old Church*, London, 1904, pp. 58–65; it will be seen that my transcriptions differ from his, not only in the spelling and punctuation, which he modernised, but occasionally in the

reading.

72. EL 11121; Davies, *op. cit.*, p.58.

73. EL 11123; Davies, *op. cit.*, p. 58.

74. Most of the little that is known about Edward Altham comes from two article by 'a Descendant': 'Some Althams of Mark Hall in the Seventeenth Century' *The Essex Review*, XVII, 1908, pp. 74–87, and XVIII, 1909, pp. 91–100 (kindly shown to me by Alastair Laing). He was the son of Sir Edward Altham and Joan Leventhorpe; his date of birth, 1622, was found by Geneviève Michel, and he graduated from St Catharine's college, Cambridge, in 1643–4 (*Alumni Cantabrigienses*, compiled by John Venn and J. A. Venn, part I, vol. I, Cambridge, 1922, p. 25). He arrived at Rome in the company of his cousin Jerome Bankes by 1650, and was received into the Catholic church by 1652; he died there in February 1694. The fascinating painting by Salvator Rosa of him as a hermit demonstrates both his familiarity with artistic circles in Rome, and his extreme, indeed exaggerated, Catholic piety (at Kingston Lacy, no. 70 of the list of paintings in the National Trust booklet, from which the above information is taken; recently there has been an attempt to identify the sitter as Sir James Altham, but Alastair Lang assures me that the early inventories identify the sitter as Edward Altham).

75. EL 11124; Davies, *op. cit.*, pp. 58–60. Almost invariably Altham uses the double dating, due to the difference of ten days between the Roman and English calendars.

76. Letter of 1/11 April 1671, EL 11125; Davies, *op. cit.*, p. 61.

77. In his letter of 9/19 March 1672 (EL 11134) Altham, recapitulating this episode, writes that the monument was 25 'palmes' high, and the space for it 22; he adds that Cheyne had ordered 'the first Modell to be followed without altering aught, which you desired to be dispatched with all possible expedition'.

78. The Roman *palmo* at that time equalled 22.3 centimetres, the English foot 30.48 cm. It should be noted that the Genoese *palmo* was of a different length, a matter of some consequence if marble was to be ordered from the quarries there, and that even within Rome the architect's *palmo* was of a different length to that of the cloth merchant.

79. EL 11125; Davies, *op. cit.*, pp. 60–61.

80. The 'crowne' was the unit of currency more usually called a *scudo*; the 'pistol' was a term for various foreign coins, ranging from 16s 6d to 18s, but a reference in 1678 values it at 17s 6d (J. Murray, *New English Dictionary*, VII, Oxford, 1909, p. 908). Altham's habit of mixing currencies makes it very difficult to interpret the costs involved. He had stated previously, in his letter of 11/21 March 1671, that 355 crownes, of 10 giulios to the crowne, was currently worth 100 pounds sterling.

81. EL 11126; Davies *op. cit.*, pp. 61–2.

82. Letter of 17/27 June 1671, EL 11127; Davies, *op. cit.*, pp. 62–3.

83. Letter of 8 August 1671, EL 11137; Davies, *op. cit.*, p. 63.

84. EL 11129

85. EL 11134.

86. This is the date on the bill of lading.

87. Letter of 9/19 March, EL 11134.

88. Letter of 27 August 1672, EL 11135; Davies, *op. cit.*, pp. 64–5. In truth, while it might already have been too late to alter the design, Altham (who had always referred to the 'Chancell') had included in his letter of 1/11 April a request 'to expresse to mee the grandeur of the Chancell where the monument is to stand and whether there are more windowes than one in it, and how placed, and what doores there are whether South or North: I suppose the Chancell stands East'; this should have alerted Cheyne to Altham's belief that the tomb was to stand, presumably, behind the altar, in the east end of the church, whereas it is actually against the north wall of the church.

89. Letter of 8 August, 'style loco' (1671), EL 1137.

90. Even when Altham suggested adding Lady Jane's crown in England, we may assume that this would have been made of gilt metal.

91. Letter of 9/19 October 1671, EL 11139.

92. M. C. Dorati, *op. cit.*, doc. 89, p. 248.

93. G. M. De Luca Savelli, *op. cit.*, p. 82, cat. 24, and p. 135 (15 October 1644).

94. *Ibid.*, cat. 81, pp. 80–82. The struts run from the raised right hand to the shoulder and from the index finger to the third finger of the right hand, and from the hilt of the sword to the quillon.

95. S. Pressouyre, *op. cit.*, cat. 5, p. 379.

96. *Ibid.*, cat. 4, p. 377; for many years now this statue has been out of its niche, in the middle of the chapel, the completion of the restoration of the chapel evidently proving as difficult to finance as its original construction.

97. Letter of 11/21 March 1671.

98. ASR, Arch. Spada Veralli, vol. 192, p. 423 (see K. Güthlein, *op. cit.*, 1981, p. 188): '... che non patiscie le macchie ne sinsudicia come il bianco et anco ... non lascia conoscere le inbrattature, ne anche se qualche cagnolo saccosta à far acqua non resta macchiato come resta il bianco ma quello che più inporta fù per far pianta e nascimento uniforme alli baldigli delli Tabernacoli che viene haver invito e principio dal pavimento tutto uniforme e resta l'opera soda che non pare riportata ma nata insieme con il tutto e cosi detto baldiglio ricorre e recingie tutte le cinque nave ...'.

CHAPTER III

1. This admiration was tempered by distrust, at least on the part of Sublet de Noyers, who wrote from Paris on 26 November 1642 to Paul Fréart de Chantelou about the Roman founders that 'lon dit que les foundeurs sculpteurs [he clearly meant bronze founders] sont fourbes et trompeurs mais vous scaurés bien le choisir et vous précautionner contre leurs artifices' (Charles Jouanny, *Correspondence de Nicolas Poussin*, Archives de l'art français, Nouv.

Pér. 5, Paris, 1911, p. 186).

2. On Giovanni Antonio Lorenzani (the spelling of the name was inconsistent) see Giorgio Morelli, 'Appunti bio-bibliografici su Gaspar e Luigi Vanvitelli', *Archivio della Società Romana di Storia Patria*, XCII (ser. III, XXIII), 1969, pp. 117–136; idem, 'Giovanni Andrea Lorenzani artista e letterato romano del Seicento', *Studi secenteschi*, XIII, 1972, pp. 193–251. On his collection, see his inventory, Arch. Capitolino, Not. del Borgo Domenico Angelo Seri, 24 May 1710.

3. See below, note 56.

4. See Gaetano Moroni, *Dizionario di erudizione storico-ecclesiastico*, LXXVII, Venice, 1856, pp. 289–300 for the bells of Sta Maria Maggiore cast by Giovanni Lucenti in 1845, and again in 1852; whether or not Giovanni was a descendant of the same family, has not been firmly established by archival evidence.

5. A typical example is Giovanni Pietro del Duca, who was a brass-worker as well as a bronze-founder, and as such was employed by the Borghese between 1632 and 1653, not only to complete the casting of the ornamental support for a jasper table (J. Montagu, 'Alessandro Algardi and the "Borghese Table"', *Antologia di belle arte*, I, 4, 1977, pp. 311–28; idem, *Alessandro Algardi*, 1985, cat. 208, pp. 459–60), but also for taps etc. for the plumbing of fountains, and the casting of bells; during the same period, in 1649, together with Sebastiano Sebastiani, he was commissioned to cast the *Athlete with a Discus*, the *Orator*, and a *Faun*, or *Pan* for Philip IV of Spain (see Document II). Nor did he work only in metal, for on 10 September 1648 he was paid 25.20 *scudi* for having made 'due forme di gesso dello scoglio et ornam[en]to della fonte, che si deve fare sotto la guglia in piazza navona', i.e. the rock beneath Bernini's *Four Rivers Fountain* (ASR, Camerale 1°, Giust. di Tesoreria, busta 106, int. 15, no. 271).

6. Giovanni Baglione, *Le Vite de' pittori scultori et architetti . . .*, Rome, 1642, pp. 324, 326.

7. *Ibid.*, p. 326.

8. A candlestick with the Strozzi arms was in Berlin until it was lost in 1945; no provenance is given, and its attribution to Florence, *c*.1600, seems to depend on nothing more than the arms of a Florentine family a branch of which was also established in Rome (Klaus Pechstein, *Staatliche Museen preussischer Kulturbesitz. Kataloge des Kunstgewerbemuseums Berlin, III: Bronzen und Plaketten*, Berlin, 1968, no. 94,269, p. 12). Another candlestick of similar form, with no arms, is in Chester Cathedral, and is said to come from a deconsecrated church in Milan.

9. *Tesori d'arte sacra* (exhibition catalogue), Rome, 1975, cat. 241, p. 105, and pl. CXII. This candlestick is said to come from S. Andrea della Valle.

10. The Strozzi candlestick, but neither of the others, is mentioned in *Guide rionali di Roma, Rione VIII – S. Eustachio*, part 1, Rome, 1977, p. 80. The Strozzi candlestick, with details, was drawn in the so-called 'Perrier Album' in the Louvre, RF

11. Arch. Cap., Credenza VI, vol. 29, pp. 370, 383; Giovanni Baglione, *op. cit.*, p. 325; Vasco Rocca, *SS. Trinità dei Pellegrini* (Le Chiese di Roma illustrate, 133), Rome, 1975, p. 94, note 91; *Guide rionali di Roma, Rione VII–Regole*, parte 1, Rome, 1980, p. 30.

12. *Tesori d'arte sacra*, 1975, cat. 242, p. 105, and pl. CXII.

13. These drawings are catalogued by John Pope-Hennessy, *The Drawings by Domenichino in the Collection of His Majesty the King at Windsor Castle*, London, 1948, cats. 1730–1732 (inv. 1565–7).

14. See the inventory of Giovanni Andrea Lorenzani, of 24 May 1710, which included 'divese modelli di vasi, et altra tutto di legno', 'diverse stampe di legno di piedi di croce, balaustri, corpi di vasi, campane, et altro', and 'diversi modelli, piccoli, e grandi in fogliamelli fioretti di vasetti . . .' (see above, note 2).

15. Giuseppe Giorgetti modelled figures of Sts. Peter, Paul and Clement, and a Virgin for the bell which Giacomo Pucci cast in 1672 for the Cathedral of Velletri (J. Montagu, 'Antonio and Giuseppe Giorgetti', *Art Bulletin*, 1970, p. 292).

16. London, Victoria and Albert Museum, inv. A.2–1974.

17. ASR, Camerale 1°, Fabbriche, busta 1528, Libro Mastro delle Fabbriche di N. S^r . . . , 1585–1590, f. 87 right (payment of 1590).

18. ASR, Camerale 1°, Fabbriche, busta 1537, Mandati 1609–14, passim; Camerale 1°, Giust. di Tesoreria, busta 37, int. 2, submitted 1612.

19. See Ernst Kris 'Der Stil "rustique"', *Jahrbuch der Kunsthistorischen Sammlungen in Wien*, N.F. I, 1926, pp. 137–208; Norberto Gramaccini, 'Das genaue Abbild der Natur – Riccios Tiere und die Theorie des Naturabgusses seit Cennino Cennini', in *Natur und Antike in der Renaissance* (exhibition catalogue), Frankfurt am Main, 1985, pp. 198–225.

20. On the *Baldacchino* and its casting, see W. Chandler Kirwin and Philipp Fehl, 'Bernini's *Decoro*: Some Preliminary Observations on the Baldachin and on his Tombs in St Peter's', *Studies in Iconography*, VII–VIII, 1981–2, pp. 323–69.

21. See BAV, MS. Chigi H.II.22, esp. f. 49r.

22. W. C. Kirwin and P. Fehl, *op. cit.*, pp. 330–31. This is an adaptation of the term 'lost beetle process' that is used to describe the Alcan gold weights.

23. However, the 1704 inventory after the death of Carlo Barberini included 'due vasi di legno . . . color di rame, modelli delli due vasi d'argento, che sono al Palazzo delle quattro fontane', and 'un focone di legno finto rame . . . , modello del focone d'argento che stà alle quattro fontane' (BAV, Arch. Barb., Indice II, vol. 2454, f. 179v). Although they were in the casino at S. Cosimato, rather than the main palace, their preservation suggests that they were of some artistic form; but possibly the silver was not cast, as *repoussé*, in which case the use of a wooden model would have been the standard technique.

24. See Lorenz Seelig, *Studien zu Martin van*

den Bogaert gen. Desjardins (1636–94), Hamburg, 1980, cat. LXIV/15, pp. 531–2; François Souchal, *French Sculptors of the 17th and 18th centuries. The Reign of Louis XIV*, I, Oxford, 1977, cat. 47b, pp. 258–9.

25. The best general guide to the processes of founding is Marie-Thérèse Baudry and Dominique Bozo, *La sculpture: méthode et vocabulaire*, Paris, 1978, pp. 239–74, 286–96. Accounts of renaissance practice are given in Giorgio Vasari's introduction to his *Vite* (see Louisa S. Maclehose, *Vasari on Technique*, ed. of New York, 1960, pp. 158–166), in Cellini's *Due Trattati . . .* (see Charles R. Ashbee, *The Treatises of Benvenuto Cellini on Goldsmithing and Sculpture*, ed. of New York, 1967, pp. 111–133), and in Vannoccio Biringuccio *Pirotechnia*, 1540 (see the translation by C. S. Smith and M. T. Gnudi, *The Pirotechnia of Vannoccio Biringuccio*, Cambridge (Mass.)/London, 1966, first published 1942).

26. Pietro Tacca 'inventò . . . non più usate composizioni per far le forme per gettare il metallo', and such was his expertise that, when he was in Rome in 1625, he gave advice to Bernini for the casting of the *Baldacchino* (Filippo Baldinucci, *Notizie dei professori del disegno da Cimabue in qua*, ed. F. Ranalli, Florence, IV, 1846, p. 98); see also W. C. Kirwin and P. Fehl, *op. cit.*, p. 326.

27. W. C. Kirwin and P. Fehl, *op. cit.*, p. 329; as Chandler Kirwin pointed out to me, a similar technique was used by Cellini for his bust of Cosimo I in the Museo Nazionale in Florence.

28. Philipp Fehl interprets the use of the iron bar differently (W. C. Kirwin and P. Fehl, *op. cit.*, p. 353).

29. 'Per haver fatto far il getto di bronzo di d[ett]a statua tutto con suo ord[in]e, invent[ion]e, modo, et assistenza attuale' (BAV, Arch. Barb., Indice IV, 1615, int. 73, f. 166; the whole document is transcribed in Giovanni Morello, 'Documenti berniniani', in *Bernini in Vaticano*, exhibition catalogue, Rome, 1982, p. 317). So far as I am aware, this was not a normal method among Roman founders, though bricks were also used in making the core of the architrave above the columns of the *Baldacchino*.

30. Cellini's use of additional tin, in the form of plates and dishes from his household, hurled into the furnace when the molten metal caked, is vividly recorded in his autobiography, chapter LXXVII (*The Life of Benvenuto Cellini Written by Himself*, ed. John Pope-Hennessy, Oxford/New York, 1949, p. 367); see also the following note.

31. Somigli has made the attractive suggestion that the old bronze Cellini used for casting the *Perseus* (together with new brass and tin) was left over from that which he had formerly lent to Zanobi di Pagnio to cast a bust of Duke Cosimo, and therefore he was unaware of how much tin was left in it; he also suggests that some of the tin supplied to Cellini might have been illicitly disposed of (Guglielmo Somigli, *Notizie storiche sulla fusione del Perseo*, Milan, 1958).

32. Ridolfo Lanciani, *Storia degli scavi di Roma*, Rome, IV, 1912, p. 154; the metal was

described as 'quei bronzi che non servono a nulla'. These statues were cast by Sebastiano Torrigiani, from models by Tommaso della Porta and Leonardo Sormani (see Cesare D'Onofrio, *Gli Obelischi di Roma*, Rome, 1965, pp. 200, 202). For the Altar of the Sacrament in the Lateran in 1599 Orazio Censore made use of bronze from the doors of the Pantheon, as well as a 'pezzo di artiglieria rotto da servire per l'architrave et capitelli delle colonne' (*ibid.*, p. 193).

33. Occasionally, the same mould might be used, with minor modifications, to make a new figure; so, when on 19 January 1712 the Neapolitan sculptor Domenico Antonio Vaccaro was commissioned to produce a clay bust of St Antimo we read 'servata la forma della figura di S. Francesco Xaverio ... e solamente dovrà mutare il modo di gestire' (Gian Giotto Borrelli, 'Domenico Antonio Vaccaro autore di modelli per argenti', *Antologia di belle arti*, N.S. 21–22, 1984, p. 127); Borrelli interprets this document differently, assuming that the 'forma' probably refers to a devotional engraving. We may note that Vaccaro was to provide two 'cavi in cera' (by which were apparently meant casts) from his model, one for the casting of the silver statue, while the other was to 'restare in potere delli med[esi]mi [Deputati], per riscontrare se la statua viene fatta in conformità del modello seu cavo' (*loc. cit.*).

34. See, for example, the inventories of Giovanni Battista Malpighi of 30 July 1631 (ASR, Not. Trib. A.C., Fonthia, vol. 3200, insert after f. 828ff), and of Elpidio Benedetti of December 1690 (ASR, 30 Not. Cap., Uff. 30, T. Octavianus, vol. 305, ff. 518–527v, 530–538).

35. The account of 10 July 1675 of Antonio Pellicani for the silver Ciborium for S. Lorenzo in Damaso included 25 *scudi* paid on 6 March 'al gettatore, che hà formato in creta le figure de SS.^{ti} Lorenzo e Damaso, e fattoci diversi cavi con haverci formate due figure in cera delli detti santi ...' (BAV, Arch. Barb., Card. Francesco Barberini Sr, Giust. 11789–11852, no. 11834, f. 201).

36. Some time before his death in 1658, the silversmith Tomasso Ilari gave a bronze statue of two figures, representing the *Rape of a Sabine*, about 67 centimetres high, to 'Antonio Neri ottonaro per rifinirla di polire', and had paid him for doing so (ASR, 30 Not. Cap., Uff. 32, vol 178, f. 45r).

37. The account of this trial was published by Antonino Bertolotti, *Artisti lombardi a Roma*, Milan, 1881, II, pp. 119–161.

38. J. Montagu, 'Un Dono del Cardinale Francesco Barberini al Re di Spagna', *Arte illustrata*, IV, 43/44, 1971, pp. 42–51.

39. When on 3 August 1662 Michele Sprinati (1613–65) submitted his account for the making of a silver version of the *Nativity*, probably from a composition by Antonio Giorgetti, he had to pay the founder for making two wax casts, again because the first was too thick (BAV, Arch. Barb., Card. Francesco Barberini Sr, Giust. 6789–8879, no. 8827, f. 124r; see also J.

Montagu, 'Antonio and Giuseppe Giorgetti', *Art Bulletin*, 1970, pp. 297–8). Francesca Bewer has pointed out to me that silver casts are normally thinner than those of bronze, which may explain the mistake made by the founder, more accustomed to working in bronze.

40. It remains possible, and to my mind highly probable, that a sculptor was involved, even though neither the documents, nor the guidebooks, record his name.

41. See the inventories of the brass-worker Bartolomeo Simonini, of 24 May 1636, which included 'diversi modelli di legno, e di piombo' (ASR, 30 Not. Cap., Uff. 31, S. Spada, vol. 146, ff. 190–191v, f. 191v); that of the silversmith Francesco Spagna of 15 October 1640, included 'undici stampe di metallo di piedestalli da candelieri d'altare tra grandi, e piccole ...' (ASR, Not. Trib A.C., vol. 3173, f. 923v). See also note 14 above.

42. On 13 February 1661 Marco Gamberucci submitted an account for having made for Alexander VII 'una pannattiera d'arg[en]to dorata ottangola con quattro putti sotto e dui Ianne per salierine', in which he claimed for ninety *baiocchi* 'pag[a]to all'intagliatore per haver intagliato li monti per ciascheduno cantonata, et una stella grande in mezzo con suoi profili' and two *scudi* 'pag[a]to allo scultore per li modelli de putti e salierine' (ASR, Cam. 1°, Giust. di Tes., vol. 144, int. 4). The mountains and stars formed part of the arms of the pope, Flavio Chigi.

43. Giovan Pietro Bellori, *Le Vite de' pittori scultori e architetti moderni*, ed. Evelina Borea, Turin, 1976, p. 402. We know of figures to decorate silver made, presumably, by du Quesnoy, from a letter Fulvio Testi wrote on 3 December 1633 to the Duke of Modena, in which he boasted that 'i miei Vasi' would be more beautiful than the Duke's cross and candlesticks; 'i modelli di quelle figurine che vanno gettate sono fatte per mano d'un Fiamingo, che, trattone il Cav.^r Bernino, è il primo statuario che oggidi sia al Mondo' (Stanislao Fraschetti, *Il Bernini*, Milan, 1900, p. 75, note 3). But it is not clear whether these were commissioned by the silversmith, or by the patron, like the 'vari ornamenti per uso della casa' commissioned from du Quesnoy by Filippo Colonna (G. P. Bellori, *op. cit.*, pp. 288–9).

44. BAV, Arch. Barb., Card. Francesco Barberini Sr, Giust. 7893–7999, no. 7904, f. 39; see J. Montagu, *op. cit.*, p. 280.

45. J. Montagu, *op. cit.*, p. 283. Marc Worsdale has pointed out that swags had previously been planned, presumably in some more perishable material, as is proved by the unpublished 'Misura, e stima di diversi lavori d'intaglio tanto nell'arme della fel. mem. di Papa Urbano VIII, tanto nel piedestallo ...' which he showed me: 'E più per l'intaglio di 2. cartocci grandi di pietra gialla, e negra, gli fanno contorno e fini[men]to dalli dui terzi dell'arme in sù, di dove hanno principio li 2. festoni, che calano abasso ...' (BAV, Arch. Barb., Indice IV, 1615, int. 51, f. 137).

46. '... et havendo pagato scudi venti allo

scultore, et intagliatore per il modello di d[ett]o martello' (ASR, Cam. 1°, Giust di Tesoreria, busta 107, int. 10). Pellicani in fact received only seventy-five *scudi*.

47. J. Montagu, *Alessandro Algardi*, New Haven/London, 1985, cat. 92, pp. 387–8. See also the bronzes for the tabernacle in Savona, for which the stone-merchant Santi Ghetti, who was to produce the tabernacle, signed the contract with Giovanni Piloti for the bronzes, and it was presumably left to Piloti to subcontract for the models with Algardi, who had been designated as the sculptor to provide the models by the original contact between the Jesuits who commissioned the tabernacle and Santi Ghetti (*ibid.*, cat. 97, pp. 391–2).

48. 'Per il modello che lui fa della Santiss.^{ma} vergine ...' (ASR, Camerale 1°, Fabbriche, Mandati, Busta 1537, ff. 251v [23 August 1613], 255r [14 September 1613]).

49. '... l'appalto che ha preso di fare la statua di metallo della Santma Vergine ...' (*ibid.*, 252v [14 September 1613], 257r [27 September 1613]).

50. Sylvia Pressouyre, *Nicolas Cordier*, Rome, 1984, doc. 69, pp. 256–8. This statue is described under cat. 18, pp. 401–405.

51. *Ibid.*, doc. 96, p. 266. The bronze was bought from Marcello Menaccio, who is probably identical with the Marcello Manachi who was to work with Mochi in Piacenza (see below, note 73).

52. *Ibid.*, doc. 127, p. 276, and p. 277, note 9.

53. *Ibid.*, doc. 162, p. 289.

54. It is said that he 'modellava per cagione di gettar le figurine d'argento' (Giovanni Battista Passeri, *Die Künstlerbiographien*, ed. Jacob Hess, Leipzig, 1934, p. 315). The acount he submitted on 26 April 1657 for the copper ornaments of the 'carrozza di campagna' for the Vatican Palace included an item 'per haver fatto quattro vasi in sei angoli per la sud[ett]a carrozza fatto il suo modello, e il cavo gettati di cera, e di rame per fattura, e cisellato lì sud[ett]i quattro vasi scudi sei e baiochi 50. l'uno' (ASR, Camerale 1°, Giust. di Tesoreria, busta 118).

55. On the arch of Gregory XV of 17 April 1621, see Gian Ludovico Masetti Zannini, 'I Pontefici in Campidoglio', *Capitolium*, XLI, 1966, 6, p. v; Maurizio Fagiolo Dell'Arco and Silvia Carandini, *L'Effimero barocco*, I, Rome, 1977, p. 43. For that of Innocent X of 23 November 1644, see *ibid.*, pp. 131–3, and the documents in Arch. Capitolino, Credenza VI, no. 38, ff. 36r–37v, and Credenza IV, no. 112, ff. 170r–171r. He was also involved in the construction of the catafalque of Carlo Barberini, for which see Arch. Cap., Credenza VI, no. 30, pp. 484, 489.

56. See Mark S. Weil, *The Decoration of the Ponte S. Angelo*, University Park/London, 1974, pp. 144–5. The Florentine Bartolomeo Cennini was active both as a founder and a sculptor, indeed Bernini originally employed this disciple of Pietro Tacca to assist him on the casting of the *Baldacchino* (F. Baldinucci, *op. cit.*, IV, pp. 98–9).

57. See Cesare D'Onofrio, *Roma vista da Roma*, Rome, 1967, pp. 130–8. The date of his

58. O. Pollak, *Die Kunsttätigkeit unter Urban VIII*, II, Vienna, 1931, pp. 213–4, 491, 493, 495, 505–6 docs. 647–50, 1965–6, 1971–7, 1982–3, 2031–8.

59. AFP 1° piano, armadi, vol. 276, pp. 74, 173.

60. See Jörg Garms, *Quellen aus dem Archiv Doria-Pamphilj*, Rome/Vienna, 1972, 'Regesten', *passim*.

61. Enriqueta Harris, 'La Misión de Velázquez en Italia', *Archivo Español de arte*, XXXIII, 1960, pp. 117–19; see also Document II, note 1.

62. E. Harris, *op. cit.*, pp. 114–116; J. Montagu, *Alessandro Algardi*, cat. R.59, pp. 477–8.

63. On Guidi, see M. S. Weil, *op. cit.*, pp. 148–51.

64. On de Rossi see S. Pressouyre, *op. cit.*, pp. 96–9.

65. J. Montagu, *op. cit.*, cat. 65, pp. 365–6.

66. *Ibid.*, cats. 52, 53, pp. 356–7.

67. *Ibid.*, pp. 214–5.

68. Hannibal P. Scicluna, *The Church of St John in Valletta*, San Martin, 1955, p. 101, fig. 128.

69. I owe this reference from the Ottoboni archives, vol. 19, no. 37, 9 May 1690, to the kindness of Edward S. Olszewski. The terracotta model is in the Los Angeles County Museum, inv. 47.8.30.

70. J. Montagu, *op. cit.*, cat. 15.D.1, p. 327.

71. On Mochi, see the catalogue, '*regesto*' of documents and bibliography contributed by M. De Luca Savelli to the exhibition catalogue, *Francesco Mochi, 1580–1654*, 1981. Giambologna was born in 1529 and died in 1608.

72. Patrizio Patrizi, *Il Gigante. Note storiche aneddotiche e cronache*, Bologna, 1897, pp. 28–9.

73. The founder was Marcello Manachi, and the rupture occurred in 1614 (Arturo Pettorelli, *Francesco Mochi e i gruppi equestri farnesiani*, Piacenza, 1926, p. 30, and doc. IX, pp. 75–6).

74. *Francesco Mochi, 1580–1600*, cat. 17, p. 70.

75. 'Über alle die massen frech, stoltz undt superbe' (Osvald Sirén, *Nicodemus Tessin d.y:s studieresor*, Stockholm, 1914, p. 165).

76. J. Montagu, 'A Model by Francesco Mochi for the "Saint Veronica"', *Burlington Magazine*, CXXIV, 1982, pp. 430–7.

77. See above, p. 35.

78. G. B. Passeri, *op. cit.*, pp. 133–4; he argues that the word '*statua*' comes from the Latin verb '*sto*', '*stas*'; see, however, the comments of Lione Pascoli, *Vite de' pittori, scultori, ed architetti moderni*, Rome, II, 1736, p. 416.

79. See Sidney J. A. Churchill and Cyril G. E. Bunt, *The Goldsmiths of Italy*, London, 1926, pp. 9–10. It should, however, be remembered that a number of members of the guild were also founders (most notably Girolamo Lucenti and Francesco Perone), while Giacomo Laurentiani, although not a goldsmith, produced a book of designs for goldsmiths' work.

80. We may note that when Paolo Naldini was living with Count Orazio Ferretti at Perugia, 'capitato un bravo gettatore Oltramontano, il [the Count] prese pur in casa

per fargli gettare due statuette compagne a due antiche; e pregò Paolo a fargliene i modelli' (Leone Pascoli, *Vite de' pittori, scultori ed architetti moderni*, 1730, II, p. 463).

81. S. Pressouyre, *op. cit.*, cat. 19, pp. 405–410.

82. ASR, 30 Not. Cap., Uff. 1, A. Ricci, vol. 81, ff. 450–52, 461; S. Pressouyre, *op. cit.*, doc. 220, pp. 305–7.

83. S. Pressouyre has no doubt that it was the model that was sent to Recanati (*op. cit.*, p. 408).

84. J. Montagu, *op. cit.*, cat. 152, p. 428.

85. W. C. Kirwin and P. Fehl, *op. cit.*, p. 329.

86. G. B. Passeri, *op. cit.*, p. 202: literally, 'he was now learning that crosses were an honour for them'.

87. J. Montagu, *op. cit.*, cat. 69, pp. 372–3.

88. A similar example of the founder being paid by the sculptor, who was then repaid by the patron, was Algardi's bust of Innocent X for the memorial in the Trinità dei Pellegrini, where the sculptor's account included payments made to the founder, Ambrogio Lucenti (*ibid.*, cat. 155, pp. 430–31).

89. *Ibid.*, cat. 69.C.10, p. 374. The medallion has recently been moved for security reasons into the Museum of St Paul's Collegiate Church, Wignacourt College (see John Azzopardi, *The Museum of St Paul's Collegiate Church, Wignacourt College, Rabat, Malta*, Rabat, 1987, p. 13), and replaced in the grotto by a modern cast by Giuseppe Galea.

90. His accounts include the statement 'Il ritratto pesa 200 libre di bronzo e l'ho pagato à Giovanni Piscina [Giovanni Artusi] fonditore à conto di cinque giuli la libra con la forma e fattura di d[ett]o fonditore, che in tutto som[ma] – s. 100. Per rinettatura pulitura cisellatura indoratura della stola dove vi sono adoperati sei zecchini inporta – s. 50'; on 8 August 1667 he was paid 200 *scudi*, including fifty *scudi* 'per il modello, e fatiche' (BAV, Arch. Chigi, vol. 482: giustificazioni del giornale di Fabio Chigi, 1667; see Vincenzo Golzio, *Documenti artistici sul Seicento*, 1939, p. 302).

91. L. Pascoli, *op. cit.*, I, p. 257. See Rudolf Wittkower, 'Melchiorre Cafà's Bust of Alexander VII', *The Metropolitan Museum of Art Bulletin*, XVII, 8, 1959, pp. 197–204.

92. For the documentation of this work, see Oskar Pollak, *op. cit.*, pp. 306–421; for the history and aesthetics, see Irving Lavin, *Bernini and the Crossing of Saint Peter's*, New York, 1968; for the method of construction, see W. C. Kirwin, in W. C. Kirwin and P. Fehl, *op. cit.*, pp. 323–50.

93. O. Pollak, *op. cit.*, doc. 1132, pp. 345–6.

94. ASR, 30 Not. Cap., Uff. 38, P. Roverius, vol. 11, ff. 235–253v.

95. O. Pollak, *op. cit.*, doc 186, p. 333. Omitted by Pollak is a further receipt of 18 October 1625 from the younger Cordier, 'Io Nicolo Cordier Lorenese ho riceuti del Signore Cavalliero Bernini scudi sei per haver nettato intorno le colonne di cera nella fonderia a S. Pietro . . .' (ASF, 1° piano, serie 1, vol. 4, no. 9; printed in S. Pressouyre, *op. cit.*, doc. 299, p. 342).

Acording to a summary list of the costs of the *Baldacchino*, unspecified '*rinettatori*' were paid unspecified amounts for working on the columns (O. Pollak, *op. cit.*, doc. 1141, p. 348).

96. O. Pollak, *op. cit.*, docs. 1325, 1332, pp. 379–80, 381–3. It was made of beaten copper.

97. *Ibid.*, doc. 1532, p. 413; see also docs. 1548, 1556, 1564, etc., pp. 415, 416, etc.

98. *Ibid.*, doc. 1332, pp. 382–6.

CHAPTER IV

1. Some of the material from this chapter was published in 'Architects and Sculptors in Baroque Rome', *Bollettino del Centro Internazionale di Studi d'Architettura 'Andrea Palladio'*, XXIII, 1981, pp. 71–83; parts also appeared in 'Disegni, Bozzetti, Legnetti and Modelli in Roman Seicento Sculpture', *Entwurf und Ausführung in der europäischen Barockplastik*, Munich, 1986, pp. 9–30.

2. See Filippo Baldinucci, *Vocabolario toscano dell'arte del disegno*, Florence, 1681, p. 51.

3. Bernini is an obvious exception (see Heinrich Brauer and Rudolf Wittkower, *Die Zeichnungen des Gianlorenzo Bernini*, Berlin, 1931), and Algardi, though less expert, was none the less a competent draftsman to whom many drawings can be attributed (see J. Montagu, *Alessandro Algardi*, New Haven/London, 1985, pp. 478–86), but no drawings have been convincingly ascribed to François du Quesnoy, though he certainly made drawings, e.g. for Cassiano dal Pozzo's 'Museum cartacheum'. There are two drawings known by Nicolas Cordier (Sylvia Pressouyre, *Nicolas Cordier*, Rome, 1984, cats. 6 bis, 20 bis), although, as he probably produced paintings (*ibid.*, p. 433), it is likely that he made many more, and only one is known by Giuliano Finelli (Besançon, Musée des Beaux-Arts, D.1036; see Walter Vitzthum, *I Disegni dei maestri: il barocco a Roma*, Milan, 1971, fig. 28, and p. 91). The three ascribed to Domenico Guidi, (Edgar Wind, 'Shaftesbury as a Patron of Art, with a Letter by Closterman and Two Designs by Guidi', *Journal of the Warburg Institute*, II, 1938–39, pp. 185–8, and Frederick den Broeder, 'A Drawing by Domenico Guidi for a Monument to Innocent XII', *Burlington Magazine*, CXVII, 1975, pp. 110–113), look suspiciously like the work of Giuseppe Passeri, who is known to have copied Guidi sculptures (see Berlin, KdZ 18099), and Dr. Dieter Graf had kindly confirmed (orally) that, in his opinion, they are all the work of Passeri. The three drawings tentatively attributed to Ercole Ferrata by Wibiral (Norbert Wibiral, 'Die Agnes Reliefs für S. Agnese in Piazza Navona', *Römische historische Mitteilungen*, III, 1958/9, 1959/60, pp. 264–73) appear inconceivable before the late eighteenth century. A striking exception is Melchiorre Cafà, whose particular application to drawing, and the quality of its results, is noted by his biographer (Leone Pascoli, *Vite de' pittori,*

scultori, ed architetti moderni, Rome, 1730, I, p. 258), but only a few graphic works by him are known (see J. Montagu, 'The Graphic Work of Melchior Cafà', *Paragone Arte*, 413, 1984, pp. 50–61).

4. Irving Lavin's masterly study, *Bernini and the Unity of the Visual Arts*, Oxford/New York/London, 1980, concentrates on the aesthetic ideals of Bernini, the artist in charge, and has little to say about the way in which he directed the artists working under him.

5. An example of this is provided by the stuccoes made to Domenichino's designs for the Cappella della Strada Cupa in Sta Maria in Trastevere, where one can compare the relatively 'unsculptural' work of the professional *stuccatori* with the one splendidly volumetric and lively figure attributable to Algardi. See Richard E. Spear, 'The Cappella della Strada Cupa: A Forgotten Domenichino Chapel', *Burlington Magazine*, CXI, 1969, pp. 12–23; J. Montagu, *Alessandro Algardi*, 1985, cat. 195, p. 453.

6. Leone Pascoli, *op. cit.*, I, pp. 260–61.

7. See, for example, the relationship between Domenichino and Jacques Sarrazin (1588 or 1590–1660), as discussed by Richard E. Spear, *Domenichino*, New Haven/London, 1982, pp. 254–5, 267.

8. ASR, Congregazione dell'Oratorio, Busta 201, mandato 1648 no. 289.

9. Those who have written on this project name only Cosimo Fancelli and Ferrata, but a perusal of the *mandati* (ASR, Congregazione dell'Oratorio, Buste 201–206) show that several other sculptors were employed. During the first campaign of the cupola and tribune (1648–51), apart from Jacopantonio Fancelli, who shared Cosimo's payments in January and February 1649, Domenico de Rossi made six putti and one 'figura grande' for 74 *scudi*, and a certain 'Daniele Fiamingo' one of the putti in the window embrasures for 18 *scudi*; Ercole Ferrata made ten putti, three cherubim, and five 'figure grande' for a total of 310 *scudi*. Cosimo Fancelli's work is not specified, but presumably he did all the rest, for a total of 384.45 *scudi* (of which two payments of 15.75 *scudi* each were shared with his brother) plus a few *scudi*-worth of capons and fruit, etc. given to Fancelli and Ferrata. The stuccoes of the nave were paid for between January and December 1664, Fancelli receiving 210 *scudi*, Ferrata 90 *scudi*, and a certain Piscina (who is hardly likely to have been the bronze founder, Giovanni Artusi, who was also called by that name, but may have been a sculptor from the same town) received 32 *scudi*. After the work was completed, Pietro da Cortona complained that they and the stonemason should have received some further recognition for their efforts, and three *scudi* were given to the mason, and 1.50 each to the two *stuccatori* (Arch. Vallicella, C.I.8, p. 300).

10. A drawing after some of the stuccoes was sold by Sotheby's, 4 July 1977, 'Fine Old Master Drawings', lot 191, with an old ascription to Simon Vouet, which was repeated in the catalogue.

11. Giuliano Briganti, *Pietro da Cortona o della pittura barocca*, Florence, 1982, cat. 141, pp. 267–8.

12. See J. Montagu, *Alessandro Algardi*, p. 217. We may note that she is the only one of the four figures not represented as looking down.

13. See Hans Ost, 'Studien zu Pietro da Cortonas Umbau von S. Maria della Pace', *Römisches Jahrbuch für Kunstgeschichte*, XIII, 1971, pp. 231–85.

14. Anthony Blunt and Hereward L. Cooke, *Roman Drawings of the XVII and XVIII Centuries ... at Windsor Castle*, London, 1960, cat. 593.

15. See Richard Krautheimer and Roger B. S. Jones, 'The Diary of Alexander VII: Notes on Art, Artists and Buildings', *Römisches Jahrbuch für Kunstgeschichte*, XV, 1975, pp. 199–225; Giovanni Morello, 'Bernini e i lavori a S. Pietro nel 'diario' di Alessandro VII' in *Bernini in Vaticano* (exhibition catalogue), Rome, 1981, pp. 321–40.

16. See Michael Hirst, 'The Chigi Chapel in S. Maria della Pace', *Journal of the Warburg and Courtauld Institutes*, XXIV, 1961, pp. 161–85; Roger Jones and Nicholas Penny, *Raphael*, New Haven/London, 1983, pp. 99–105.

17. Jörg Martin Merz kindly drew my attention to the information concerning this altar in Karl Noehles, 'Architekturprojekte Cortonas', *Münchner Jahrbuch der bildenden Kunst*, F. 3, XX, 1969, note 33, pp. 203–4. Cortona presented his project to Alexander VII on 27 August 1656, and the casting of the relief was undertaken by Giovanni Artusi. It will be discussed further in Merz's forthcoming book on Cortona.

18. This drawing (pen and brown ink over black chalk heightened with white, on brown paper, 39.8 x 26.3 cm.) was included in the Royal Academy exhibition of *17th Century Art in Europe* of 1938, no. 417, when in the collection of Arthur Hobhouse; I have been unable to ascertain whether it still belongs to the same owner.

19. See the entry in Alexander VII's diary for 20 August 1656, 'che nella nicchia si pona la SS. Trinità' (H. Ost, *op. cit.*, p. 243). The image used is that commonly referred to as the Throne of Grace, in which God the Father holds His crucified Son.

20. See Emilio Lavagnino, Giulio R. Ansaldi and Luigi Salerno, *Altari barocchi in Roma*, Rome, 1959, pp. 107–9.

21. Bruce W. Davis, *The Drawings of Ciro Ferri*, Ann Arbor, 1982, p. 30. Cortona's drawings for the architectural frame will be discussed in the forthcoming book on Cortona's architecture by Anthony Blunt and Jörg Martin Merz. There is a drawing by Ferri (Rome, GND, F.C. 124411) including the same image within a much more elaborate frame, which may be an alternative idea for this altar, or possibly a design for a smaller, portable piece of metalwork (Maria Giannatiempo, *Disegni di Pietro da Cortona e Ciro Ferri*, exhibition catalogue, Rome, 1977, cat. Ferri 108, where the image passes unrecognised; Bruce W. Davis, *op. cit.*, p. 31).

22. Rome, GND, F.C. 124425; see M. Giannatiempo, *op. cit.*, cat. Ferri 73; Bruce W.

Davis, *op. cit.*, pp. 30–31.

23. Osvald Sirén, *Nicodemus Tessin d.y:s Studieresor*, Stockholm, 1914, p. 194.

24. On the chapel see the account in BAV, MS. Barb. Lat. 1572, ff. 274 ff., published by Benedetto Pesci, 'Un Atto notarile del 29 marzo 1672 relativo all'altare di S. Sebastiano ...', *Antonianum*, XV, 1940, pp. 125–154; see also J. Montagu, 'Antonio and Giuseppe Giorgetti', *Art Bulletin*, LII, 1970, pp. 288–90, 291–2. We may note that, in accordance with the rites of the early church, the altar is so placed that the priest could say the mass from behind it, facing the congregation.

25. The chapel is attributed to Ferri in Filippo Titi, *Studio di pittura, scoltura, et architettura, nelle chiese di Roma*, Rome, 1674, p. 77.

26. Giovanni Maria Giorgetti's account, submitted on 24 January 1674, included the payment he had made to the turner for two vases, and his own work in carving them (in fact, only half of each, 'perche servito di pensiero') 'per ordine del ordine e modello del Sig.r Cirro' (BAV, Arch. Barb., Cardinal Francesco Barberini Senior Giustificazioni 11600–11732, no. 11684, f. 265). For the casting see *ibid.*, Giustificazioni 12012–12017, no. 12014, f. 24v; they were formerly gilded by Girolamo Neri (*ibid.*, Giustificazioni 12012–12107 no. 11854, and 11853–11927, no. 11854). The gilding has now disappeared, though one of the two pairs was later silvered (B. Pesci, *op. cit.*, p. 151 note 1), and some of this remains.

27. Antonio Pellicani cast the gilt bronze sun (BAV, Arch. Barb., Cardinal Francesco Barberini Senior, Giustificazioni 11230–11305, no. 11294, f. 255), originally made as a grille through whose rays one could look down into the crypt below, but after this was closed by a marble slab the sun was merely placed upon it. At some time after 1970 it disappeared, and, since the monks in the church disclaim any knowledge of it, I can only assume it to have been stolen; one may question how long the lamps will survive it.

28. BAV, Arch. Barb., Cardinal Francesco Barberini Senior, Giustificazioni 12012–12107, no. 12014, f. 24v.

29. See below, note 32.

30. M. Giannatiempo, *op. cit.*, cats. Ferri 82v, 83, 84, 82r; Giannatiempo's assumption that it was commissioned by Innocent XI is disproved by the documents, and his arms do not appear on the font as it was executed.

31. A drawing in Berlin, KdZ 25396, may be related to the relief of the *Baptism* recorded in this version.

32. Besides his own fee, he also received a gratuity of one hundred and fifty *scudi* for all the workmen involved (BAV, Arch. Barb., Cardinal Francesco Barberini Senior, Computisteria vol. 91, Mandati 1675–8 nos. 1792, 2319, 2538, 2552, Computisteria vol. 92, Mandati 1678 no. 135).

33. O. Sirén, *loc. cit.*.

34. See Klaus Lankheit, *Florentinische Barockplastik*, Munich, 1962, pp. 39–47; J. Montagu, 'A Bozzetto in Bronze by Ciro Ferri',

Jahrbuch der hamburger Kunstsammlungen, XVIII, 1975, pp. 119–124.

35. See E. Lavagnino *et al.*, *op. cit.*, pp. 61–5; Karl Noehles, 'Das Tabernakel des Ciro Ferri in der Chiesa Nuova zu Rom', *Miscellanea Bibliothecae Hertzianae*, 1961, pp. 429–36; M. Giannatiempo, *op. cit.*, cat. Ferri 68). The history of this Tabernacle was very much more complicated and more fully documented than has been recognised hitherto, and I hope to return to it on a later occasion; here it is sufficient to state that the bronzes were cast not by Benincasa da Gubbio, as was recorded by Titi, and followed by subsequent authors, but by the almost equally shadowy Stefano Benamati, to whom Bertolotti found a reference in the Roman archives in 1671 (Antonio Bertolotti, *Artisti bolognesi ...*, Bologna, 1885, p. 202, without reference).

36. Rome, GND, F.C., 124451, see M. Giannatiempo, *op. cit.*, cat. Ferri 68. A. Blunt and H. L. Cooke, *op. cit.*, cat. 657; Anthony Blunt, *Supplement to the Catalogues of Italian and French Drawings ... at Windsor Castle*, London, 1971, cat. 172; *The Twilight of the Medici ...* (exhibition catalogue), Detroit, 1974, cat. 7.

37. It was modelled by Francesco Nuvolone in 1684 (Giovanni Incisa della Rocchetta, 'Del Ciborio di Ciro Ferri alla Vallicella', *L'Oratorio di S. Filippo Neri*, XIX, Oct, 1962, pp. 1–6).

38. K. Lankheit, *op. cit.*, docs. 55, 62, 81, 83, 84, 87 and 91, pp. 246–251.

39. See above, p. 11.

40. Two are studio works: a drawing for the lunette above the altar of St Alexis is in the Witt Collection of the Courtauld Institute (inv. 2497; *Italian Drawings of the Seventeenth and Eighteenth Centuries from the Witt Collection* (exhibition catalogue), London, 1971, cat. 18, attributed to Pietro da Cortona, and Bruce W. Davis, *op. cit.*, p. 24), and another for that above the altar of St Cecilia in a private collection differs very slightly from a tracing in West Berlin (KdZ 23282) which was presumably made from Ferri's original; another similar tracing (KdZ 23283) records his design for the lunette above the altar of St Eustace. The fact that no drawing appears to have survived for the lunette over the altar of St Emerenziana may be significant, for this altar was carved by Ferrata himself, and Rudolf Preimesberger has suggested (orally) that Ferrata may have made this rather different relief on his own invention.

41. The same remarks apply to the relief over the altar of St Cecilia; that over the St Eustace altar departs much further from the design.

42. For a somewhat different interpretation of the word to that discussed here, see Filippo Baldinucci, *Vocabolario toscano*, Florence, 1681, p. 78.

43. For a discussion of the views of Poussin and Pietro Testa on the subject of invention, see Elizabeth Cropper, *The Ideal of Painting*, Princeton, 1984, pp. 120–8.

44. See the discussion of Carlo Pellegrini's *Conversion of St Paul* in *Bernini in Vaticano* (exhibition catalogue), Rome, 1981, cat. 38, pp. 64–5; see also the discussion of the

vault of the Gesù in Robert Enggass, *The Paintings of Baciccio*, University Park, Penn., 1964, pp. 52–3.

45. See *Bernini in Vaticano*, cats. 52, 53, 55, 63, 64, 66, 67, 71 and 75; J. Montagu, *op. cit.*, pp. 179–181; *idem*, 'The Graphic Work of Melchior Cafà'.

46. Another pupil of Pietro da Cortona, Giovanni Francesco Romanelli, designed the stuccoes executed by Michel Anguier in the Louvre (See Louis Hautecoeur, *L'Histoire des Châteaux du Louvre et des Tuileries ...*, Paris/Brussels, 1927, pp. 40–3, quoted in part in Christiane Aulanier, *Histoire du Palais et du Musée du Louvre: La Petite Galerie, Appartement d'Anne d'Autriche, Salles Romaines*, Paris, 1955, p. 26), and appears to have designed the iconostasis at Grottaferrata (J. Montagu, 'Disegni, Bozzetti, Legnetti and Modelli in Roman Seicento Sculpture', p. 10).

47. I know of no equivalent in Rome to the contract of 11 October 1692 for the high altar in the monastery of SS. Rosariello delle Pigne in Naples, which was to be made 'in conformità del disegno fatto in piccola su carta e disegnato in grande nel muro rimpetto del suddetto altare maggiore ...' (Vincenzo Rizzo, 'Contributo alla conoscenza di Bartolomeo e Pietro Ghetti', *Antologia di belle arti*, N.S. XXI–XXII, 1984, doc. 23, p. 106). This was presumably made by the architect, and was therefore rather different to the drawing made by the *scarpellino* in the Gessi chapel in Sta Maria della Vittoria: 'Dovrano d[ett]i scarpellini disegnare in grande della sua giusta misura detti piccoli disegni del S.re Algardi sopra il muro nel luogo avanti di principiare lopera per caminare d'accordi' (ASR, 30 Not. Cap., Uff. 25, T. Raimundus, vol. 186, 24 Nov. 1639, f. 271v).

48. Apart from the larger-scale works above, on 13 April 1658 Fancelli was paid for '6 modelli d'Angeli che tengono li Misterij della Passione' to be made in silver for the papal chapel, 'come il tutto appare per attestat[io]ne data in Comput[iste]ria dal Signor Cavalier Pietro Berettini da Cortona' (ASV, Sacri Palazzi Apostolici, Computisteria vol. 3025, p. 142, quoted by Marc Worsdale, 'Bernini inventore', in *Bernini in Vaticano*, exhibition catalogue, Rome, 1981, p. 235, note 18); from this it is plausible to assume that Cortona provided the drawings. These lost angels are described in various inventories of the Vatican, e.g. A.S.R., Camerale 1°, Inventari, Busta 1560, int. 25 (Inventario della Sagrestia Segreta of 1728).

49. See Furio Fasolo, 'Carlo Rainaldi e il prospetto di S. Andrea della Valle a Roma', *Palladio*, N.S. I, 1951, p. 38; Howard Hibbard, *Carlo Maderno and Roman Architecture 1580–1630*, London, 1971, p. 154. The words 'conforme al disegno' appear in each of the contracts.

50. Terracotta models for this figure, and Ferrata's other figure of *St Andrea Avelino*, exist in the Hermitage, and it has been plausibly suggested that they were made by Ferrata's more skilful and creative pupil, Melchiorre Cafà (Ljubov' Ja. Latt, 'Melchior Kaffá i ego proizvedenija v Ermi-

taže', *Trudy Gosudarstvennogo Ermitaža*, VII, 1964, pp. 61–83, figs. 17 and 20).

51. According to the biography of Guidi by Filippo Baldinucci, Guidi got his assistants to carve the *St Sebastian* and *St Gaetano Thiene* (Florence, Bibl. Naz., MS. II.II.11°, f. 56v).

52. See E. Lavagnino *et al.*, *op. cit.*, pp. 145–8.

53. According to Titi's guidebook of 1674, 'l'altar maggiore fù fatto di inventione, e disegno di Melchior Gafar Maltese' (F. Titi, *op. cit.*, p. 205).

54. Other payments were made to the wood-carver, Antonio Duca, who was a competent coach carver. The accounts for the making of this altar were published by Gianfrancesco Spagnesi, *Giovanni Antonio De Rossi architetto romano*, Rome, 1964, pp. 237–8. In such a case, where Ferrata was working on a model provided by Cafà, the subject of this chapter merges with that of Chapter 5.

55. Published in Furio Fasolo, *L'Opera di Hieronimo e Carlo Rainaldi*, Rome, 1960, pl. 68, with the indication 'Codice dell'Archivio del Convento'; I have not seen the original of the drawing, which is dated to *c.*1660 by Salerno (in E. Lavagnino *et al.*, *loc. cit.*). Spagnesi (*op. cit.*, pp. 119–20) has argued that the design must have been made by De Rossi, as he was the architect of the hospital, and signed the accounts; however, while I do not wish to discuss the authorship of the drawings, it should be remembered that patrons often used their own 'house' architects to oversee the execution of work, the importance of which justified the employment of an outside architect to make the design.

56. Died 1703; see Laura Russo, in Valentino Martinelli, *Le Statue berniniane del Colonnato di San Pietro*, Rome, 1987, pp. 213–5.

57. Ottone was born in 1648 and died in 1736; see Laura Falaschi, in V. Martinelli, *op. cit.*, pp. 223–4.

58. I take this attribution from the Touring Club Italiano guide, *Roma e dintorni*, Milan, 1962, p. 253, where the angel on the left is given to Maglia and that on the right to Ottone. This seems more acceptable than the rather confused statement in Filippo Titi, *Ammaestramento utile, e curioso di pittura, scoltura et architettura nelle chiese di Roma ...*, Rome, 1686, p. 161, that 'li stucchi sono di Monsù Michele [Maglia], e del Cavallini, e di Lorenzo Ottone li due Putti, che tengono la Corona.' It should be noted that the two cherubs holding the crown over the altar are indeed of stucco.

59. See Hellmut Hager, 'Zur Plannungs- und Baugeschichte der Zwillingskirchen auf der Piazza del Popolo: S. Maria di Monte Santo und S. Maria dei Miracoli in Rom', *Römisches Jahrbuch für Kunstgeschichte*, XI, 1967/68, figs. 170, 171, discussed on pp. 250–51. Mattia de' Rossi was born in 1637, and died in 1695.

60. See H. Hager, *op. cit.*, figs. 152, 153, 185, pp. 209, 259; Allan Braham and Hellmut Hager, *Carlo Fontana: The Drawings at Windsor Castle*, London, 1977, pp. 64–5. The statues on Fontana's drawing for Sta Maria dei Miracoli (H. Hager, *op. cit.*, fig. 185) are rather more developed.

61. Pietro Petraroia, in V. Martinelli, *op. cit.*, p. 241.
62. See P. Petraroia, in V. Martinelli, *op. cit.*, pp. 240–41, and the relevant biographies in the same book for the artists employed on both churches.
63. See Vincenzo Golzio, 'Le Chiese di S. Maria di Montesanto e di S. Maria dei Miracoli a Piazza del Popolo in Roma', *Archivi d'Italia* . . ., Ser. II, VIII, 1941, pp. 122–48.
64. See below pp. 146–50. Despite Bernini's involvement in the architecture of these churches, there is no firm evidence to support the supposition of Maria Letizia Casanova that Morelli and his companions 'eseguì probabilmente alcune di queste sculture su disegni del Bernini' (*S. Maria di Montesanto e S. Maria dei Miracoli*, [Le Chiese di Roma illustrate, no. 58], Rome, n.d., p. 25).

CHAPTER V

1. On this tomb see the not entirely accurate entry in J. Montagu, *Alessandro Algardi*, New Haven/London, 1985, cat. 161, pp. 434–6; see also below, note 4.
2. The contract of 21 July 1634 is printed in Oskar Pollak, *Die Kunsttätigkeit unter Urban VIII*, II, Vienna, 1931, doc. 907, pp. 281–5.
3. On the interpretation of these two phrases in the quattrocento, see Charles Seymour Jr., '"Fatto di sua mano". Another Look at the Fonte Gaia Drawing Fragments in London and New York', *Festschrift Ulrich Middeldorf*, Berlin, 1968, pp. 93–105.
4. See J. Montagu, *op. cit.*, pp. 46–8. In disputing these attributions because I believed the tomb to have been complete by 1644, I had overlooked a letter from Algardi (though not in his own hand) of 1650 stating that only the two lateral figures remain to be finished ('essendo aplicato di presente nel'finire le due figure laterale, che solo restano per compimento del Deposito di marmo . . .') and asking for the money to enable him to finish it (Arch. Propaganda Fide, Cong. Part., vol. VI, f. 409r, referred to in Giovanni Antonazzi, *Il Palazzo di Propaganda*, Rome, 1979, p. 76; see also *ibid.*, note 110, p. 91).
5. It is reasonable that the artist, writing of his own work, should use the phrase '*di sua mano*', whereas Algardi's contract for the tomb of Leo XI, written by the patron, used the more precise phrase '*di sua propria mano*'.
6. BAV, Arch. Barb., Indice IV, 1615, ff. 166r–v (printed in full in Giovanni Morello, 'Documenti berniniani nella Biblioteca Apostolica Vaticana', in *Bernini in Vaticano* (exhibition catalogue), Rome, 1981, p. 317). For the tomb of the Countess Matilda in St Peter's, Bernini made the large and small drawings, and models for the decorative parts, the figures, and the reliefs, and claimed to have retouched them all 'with his hand', and particularly the relief and the figure of Matilda, adding that 'si

pol quasi dire che abbia fatta tutta perche non cie parte che non abbia riparrata e finita', and to have spent much time in assembling the tomb, 'perche ci sono molte chose centinate et inaria chome si vede' (*ibid.*, f. 184).
7. *Ibid.*, ff. 133r–v. For the payments to other workmen, see G. Morello, *op. cit.*, pp. 315–6.
8. J. Montagu, *op. cit.*, cat. 166, pp. 437–8.
9. *Ibid.*, cat. 155, pp. 430–1.
10. *Ibid.*, cat. 167, p. 439.
11. The same applies even more strongly to the satyr-masks; see *ibid.*, p. 167.
12. On the importance of the sculptor's design and control, see also the discussion of the tomb of Prospero Santacroce and that of Livia Primi Santacroce in J. Montagu, *op. cit.*, pp. 167–8.
13. J. Montagu, 'Bernini Sculptures Not by Bernini', in *Gianlorenzo Bernini: New Aspects of His Art and Thought*, ed. I. Lavin, 1985, p. 26, and p. 37, note 3, citing Giovanni Battista Passeri, *Die Künstlerbiographien*, ed. J. Hess, Leipzig/Vienna, 1934, p. 247, on Bernini's use of Finelli's assistance in the carving of this group, and *ibid.*, p. 246, on Finelli's skills as a marble-carver.
14. J. Montagu, *op. cit.*, p. 26, and pp. 37–8, note 5. The original passed with much of the Barberini inheritance to the Palazzo Sciarra, where it was photographed by Anderson. These photographs have recently been rediscovered, and have been published by Valentino Martinelli, fully confirming my hypothesis on the origin of the Bologna bust (V. Martinelli, 'Il Busto originale di Maria Barberini, nipote di Urbano VIII, di Gian Lorenzo Bernini e Giuliano Finelli', *Antichità viva*, XXVI, 1987, 3, pp. 27–36).
15. Osvald Sirén, *Nicodemus Tessin d.y:s studieresor*, Stockholm, 1914, p. 169. The extent of Bernini's contribution to the marble is open to question. Martinelli would see Bernini's hand in the hair and also in the face (*op. cit.*, pp. 32–3); I should be more inclined to see the hair as worked by Finelli, allowing Bernini at most some retouching in the face, but in the absence of the original marble such distinctions remain entirely hypothetical. What seems beyond question is that Bernini would have had neither the time nor the patience for the meticulous carving of the costume.
16. G. B. Passeri, *op. cit.*, pp. 247–8.
17. G. B. Passeri, *loc. cit.*
18. G. B. Passeri, *loc. cit.*
19. J. Montagu, *op. cit.*, p. 38, note 7.
20. See J. Montagu, *op. cit.*, especially p. 37, note 5.
21. Théodon was born in 1646 and died in 1713; see Paola S. M. Mannino, in Valentino Martinelli, *Le Statue berniniane del Colonnato di San Pietro*, Rome, 1987, pp. 226–7.
22. He was dismissed from the Academy in 1690 (François Souchal, *French Sculptors of the 17th and 18th Centuries. The Reign of Louis XIV*, III, Oxford, 1987, p. 288). The companion marbles of *Atlas* and *Phaetusa* were made between 1688 and 1692 (*ibid.*, cats. 9 and 10, pp. 290–91).

23. Anatole de Montaiglon, *op. cit.*, letter 325 of 1 January 1692, pp. 245–6; to make it worse, this was done after the bark had already been carved 'par le sculpteur qui a travaillé le nu' (not Théodon himself, who had only retouched the flesh) at great expense to the king. La Teulière wrote scathingly of the lack of '*vraisemblance*' in placing ivy round a still incompletely formed tree and giving it two large branches, and also of the swan, which he regarded as a different metamorphosis.
24. Vincenzo Giustiniani (1564–1637), writing of the requirements of a sculptor, says that 'sarà necessario allo scultore essere anco buono intagliatore, la quale professione presuppone il saper mettere in esecuzione tutte le regole e condizioni suddette nell'arte dello scarpellino, e di più avere qualche termine di disegno, non già in sommo grado, come fa bisogno al modellatore e scultore, ma a segno di potere, e saper far intagli di rabeschi, fogliami grandi e piccoli, capitelli Corinti e misti, e alla Michelangelesca, armi, grotteschi, tempj, prospettive, paesi, e mascheroni, ed altri lavori, a' quali lo scarpellino non può arrivare con li suddetti istromenti.' (Vincenzo Giustiniani, *Discorsi sulle arti e sui mestieri*, ed. Anna Banti, Florence, 1981, pp. 68–9). In fact, works of this kind were usually executed by men described as *scarpellini* (but see the following note).
25. 'Angelo Naldini *Scarpellino*', who had made a number of pedestals etc. for the papal gardens on the Quirinal, some decorated with the arms of Paul V, in 1613 carved some animals (a stag, a goat and a leopard) in peperino for the same gardens, and the payment for these of 27 September is made out to 'Angelo Naldini *Scultore*' (ASR, Camerale 1°, Fabbriche, busta 1537, f. 258v; see also Camerale 1°, Giust. di Tesoreria, busta 38, int. 13. His work as a *scarpellino* had been included under 'artigiani minori' in int. 12). We may note that Antonio Chiccari worked both as a carpenter ('*falegname*') and as a carver ('*intagliatore*'), and on 20 December 1656 he received two successive payments in these two capacities (ASR, Camerale 1°, Registro de Mandati, vol. 1021, p. 271). However, despite what Vincenzo Giustiniani wrote (see the previous note), no major sculptor seems to have practised as an *intagliatore*.
26. ASR, 30 Not. Cap., Uff. 25, T. Raimundus, 24 November 1639, ff. 271–3v, 290–92v.
27. 'Fatti per mano di persona eccellente nell'arte' (*ibid.*, f. 172v, clauses 12 and 13).
28. 'Per quello che tocca all'opera d'intaglio [the *scarpellini*] si debbano in tutto servire di M[aest]ro Gaspare Casella a spese di dette scarpellini, mentre essi non voglino farlo di loro mano propria' (*ibid.*, f. 273v, clause 23). The word '*mentre*' is ambiguous: it can have a conditional sense, but can also be used with a causal value – in which case the translations should be 'since'.
29. *Ibid.*, f. 292, clause 36.
30. For the two marble statues, the book of '*paragone*' held by death, and the inscription tablet on the tomb of Urban VIII, Bernini had made use of Francesco Borzone '*lustra-*

tore' (BAV, Arch. Barb., Indice IV, 1615, f. 122, printed in G. Morello, *op. cit.*, p. 315); see also also the following note.

31. A. de Montaiglon, *op. cit.*, I, letter 227 (list of expenses of the Academy, April–June 1683), p. 124; in the next entry is a payment for a *scarpellino* to block out one figure, and to a polisher for working on another. Jean Joly was born in 1654, and died in 1740. 'Pietrouche', or Pietruccio, was Pietro Maria Balestra, who filed and finished many of the statues for the tomb of Alexander VII (Vincenzo Golzio, *Documenti artistici sul Seicento nell'archivio Chigi*, Rome, 1939, pp. 131, 135, 137–9); in these accounts he is usually described as '*scultore*', and his payments are for work '*in ripulire e raspare*' the statues, an activity distinct from that of 'Domenico Sicurati *Lustratore*', paid for work '*in lustrare*' the statues.

32. For a brief history of the tomb, and the transcription of the documents, see Vincenzo Golzio, *op. cit.*, pp. 107–147.

33. The two drawings regarded as autograph by Heinrich Brauer and Rudolf Wittkower (*Die Zeichnungen des Gianlorenzo Bernini*, Berlin, 1931, pls. 129a and b) have been recognised by Rudolf Preimesberger as related to Bernini's project for the tomb of Innocent X (Rudolf Preimesberger, 'Das dritte Papstgrabmal Berninis' *Römisches Jahrbuch für Kunstgeschichte*, XVII, 1978, pp. 157–81).

34. Philadelphia Museum of Art, inv. 1984-56–118, published by Ursula Schlegel ('Zum Grabmal Alexanders VII. (1671–1678)', *Mitteilungen des Kunsthistorischen Institutes in Florenz*, XXVIII, 1984, p. 418, fig. 4, with bibliography) while it was still the property of the Philadelphia Academy.

35. See Jan Białostocki, 'The Door of Death. Survival of a Classical Motif in Sepulchral Art', *Jahrbuch der hamburger Kunstsammlungen*, XVIII, 1973, pp. 7–32.

36. Anthony Blunt and Hereward L. Cooke, *The Italian Drawings in the Collection of Her Majesty the Queen at Windsor Castle, Roman Drawings of the XVII and XVIII Centuries*, London, 1960, cat. 35, p. 23.

37. Black chalk, pen and brown ink, brown wash; 57.4 × 38.9 cm. This drawing, in a private collection, was offered for sale by Christie's, 9 December 1986, lot 49, and again 5 July 1988, lot 74. I cannot accept the interpretation of the skeleton above as being borne to heaven by Fame.

38. Such an activity usually presupposes that an artist develops his ideas in a logical sequence, whereas in actual life they are all too likely to abandon one line of development and return to an earlier, previously discarded, idea, to pursue another possible line which may, or may not, incorporate motifs originating from the abandoned development.

39. London, Victoria and Albert Museum, inv. A.17–1932; John Pope-Hennessy and Ronald Lightbown, *Catalogue of Italian Sculpture in the Victoria and Albert Museum*, London, 1964, II, pp. 606–7; J. Montagu, 'Disegni, Bozzetti, Legnetti and Modelli in Roman Seicento Sculpture', in *Entwurf und Ausführung in der europäischen Barockplastik*, Munich, 1986, pp. 11–12.

40. J. Montagu, *loc. cit.*, and fig. 15.

41. The contract of 9 April 1672 is published in Golzio, *op. cit.*, p. 118; for the models see J. Montagu, *op. cit.*, p. 12, and fig. 16.

42. See above, note 31.

43. V. Golzio, *op. cit.*, p. 120; it was presumably given to him in a silver dish (*ibid.*, p. 121).

44. I have not myself checked whether Golzio might have overlooked some further payment to Bernini.

45. Situations where they assumed a very high degree of personal responsibility will be examined in the following chapter.

46. See above, p. 97.

47. See below, p. 144.

48. See Giovanni Incisa della Rocchetta, 'Notizie sulla fabbrica della chiesa collegiata di Ariccia (1662–1664)', *Rivista del Reale Istituto d'Archeologia e Storia dell'Arte*, I, 1929, pp. 348–77.

49. There is a sketch by Bernini's own hand, (H. Brauer and R. Wittkower, *op. cit.*, fig. 97a) and three workshop drawings (*ibid.*, figs. 169c and 174b, and another in Berlin, discussed by Brauer and Wittkower on pp. 125–6, and illustrated by G. Incisa della Rocchetta, *op. cit.*, fig. 8, p. 361). Brauer and Wittkower suggest that the overdrawing in pen on their fig. 97a and the workshop drawing 169c are by Naldini, but this cannot be substantiated since no drawings by Naldini are known; moreover, it seems rather unlikely that a man originally trained as a painter under Andrea Sacchi would have drawn in a manner so close to that of Bernini. Blunt and Cooke ascribe Brauer and Wittkower's fig. 174b to Bernini himself, and also suggest that he probably added the putti in 169c (A. Blunt and H. L. Cooke, *op. cit.*, cats. 16 and 17, p. 21).

50. G. Incisa della Rocchetta, *op. cit.*, pp. 369–70.

51. That this was not often the case with stucco decoration is evident from those of the Villa Doria Pamphili (J. Montagu, *Alessandro Algardi*, cats. A.198–A.201, pp. 454–6, especially cat. A.200).

52. Domenico Bernini, *Vita del Cavalier Gio. Lorenzo Bernino*, Rome, 1713, p. 158.

53. Giovan Pietro Bellori, *Le Vite de' pittori, scultori et architetti moderni*, ed. Evelina Borea, Turin, 1976, p. 417.

54. *Ibid.*, p. 402.

55. Archivio di Stato di Modena, Carteggio fra Principi Estensi, busta 109: Lettere di Francesco I° d'Este al fratello Cardinale Rinaldo, and busta 239: Lettere di Rinaldo di Alfonso III … al fratello Francesco I Duca, letters from March to June 1654. I owe this reference to the kindness of Janet Southorn.

56. The Orsini kept in their *guardarobba* a quantity of nails of various sizes decorated with their heraldic rose (ASR, 30 Not. Cap., Uff. 29, S. de Comitibus, vol. 281, ff. 1350r–v).

57. J. Montagu, *Alessandro Algardi*, cat. L.A.207, pp. 458–9; the dove with an olive branch and the lilies composed the pope's coat of arms.

58. *Ibid.*, cat. R.36, pp. 472–3.

59. Sometimes it was possible simply to change the arms, as when, in 1644, at the beginning of the reign of Innocent X, the brassworker Giuseppe Fiocchini included in his account the item 'per haver levato l'armi à cinque vasi con putti, refattoci l'arme di nuovo quattro armi per vaso, allustrato come nuovi servono per d[ett]a lettica …' (ASR, Camerale 1°, Giust. di Tesoreria, vol. 99, int. 13, under the date of 20 October 1644).

60. Giacinto Gigli, *Diario romano*, ed. Giuseppe Ricciotti, Rome, 1958, p. 235. This was on 2 September 1643; however, on 11 September a new edict ordered that all silver of the value of 50 *scudi* or over should be consigned to the mint, but many hid their silver, and no serious attempt was made to enforce the edict (*loc. cit.*).

61. Marilyn A. Lavin, *Seventeenth-Century Barberini Documents and Inventories of Art*, New York, 1975, doc. 42, p. 6. Francesco Spagna was born in 1602, and died in 1642.

62. *Ibid.*, doc. 48, p. 7.

63. J. Montagu, *op. cit.*, cat. L.A.206, p. 458. Taglietti was born in 1574, and died in 1649.

64. BAV, MS. Vat. Barb. Lat. 6367, f. 564.

65. J. Montagu, *op. cit.*, cat. L.A.210, p. 460.

66. *Ibid.*, cat. A.204, p. 457.

67. The payment of 6 *scudi* ordered on 10 April 1640 was 'per una pittura in Rame di una Mad.ª con il Bambino et un angelo … per mettere in un ornamento ove era un specchio ottangolo' (ASV, Casa Borghese, vol. 5599, mandato 206(92)).

68. A. Blunt and H. L. Cooke, *op. cit.*, cat. 47, p. 25.

69. Stockholm, Nationalmuseum, THC 4837. Both drawings are reproduced and discussed in Rudolf Wittkower, *Gian Lorenzo Bernini*, London, 1966, pp. 211–12; it is worth recording the comments of Nicodemus Tessin the younger, to which Wittkower refers: 'Dans le Palais de la Reine Christine à Rome & au bel étage il y avoit un grandissime Miroir, composé de plusieurs glaces de differentes grandeurs, dont l'assemblage étoit câché par des morceaux de Draperies qu'une forte grande figure en l'air, qui representoit le tems, rélevoit pour faire connoître la verité, la figure étoit presque de ronde bosse & toute dorée; le Dessein en étoit du Chevalier Bernini, qui n'a rien fait que d'extraordinaire pendant toute sa vie.' (Nicodemus Tessin, 'Traité de la décoration intérieure', Stockholm, Kungliga Biblioteket, MS. 41, p. 380). He continues by remarking on another mirror in the same palace, where the joints were masked by painted roses and leaves (*loc. cit.*, also mentioned on p. 182).

70. This was in a talk delivered at the symposium on Bernini, held at Princeton in 1981.

71. Compare Rubens's explanation of how the controversial aspects of the *Medici Cycle* were given a more diplomatic reading by a clever courtier in order not to offend Louis XIII when he came to view her gallery (Elizabeth McGrath, '"Il Senso Nostro": The Medici Allegory Applied to Vasari's Mythological Frescoes in the Palazzo Vecchio', in *Giorgio Vasari tra decorazione ambientale e storiografia artistica*, ed. G. C. Garfagnini, Florence, 1985, p. 124).

72. H. Brauer and R. Wittkower, *op. cit.*, fig. 122a; for a damaged version of the same design, with measurements, see *Bernini in Vaticano*, cat. 273, p. 268. Steven Ostrow has discussed these designs in *Drawings by Gianlorenzo Bernini from the Museum der Bidlenden Künste, Leipzig* (exhibition catalogue), Princeton, 1981, pp. 275–81. The purpose of the measurements is unclear: they record the distance of the points of the figure as if within an imaginary block, and would be helpful for pointing, were the figures to be carved in marble, which cannot have been envisaged; Ostrow suggests that they were used for enlargement, which is not impossible, but it seems an unduly cumbersome method.

73. H. Brauer and R. Wittkower, *op. cit.*, fig. 123a; on a sketchier sheet (123b) she is apparently holding up an urn, and one of the cupids has skewered several hearts on an arrow, like a kebab.

74. J. Montagu, *op. cit.*, cat. A.211, p. 461.

75. *Ibid.*, cats. 212 and 213, pp. 461–2. Calci had also carved the porphyry urn for the reliquary of St Mary Magdalen (*ibid.*, cat. 94, pp. 389–90). The carving of such hard stones was a very specialised process, which would not be done by an ordinary sculptor. We may note that, in 1692 La Teulière wrote of a Guidotti (perhaps a descendant of the Daniele Guidotti who had worked for Algardi) who carved decorative marble urns etc. for the King of France, and who was the only porphyry carver who could be employed, since, according to La Teulière, 'je n'en sache que trois dans Rome; de ces trois l'on ne saurait jouir de deux, parce que ce sont des yvrognes; de ces deux même, l'un, outre l'yvrognerie, est un peu fol.' Guidotti had a further advantage in being 'commode pour les payments', despite the Roman custom of demanding a payment in advance before starting work, and regular payments while they worked (A. de Montaiglon, *Correspondance des directeurs de l'Académie de France à Rome*, I, Paris, 1887, letter 338, of 20 May 1662, p. 271).

76. See Richard Krautheimer and Roger B. S. Jones, 'The Diary of Alexander VII: Notes on Art, Artists and Buildings', *Römisches Jahrbuch für Kunstgeschichte*, XV, 1975, pp. 199–225, and, fuller but specifically for Bernini, Giovanni Morello, 'Bernini e i lavori a S. Pietro nel 'diario' di Alessandro VII', in *Bernini in Vaticano* (exhibition catalogue), Rome, 1981, pp. 321–40.

77. The medal for 1662 was made by Gaspare Morone, on a design by Bernini, which is now in the British Museum, 1946-7-13-689a; see *Bernini in Vaticano*, cat. 299. On the annual medal see Franco Bartolotti, *La Medaglia annuale dei romani pontefici da Paolo V a Paolo VI, 1605–1967*, Rimini, 1967. Much of the bibliography on Bernini as a medal designer is over-inclusive, and unreliable; see Luigi Michelini Tocci and Marc Worsdale, 'Bernini nelle medaglie e nelle monete', in *Bernini in Vaticano*, pp. 281–309, with bibliography.

78. Paris, École des Beaux-Arts, Masson Collection, no. 36; see Marc Worsdale, 'Eloquent Silence and Silent Eloquence in the Work of Bernini and His Contemporaries', in *Vatican Splendour* (exhibition catalogue), Ottawa, 1986, fig. 16, p. 33.

79. One of the few such roses to have survived the melting-pot shows a more cautious design, though there is still some play in the incorporation into the design of the elements of the Chigi arms, the star and the triple mountain; see Marc Worsdale, 'Bernini inventore', in *Bernini in Vaticano*, p. 232.

80. M. Worsdale, *op. cit.*, 'Bernini inventore', p. 231.

81. On these bronzes, and the documentation, see Roberto Battaglia, *Crocifissi del Bernini in S. Pietro in Vaticano*, Rome, 1942; *Bernini in Vaticano*, cat. 271, pp. 270–1; *The Vatican Collections: Papacy and Art* (exhibition catalogue), New York, 1982, cat. 33; *Vatican Splendour*, cats. 24 and 25, pp. 96–9. Recently Ursula Schlegel has analysed the style of the *Corpi*, and argued powerfully for a more direct involvement of the master than is apparent from the documents (Ursula Schlegel, 'I Crocifissi degli altari in San Pietro in Vaticano', *Antichità viva*, XX, 1981, pp. 37–42).

82. A. Blunt and H. L. Cooke, *op. cit.*, cat. 66, p. 27.

83. The moulds for them are listed in his inventory (Vincenzo Golzio, 'Lo "Studio" di Ercole Ferrata', *Archivi*, ser. II, II, 1935, p. 74).

84. On 1 September 1658 Alexander VII records in his diary 'è da noi il Cav. Bernino co' candelieri grandi per la Cappella del Pop[ol]o' (G. Morello, *op. cit.*, p. 325). For some years now, while work has been undertaken, but apparently suspended, on the Chigi chapel, these candlesticks have been awkwardly placed in the adjoining Mellini chapel.

85. See below, pp. 134–40.

86. Giuseppe Cugnone, 'Appendice al "Commento della vita di Agostino Chigi il Magnifico"', *Archivio della Società Romana di Storia Patria*, VI, 1883, pp. 531, 534; Verpoorten (died 1659) was to work for Bernini on the *Cattedra Petri*, see Roberto Battaglia, *La Cattedra berniniana di San Pietro*, Rome, 1943, pp. 160–1. Other, usually smaller, casts of this lamp are known (e.g., one used to hang in the Cybo chapel opposite), sometimes ascribed to the school of Raphael, if with considerable confusion, as when one such cast was included in the exhibition *Builders and Humanists* (University of St Thomas, Houston, 1966, cat. 84) described as 'believed to be the original made by Francesco Francucci in 1656 after a design by Raffaello da Montelupo for the Chigi chapel in Santa Maria del Popolo, Rome'.

87. G. Cugnone, *op. cit.*, pp. 531–2, 535.

88. R. Krautheimer and R. B. Jones, *op. cit.*, no. 109, p. 205; G. Morello, *op. cit.*, p. 323.

CHAPTER VI

1. Much of the material in this chapter was published in the article, 'Bernini Sculp- tures Not by Bernini' in *Gianlorenzo Bernini: New Aspects of his Art and Thought*, ed. Irving Lavin. I am grateful to Professor Lavin and the College Art Association of America for permission to reuse it here.

2. Klaus Güthlein, 'Quellen aus dem Familienarchiv Spada zum römischen Barock, 2 Folge', *Römisches Jahrbuch für Kunstgeschichte*, XIX, 1981, p. 209.

3. E. Dony, 'François Duquesnoy: sa vie et ses oeuvres', *Bulletin de l'Institut Belge de Rome*, II, 1922, p. 125.

4. See below, note 52.

5. The documentation provided in Minna Heimbürger Ravalli's *Architettura scultura e arti minori nel barocco italiano: Ricerche nell'archivio Spada*, Florence, 1977, pp. 217–50, has been largely superseded by Klaus Güthlein's two-part publication, 'Quellen aus dem Familienarchiv Spada zum römischen Barock', *Römisches Jahrbuch für Kunstgeschichte*, XVIII, 1979, pp. 173–246, and XIX, 1981, pp. 173–247.

6. K. Güthlein, *op. cit.*, 1979, pp. 208–9.

7. M. Heimbürger Ravalli, *op. cit.*, p. 222.

8. *Ibid.*, pp. 225, 226, 227, 248 note 119.

9. K. Güthlein, *op. cit.*, 1981, p. 209.

10. K. Güthlein, *op.cit.*, 1979, pp. 237–8; see also pp. 207–8.

11. He says that he had received the request from Spada only that day, and apologises for the 'lettera scritta in fretta, e con rimesse . . .' (K. Güthlein, *op. cit.*, 1979, p. 238).

12. See J. Montagu, *Alessandro Algardi*, New Haven/London, 1985, cat. A.35, pp. 343–6; see also cat. R.12, pp. 465–6.

13. *Ibid.*, pp. 219–20.

14. J. Montagu, *op. cit.*, pp. 220–1; see also François Souchal, *French Sculptors of the 17th and 18th Centuries: The Reign of Louis XIV*, II, London, 1981, pp. 167–9.

15. See Stanislas Lami, *Dictionnaire des sculpteurs de l'école française sous le règne de Louis XIV*, Paris, 1906, pp. 161–2; Jacques Bousquet, *Recherches sur le séjour des peintres français à Rome au XVIIième siècle*, Montpellier, 1980, pp. 206, 223.

16. *Ibid.*, pp. 218–9.

17. This was the Alaleoni altar in SS. Domenico e Sisto (see Rudolf Wittkower, *Gian Lorenzo Bernini*, London, 1966, cat. 52, p. 223).

18. See, for example, the relief of *The Finding of the Body of St Alexis* in S. Agnese, on the tomb of Cardinal Francesco Cennini in S. Marcello, part of which is illustrated in Władysław Tomkiewicz, 'Francesco Rossi i jego Działalność Rzeźbiarska w Polsce', *Biuletyn Historii Sztuki*, XIX, 1957, p. 199, fig. 1.

19. On 16 August 1673 Giovanni Francesco de Rossi wrote to beg for extra payment, since he had had to remake the Glory twice; first because, after it had been orientated towards the altar, the architect Camillo Arcucci and the patron Orazio Spada decided it should be orientated towards the entrance of the chapel, and in higher relief, and again after Arcucci's death in February 1667, when the patron and the new architect, Carlo Rainaldi, wanted the Glory in even higher relief, and the whole vault enlarged. De Rossi had

worked continuously for ten months, with two assistants paid at his own expense, and, not unnaturally, having in effect made three works, was dissatisfied to receive only the payment originally agreed upon for one. This statement of his work was confirmed by Antonio Nuvolone and Agostino Bernasconi, who had also worked on the stucchi of this chapel (ASR, Arch. Spada Veralli, busta 490, ff. 20v–21).

20. See W. Tomkiewicz, *op. cit.*, pp. 199–217; Marius Karpowicz, 'Nieznane Dzieło Francesca Rossiego', *Biuletyn Historii Sztuki*, XXII, 1960, pp. 378–83; Olgierd Zagórowski, 'Z Działalności Gian Francesco Rossiego w Polsce', *Biuletyn Historii Sztuki*, XXV, 1963, pp. 34–52.

21. J. Montagu, *op. cit.*, p. 219.

22. See Mercedes Agulló and Alfonso E. Pérez Sánchez, 'Juan Bautista Moreli', *Archivo español de arte*, XLIX, 1976, pp. 109–20.

23. The exception is Alexandre Jacquet, who was not employed at St Peter's; nor was Francesco Pinazzi, unless he is identical with Francesco Purazzi, as seems probable (see J. Montagu, *op. cit.*, p. 255 n. 33).

24. Although he was to model the figure of *Obedience* for the stucchi discussed below, in the 1660s he chased the *Crucifixes* for St Peter's (Roberto Battaglia, *Crocifissi del Bernini in S. Pietro in Vaticano*, Rome, 1942, doc. H, p. 24) and worked extensively on the bronze figures for the *Cattedra* (idem, *La Cattedra berniniana di San Pietro*, Rome, 1943, docs. 88–101, pp. 167–8). See further Maria P. Bertoni, in Valentino Martinelli, *Le Statue berniniane del Colonnato di San Pietro*, Rome, 1987, p. 208.

25. See Jörg Garms, *Quellen aus dem Archiv Doria-Pamphilj*, Rome/Vienna, 1972, docs. 327, 362, 1021, 1040, 1063, 1095; see also Raissa Calza, ed., *Antichità di Villa Doria Pamphilj*, Rome, 1977, cat. 440, pp. 338–9, pl. CCXLI, for a sculpture which, if indeed it was restored by Giovanozzi, does no credit to his ability.

26. K. Güthlein, *op. cit.*, 1979, p. 185.

27. *Ibid.*, 1979, pp. 184–5.

28. Heinrich Brauer and Rudolf Wittkower, *Die Zeichnungen des Gianlorenzo Bernini*, Berlin, 1931, p. 44, pl. 154b.

29. *Ibid.*, p. 44, pl. 19c.

30. It was carved by Jacomo Balsimelli, who on 10 March 1648 received a payment of 120 *scudi* for 'dui putti di marmo, che tengono la spada, e libro' (ARF, 1° Piano, serie Armadi, vol. 276, f. 155)

31. As Spada points out, this avoids the multiplication of papal coats of arms seen in the earlier incrustation, which Innocent X, in his modesty, wished to avoid (K. Güthlein, *op. cit.*, 1979, p. 185).

32. On these stuccoes and their sculptors, see Robert Enggass, 'New Attributions in St Peter's: The Spandrel Figures in the Nave', *Art Bulletin*, LX, 1978, pp. 96–108.

33. The pair of standing stucco *Angels* with *God the Father* which Prestinari carved over the high altar of the small church of Sta Maria del Pianto (Giovanni Battista Mola, *Breve racconto delle miglior opere . . . fatte in Roma descritto . . . l'anno 1663*, ed. Karl Noehles, Berlin, 1966, p. 106) were replaced by stucco *Angels* by Vincenzo Pacetti

(*Memorie enciclopediche romane sulle belle arti, antichità ec.*, III, [1807], p. 88, no. 28); Prestinari was employed by the Borghese, and on restoration of antique sculpture for the Pamphilj (J. Garms, *op. cit.*, docs. 1039, 1062, 1149) and on various ephemeral structures.

34. R. Enggass, *op. cit.*, p. 99, note 19.

35. On Alexander VII's work on the church, see Giuseppe Cugnone, 'Appendice al "Commento della vita di Agostino Chigi il Magnifico"', *Archivio della Società Romana di Storia Patria*, VI, 1883, pp. 497–539.

36. For a diagram of the nave, see Enzo Bentivoglio and Simonetta Valtieri, *Santa Maria del Popolo*, Rome, 1976, p. 61, fig. 21.

37. Leipzig, Museum der bildenden Künste, Graphische Sammlung, Rensi 6, f. 193r. For a slightly different interpretation, see the discussion of this drawing by Sharon Cather in *Drawings by Gianlorenzo Bernini from the Museum der Bildenden Künste, Leipzig* (exhibition catalogue), Princeton, 1981, cat. 28, pp. 149–55.

38. This volume, Leipzig, Rensi 6, has already been discussed (see above, p. 16), and the greater part of the drawings in it related to an artist working in the studio of Ferrata and copying models available to him there. The kneeling angels on folios 147r, 148r, and 153r were evidently drawn from the same three-dimensional model (there is an illegible inscription below 148r); those on folios 169r and 172v were also drawn after a single model. Although not identical to the angels shown on f. 193r (which are by a different, and much superior hand), they are close in type to these figures which, shown in projecting three-quarter positions, must have been modelled in the round.

39. The payments describe Raggi's figures as '*Vittorie*' (G. Cugnone, *op. cit.*, p. 528), and they do, indeed, hold palms in their hands, but this in no way diminishes their angelic appearance.

40. R. Wittkower, *op. cit.*, cat. 58, pp. 232–3. The documents were published in G. Cugnone, *op. cit.*, pp. 523–39. See also Rosella Carloni, in V. Martinelli, *op. cit.*, p. 53, note 40.

41. They were Ercole Ferrata, Antonio Raggi, Giovanni Francesco de Rossi, Paolo Naldini (Sta Prassede), Giovanni Antonio Mari (Sts. *Cecilia* and *Ursula*), Lazzaro Morelli (Sta *Pudenziana*), and Giuseppe Perone (Sts. *Dorothy* and *Agatha*).

42. The drawing for the window is in Leipzig, no. 31–74 (H. Brauer and R. Wittkower, *op. cit.*, p. 57), to which Linda Klinger kindly drew my attention. One of those for the nave is discussed below, and the other is in the Metropolitan Museum of Art, inv. 87–12–113 (Jacob Bean, *17th Century Italian Drawings in the Metropolitan Museum of Art*, New York, 1979, no. 65, p. 43); it is attributed to the school of Bernini, and shows the figures of Sts. Ursula and Cecilia in reverse, and the many variations from the executed stucco, and from the Leipzig drawing discussed below, show that it belongs to an earlier fomulation of the scheme. I am grateful to Steven Ostrow for telling me of this study. On these

drawings see also S. Cather in *Drawings by Gianlorenzo Bernini*, 1981, pp. 149–57.

43. Leipzig, no. 76.135; H. Brauer and R. Wittkower, *op. cit.*, pp. 56–7, pl. 41.

44. Died 1631; see Maria Teresa De Lotto, in V. Martinelli, *op. cit.*, p. 215 (under Francesco Mari).

45. George and Linda Bauer, in 'Bernini's Organ Case for S. Maria del Popolo', *Art Bulletin*, LXII, 1980, pp. 115–123, have pointed to its further symbolism: The church was situated above Nero's grave, from which grew a walnut tree inhabited by a host of devils, who assaulted and murdered innocent passers-by, until Pope Paschal, instructed in a dream, took an axe and chopped the tree down. The oak tree of the Chigi is a flourishing replacement for this pernicious walnut, and from it should issue the sweet music of the liturgy where once the nut-tree had produced its crop of devils.

46. Mark S. Weil, *The History and Decoration of the Ponte S. Angelo*, University Park/London, 1974, pp. 73–4.

47. See Peter Dreyer, *Römische Barockzeichnungen aus dem berliner Kupferstichkabinett, Staatliche Museen Preussischer Kulturbesitz* (exhibition catalogue), Berlin, 1968, cats. 76 and 77, pp. 37–40.

48. Little is known about Arrigo Giardé, but from at least 1654 to 1657 he was living in Bernini's house (information kindly provided by Ann Percy, from the *Stati d'Anime*).

49. On the negotiations concerning the fountains at Sassuolo, see Giovanni Canevazzi, *La Scuola militare di Modena*, Modena, 1914–20, I, pp. 17–18; the ducal agent Francesco Gualengo asked Bernini to send designs at the end of July or early in August 1652. After various questions, which indicate how seriously Bernini considered the position and background of such structures, he sent two drawings on 7 September and a third on the 14th (Stanislao Fraschetti wrongly believed the Duke's comments on the first two referred to designs for the Ducal Palace in Modena [S. Fraschetti, *Il Bernini*, Milan, 1900, pp. 227–8]). In addition, Bernini advised that, if these drawings were acceptable, a 'giovane capace e intelligente della maniera [of Bernini]' should be sent from Modena to execute them in Rome. It was presumably after this that the Duke instituted enquiries about the sculptors available in Rome.

50. Archivio di Stato di Modena, Archivio Secreto Estense, Arti Belle. Cose d'Arte, Cass. 18/1, unpaginated. This report was brought to my attention by Jennifer Fletcher; the Italian text is given in J. Montagu, 'Bernini Sculptures Not by Bernini', in *Gianlorenzo Bernini: New Aspects of His Art and Thought*, ed. Irving Lavin, University Park/London, 1985, p. 39, note 42.

51. This, indeed, was what happened. Although the model for the *River God* for the fountain, now in the Museo Estense, is generally agreed to be by Raggi, it was in all probability made under Bernini's direct supervision (see Eugenio Riccòmini, *Ordine e vaghezza*, Bologna, 1972, no. 18, p. 56).

52. I do not have the exact dates when these sculptors joined the Academy, but a list of sculptors drawn up before 1643 (it includes du Quesnoy, who died in that year) contains the names of both Fancelli brothers, and lists 'Monsù Claudio Lorenese' among the '*giovani*' (Rome, Accad. S. Luca, vol. 69, p. 108). By 1651 he too was a full member (see Godefridus J. Hoogewerff, *Bescheiden in Italië omtrent nederlandsche Kunstenaars en Geleerden*, II, The Hague, 1913, pp. 62 and 130).

53. S. Fraschetti, *op. cit.*, p. 414, note 1; *idem*, in *Annales internationales d'histoire, Congrès de Paris 1901, VIIe section; Histoire des arts du dessin*, Paris, 1902, p. 45, cited in Jacques Bousquet, *op. cit.*, p. 150 (chap. 4, note 48), and see also p. 187. He is presumably the 'Monsù Claudio' who was considered in 1647 for one of the statues for the Lateran (K. Güthlein, *op. cit.*, 1979, p. 228).

54. The letter of 5 November 1651 which accompanied it is printed by Giuseppe Campori, *Memorie biografiche degli scultori, architetti, pittori ec. nativi di Carrara . . .*, Modena, 1873, p. 17. Baratta says that he would have wished to present the relief in person, 'ma per cause troppo urgenti non posso al presente partirme da Roma'.

55. On these statues, see Mark S. Weil, *op. cit.*, 1974, to which I am indebted for the factual information about the project, and where further illustrations, and information about the artists, can be found.

56. On drawings for these *Angels*, with unacceptable attributions of a group in Düsseldorf, see Hanno-Walter Kruft and Lars Olof Larsson, 'Entwürfe Berninis für die Engelsbrücke in Rom', *Münchner Jahrbuch der bildenden Kunst*, XVII, 1966, pp. 145–160.

57. This respect, at least as regards his abilities as a marble carver, is not shared by Cecilia Bernardini and her assistants currently restoring the *Angels*, who have kindly told me of their findings that his *Angels* are the most incompetently carved of all those on the bridge; that with the Crown of Thorns may have been carved flat, and the attachment of the left wing was almost criminally negligent.

58. Compare the head of the *Dying Alexander*, now in the Uffizi (Francis Haskell and Nicholas Penny, *Taste and the Antique*, New Haven/London, 1981, no. 2, pp. 134–6).

59. Examination of this statue, made possible by the kindness of those in charge of its recent restoration, showed that it must have been finished in some haste (being the last statue to be set up), and numerous changes were made during the execution, leading to considerable incoherence in the drapery.

60. On these statues see Andreas Haus, *Der Petersplatz in Rom und sein Statuenschmuck; neue Beiträge*, Berlin, 1970, which I have relied on for much of what follows. Valentino Martinelli's *Le Statue del Colonnato di San Pietro*, Rome, 1987, appeared in 1988, when this chapter was already written, and references which duplicate those in Haus have not been included.

61. Bernini himself had built one such tower

between 1637 and 1642, but it had been torn down in 1646, because, it was said, it weakened the structure (see H. Brauer and R. Wittkower, *op. cit.*, pp. 37–43; Maurizio and Marcello Fagiolo Dell'Arco, *Bernini*, Rome, 1967, cats. 84 and 126; *Bernini in Vaticano*, exhibition catalogue, Rome, 1981, cat. 135, pp. 166–7).

62. A. Haus, *op. cit.*, p. 13.

63. *Ibid.*, pp. 13–14.

64. Valentino Martinelli says that they were of 2 *palmi*, or *c.* 40 centimetres (*op. cit.*, p. xxiv), but he provides no evidence. The model is described as of 25 *palmi*, and, if we can assume that this is the maximum dimension (a hazardous assumption, but I know of no other evidence on which to base an estimate of its size), and the maximum diameter of the colonnade is usually given as close to 1,000 *palmi*, the model was on a scale of 1/40, which means that the wax *Saints* would have been one fortieth of approximately 3.10 metres. In 1661 models were set up on a section of the colonnade (Rosella Carlone, in V. Martinelli, *op. cit.*, p. 273), but these would have been full size.

65. H. Brauer and R. Wittkower, *op. cit.*, p. 87, pls. 66c, 67a, 67b.

66. *Ibid.*, pp. 87–8, pls. 65, 66b.

67. *Ibid.*, p. 88, pl. 66a.

68. *Ibid.*, pp. 87–8, pl. 184a; intended for a bearded male saint, and, indeed, closely related in pose to the *St Mark*.

69. There are four known casts of the *St Agnes* (see J. Montagu, 'Two Small Bronzes from the Studio of Bernini', *Burlington Magazine*, CIX, 1967, pp. 566–70, and Michael Mezzatesta, *The Art of Gianlorenzo Bernini*, exhibition catalogue, Fort Worth, 1982, cats. 5 and 6), and one, rather coarser, of the *St Catherine* (Christie's, 16 December 1986, lot 36; see also J. Montagu, *op. cit.*, p. 570, for a probably later cast from a variant model). These are all between 36 and just over 38 cm., and therefore cannot have been cast from the waxes on the model. The terracotta for the *St Justus* is in Berlin (see Ursula Schlegel, *Staatliche Museen Preussischer Kulturbesitz. Die Bildwerke der Skulpturengalerie Berlin, 1: Die italienischen Bildwerke des 17. und 18. Jahrhunderts . . .*, Berlin, 1978, cat. 11, pp. 34–5). In 1967, in ascribing the *St Agnes* bronze to Bernini, I had carelessly overlooked the existence of the Berlin terracotta; it is possible, though by no means certain, that both are by the same hand, though not necessarily that of Giovanni Antonio Mari, as Schlegel suggests.

70. Printed in A. Haus, *op. cit.*, pp. 24–5.

71. For some reason, Cosimo Fancelli was excluded.

72. 1641–1700; see Maria Teresa De Lotto, in V. Martinelli, *op. cit.*, pp. 211–12.

73. 1644–1725; see Maria P. Bertoni, in V. Martinelli, *op. cit.*, pp. 216–17.

74. A. Haus, *op. cit.*, p. 43, quoting the 'Aggiuntamento dello studio'.

75. These engravings are by Pietro Bombelli.

76. 'Imaginez ce que c'est qu'un peuple dont le quart est de prêtres, le quart de statues, le quart de gens qui ne travaillent guère et le quart des gens qui ne font rien de tout' (Charles de Brosses, *Lettres d'Italie*, first

published 1799, ed. Fréderic d'Agay, Paris, 1986, Lettre XXXVI, vol. II, p. 11). Compare the judgement that in ancient times 'Romæ vero tantum statuarum, ut alter Populus lapideus videretur' (Giovanni A. Borboni, *Delle Statue*, Rome, 1661, p. 112).

CHAPTER VII

1. Inventory of Stefano Guglielmini, of 20 March 1690 (ASR, Not. Trib. A.C., L. Belli, vol. 918, f. 564v).

2. Pietro Santi Bartoli, in Carlo D. F. I. Fea, *Miscellanea filologica, critica e antiquaria*, Rome, 1790, p. ccxxxiii, para. 45.

3. ASR, Not. Trib A.C., Simoncellus, vol. 6640, ff. 87–88v, 97–98r, 88r; the land was leased on 7 July 1654 by Duke Jacopo Salviati.

4. According to Baglione it was said to have been a Florentine, Lorenzetto Lotti, who 'fu il primo, che quì in Roma le statue antiche di marmo mal concie, e rotte con diligente cura diede a racconciare a'buoni Scultori, perchè rifacessero ciò, che loro interiamente mancava. Onde in questa Città tutti i Signori cominciarono a restaurare molte cose antiche'. (Giovanni Baglione, *Le Vite de' pittori scultori et architetti . . .*, Rome, 1642, p. 69). He is here following Giorgio Vasari, *Le Vite de' più eccellenti pittori scultori et architetti*, ed. Gaetano Milanesi, IV, Florence, 1879, pp. 579–80, who adds 'e nel vero, hanno molto più grazia queste anticaglie in questa maniera restaurate, che non hanno que'tronchi imperfetti, e le membra senza capo, o in altro modo difettose e manche'.

5. O. Boselli, *Osservazioni della scoltura antica*, ed. P. D. Weil, 1978, MS. Corsini f. 171v; the reference is to Horace, *Ars poetica*, lines 1–4 (transl. H. Rushton Fairclough, London (Loeb), 1926, p. 451). We may note that Boselli's own overdoors in the Palazzo Cardelli have been condemned in not dissimilar terms by Michelangelo Cagiano de Azevedo (*Il Gusto nel restauro delle opere d'arte antiche*, Rome, 1948, pp. 28–9).

6. Bernini's only securely documented restorations were those undertaken for Cardinal Ludovico Ludovisi; his activity among the restorers employed by the Cardinal 'n'est qu'un intermède au cours des premiers mois de l'année 1622.' (Yves Bruand, 'La Restauration des sculptures antiques du Cardinal Ludovisi (1621–1632)', *Mélanges d'archéologie et d'histoire*, LXVIII, 1956, p. 399).

7. Even as early as 1638, when Algardi was paid for restoring the noses and fingers of some antiques for Marcantonio Borghese, it is highly unlikely that he did the work himself (J. Montagu, *Alessandro Algardi*, New Haven/London, 1985, p. 35).

8. O. Boselli, *op. cit.*, MS. Corsini f. 171v.

9. *Ibid.*, MS. Corsini f. 171v; see also ff. 35–6.

10. *Ibid.*, MS. Corsini f. 171v. The source of this story is G. Baglione, *op. cit.*, p. 151;

see also Seymour Howard, 'Pulling Herakles' Leg . . .', in *Festschrift Ulrich Middeldorf*, Berlin, 1968, pp. 402–7; Francis Haskell and Nicholas Penny, *Taste and the Antique*, Hew Haven/London, 1981, no. 46, esp. p. 230.

11. Y. Bruand, *op. cit.*, p. 408.

12. S. Pressouyre, *Nicolas Cordier*, Rome, 1984, cat. 22, pp. 415–17; see also F. Haskell and N. Penny, *op. cit.*, p. 341.

13. F. Haskell and N. Penny, *op. cit.*, cat. 95, pp. 339–41. Another pair of similarly constructed figures, also from the Borghese collection and now in the Louvre, were made from coloured antique marbles, with heads and limbs cast in bronze from the antique Capitoline *Camillus*, the assistant at a sacrifice (see Ennio Quirino Visconti, *Monumenti scelti borghesiani illustrati*, reprinted in E. Q. Visconti, *Opere*, Milan, 1837, pp. 81–2; F. Haskell and N. Penny, *op. cit.*, p. 169; S. Pressouyre, *op. cit.*, p. 181). I am grateful to Nicholas Penny for bringing these figures to my attention, and indeed for many other observations and suggestions which I have incorporated into this chapter.

14. Jean-Pierre Cuzin, *La Diseuse de bonne aventure de Caravage* (Les dossiers du Département des Peintures, 13), Paris, 1977.

15. O. Boselli, *op. cit.*, MS. Corsini ff. 174v–175; Phoebe Dent Weil, 'Contributions towards a History of Sculpture Techniques. I: Orfeo Boselli on the Restoration of Antique Sculpture', *Studies in Conservation*, XII, no. 3, 1967, p. 93.

16. Although his responsibility was tentatively suggested by F. Haskell and N. Penny (*op. cit.*, p. 27), Sylvia Pressouyre does not even discuss it among the rejected works in her monograph on the sculptor. On this statue see F. Haskell and N. Penny, *op. cit.*, cat. 76, pp. 303–5. It was found, presumably, some time before 1594, and, although not immediately identified as Seneca, it could have been restored before entering the Borghese collection.

17. This has been removed from the statue but is still in the Louvre, though no longer exhibited; the catalogue of the Louvre describes the basin as of '*brèche violette*' (Étienne Michon, *Catalogue sommaire des marbres antiques*, Paris, 1922, p. 75, no. 1354), but Manilli says that 'il bagno è di porfido, per meglio esprimere il colore, formato dall'aqua meschiata co'l sangue: e'l vaso, che lo contiene, è opera moderna di pietra d'Africano.' (Jacomo Manilli, *Villa Borghese fuori di Porta Pinciana*, Rome, 1650, p. 62). Since the slab representing the water has been lost, it is no longer possible to check its material, which has elsewhere been described as red marble.

18. The painting is in the Alte Pinakothek in Munich, inv. 305; see Wolgang Stechow, *Rubens and the Classical Tradition*, Cambridge (Mass.), 1968, pp. 28–31. For further discussion of the drawings, see Justus Müller Hofstede, 'Zur Kopfstudie im Werk von Rubens', *Wallraf-Richartz-Jahrbuch*, XXX, 1968, pp. 233–4, and *ibid.*, 'Rubens in Italien', in *Peter Paul Rubens . . .* (exhibition catalogue), Cologne, 1977, pp. 246–7, no. 52. Further information on the painting, and on the antique statue, will be provided in Elizabeth McGrath's forthcoming volume on the paintings of classical history in the *Corpus Rubenianum*; I am grateful to her for letting me see her entry on this picture.

19. Christian Klemm, 'Sandrart à Rome', *Gazette des beaux-arts*, pér. 6e, XCIII, 1979, pp. 153–6; *ibid.*, *Joachim von Sandrart: Kunst-Werke und Lebens-Lauf*, Berlin, 1986, cat. 11, pp. 63–7. The painting was formerly in Berlin but was destroyed in the war; a drawing related to it is in Augsburg, Städtische Kunstsammlungen, inv. G.4818.71. For the print, see Joachim von Sandrart, *Der teutschen Academie . . . von der edlen Bau- Bild- und Mahlerey-Künste . . .*, Nürnberg, 1679, II, fig. b.

20. See his lecture on Poussin's *Israelites Gathering the Manna* (Henry Jouin, *Conférences de l'Académie Royale de Peinture et de Sculpture*, Paris, 1883, p. 54).

21. See Louis Réau, *J.-B. Pigalle*, Paris, 1950, pp. 63–4; Willibald Sauerländer, *Jean-Antoine Houdon; Voltaire*, Stuttgart, 1963, pp. 7–8; Judith Colton, 'Pigalle's *Voltaire*: realist manifesto or tribute *all'antica*?', *Studies on Voltaire and the Eighteenth Century*, CXCIII, 1980, pp. 1680–87 (with further bibliograhy). It was Diderot who advised the sculptor to take the dying Seneca as his model.

22. François Raguenet, *Les Monumens de Rome . . .*, Paris, 1700, pp. 41–5.

23. The identity of the closely related bust of the 'Pseudo-Seneca' had already been doubted by Winckelmann; on this bust, and the true portrait of Seneca, see Wolfram Prinz, 'The "Four Philosophers" by Rubens and the Pseudo-Seneca in Seventeenth-Century Painting', *Art Bulletin*, LV, 1973, pp. 410–28; Oreste Ferrari, 'L'Iconografia dei filosofi antichi nella pittura del sec. XVII in Italia', *Storia dell'arte*, LVII, 1986, pp. 104–5, with bibliography.

24. See F. Haskell and N. Penny, *op. cit.*, cat. 76, pp. 303–5. On the low status of fishermen in the ancient world, where they were represented as symbols of poverty, see the report of the lecture by Nicholas Purcell in *The Times*, 13 April 1987, p. 3; see also Hans Peter Laubscher, *Fischer und Landleute*, Mainz am Rhein, 1982.

25. Friedrich Matz and Friedrich von Duhn, *Antike Bildwerke in Rom . . .*, I, Leipzig, 1881; Wolfgang Helbig, *Führer durch die öffentlichen Sammlungen klassischer Altertümer in Rom*, II, Tübingen, 1966, pp. 699–748.

26. See the brief, and not entirely accurate, article by Walther Amelung, 'Di Statue antiche trasformate in figure di santi', *Mittheilungen des Kaiserlich Deutschen Archaeologischen Instituts, römische abtheilung*, XII, 1897, pp. 71–4.

27. S. Pressouyre, *op. cit.*, cat. 20, pp. 411–12; the palm is a modern replacement.

28. See Govanni Antonio Borboni, *Delle Statue*, Rome, 1661, pp. 116–17 (and pp. 100, 105–6); Michele Mercati, *De gli Obelischi di Roma*, [Rome, 1589], ed Gianfranco Cantelli, Bologna 1981, pp. 293–6.

29. Conyers Middleton, *A Letter from Rome*, London, 1729, p. 31; see S. Pressouyre, *op. cit.*, p. 28, note 137; the nearby church of Sta Costanza was believed to have been a temple of Bacchus, which may explain the confusion.

30. J. Montagu, *op. cit.*, cat. 123, p. 402.

31. *Ibid.*, cat. 122, p. 402.

32. See Isa Belli Barsali, *Ville di Roma*, Milan, 1970, p. 25, where the origin of the practice is documented in the Palazzo Brancone Dell'Aquila, finished in 1520, the garden constructed by Cardinal Della Valle in the same year, and the Villa Giulia of shortly after 1550.

33. I. Belli Barsali, *op. cit.*, p. 254.

34. On these see Raissa Calza, ed, *Antichità di Villa Doria Pamphilj*, Rome, 1977. See also M. Cagiano de Azevedo, *op. cit.*, p. 27.

35. Jörg Garms, ed., *Quellen aus dem Archiv Doria Pamphilj*, Rome/Vienna, 1972, docs. 1011, 1044, 1090, etc.

36. See the letter of 20 Aug. 1645: 'la raison est que il voudroit que ce qui est à vendre servist d'ornement à la ville qu'il fet faire sans le payer – ou bien l'avoir pour bien peu de chose' (Charles Jouanny, *Correspondance de Nicolas Poussin*, Paris, 1911, p. 316).

37. R. Calza, *op. cit.*, nos. 204, 206, and 180, on the South façade.

38. O. Boselli, *op. cit.*, MS. Corsini f. 172r.

39. For these statues, see Beatrice Palma and Lucilla de Lachenal, *Museo Nazionale Romano, le sculture; I, 5, I marmi ludovisi nel Museo Nazionale Romano*, Rome, 1983, cat. 75, pp. 177–180, and cat. 51, pp. 115–121; for the former, see also J. Montagu, *op. cit.*, cat. 120, p. 401.

40. Giovan Pietro Bellori, *Le Vite de' pittori, scultori e architetti moderni*, ed. Evelina Borea, Turin, 1976, p. 401. This favour is more easily to be understood if the *Hermes* is compared with two other restorations he undertook for the Ludovisi, the *Athena* which is certainly earlier, being paid for in 1627, and the *Torchbearer*, which is no doubt correctly associated with a payment of 1626, and would therefore represent Algardi's first such work for the Ludovisi. For these statues, see B. Palma and L. de Lachenal, *op. cit.*, cat. 67, pp. 159–161, and cat. 22, pp. 47–9; J. Montagu, *op. cit.*, cat. 115, p. 398, and cat. 121, pp. 401–2.

41. Se F. Haskell and N. Penny, *op. cit.*, cat. 42, pp. 219–20. It is not known when the statue was found; it is first recorded in 1649, when it was to be copied by Giovanni Pietro del Duca and Cesare Sebastiani for Philip IV of Spain (see Document II).

42. For Muñoz, the gesture of the right hand appears to accompany a lively discourse, 'e perciò male si adatta alla figura raccolta e pensosa. . . . L'artista del Seicento non poteva certo imaginare un atteggiamento così profondo e composto, incomprensibile al suo spirito di barocco, e per quella tendenza propria del suo tempo ad accentuare i movimenti, a scaldare le passioni,

ha dato al braccio un vivace gesto, proprio di un oratore caldo e artificioso' (Antonio Muñoz, 'La Scultura barocca e l'antico', *L'Arte*, XIX, 1916, p. 140). According to Cagiano de Azevedo, 'il restauro nella idea dell'Algardi era ortodosso e secondo lui consono alla maniera antica. Il tradimento del motivo originale è inconscio e spontaneo, quindi espressione della personalità dell'artista' (*op. cit.*, p. 33). According to Bruand, the correct attitude 'ne pouvait être comprise par un sculpteur de l'époque baroque' (*op. cit.*, p. 415).

43. See J. Montagu, *op. cit.*, pp. 12–14. On the *Mercury*, see Leo Planiscig, *Die Bronze-plastiken . . .*, Vienna, 1924, cat. 102.

44. See Y. Bruand, *op. cit.*, pp. 400–402; Rudolf Wittkower, *Gian Lorenzo Bernini*, London, 1966, cat. 11 (3), p. 179; F. Haskell and N. Penny, *op. cit.*, cat. 58, pp. 260–62.

45. R. Wittkower, *op. cit.*, cat. 8, p. 177.

46. B. Palma, *Museo Nazionale Romano, le sculture; I, 4, I marmi ludovisi: storia della collezione*, Rome, 1983, p. 22, and figs. 30–32. For the battle sarcophagus, see B. Palma and L. de Lachenal, *op. cit.*, cat. 25, pp. 56–67.

47. It was clearly too much for Johannes Riepenhausen, who converts it into a severely functional form in his drawing of the statue (B. Palma, *op. cit.*, p. 189, fig. 195).

48. F. Haskell and N. Penny, *op. cit.*, cat. 48, pp. 234–6.

49. Charles de Brosses, *Lettres d'Italie*, letter XXXIX, ed. of Paris, 1986, II, p. 44.

50. F. Raguenet, *op. cit.*, pp. 37–9: '& chacun sent, avec je ne sai quelle horreur qui fait frémir, la dureté du marbre qui résiste où il étoit naturel de croire que le doigt allât enfoncer.'

51. John Moore, writing in 1781, reported that 'Some critics say, he has performed his task *too well*, because the admiration of the spectator is divided between the statue and the mattress. This, however, ought not to be imputed as a fault to that great artist; since he condescended to make it [at] all, it was his business to make it as perfect as possible' (J. Moore, *A View of Society and Manners in Italy*, 1781, I, p. 492).

52. Francesco Milizia, *Dell'Arte di vedere nelle belle arti . . .*, Genoa, 1786, p. 12, quoted by Italo Faldi, 'Note sulle sculture borghesiane del Bernini', *Bollettino d'arte*, XXXVIII, 1953, p. 142.

53. Y. Bruand, *op. cit.*, pp. 407, 410. On this statue see Guido A. Mansuelli, *Galleria degli Uffizi: le sculture*, I, Rome, 1958, cat. 53, pp. 82–3; F. Haskell and N. Penny, *op. cit.* p. 235 (no. 1).

54. 'E a di 21 [March] s. 70 – m[one]ta pagati à Simone Lagi indoratore per saldo di un conto di doratura fatta a dui Lettucci, che uno da riposar l'estate l'altro per l'Ermafrodite posti al Casino della nostra Vigna di Porta Pinciana.... E a di detto s. 100 – m[one]ta pagati à Gio[vanni] Volpetta falegname per saldo di dua letticci fatti e messi al Casino della n[ost]ra Vigna di Porta Pinciana, che uno per basa dell'Ermafrodite, et l'altro da riposar l'estate . . .' (ASV, Arch. Ludovisi Buoncompagni, Libro Mastro A, f. 99, 21 March 1622).

55. See Laura Giovannini, *Lettere di Ottavio Falconieri a Leopoldo de' Medici* (Carteggio d'artisti dell'Archivio di Stato di Firenze), Florence, 1984, pp. 58–60.

56. Rudolf Wittkower, 'The Role of Classical Models in Bernini's and Poussin's Preparatory Work', in *Studies in Western Art: Latin American Art and the Baroque Period in Europe. Acts of the Twentieth International Congress of the History of Art*, III, Princeton, 1963, pp. 41–50 (reprinted in *Studies in the Italian Baroque*, London, 1975, pp. 104–114); see also Paul Fréart de Chantelou, *Journal de voyage du Cavalier Bernin en France*, ed. Ludovic Lalanne, Paris, 1981, pp. 156–7 (5 Sept.), 182 (13 Sept.) 233–4 (2 Oct).

57. Giovanni Battista Passeri, *Die Künstlerbiographien*, ed. J. Hess, Leipzig/Vienna, 1934, p. 112. It may have been with this in mind, rather than because of the classicism of du Quesnoy's own sculpture, that Sandrart included the Flemish sculptor's bust of *Sta Susanna* among the broken remains of ancient Rome in one of the plates of his *Der teutschen Academie . . .*, 1679, 2nd part, pl. qq, and illustrated his bronze *Mercury and Cupid* as if it were an antique statue (*ibid.*, pl. p).

58. Orfeo Boselli writes of 'la figura di un fauno saltante de Signori Rondinini . . . al quale sono rifatte, coscie gambe braccia e testa, a meraviglia accompagnata la maniera antica' (*op. cit.*, f. 172; see also G. P. Bellori, *op. cit.*, p. 300). The London marble was acquired from a Mr Thomas Shew and said to have come from the Rondinini Palace (Henry Ellis, *The Townley Gallery of Classic Sculpture in the British Museum*, I, London, 1846, p. 239). There seems no reason to doubt this, as, except for some understatement of the restorations (which are known from other sources), it corresponds to the description in the 1662 inventory of the Rondinini Palace: 'Un satiro figura più che del Naturale che sta in atto come di saltare tutto antico, eccetto, che in alcune parti ristorato da Fran.co Fiamingo con il suo piedistallo . . .' (Luigi Salerno, *Palazzo Rondinini*, Rome, 1965, p. 281).

59. *Galleria Giustiniana*, I, 132; see Jacob Hess, 'Notes sur le sculpteur François Duquesnoy (1594–1643)', in *Kunstgeschichtliche Studien zu Renaissance und Barock*, Rome, 1967, p. 131 (originally published in *Revue de l'art*, 1936, pp. 21–36).

60. See J. Hess, in Passeri, *Künstlerbiographien*, p. 113, note 1; François Souchal, 'La Collection du sculpteur Girardon', *Gazette des beaux-arts*, pér 6e, LXXXII, 1973, no. 234, pp. 87–8, and pl. XII of the 'Galerie', illustrated *idem*, p. 28.

61. According to Bellori, this statuette was made to accompany an antique *Hercules* (*op. cit.*, p. 300); several casts of the *Mercury* are known. For the most recent discussion, see *Die Bronzen der Fürstlichen Sammlung Liechtenstein* (catalogue of the exhibition in the Liebieghaus), Frankfurt am Main, 1986, cat. 6 (by Olga Raggio). While an influence from the ancient statue of the Belvedere *Antinous* is undeniable (see the essay by Brita von Götz-Mohr, 'Der neue Umgang mit der Antike: Merkur und Apollo von François Duquesnoy' in the Frankfurt catalogue, pp. 87–95), one might mention also the figure on the left of Saenredam's engraving of *Autumn* after Goltzius (Adam Bartsch, *Le Peintre graveur*, III, p. 258, no. 121). A drawing after the original bronze in the Giustiniani collection on p. 72 of the Carpio Album in the Society of Antiquaries in London has been overlooked in the literature.

62. Jean-René Gaborit, 'A propos de l'Hercule de Fontainebleau', *Revue de l'art*, 36, 1977, pp. 57–60.

63. On this point I differ from Gaborit; however, his attribution of the restoration to du Quesnoy is certainly to be preferred to Hildegard Utz's attempt to identify the statue as Michelangelo's *Hercules* for Fontainebleau (H. Utz, *Der wiederentdeckte Herkules des Michelangelo*, Munich, 1975).

64. For a similar reflection of painting in a restoration, see Marilyn Perry, 'On Titian's "Borrowings" from Ancient Art: A Cautionary Case', *Tiziano e Venezia*, Vicenza, 1980, pp. 187–191.

65. Heinrich A. Hase, *Verzeichniss der alten und neuen Bildwerke in Marmor und Bronze in den Sälen der Kgl. Antikensammlung zu Dresden*, Dresden, 1829, cat. 159, p. 42. This marble has since fallen victim to the archaeological bigots, but, in view of the subsequent condemnation of the group, it is of interest to note that it was drawn in the eighteenth century, while still in the Chigi collection, in one of the three volumes of drawings, predominantly after the antique, known as the 'Meade Volumes' (acquired by Lyde Browne from Meade's sale on 21 January 1755, and now in the Department of Greek and Roman Antiquities of the British Museum, 3rd vol., unpaginated).

66. Wilhelm Gottlieb Becker, *Augusteum*, II, Leipzig, 1808, pl. LXXXIII, pp. 101–103.

67. Ercole Boselli is first mentioned in the Chigi account books in 1667 (see Vincenzo Golzio, *Documenti artistici sul seicento nell'archivio Chigi*, Rome, 1939, p. 318); in his long account of 2 May 1668, covering work done since July 1667, he includes 'E più al Gluppo di Marsia e Apollo ritacatoli un dito firmato un bracio al Apollo e fatoli sotto un dato di Gesso di tre quarti stucato e dato colore' (BAV, Arch. Chigi, vol. 482, Giustificazioni del Giornale B), which relatively minor work, for which he claimed three *scudi*, indicates that the group had already been made up. I have been unable to find any reference to its acquisition.

68. That Orfeo Boselli's practice was less strict than his theory is demonstrated by the *Flora* in the Galleria Colonna, which he restored in 1666 with a head entirely modern in feeling (Guido Corti, *Galleria*

Colonna, Rome, 1937, p. 75, no. 92); I owe this example to Katrin Kalveram.

69. See Paul Zanker, 'Galba, Nero, Nerva. Die barocke Charakterstudien', *Studies in Classical Art and Archaeology*, Locust Valley (NY) 1979, p. 306, for a bust converted into a portrait of Galba, 'wahrscheinlich um eine Lücke in einer der beliebten Kaisergallerien zu schliessen' (*idem*, p. 305). On earlier collections of emperor busts, see Gerda Panofsky-Sörgel, 'Zur Geschichte des Palazzo Mattei di Giove', *Römisches Jahrbuch für Kunstgeschichte*, XI, 1967/8, p. 162.

70. The payment was made on 12 January 1627 to Bernini for 'un petto antico di marmo messo ad'una testa antica e suo peduccio' (BVA, Arch. Barb., Cardinal Francesco Barberini Sr, Giornale A, f. 140v; Marilyn Aronberg Lavin, *Seventeenth-Century Barberini Documents and Inventories of Art*, New York, 1975, doc. 26, p. 4). Like most sculptors, Bernini also dealt in antiques, and we may cite a payment of 25 *scudi* made on 28 September 1639 to the antiquarian Leonardo Agostini 'per prezzo d'una testa di una flora, la quale serve per il torso comprato già del Cav.re Bernini . . .' (BVA, Arch. Barb., Cardinal Francesco Barberini Senior, Registro de Mandati 1637–1641, no. 6645).

71. A.S.F., Carte Strozzi Uguccioni, f. 6, (no day given) September 1652; the agent was Leonardo Agostini.

72. Gabriella Capecchi, 'La Collezione di antichità del Cardinale Leopldo dei Medici: i marmi', *Atti e memorie dell'Accademia . . . La Colombaria*, XLIV, n.s. XXX, 1979, pp. 141–2, note 68.

73. Adolf Furtwängler, *Beschreibung der Glyptothek König Ludwig's I. zu München*, Munich, 1900, no. 218, pp. 199–206; Heinrich Bulle, 'Der barberinische Faun', *Jahbuch des Kaiserlich Deutschen Archäologischen Instituts*, XVI, 1901 pp. 1–18; F. Haskell and N. Penny, *op. cit.*, cat. 33, pp. 202–5.

74. Its discovery was noted by the contemporary Cassiano dal Pozzo (undated letter, see Bulle, *op. cit.*, p. 2, note 2), and slightly later, by Pietro Santi Bartoli (C. Fea, *op. cit.*, p. cclvi, para. 116). While there is no firm evidence, I should connect the *Faun* with the reference in the account of the carters Paolo and Girolamo Capelletti, 'E piu Adi d[ett]o [15 May 1627] per un viaggio pig[lia]to ad d[ett]o Castello cioe un torso di statua e portato al d[ett]o Palazzo scudi 2 [reduced to 1.20]' (BVA, Arch. Barb., Giustificazioni di Cardinale Francesco Barberini Sr, 803–925, no. 876, p. 251).

75. *Ibid.*, 1013–1094, no. 1073, f. 277.

76. *Ibid.*, 1013–1094 unnumbered, after no. 1063, f. 236. This marble was 'per la statua che al prese[n]te ristaura [?]'.

77. Letter of 26 June 1644 (C. Jouanny, *op. cit.*, pp. 277–8).

78. Inventory no. 42.

79. See Carl Robert, *Die antiken Sarkophag-Reliefs . . .*, III, 1, Berlin, 1897, plates XII–XXV.

80. See, for example, that by Giovanni Bellini at Besançon (Terisio Pignatti, *L'Opera*

completa di Giovanni Bellini, Milan, 1969, no. 211), or that by Giovanni Andrea de Ferrari at Parma (Armando O. Quintavalle, *La Regia galleria di Parma*, Rome, 1939, no. 220, pp. 207–8); for other comparisons, see Seymour Howard 'Identity Formation and Image Reference in the Narrative Sculpture of Bernini's Early Maturity . . .', *Art Quarterly*, New Series, II, 1979, p. 166, note 17.

81. A. Bartsch, *op. cit.*, XV, p. 405, no. 55; see also Michael and R. E. Lewis, *The Engravings of Giorgio Ghisi* (exhibition catalogue), New York, 1985, no. 3, pp. 39–40.

82. *Op. cit.*, pl. oo. The sculpture is now in Saint Louis. See Helmuth Bethe, Ein Pseudoantike des Cinquecento und ihr Echo in der Kunst des, XVII. und XVIII. Jahrhunderts', *Zeitschrift für bildende Kunst*, LXIV, 1930/31, pp. 181–184; Karl Möseneder, *Montorsoli. Die Brunnen*, Mittenwald, 1979, pp. 131–141. In the drawing made by Rubens in Italy (Bethe, *op. cit.* p. 182) he appears even more horizontal, seen from a viewpoint not unlike that of Teti's illustration of the *Faun*.

83. R. Wittkower, *Gian Lorenzo Bernini*, 1966, cat. 3, p. 174. This suggestion was made by Anny E. Popp, 'Der barberinische Faun', *Jahrbuch für Kunstgeschichte*, I, 1921–2, p. 232, though she did not believe that the horizontal restoration was ever carried out.

84. R. Wittkower, *op. cit.*, cat. 4, p. 174; Wittkower refers, apparently favourably, to this association (cat 11 (2), p. 179), though recognising that the *St Sebastian* anticipates the discovery of the torso of the *Faun*. Anny Popp, who would date 'Bernini's' diagonal restoration to the end of the reign of Urban VIII, relates it to the figures on Bernini's slightly later *Four Rivers Fountain* (*op. cit.*, p. 234). For an examination of the relationship of Bernini's *St Sebastian* to the *Faun* see S. Howard, *loc. cit.*

85. BAV, Arch. Barb., Cardinal Francesco Barberini Senior, Giustificazione 12861. The pages relevant to the *Faun* are reproduced in Document III, both because they have never hitherto been published, and because they provide a typical example of the procedure, and labour, of restoration.

86. Dr Dieter Ahrens of the Glyptothek pointed out to me that one of these blocks was a piece of antique marble.

87. Giuseppe Morazzoni and Saul Levy, *Le Porcellane italiane*, Milan, 1960, II, tav. 276. Volpato was born in 1733, and died in 1803.

88. The copy, now in the Louvre, was made between 1726 and 1730; see Alphonse Roserot, *Edme Bouchardon*, Paris, 1910, pp. 16–18 (illustrated opposite p. 18).

89. To the bibliography of the statue cited above should be added the 'Giornale di Vincenzo Pacetti', Rome, Bibl. Alessandrina, MS. 321 (old 90365), passim; the 'Diario di Vincenzo Pacetti, a forma di rubriche', Rome, Regio Istituto per la Storia del Risorgimento Italiano, Busta 654, no. 5 (under 'B' and 'P'); Orietta Rossi Pinelli, 'Artisti, falsari o filologhi?',

Ricerche di storia dell'arte, XIII–XIV, 1981, pp. 43–4, and note 13, pp. 54–5.

90. *Documenti inediti per servire alla storia dei musei d'Italia*, IV, Florence/Rome, 1880, pp. 41–2.

91. A rather pretty little stucco model in a private collection in America is said to have had an early inscription painted on the back reading 'fatto del Mano del Cavaliere Gianlorenzo Bernini', until it was washed off by an over-zealous char. Unless the inscription were autograph, this would hardly constitute proof.

92. A Barberini inventory, taken at the death of Cardinal Carlo in 1704, includes 'il modello del Fauno di creta cotta dorato' (ASV, Arch. Barb., Indice II, vol 2454, f. 180v); the fact that it is anonymous does not, alas, prove anything, as scarcely any names are given in this inventory.

93. One might suggest that his advice would have been sought for such a famous and important piece. That he did accept to oversee restorations by others (though how closely he actually did so remains unknown) is proved by a letter from Orazio Falconieri to Cardinal Leopoldo de' Medici of 23 June 1668, stating that he had given a marble group of *Cupid and Psyche* to Cosimo Fancelli for restoration, and 'perché l'A.V. resti meglio servita, procurerò che il Cav.re Bernino, in conformità di quello che ha dato intenzione di voler fare, sopraintenda al lavoro' (L. Giovannini, *op. cit.*, Florence, 1984, no. 99, p. 20l). Although in the next reference to this group he says that 'al Cav.re Bernino rappresenterò il desiderio di V.A. perché vi cooperi anche lui' (*ibid.*, no. 111, p. 220), it is questionable whether Bernini did so, particularly as at this time he was more concerned that Fancelli complete his marble *Angel* for the Ponte Sant'Angelo (*ibid.*, no. 120, p. 229).

94. Anatole de Montaiglon, *Correspondance des directeurs de l'Académie de France à Rome*, I, Paris, 1887, letter 354, p. 298. The statue has since been moved to the Loggia dei Lanzi in Florence, and has passed under many names (Hans Dütschke, *Die antiken Marmorbildwerke der Uffizien in Florenz (Antike Bildwerke in Oberitalien*, III, Leipzig, 1878, no. 560, p. 256, where it is catalogued as the 'so-called Thusnelda'). We should note that Le Gros worked, at least in part, from moulds; see letter 361, p. 321: 'Le S.r Legros commencera son modelle de terre . . . dès lors que le mouleur aura moulé les parties nues de lad. figure . . .'.

95. The finished marble is in the Tuileries gardens (François Souchal, *French Sculptors of the 17th and 18th centuries. The Reign of Louis XIV*, II, Oxford, 1981, p. 274, no. 2; Geneviève Bresc-Bautier and Anne Pingeot, *Sculptures des jardins du Louvre, du carrousel et des Tuileries*, Paris, 1986, II, no. 220, pp. 258–60); a large terracotta was owned by Lalive de Jully (Ibid., p. 274, note 3). A 'Matron of the Villa Medici Model by Mons.r Le Gros' was acquired by Brettingham for Lord Leicester (Malcolm Baker, 'That "most rare Master Monsii Le Gros" and his "Marsyas"',

Burlington Magazine, CXXVII, 1985, p. 706).

96. The figure is placed close to the wall of the Loggia dei Lanzi, which is now under restoration, and closed off. I am grateful to Benita Cioppa for the photo used here.

97. A. de Montaiglon, *op. cit.*, letter 394, p. 372. He took the liberty of changing the folds that touched the ground, made one foot more visible than the other for the sake of variety, and replaced the sandals with ones copied from a fragment in the collection of Bellori.

98. *Ibid.*, letter 393, p. 369; see also the reply from La Teulière, letter 396, p. 376.

99. *Ibid.*, letter 369, p. 376.

100. *Ibid.*, letter 393, pp. 369–70.

101. *Ibid.*, letter 396, pp. 375–81.

102. *Ibid.*, letter 404, pp. 392–3.

103. It should be remembered that Viallacerf's criticisms were based on François Perrier's print of the antique, and Sarrabat's defective drawings of the model, which itself may well have been modified in execution.

CHAPTER VIII

1. 'Il teatro rimane nei palazzi delle élites, le macchinazioni effimere sono lo spettacolo per tutti' (M. Fagiolo Dell'Arco and S. Carandini, *L'Effimero barocco*, 1978, II, p. 21). However, for the public theatrical entertainments of the pontificate of Clement IX, see Alessandro Ademollo, *I Teatri di Roma del secolo decimosettimo*, Rome, 1888, pp. 109–113.

2. See Alberto Cametti, *Il Teatro di Tordinona poi di Apollo*, I, Tivoli, 1938.

3. See, for example, Stefano della Bella's prints of the entry of the Polish ambassador to Rome in 1633 (Alexandre de Vesme, *Etienne Della Bella*, ed. Phyllis Dearborn Massar, New York, 1971, nos. 44–9).

4. See Giacinto Gigli, *Diario romano*, ed. Giuseppe Ricciotti, Rome, 1958, pp. 81–338, *passim*.

5. G. Gigli, *op. cit.*, pp. 81–3, 228.

6. Compare its present-day substitute, a painting by Caravaggio or some equivalently fashionable master, in honour of which tourists can be persuaded to make an offering of 100 or 200 *lire* to turn the lights on.

7. G. Gigli, *op. cit.*, pp. 361–62.

8. *Ibid.*, p. 363: 'Ma di questo io mi stupisco, che il Demonio, il quale le vuol far la scimia di Dio, par che voglia ajutarlo a fare i miracoli, o più tosto cerca, per così dire, di screditarlo, mentre li miracoli si scoprono poi esser finti, e non veri. Ma finalmente torna poi ogni cosa in sua maggior confusione, perchè si sà che li Miracoli, che fa Dio son veri, et li suoi sono falsi e bugiardi'. However, it is notable that after this date Gigli records no further miracles in his diary.

9. See Mark S. Weil, 'The Devotion of the Forty Hours and Roman Baroque Illusionism', *Journal of the Warburg and Courtauld Institutes*, XXXVII, 1974, pp.

218–48; Per Bjurström, 'Baroque Theater and the Jesuits', in *Baroque Art: The Jesuit Contribution*, ed. Rudolf Wittkower and Irma B. Jaffe, New York, 1972, pp. 104–110.

10. See, for example, Paolo Brezzi, *Storia degli Anni Santi*, Mursia, 1975; Pericle Perali, *Prontuario bibliografico per la storia degli Anni Santi*, Rome, 1928.

11. See M. Fagiolo Dell'Arco and S. Carandini, *op. cit.*, I, pp. 69–70 and 279–81 for the Feast of the Rosary in the Dominican church of Sta Maria sopra Minerva in 1625 and 1675.

12. See G. Gigli, *op. cit.*, pp. 24, 27, 29–30, etc. For a readily accessible description of such celebrations, see those surrounding the taking of the image of the Madonna del Fuoco at Forlì to its new chapel (A. Hyatt Mayor, 'The First Famous Print', *The Metropolitan Museum of Art Bulletin*, IX, 3, 1950, pp. 73–6).

13. Pietro Tacca, whose advice Bernini had sought on the casting of the *Baldacchino* (see above, Chapter 3, note 26), had come to Rome for the Holy Year of 1625 with the Company of St Benedict from Florence; when the same Company returned to Rome for the Holy Year of 1675 they were given dinner by Francesco Barberini, and the payment he made to the silversmith Antonio Pellicani on 10 July 1675 included 3.30 *scudi* 'per il prezzo d'una posata d'argento, cioè cocchiaro, e forchetta presa nella cena fatta fare da noi alla Compagnia di S. Benedetto di Firenze' (BAV, Arch. Barb., Cardinal Francesco Barberini Sr, Mandati 1675–78, no. 12; see also Giustificazione 11834). Such losses were a normal consequence of almost any banquet, no matter how distinguished the guests; for example, after the Christmas banquet provided by Alexander VII for the cardinals in 1654 he had to replace a silver basin (*navicella*) and two silver dishes (ASV, Sacri Palazzi Apostolici, Computisteria, vol. 3024, p. 40).

14. G. Gigli, *op. cit.*, p. 365.

15. *Ibid.*, pp. 365, 366.

16. *Ibid.*, p. 364; see also pp. 354–5, 360, 363, 377.

17. Giovanni Simone Ruggieri, *Diario dell'anno del Santissimo Giubileo MDCL ...*, Rome, 1651, p. 87.

18. *Ibid.*, p. 133; G. Gigli, *op. cit.*, pp. 353, 379.

19. G. Gigli, *op. cit.*, pp. 353–4.

20. *Tesori d'arte sacra* (exhibition catalogue), Rome, 1975, cat. 431.

21. J. Montagu, *Alessandro Algardi*, New Haven/London, 1985, pp. 341–2, cat. L.30. This confraternity, one of the most respected in Rome, was in regular competition with another attached to S. Marcello, that of the Crucifix, and both, by tradition, held their processions on Maundy Thursday.

22. G. S. Ruggieri, *op. cit.*, p. 86.

23. J. Montagu, *op. cit.*, pp. 127–8, p. 484, list 71.

24. Munich, Graphische Sammlung, inv. 34863. We may note that very similar images of the resurrected Christ occur on

the confessionals and on the doors of the chancel balustrade in S. Lorenzo in Lucina (as was pointed out to me by Marc Worsdale), but I have failed to find any connection, such as a Confraternity of the Resurrection attached to the church.

25. G. Gigli, *op. cit.*, pp. 353, 355; G. S. Ruggieri, *op. cit.*, pp. 77, 87.

26. G. S. Ruggieri, *op. cit.*, p. 272. We may assume that the candles so often remarked upon by Gigli were set in silver candlesticks.

27. See Per Bjurström, *Feast and Theatre in Queen Christina's Rome*, Stockholm, 1966, pp. 70–87.

28. See Rudolf Berliner, *Die Weihnachtskrippe*, Munich, 1955, especially pp. 74–5. Neither this standard source, nor any other, contains much information about Roman seventeenth-century cribs, though a great deal of attention has been given to Neapolitan cribs from the end of the seventeenth century, and the even more numerous productions of the eighteenth century.

29. See, for example, J. Montagu, 'Antonio and Giuseppe Giorgetti', *Art Bulletin*, 1970, p. 280, note 19. For others, including one of papier mâché and wood, presumably covered with real clothes, see *ibid.*, p. 293.

30. Marilyn A. Lavin, *Seventeenth Century Barberini Documents and Inventories*, New York, doc. 324, p. 40.

31. M. A. Lavin, *op. cit.*, doc. 54, p. 7.

32. Düsseldorf, Kunstmuseum, Kupferstichkabinett, inv. FP. 3505. The attribution is presumably to Pietro Lucatelli.

33. Andrea Pozzo, *Perspectiva pictorum atque architectorum*, published originally in Rome, 1693–1700, reprinted at Augsburg 1706–9, I, fig. 66.

34. No. 3047; red chalk, sheet irregularly trimmed, maximum measurements 21.3 × 32.1 cm. It is ascribed to Gianlorenzo Bernini.

35. It could, of course, be argued that Pozzo was copying already existing figures, designed by another artist; but this seems unlikely, and the style of the drawing is fully acceptable as his.

36. The print was produced as a demonstration of perspective, which may be why it does not include the image of the dead Christ, which Pozzo says should be below the remarkably bare-looking altar.

37. M. Fagiolo Dell'Arco and S. Carandini, *op. cit.*, provides the most notable and extensive contribution, with references to earlier bibliography.

38. See above, note 9.

39. The only certain surviving works by him are the figure of *Sta Martina* below the high altar of SS. Luca e Martina (see Karl Noehles, *La Chiesa dei SS. Luca e Martina nell'opera di Pietro da Cortona*, Rome, 1969, pp. 101, 182, and docs. 35 and 55), the figures of the relief above the niche of the *Volto Santo* in St Peter's (Oskar Pollak, *Die Kunsttätigkeit unter Urban VIII*, II, Vienna, 1931, pp. 499–501), and the stucco figures of *Chastity* and *Faith* in the nave of the same church (Robert Enggass, 'New Attributions in St Peter's: The

40. M. Fagiolo dell'Arco and S. Carrandini, *op. cit.*, p. 150–52.

41. *Ibid.*, pp. 120–2; M. S. Weil, *op. cit.*, pp. 232–4; the engraving was made by Grimaldi.

42. On this altar see Irving Lavin, *Bernini and the Unity of the Visual Arts*, Oxford/New York/London, 1980, pp. 104–6; It should be pointed out that, while artificial light today augments the effect, Bernini relied here on natural light alone.

43. M. S. Weil, *op. cit.*, p. 227, quoting BAV, MS. Urb. Lat. 1098, part 2, f. 701.

44. W. Chandler Kirwin, 'Bernini's Baldacchino Reconsidered', *Römisches Jahrbuch für Kunstgeschichte*, XIX, 1981, p. 169, quoting Arch. Capitolari di S. Pietro, Diari, vol. 11, ff. 54r–56r. On this occasion the decorations were dispersed in various ways, but those for the canonisation of Sts. Peter of Alcantara and Maria Maddalena de' Pazzi of 1669 were given to Sta Maria Maggiore (Marc Worsdale, 'Bernini inventore', in *Bernini in Vaticano*, exhibition catalogue, Rome, 1981, p. 232).

45. M. Fagiolo Dell'Arco and S. Carandini, *op. cit.*, I, pp. 46–53, with additional bibliography.

46. Compare the catafalque for Sixtus V of 1591, designed by Domenico Fontana (*ibid.*, pp. 3–13).

47. G. Gigli, *op. cit.*, p. 56.

48. See M. Fagiolo Dell'Arco and S. Carandini, *op. cit.*, I, pp. 79–81; see also J. Montagu, *Alessandro Algardi*, 1985, pp. 27–9, and pp. 421–2, cat. L.139.

49. This was a relative of the better-known Nicolas, 'il Franciosino', who had died in 1612. See, in particular, Sylvia Pressouyre, *Nicolas Cordier*, 1984, pp. 42–3; a litttle more about his work emerges from the Roman archives than is included in that book, 343ff.

50. It was made by Annibale Serena and cost 304 *scudi* (Arch. Cap., Credenza VI, vol. 30, p. 492).

51. Arch. Cap., Credenza VI, vol. 30, p. 491, payment of 4 September 1630 for the cost of the 'Privileggio di Cittadinanza' accorded to Bernini 'per essersi portato valorosam[en]te in far fare il sud[et]to catafalco'.

52. On these processions, see Francesco Cancellieri, *Storia de' solenni possessi de' Sommi Pontefici*, Rome, 1802, and M. Fagiolo Dell'Arco and S. Carandini, *op. cit.*, *passim*.

53. F. Cancellieri, *op. cit.*, pp. 207–56; M. Fagiolo Dell'Arco and S. Carandini, *op. cit.*, pp. 131–3.

54. For the artists employed on this arch see Arch. Capitolino, Credenza IV, vol. 112, ff. 170–171r.

55. See above, p. 140.

56. '... havendo io cura come Architetto di detto Arco di dar a far et distribuire li lavori che si dovevano far ...' (ASR, Tribunale del Governatore, Miscellanea Artisti, fasc. 157; an attestation as to Domenico Prestinari's work on the arch of 23 March 1646).

57. G. Gigli, *op. cit.*, pp. 262–3. Gigli informs us that the arch of the Conservatori was finished a few days later, and the pope 'passed by as if on purpose to see it' (*idem*, p. 263).

58. From the extensive list of contemporary references to uncompleted decorations, both in Italy and the North, kindly supplied to me by Elizabeth McGrath, one may cite the triumphal entries of Albert and Isabella into Pavia and Valenciennes in 1559 (Joannes Bochius, *Historica Narratio profectionis et inaugurationis Serenissimorum Belgii Principum Alberti et Isabelae, Austria Archiducum ...*, Antwerp, 1602, pp. 103, 421), that of Henri IV into Lyon in 1595 (Théodore Godefroy, *Le Cérémonial françois*, I, Paris, 1649, pp. 932–3, citing Pierre Matthieu), or that of Ferdinand of Austria into Ghent of 1635 (Guglielmus Becanus, *Serenissimi Principis Ferdinandi Hispaniarum Infantis ... triumphalis Introitus ...*, Antwerp, 1636, pp. 40, 49).

59. G. Gigli, *op. cit.*, p. 263. Prints are not always reliable records of events; for example, the Forty Hours' display in the Gesù of 1650 was engraved from the architect's design, which was not entirely realised (*ibid.*, p. 351; for the print see M. Fagiolo Dell'Arco and S. Carandini, *op. cit.*, p. 140).

60. I have found no evidence as to how long such ephemeral decorations remained up.

61. Arch. Capitolino, Credenza IV, vol. 112, f. 170. In mid-sixteenth-century Florence the decorations of the famous obsequies of Michelangelo were later sold by the Accademia del Disegno (Zygmunt Waźbiński, 'La Prima mostra dell'Accademia del Disegno a Firenze', *Prospettiva*, 14, 1978, pp. 47–57). Compare the fate of the Regent Street Christmas decorations which may reappear at Blackpool in the summer, or the carnival figures and decorations of Nice which may be sold in Europe, North Africa or Japan, to raise money for next year's celebrations (*New York Times*, 4 March 1981, p. A7).

62. G. S. Ruggieri, *op. cit.*, p. 10.

63. ASR, Corp. Relig. Maschile, Agostiniani Scalzi (Gesù e Maria), Busta 191, fasc. 259, pp. 15–17. See also M. Fagiolo Dell'Arco and S. Carandini, *op. cit.*, II, p. 90; Filippo Tevisani, 'Carlo Rainaldi nella chiesa di Gesù e Maria al Corso' *Storia dell'arte*, XI, 1971, pp. 164–171.

64. The Bernini studio drawing is in Paris, Archives des Affaires Étrangères, Correspondance politique, Rome 192; that by Sevin is in Stockholm, Nationalmuseum, THC 3624. The true purpose of these drawings was identified by Marc Worsdale, 'Bernini Studio Drawings for a Catafalque and Fireworks, 1668', *Burlington Magazine*, CXX 1978, pp. 462–6. It is interesting to note that the figure of the Catholic Church was identified by Carlo Cartari as Religion, and that of Victory as Peace (*ibid.*, appendix III, p. 466); evidently the quite simple iconography of such a display was not always understood, even by an educated Roman.

65. M. Fagiolo Dell'Arco and S. Carandini, *op. cit.*, I, pp. 197–203.

66. See J. Montagu, 'Antonio and Giuseppe Giorgetti', *Art Bulletin*, 1970, pp. 278–98.

67. Even for so fully documented a sculptor as Bernini, we should note that a list of his works, quite possibly drawn up by the artist himself, includes the note that 'non si pongono le scene, quarant'hore, fochi d'alegrezza, catafalchi, mascherate e cose simili quali sono innumerabile' (Cesare D'Onofrio, *Roma vista da Roma*, Rome, 1967, p. 438); so famous was he for such marvels that, when Pope Urban VIII appeared at a window after an illness to prove that he was still alive, some of the populace preferred to believe 'quella non esser il loro Pontefice Urbano, mà il corpo di Urbano, che per artificio del Bernino si manteneva intatto, e si moveva: Haver'essi veduto poco prima in quell'istessa finestra il Cavaliere, & altra che sua non poter essere l'invenzione di dar moto ad un Corpo già morto.' (Domenico Bernini, *Vita del Cavalier Gio. Lorenzo Bernino*, Rome, 1713, p. 36).

68. Per Bjurström describes the elaborate 'festa gastronomico comico-musicale' given by Cardinal Chigi on August 15th 1668, in Monsignor Salvietti's garden, a combination of opera, spectacle and food – or it would have included food, had the stoves not failed to light – which cost two thousand *scudi* (Per Bjurström, *Feast and Theatre in Queen Christina's Rome*, 1966, pp. 65–9). Alexander VII's banquet for the ambassadors of Venice on 35 November 1655 cost 1277.90 *scudi*, and his total expenses for banquets, 'regalli', and the entertainment of Queen Christina for the last three months of that year came to 6878.37 scudi (ASV, Sacri Palazzi Apostolici, Computisteria, vol. 3024, p. 118); those for the cardinals, bishops and priests on Thursday and Friday of Holy Week in 1656 cost 1820.51½ *scudi* (*ibid.*, vol. 3025, p. 8).

69. The Libri Mastri of Cardinal Francesco Barberini Senior (kindly shown me by Jörg Martin Merz) indicate that the cost of those in S. Lorenzo in Damaso might vary from around two hundred *scudi* to close on nine hundred. While that of the Holy Year of 1650 cost 857.60 *scudi*, that of 1649 cost only 197.48, and that of 1651, 276.29. References to payments for refurbishing the clouds, etc., make it clear that much of the apparatus would serve for several years.

70. If one examines the accounts of Cardinal Flavio Chigi for 1663–8 (BAV, Arch. Chigi. vol. 537, Registro de Mandati), Giovanni Battista Gaulli's two paintings of the *Assumption of the Virgin* and a *Pietà*, each of 8 × 6½ *palmi*, cost 180 *scudi* (no. 2942, of 25 May 1667), almost the same as the food for two months, exclusive of bread and wine, which came to 172.18½ *scudi* (nos. 2831–5, of 13 April 1667, covering January and February). At a lower level, Michele Pace's six paintings, each of two dogs, cost 24 scudi (no. 1842, of 25 January 1666), where as the twenty-four collars and leads for the same twelve hounds cost 15.6 *scudi* (no. 1840, of 23 January 1666).

71. The price of a horse in the same Chigi account book varied from about forty *scudi* to two hundred, perhaps because some were bought to race in the *palio* at Siena.

72. J. Montagu, *Alessandro Algardi*, pp. 109–110, and p. 484, list 74.

73. Giulia Fusconi, 'Disegni decorativi di Johann Paul Schor', *Bollettino d'arte*, ser. VI, LXX, 1985, 33–34, p. 161, and fig. 7.

74. Giulia Fusconi, 'Per la storia della scultura lignea in Roma: le carozze di Ciro Ferri per due ingressi solenni', *Antologia di belle arti*, N.S., 21/22, 1984, pp. 80–97.

75. Stockholm, Nationalmuseum, THC 2089, 2085; see Ragnar Josephson, *Tessin*, Stockholm, 1930, I, figs. 41, 45.

76. Bernini also used such motifs in other places, for a list of payments of 30 August 1680 to the *spadaro*, Carlo Mattei, for polishing and gilding metalwork, included six firedogs each with a metal mask 'con modello del Signor Cavaliere Bernini' (Vincenzo Golzio, *Documenti artistici sul Seicento nell'archivio Chigi*, Rome, 1939, p. 348).

77. Casts of these four heads are sometimes encountered on the market. The originals are listed in the 1706 inventory of Bernini's heirs as 'quattro testine di gettito di bronzo con li suoi piedi di pietra, quali erano li vasi della carrozza del Cavaliere' (Franco Borsi, Cristina A. Luchinat, Francesco Quinterio, *Gian Lorenzo Benini: Il testamento, la casa, la raccolta dei beni*, Florence, 1981, p. 108). All previous references had transcribed '*vasi*' as '*nasi*', despite the fact that there is no such part of a carriage (see *Meesters van het brons der Italiaanse Renaissance*, exhibition catalogue, Amsterdam, 1961, cat. 182, with bibliography). We may note that the manuscript 'v' and 'n' are virtually indistinguishable, and a similar error was made in the transcription of Ferrata's inventory, which includes 'quattro pezzi di gesso del naso della Regina' (Vincenzo Golzio, 'Lo "studio" di Ercole Ferrata', *Archivi*, II, II, 1935, p. 67); despite the size of Queen Christina's nose, which was often remarked on, this seems hardly likely.

78. ASV, Casa Borghese, vol. 5598, 333 (account of Pietro Paolo Giorgetti for the wood-carving) etc.

79. New York, Metropolitan Museum of Art, inv. 1979.131 (J. Montagu, *op. cit.*, pp. 109–110, and list 79, p.485); it can hardly have balanced properly as a free-standing decorative vase, and it looks too big and complex to have decorated a chair-back.

80. Georgina Masson, 'Papal Gifts and Roman Entertainments in honour of Queen Christina's Arrival', *Queen Christina of Sweden: Documents and Studies*, Stockholm, 1966, pp. 244–251. It should be noted that the archive of the Sacri Palazzi Apostolici in the ASV has been reorganised with an inadequate inventory, and no concordance: Masson's vol. 771 is now Computisteria 3024.

81. *Ibid.*, p. 245.

82. G. Masson, *loc. cit.* According to Domenico Bernini, this coach for Christina 'fù con artificio meraviglioso intagliato conforme il disegno del Bernino, che non hebbe piccola parte ancora nella maestroso apparecchio del suo alloggio nel Palazzo del Vaticano.' (D. Bernini, *op. cit.*, p. 103).

83. Giovanni Incisa della Rocchetta, 'Frammenti di una carrozza secentesca', *Colloqui del sodalizio*, II, 1951/2–1953/4, (1956), pp. 135–9 (this article does not completely clarify the origins of these frames: payments were made in 1680 for the paintings by Nicolò Stanchi 'per mettere in sei cornice di rame dorato, che stavano alla carrozza delle ghiande', or 'che si sono levato dalla carrozza della ghiande'; Incisa della Rocchetta says that this coach, decorated with the acorns of the Chigi arms, was being made in 1679, yet accepts that the frames are those made to go in the 'carrozza di velluto nero' made in 1658–61); Giulia Fusconi doubts that the closely related drawing by G. P. Schor (Rome, GND, F.C. 127536) is for this frame (see her article, *Disegni decorativi del barocco romano*, exhibition catalogue, Rome, 1986, pp. 47–8, cat. 35; see also *idem*, 'Disegni decorativi di Johann Paul Schor', p. 164); but it seems quite possible that the sketch by Schor was modified in, or before, execution.

84. P. Bjurström, *op. cit.* (*Feast and Theatre*), p. 53; most of what follows is taken from this source.

85. Stockholm, Nationalmuseum, THC 3606; see P. Bjurström, *op. cit.*, p. 128, note 10; *idem*, *Drawings in Swedish Public Collections, 2: French Drawings, Sixteenth and Seventeenth Centuries*, Stockholm, 1976, cat. 661.

86. Georgina Masson, 'Food as a Fine Art', *Apollo*, LXXXIII, 1966, p. 338. They were cast in sugar by Girolamo Lucenti, Giacinto Martinelli and Paolo Carnieri, the first and last of these being well known as bronze-founders. The payment to Ferrata is now ASV, Sacri Palazzi Apostolici, Computisteria 3024, p. 96; that to the founders *idem*, p. 94.

87. Rome, GNS, F.C. 1556; P. Bjurström, *Feast and Theatre*, p. 54, and cat. p. 142; G. Fusconi, *Disegni decorativi*, 1986, pp. 31–2, cats. 1r, 2r.

88. Stockholm, Nationalmuseum, THC 3614; see P. Bjurström, *op. cit.*, p. 64, and cat. p. 144. This shows a dinner given by Olimpia Aldobrandini, Princess of Rossano, for the newly elected Cardinal Leopoldo de' Medici in 1667 (*idem*, *Drawings in Swedish Public Collections*, cat. 679).

89. G. Fusconi, 'Disegni decorativi di Johann Paul Schor', p. 165, and figs. 13 and 14. By the figure is written 'disengno di Un triumpo di cucaro per il pasto dela Regina di Suecia nel pasto del sua sandita'. Also on the recto of this drawing (New York, Metropolitan Museum, inv. 1985.64) are sketches for a frame including Christina's emblem of the wheatsheaf, and on the verso is a horse with a saddle and cloth labelled 'modelo dela boltrapa dela Regina di shuezia per la intrata di Roma'.

90. See the dishes described in Bartolomeo Stefani, *L'Arte di ben cucinare . . .*, Mantua, 1662, edited by Gino Brunetti as *Cucina mantovana . . .*, Mantua, 1963, e.g. pp. 179, 164. The idea of marzipan hunters attacking the game dishes was one much favoured by Stefani, see pp. 172, 180, 181–2, 184.

91. Stefan Bursche, *Tafelzier des Barock*, Munich, 1974, pp. 16–17.

92. For butter see the payment of 21 July 1634 of 17.70 *scudi* 'A Franc[esc]o Monaldi Indoratore per diverse indorature di trionfi di biturio e zuccaro servite per le nozze . . .' (ADP, Banc. 86, vol. 21, p. 50A). For jelly (or, presumably, aspic) see B. Stefani, *op. cit.*, e.g. p. 168; a representation of the port of Messina in aspic with live fish enclosed and jumping in the water was made for Queen Christina (G. Masson, *op. cit.* ['Food as a Fine Art'], p. 338), but how this was made defies even the expertise of such a modern expert on cooking as Elizabeth David (oral communication). For ice see the reception given by Prince Borghese and described by Ottavio Falconieri on 27 August 1667, where the decorations consisted of 'trenta gran bacili di canditi adornati di fiori di seta ed altre galanterie, da 20 fruttiere piene di confetura bianca che tramezzavano i Bacili, guarnita di vasi et altri trionfi di ghiaccio' (Laura Giovannini, *Lettere di Ottavio Falconieri*, I, Florence, 1984, p. 189); Torquato Montauti had also referred to the 'statue di zucchero' at this reception (*ibid.*, p. 190, note 5).

93. S. Bursche, *op. cit.*, p. 44; however, a dinner given by Cardinal Flavio Chigi included gilded artichokes (BAV, Arch. Chigi, vol. 483, Giustificationi del Giornale B, account of Vincenzo Corallo for October 1668). The Germans also made extensive use of wax, especially for architectural features.

94. *Plans of the Vatican* (B.L., 75.k.1), plan no. 19, inscribed 'Abitazione dei Cuochi della forestaria, e stanza dei trionfi'. It was Olga Raggio who kindly brought this plan to my notice.

95. The art of making edible table decorations continued through the eighteenth century, and is described by Marie Antonin Carême (*Le Patissier pittoresque*, 4th ed., Paris, 1842); although he provides recipes for '*patisserie mangeable*' and almond paste, one is left in some doubt as to the edibility of his gold and silver foil, and bronze colours, which were to be bought from an ordinary colour merchant, and his '*mastic*' which will last for at least twenty-four years, containing marble dust among its ingredients, seems to defeat its purpose. On the other hand, by the later eighteenth century, sugar sculpture seems to have been used not merely for the decoration of dinner tables, and the diary of Chracas tells of Antonio Chichi who made 'il perfetto modello in sughero delle rinomate Loggie Vatican dipinte dal celebre Raffaello, commesogli a nome della Sovrana di tutte le Russie' and sent to St Petersburg (15 May 1779; see V. Minor, 'References to Artists and Works of Art in Chracas' *Diario ordinario*

– *1760–1785*', *Storia dell'arte*, XLVI, 1982, p. 255); the same source also tells of another expert, one Augusto Rosa, a great-nephew of the painter Salvator Rosa, who was able to 'formare ... con singolar simetria gli avanzi delle Romane Antichità in sugaro, e pietra pomice' (17 December 1774, see V. Minor, *op. cit.*, p. 246). Similar forms of art flourished during the Edwardian period, and are not unknown today (see the portrait of Margaret Thatcher made of salmon pâté with vermicelli hair, etc., illustrated in *The Magazine*, June, 1985, p. 40).

96. See G. Masson, *op. cit.* ('Food as a Fine Art'), p. 338, for Christina's request to have the *trionfi* brought to her room after the dinner so that she might admire them, and the embarrassment this caused as some had already been given away.

97. John Michael Wright, *Ragguaglio della solenne comparsa fatta in Roma gli otto di gennaio MDCLXXXVII. dall'Illustrissimo, et Eccellentissimo Signor Conte di Castlemaine ...*, Rome, 1687, pp. 63, 79.

98. Stockholm, Nationalmuseum THC 3610; P. Bjurström, *Feast and Theatre*, p. 62, and cat. p. 144. It shows a banquet given by the pope on Maundy Thursday, 1668 (*idem, French Drawings*, cat. 677).

99. Stockholm, Nationalmuseum THC 3608; P. Bjurström, *Feast and Theatre*, p. 66, and cat. p. 144. It shows a banquet given by the pope on Maundy Thursday, 1667 (*idem, French Drawings*, cat. 676).

100. The table was set with 'vaghe piegature, con dicinove Trionfi, posti in ordinanza nel mezzo de la Tavola, figurando molte Istorie de la Sacra Scrittura: con quantità di Vivande, Frutti, e Confettioni, imaginabili da suo pari' (Ruggiero Caetano, *Le Memorie de l'Anno Santo M.DC.LXXV*, Rome, 1691, p. 132); the same source records that on the same day the pope washed the feet of thirteen poor '*Sacerdotti Oltramontani*' and gave them a dinner 'con Trionfi, e Statue di Zuccaro, e gentilissime piegature di Salviette' (*loc. cit.*).

101. Ugo Nebbia, *La Scultura nel duomo di Milano*, 1910, p. 23.

102. J. Montagu, *Alessandro Algardi*, cat. 11, pp. 323 ff.

103. *Ibid.*, cat. 9, pp. 315 ff.

104. I have suggested that this reliquary for the skull of St Feliciano in the Treasury of S. Lorenzo in Florence is by an artist close to Algardi, while pointing out the similarity of the *Angels* to those by Antonio Giorgetti (*ibid.*, p. 188; see also figs. 215–16).

105. Apart from those sculptors already mentioned, see also the payment of 30 *scudi* made by Taddeo Barberini on 21 July 1634 'à Nicolo Cordier franzese per tutti li lavori di paste di zucchero et altro fatte da lui' (J. Bousquet, *Recherches sur le séjour des peintres français à Rome au XVIIème siècle*, Montpellier, 1980, p. 139); this was the lesser sculptor of that name (see above, note 49). On 7 February 1646 the Mantuan ambassador to Rome reported on a banquet given by Cardinal Camillo Pamphilj with 'dui Triofi di butiro bellissimi di mano dell'algardi che il primo era un Centauro, che gropina una Donna e laltro una Diana con un Arco in mano in atto di tirrare con suo Carcasso alato' (Archivio di Stato di Mantova, Cancelleria Ducale Estense: Ambasciatore, Italia, Roma Busta 243; I am grateful to Janet Southorn for this reference).

106. See above, note 86.

107. Katharine J. Watson has found descriptions of a Florentine banquet for which the *trionfi* were made by one of Giambologna's leading assistants, and the subjects were so similar to those of known small bronzes by Giambologna that she suggested that moulds might have been taken from them to cast the sugar sculpture ('Sugar Sculpture for Grand Ducal Weddings from the Giambologna Workshop', *The Connoisseur*, CLXXXXIX, 1978, pp. 20–26, with references to earlier instances).

108. Stockholm, Nationalmuseum, THC 3608; P. Bjurström, *Feast and Theatre*, p. 66, and cat. p. 144. It shows the banquet given by the pope on Maundy Thursday, 1666 (*idem, French Drawings*, cat. 675).

109. J. M. Wright, *op. cit.*; see also G. Masson, *op. cit.* ('Food as a Fine Art'), pp. 340–41.

110. 'Il Costantino messo alla Berlina, o Bernina su la Porta di San Pietro', BAV, Barb. Lat. 4331, p. 5, quoted by George C. Bauer, *Bernini in Perspective*, Englewood Cliffs (New Jersey), 1976, p. 48; Bauer translated '*un trionfo*' as 'a triumph', without explanation, thus missing the point of the jibe.

DOCUMENT I
MARBLE

Letters of Carlo Cybo Malaspina, Marquis of Carrara, to Virgilio Spada; ASR, Archivio Spada Veralli, vol. 192 (ff. 487–522)

DOCUMENT I, 1

26 May 1647

... la spesa d'un Pezzo di Carrate 25, non sarà meno della somma descritta nella Nota inclusa [missing], si del marmo bianco più fino, come dell'inferiore anc[or]a, e cosi di due pezzi, oltre li rischi, fatiche, et utili, che li Mercanti considerano in simili Interessi, dicendomi anco q[es]ti, che non vogliono stare soggetti à rischi d'un pezzo, che cadesse nel Mare, se non hanno il benefitio, che li ristori dal pericolo del danno, al quale si sottoponesse bene il Cavaliere Bernini, et Algardi dicono, che hanno havuto li Marmi in altro tempo à scudi 25 la Carrata, ciò non serve per il bisogno et intent[io]ne delli Pezzi, che sono domandati hora perche li Mercanti, che li providdero in quel tempo asseriscono, che per la picca nata fra il detto Bernini, et il Not[ar]o Fonthia, che participava del negotio diedero, doppo, che gl'hebbero condotti, conto distinto della spesa, e condotta sino à Ripa, che fù veduto dalli Deputati della fabrica, dalli quali a Mercanti non fù fatta buona ne fatica, ne rischio di Mare, benche solito; si aggiunge di più, che era di Carrate 17, in 18 l'uno, oltre la differenza del Marmo ord[inar]io, che la metà meno vale alla Cava, che però la differente grossezza, e gl'accennati rispetti alterando il prezzo, non deve servire di esempio – In altri tempi il Pollina mandò a Roma un Pezzo di carrate 21 della sua Cava, che è inferiore alle quattro buone, e mi hanno riferito, che la spesa arrivò à scudi 800 di questa moneta di giulij otto per scudo. Per i due Pezzi, che dall' Agnesini, e suoi Compagni si mandorono per Monsignor Spada, Uno di quattro Carrate, che era del bianco, e l'altro di sette della Cava del so[pradet]to Pollina, servendo per fare un S. Paolo, et un Manigoldo, gli furono pagati scudi 200 di moneta di Roma ins[iem]e con la condotta in quella Città; e se bene hebbero di danno 25 scudi per ciasc[un]o, come in realtà mi hanno attestato li Mercanti, ad ogni modo volsero fare tal partito con discapito, per l'utile, che speravano dalla fabrica d'una Cappella, che disse Monsignore voleva, che facessero in Bologna quelli, che havessero dato i Marmi per le statue so[pra]dette; si vede anco la differenza da pezzi di sette Carrate, à quelle di 25, e

per ritrovar Pezzi simili aggiustati al bisogno, Le difficultà, che s'incontrano, come anco, che per ogni palmo di grossezza straord[ina]ria si rendono magg[ior]i le spese, e particolarm[en]te per condurli. . . .

DOCUMENT I, 2

2 June 1647

... V.S. Illustrissima mi avvisa, che li Pezzi non saranno minori di Carretate 15, ne magg[io]ri di Carretate 20 quelli, che haveva trattato con il Contardi [Luca Contardi, who acted for the Lateran in establishing the contract with Bonanni], e però non doverà pare strano, che essendo stato scritto à me, che li Pezzi, che si desiderano, debbano essere di Carretate 25, debba anco per q[ues]to rispetto, e per l'altre circonstanze scritte nell'altra mia, esser il prezzo differente, della q[u]ale starò aspettando risposta precisa da V.S. Illustrissima. . . .

DOCUMENT I, 3

16 June 1647

... vi saranno difficoltà grandi per la parte de i Mercanti, trovando essi impossibilità nell'effetto del loro buono desiderio, e volontà, che hanno di servire in q[ues]ta occ[asio]ne, tanto più vedendo la differenza delli accordi stabiliti per Instrum[en]ti dal Contardi di cinque statue di due pezzi l'una di marmo inferiore, da quelli sino adhora proposti da essi.

DOCUMENT I, 4

23 June 1647

Non si può stabilire cosa alcuna con li Mercanti de Marmi, se V.S. Illustrissima oltre alli particolari, che ella hà risoluti con la sua de 15, non favorisce de risposta à gl'altri, che le motivai con la mia de 9 del corr[en]te, quanto debba essere la longhezza, larghezza, e grossezza di ciasc[un]o Pezzo di qualsivoglia sorte, non potendo li Mercanti risolvere prezzo alcuno, se prima non sanno le sud[ett]e misure per apunto. Di più le dico che persistono, che il Marmo conforme al solito sia pagato vuoto pieno, cioè misurato nella maniera, che si ritrova subito cavato, e non doppo,

che sarà sbozzato, poiche la spesa del pagam[en]to, che serve per la fatica di chi sbozza non hà che fare con la misura del Marmo, che prima era intiero, e che poi và à male nello sbozzarsi, tanto più, che un pezzo ridotto in 20 carrate, sarà stato da 34 carrate in circa prima d'essere sbozzato.

Soggiungo, che havendo il Contardi contrattato per cinque statue di due pezzi l'una di marmo, che non è delle quattro Cave, à ragione di scudi 22 la Carrata con obligo di pagare di vuoto pieno, potrà da q[ues]to V.S.Illustrissima comprendere, che le statue d'un pezzo solo saranno di maggior prezzo, tantopiù dovendo eserne quattro di marmo bianco.

DOCUMENT I, 5

1 August 1647

... potrà la somma prudenza di V.S.Illustrissima fare riflessione, che quei Pezzi, che à Lei venivano figurati di 20 Carrate sbozzati, riescano quasi tutti sopra 40 in quadro, e sbozzati sopra 30.

DOCUMENT I, 6

25 August 1647

... devo dire à V.S.Illustrissima non doversi del tutto, à mio parere, fondare sopra ciò, che costì hanno detto, perche l'esperienza mostra in fatto, che cotesti statuarij ò s'ingannorono nel concetto, che hebbero di riddurre le statue à 15 Carrate, ò volsero rappresentare poca la spesa per facilitare quegl' impegni, che si confacevano à i loro fini.

Se ciò sia vero ò nò, se ne chiarirà V.S.Illustrissima con far vedere à ciascun de statuarij, che hà dato il Modello, se le misure mandate di quà sono giuste; se Le confessano tali, è chiaro che s'ingannorono in supporre 15 quel che doveva essere sop[r]a 40; se Le provano in contrario, haverò io occ[asio]ne di risentirmi con chi le [the estimates] hà fatte, perche essendo huomini di provata esperienza in q[ues]ti affari, non saranno capaci di scusa.

... hò fatto formare l'annesso foglio, nel quale si compiaccia vedere che li 4 Pezzi corrispondenti alli Disegni, importano quasi l'istessa quantità de Marmi, che fù giudicata costì necess[ari]a per tutti le 12 statue tassate à scudi 500 ciascuna, e che poi considerate in tutte l'altre circonstanze, accrescono di modo la spesa, che sono à miglior tolta li 4 Pezzi à scudi 2000, che li 12 figurati à 500; non lasciando di dire, che le domande non sono tutte uguali, e che si parlava da alcuni di condurre il Marmo à cotesta Ripa à tutte spese di chi lo dava, e pure V.S.I. in sua de 8. Giug[n]o disse, che quando non fossero bastati li scudi 500 per il prezzo, et assicurat[io]ne d'ogn'uno delli so[prade]ti pezzi, haveria la S[anti]tà di N[ost]ro S[igno]re condesceso, che il pericolo fosse caduto s[opr]a la fabrica....

Carrate 25 di Marmo bianco delle quattro
 Cave in un pezzo solo valerà sul poggio..... scudi 400 –
Tiratura sino in Marina da 350 scudi
 secondo li tempi, che vanno, e
 congiunture che succedono di ribaltarsi,
 che vi vorriano maggior giornate, per la
 qual tiratura è solito mandarsi dalla
 fabrica li cavi grossi, cioè per li tirarori,
 e taglia scudi 350 –
Nolo sino à Ripa, dove si scaricano li
 Marmi à conto della fabrica senza spesa
 del Venditore scudi <u>250</u> –
 sono di moneta di Carrara da giulij
 otto scudi <u>1000</u> –
 Di Roma scudi 32 la Carrata –
Carrate 25 di Marmo in due pezzi
 valeranno la metà meno cioè scudi 16 la
 Carrata –

Il Marmo ordinario statuario un pezzo di
 Carrate 25 valerà sul Poggio scudi 200 –
Le spese saranno l'istesse, e quasto valeria
 di Roma scudi 25.60 la Carrata
Di due Pezzi la metà cioè scudi 12.80 la
 Carrata
Queste soni tutte le spese ventilate,
 bisogna poi fare il conto oltre di questo
 di qualche utile, che vorranno li
 Mercanti havere per le loro fatiche, e
 fastidij, che non si può avanzare solo dal
 più al meno, e non vogliono star sotto-
 posti al rischio del Mare, e quando vi
 dovessero stare, vogliono, che si sia
 pagato etc.

Per quel che fù scritto nelle prime lettere li
 statuarij di Roma supposero a Sua
 Santità, che li prezzi de marmi, che
 erano necessarij per le 12 statue, sariano
 stati di 15 carrate cadauno, e che il loro
 prezzo saria di scudi 500, e q[ues]to fù il
 p[ri]mo supposto, se bene poi si sono
 andati allargando fino alli 20, e perciò si
 fà il calcolo della p[ri]ma supposit[io]ne,
 perche sopra essa fù calculato il prezzo;
 si che 12 pezzi di Carrate 15. il pezzo
 compongono Carrate n[ume]ro 180 –
Li Modelli poi, che per li quattro di dette
 statue sono stati trasmetti misurati con
 le loro proportioni importano le
 Carrate, come sotto –
Il p[ri]mo di longheza p[al]mi 18.3. –
 9.3. – 7.6. sommano p[al]mi 1266.1.1.
 che à palmi 30 la Carr[a]ta sono Carrate
 n[umer]o 42.6 –
Il 2° p[al]mi 18.3. – 8.6. – 6.9. sono palmi
 1047.1.4. C[arra]te n[umer]o 34.27 –
Il 3° p[al]mi 18.3. – 9 – 7.8. sono palmi

1259.5.3. Carrate n[ume]ro 41.29 –
Il 4º p[al]mi 18.3. – 9 – 7.6. sono palmi
1231.10.6 Carrate n[umer]o <u>41.1.</u>
Carrate n[umer]o 160.3.

Di modo che li statuarij dissero di haver bisogno di .12. Marmi che à .15. Carrate l'uno importavano Carrate 180, e poi si riducano à volerne in solo 4 Pezzi Carrate 160, si che dovendosi nelli Marmi considerare quelli tre stati, e tre spese, che furono ponderati nella l[ette]ra de 29 di Giugno; La prima del nudo marmo, quando è cavato, La 2ª nel farlo condurre alla Marina sbozzato, La 3ª nel portarlo dalla Marina a Roma; e dovendo tutto ciò seguire à spese di chi lo doveva dare, e facile il comprendere di quanto dispendio le fosse, perche il cavare .4. Pezzi di Marmo bianco, che componghino Carr[a]te 160, non hà proportione alc[un]a col doverne cavare 16, che tanto fanno le .12. statue, 8, d'un pezzo, e .4. di due, che componghino fra tutti Carrate 180: perche li pezzi di q[es]ta grossezza si trovano, cavano, tirano, imbarcano, e conducano con spesa, e facilità incomparabile à i pezzi della grosseza de i quattro, perche per trovare q[ues]ti si cava alle volte i mesi prima di trovarli, trovati ben spesso si rompano, et anco cavati intieri m[ol]te volte non si riescono, perche un pelo, che vi si trovi, rende vano il travaglio, e l'opera; Per q[es]to si avviso più volte non esser proport[ion]e di prezzo tra li Pezzi di grandezza moderata; Verbi gratia, di .15. carrate, con quelli di 30; perche se li p[ri]mi si danno per esempio à scudi 20, q[ues]ti non si daranno a 30.

La spesa poi di condurli dalla Cava alla Marina riesce incomparabilm[en]te magg[io]re, stante che li Pezzi cosi smisurati non si possono porre sopra Carrette di ruote tirati ordinariam[en]te da Buoi, mà bensi sopra certe Lizze, che si avanzano con argani con travaglio grande, cosa, che si conosce meglio nell'atto pratico, che con la considerat[io]ne, per esser la strada longa, e cattiva.

Cresce anco la spesa, nel 3º stato. che è il Nolito, non solo rispetto al peso, et ingombro, mà anco alla necessità, che si hà di prendere Vascelli m[ol]to magg[io]ri, q[u]ali mal volontieri si riducano à venire in spiaggie, ove difficilm[en]te si tirano, caricano, e varano, cose, tutte, che accrescano la spesa non solo del Nolito, mà anco dell'assicurat[io]ni, di modo, che considerato il neg[oti]o nelle sue circonst[anz]e, le domande, che parevano disorbitanti, si riducono con la proport[ion]e anco del costo, rappresentato costì da statuarij, à moderate, mentre si conosce esser m[ol]to meglio se si dessero Carrate .180. in pezzi 16, frà quali .4. anco de maggiori di marmo ordinario, come fù la domanda per scudi 6000, che Carrate 160 in 4. pezzi di Marmo bianco per scudi 8000.

Nota delle offerte, che sono state fatte dalli Mercanti, e Patroni delle Cave de Marmi di Carrara per le statue tutte d'un pezzo da farsi per servitio di Sua Santità con il supposto, che dalla fabrica di S. Giovanni Laterano si pagherà la sbozzatura di esse statue, quali condotte à Ripa, sara à peso della fabrica, farle scaricare a sue spese, e risico,

e di più piglierà essa fabrica il sopracarico, ò lo farà esitare in altro modo, et per quelli, che trattassero nella loro offerta a Carrate, li sia pagato di voto pieno, e che s'intendino li prezzi, che si diranno in appresso à scudi di m[one]ta di Roma, se non se ne farà dichiarat[ion]e in cont[ra]rio.

Francesco Bonanni sopranominato il Venetiano non vuole obligarsi di dare le statue condotte à Ripa, ne alla spiaggia di Lavenza, mà offerisce, che riuscendoli poter cavare marmi per la misura de i Modelli nella sua Cava del Polvaccio, che dice, fuori delle 4 Cave esser la migliore, che darà li Marmi à ragione di scudi Dodici da giulij otto l'uno per ciasc[un]a Carrata, di palmi trenta misura di Roma, e che spera poterne dare due statue fra un'Anno.

Il Luog[otenen]te Rafaelle Pisani, se se li daranno a fare à lui tutte le quattro statue, si obligherà darle conforme alli Modelli condotte à Ripa per prezzo di scudi quarantacinque la Carrata in quadro m[one]ta di Roma, di Marmo della Cava dell' Orsolini, che dice essere delle 4 Cave, e ne darà due condotte à Ripa per tutto il Mese di Ottobre 1648 salvo giusto impedimento.

L'Alfier Andrea Monzoni offerisce dare le 4 statue conforme alli Modelli, di Marmi delle sue Cave al Pianello, e finocchioso, che dice esser di Marmo bianco statuale, conforme si puole pigliar informat[io]ne in Roma, mentre però gli riuscira di poter cavare li Pezzi, conforme alle Misure, in che farà ogni dilig[enza] solleciterà à mandarle quantop[rim]ma, e per il prezzo di scudi Mille conquecento m[one]ta di Roma condotte à Ripa à tutte sue spese, e risico per ciascuna statua.

E più con le med[esi]me conditione darà bisognando altre quattro statue conforme à detti Modelli, di Marmo ordinario per prezzo di scudi Mille trecento moneta di Roma.

Il Ducarelli offerisce dare due delle sod[et]te statue per tutto Agosto 1648, se però nel cavarle non si guasteranno, mà si obligherà solo darle condotte alla spiaggia di Lavenza à orlo di barca, di Marmo della sua Cava, ch'è delle 4 del Polvaccio per scudi Mille seicento dieci per ciascuna statua, moneta di Roma.

Il Cap[ita]no Giacomo Guidi offerisce di dare le quattro statue conforme alli Modelli, tre fra Mesi quattro, e l'altra fra mesi sei, di Marmo della sua Cava al Pianello, condotte à Ripa à tutte sue spese, e risico per prezzo di scudi Mille seicento per ciasc[un]a, moneta di Roma.

Gio: Battista Pollina offerisce dare le 4 statue conforme alli Modelli condotte à Ripa à tutte sue spese, e risico, di Marmo della sua Cava, che è del med[esi]ma, della statua di S[an]ta Veronica, per Prezzo di scudi Due mila Cento m[one]ta di Roma per ciascuna statua, e ne darà due condotte per tutto Giugno 1648, e l'altre due quantopiù presto potra.

Il Dottor Vannelli offerisce dare due statue conforme alli Modelli di Marmi della Cava del francione, ch'è delle .4. per tutto Giugno 1648 condotte à Roma à Ripa grande, e più della med[esi]ma Cava un' altra statua per tutto Novem[b]re 1648, e l'altra per tutto Maggio 1649, per prezzo di scudi Due mila m[one]ta di Roma per ciasc[un]a

statua, con dichiarat[ion]e di non voler esser obligato à fare dette statue, quando li sassi riuscissero diffettosi, e che non fossero alla misura de i Modelli.

Di piu si offerisce, bisognando, dare per tutto Giugno 1648 due statue di marmo bianco ordinario della sua Cava, condotte à Ripa, e con le cond[itio]ni soprad[ett]e, per scudi Mille ottocento m[one]ta di Roma per ciasc[un]a statua.

Il Conte Diana, se li riuscirà di cavar Marmi proportionati alle Misure de i Modelli, li darà sul Poggio per scudi 672. il pezzo, e in Marina per scudi 1505. per ciascun pezzo.

[There follows a restatement of the measurements with slightly more precise calculations of their equivalents in *carrate*.]

DOCUMENT II
BRONZE–CASTING

Contract with Giovanni Pietro del Duca and Cesare Sebastiani for casting three bronze copies of antique statues, 13 December 1649; ASR, 30 Not. Cap., Uff. 32, vol. 143, ff. 721–724v[1]

Oblig[ati]o
Dominus Jo. Petrus q[uondam] Lud[ovi]ci del Duca Romanus mihi cog[nitus] et Dominus Cesar q[uondam] Sebastiani de Sebastianis de Recanate in infra[scripto] neg[oti]o Socij, et ambo insolidu sponte etc. et in altro omni me[liori] modo etc. promesserunt et sese obligarunt Illustrissimo Domino Didaco de Silva Velasco q[uondam] Jo[ann]is Rodriges Hispalens[is] p[rese]nti rete dicitur di fare e far fare a tutte loro proprie spese per il detto Signor Diego, et in sua assenza da Roma per l'Illustrissimo Signor Don Giovanni di Corduba Errera da me not[aro] beniss[im]o cognosciuto presente etc. al qual Signor Don Giovanni detto Signor Diego diede, e concesse amp[lissi]ma facultà in sua assenza di vedere et rivedere l'inf[rascritt]e statue, e cose, quelle ricevere accetare, quitare, pagare, e far tutte quelle cose, che esso Signor Diego puole, e potra fare in vigor del pr[rese]nte Instr[ument]o, come se fosse la propria persona di esso Signor Diego perche cosi e non altrimente constituendolo suo pro[curato]re irrevocabile come in cosa propria et conjuramento tactis etc. a fare tutte le sud[ett]e et altre cose, che per la total esecut[ion]e del pre[sen]te e total adempim[en]to sara necess[ari]o, et oppor[tu]no con le clausole amp[lissi]ma et ad omnes lati[tudi]ne extendens et pre[sen]te promesse levare etc. si obligano dico di fare, e far fare tre statue di bronzo formate sopra l'inf[rascritt]e tre statue di marmo cioé.

Una figura in piede d'un Imperatore ignuda daltezza di palmi otto in nove che sta nel Giardino del Em[inentissim]o Signor Cardinale Montalto a Termini, che ha una cascata d'un panno sopra il braccio sinistro.[2]

La seconda è d'una statua d'un fauno nudo con una pelle attorno, che sta nel entrare della loggia del Palazzo de Signori Gaetani al Corso, quale sta appogiata al tronco, e pero anco alla statua di bronzo vi doverà essere il d[ett]o tronco.

La Terza è una statua in piede nuda d'un gladiatore, che sta in casa del Signor Hippolito Vitelleschi al Corso, che nella mano manca tiene un scudo, o rotella, e nella dritta, se bene adesso è senza il braccio, non doverà tener' cos' alcuna.[3]

Quali tre statue originali d[ett]i compagni congiuramente tactis etc. dichiarono, e confessano haverne ottima cognit[ion]e, et haverle percio viste, reviste, e ben considerate.

E con l'inf[rascritt]e patti, e cond[itio]ni, e prezzi

In prima d[ett]i Signori Gio: Pietro, e Cesare compagni promettano et insolidum come sopra si obligano di fare, e consegnare d[ett]e tre statue finiti di tutta perfettione ben fatte, e conforme in tutto, e per tutto alli d[ett]i loro originali, ben pulite, rinettate, e compite di tutte punte al meno fra nove mese d'hoggi prossimi, e cominciare il lavoro da domattina, ne quello intralasciare per causa alcuna alia etc. quia super etc.

Item detti Compagni si obligano insolidum come sopra di fare, e far fare il cavo, o forma per d[ett]e statue, che sono fatti, e fatte con ogni diligenza, e quelli condurre nelli luoghi dove si haveranno da gettare a loro proprie spese, quali cavi siano, e debbano essere di gesso, e perciò fare una capota della pietra che se ne fa il gesso della più bianca, e senza machie, quale sia cosi separatamente, e posta che sara, si dovera sedacciare con un sedaccio più fino del solito, e questo gesso, che sarà più fino, e più bianco se ne doveranno servire per far li tasselli, o sottosquadri delle dette forme, et anco le prime pelli vicino le statue, e di più ingrossar le forme con gesso più ordinario, purche sià bono, e da presa, et avvertire, che nel formare, lontanandosi qualche pezzo di statua, non si deva gettare altro pezzo vicino, se primo non haveranno fatto afidare al luogo suo quello, accio nel gettare poi dette tre statue, non venghino con una parte alta, et una bassa, e percio anco li loro tasselli, o sottosquadri siano collegati dentro la forma grande con maglie di filo di ferro, et sbugiata la forma possino con uno spago ligate di fuori, accio che quando detta forma sia insieme, non venisse a cadere qualche tassello per di dentro, talmente che le d[ett]e tre statue habbiano di esser fatte, e consegnate come sopra ben fatte, polite, e finite di tutto punto conf[orm]e alli detti originali, e di tutta perfettione di bronzo come sopra, et in questo alla relatione del huomini periti nel arte quia sic alias etc.

Item convengano d[ett]e parti, che fatti saranno li d[ett]i cavi di gesso come sopra, debbano come promettano d[ett]i Compagni imprimerli con la cera dentro alli d[ett]i cavi d'una grossezza ordinaria, che possano venire di metallo le statue, e farvi le loro anime di loto sapiente, e fatte le d[ett]e cere, di Signor Don Diego, o Don Giovanni possino farli vedere, e revedere se vi sia mancamento alcuno, e trovandosi mancamento, lo debbano d[ett]i Compagni emendare, e poi d[ett]i Compagni debbiano far

rinettare d[ett]e cere da scultori a sodisfattione di d[ett]i Signor Don Diego, o Signor Don Giovanni quia sic alias.

Item convengano che d[ett]e forme, e cavi sono, e debbano esser fatti in modo tale, che volendone d[ett]i Signor Don Diego, o Don Gio, o alcun di loro far gettare altre statue di cera, o gesso, possino servire, e resistere quia sic alias.

Item che in caso alcuna di d[ett]e cose promesse, mancasse alla forma, o vi fosse altro difetto, che la rendesse inhabile, o defettosa in qualsivoglia parte, in tal caso d[ett]i Compagni siano obligati a rifarla, et accomodare il defetto conforme sarà bisogno, altram[en]te ultra puturas ad quas semper cogi possunt et sia arbitrio di d[ett]i Signori o d'alcun' di loro di farle rifare di nuovo, o accomodare conforme al bisogno à tutte proprie spese di d[ett]i Compagni quia sic alias.

Item che ciascuna di d[ett]e statue debbano d[ett]i Compagni come promettano fare un zoccolo riquadrato pure di bronzo di altezza di otto in dieci deta più, e meno secondo importera l'altezza della statua ad arbitrio di d[ett]i Signori Don Diego, o Don Gio:, o d'alcuni di loro, purche non sario più alti di dieci deta per ciascuno quia sic.

Item convengano, che qualsivoglia spesa di formare, far cavi, gesso, creta, cera, bronzo, fatture, portature, e quals[ivogli]a cosa per la total perfettione e compim[en]to di dette tre statue finite di quals[ivolgli]a sorte, spetie, qualità, e quantità, si debbia fare dalli d[ett]i Compagni, e a loro proprie spese quia sic.

Item che le sudetti cavi doppo saranno fatte le statue restino liberi per detti Signori Don Diego, e Don Gio: senza pagam[ent]e di cos'alcuna quia sic.

Item convengano, che il prezzo di d[ett]e tre statue finite, e consegnate di bronzo come sopra, in tutto, e per tutto sia, e debba essere di scudi doimilia doicento m[one]ta Romano di g[iu]li dieci per scudo cosi d'accordo, da pagarsi, si come detto Signor Don Diego premette di pagarli alli detti Compagni, e ciascun di loro insolidum; in questo modo cioè, scudi quaranta al presente incontanti, e il resto di mano in mano secondo il bisogno del opera, secondo si verra facendo l'opera, talmente che finite, e consegnate d[ett]e tre statue nel modo e forma sud[ett]o, d[ett]o Signor Diego hà ob[liga]to a pagare l'intiero prezzo sud[ett]o libere aliasque etc.

Et adesso alla p[rese]nza di me not[ar]o d[ett]i Signori Gio: Pietro, e Cesare Compagni manualm[en]te, et incontante hebbero, e recevettero da d[ett]o Signor Don Diego p[rese]nte li detti scudi quaranta m[one]ta quali tirorno à se in tanti giuli, e testoni de argento, de quali ne fan quietanza in f[orm]a etc. ...[4]

Item convengano, che d[ett]e statue debbano essere di metallo buono, e recepiente, e mercantile, e nel modo, e forma detti di sopra, e se d[ett]i Signori Don Diego, e Don Giovanni volessero consegnare metallo per d[ett]o effetto,

d[ett]i Compagni lo debbano pigliare e defalcare il prezzo di esso conforme la qualità del d[ett]o metallo nel sud[ett]o prezzo delle statue cosi d'accordo.

Item che mancando d[ett]i compagni in fare, e consegnare le d[ett]e tre statue nel modo, forma, tempi e qualità soprad[ett]e, ultra presente observat[ion]e; ad quam semper teneri, et cogi possi volerunt utilius sià anco lecito alli detti Signori Don Diego, e Signor Don Gio: di farlo fare d'altre persone per quals[ivogli]a prezzo atque ad rationem quanti plurimi e maggiore del sopradetti a tutti danni, spese, et interessi di d[ett]i Compagni quia sic.

Item convengano, che d[ett]i Signor Don Diego, e Signor Don Gio: habbanò da procurare la licenza da chi bisognerà per formare le d[ett]e statue, o di farli havere l'adito libero per d[ett]o effetto quia sic. ...[5]

Acta Romae in domo habitis d[ictis] Domini Jo[ann]is de Corduba/Dominus Andrea q[uondam] Ber[nar]di Gori Lucensis, et Dominus Joanne de Parecha q[uondam] alt[ris] Jo[ann]is de Antechero.

1. This is the first, and fullest, of the documents concerning bronze casts, or moulds, ordered for King Philip IV of Spain. It was followed by contracts drawn up by the same notary with Girolomo Ferreri for moulds and plaster casts of the *Gladiator* and *Satyr with a Child in his Arms* in the Borghese collection (29 December 1649, vol. 144, ff. 6–7v, 28r–v); with Orazio Albrici for moulds and plaster casts of the *Nile*, *Apollo* and *Antinous* in the Belvedere (26 April 1650, vol. 145, ff. 282–283v); and with Cesare Sebastiani for moulds and plaster casts of the *Laocoon* in the Belvedere (6 August 1651, vol. 150, ff. 290r–v, 303r). A receipt of Cesare Sebastiani states that he had agreed to mould the *Hercules* and *Flora* in the Farnese collection, the *Gladiator* and the 'Sporo giovine di Nerone' in the Borghese collection, ten busts in the Caetani collection, and the *Medici Venus* (20 May 1653, vol. 157, ff. 712r–v, 719). Matteo Bonarelli (who was already casting twelve bronze *Lions*) contracted to make bronze casts of the *Hermaphrodite* and *Small Venus* in the Borghese collection, of which he possessed the moulds, making good any damage that time had wrought on the originals, and also to supply plaster casts and moulds (16 April 1652, vol. 153, ff. 136r–v, 149). Documents concerning the shipment of these statues are in vol. 148, ff. 853r–v, 866 (11 March 1651); vol. 149, ff. 163r–v (19 April 1651), and vol. 157, ff. 391r–v, 422 (28 April 1653). 148 cases were ordered on 20 May 1653 (vol. 157, ff. 713r–v, 718), and 23 on 10 July 1653 (vol. 158, ff. 104r–v, 111). On 28 April 1653 Girolamo Ferreri agreed to accompany the works to Spain, together with an assistant, so as to make bronze casts from them there, and, if necessary, repair any moulds that had broken (vol. 157, ff. 375–377v); on 5 February 1657, back in Rome, he signed a receipt for his final payment (vol. 172, ff. 378r–v). For the identification of these statues, see the list by Palomino (printed in translation in Enriqueta Harris, *Velázquez*, Oxford, 1983, pp. 210–11); *idem*, 'La Misión de Velázquez en Italia', *Archivo Español de arte*, XXXIII, 1960, pp. 109–136.
2. *Germanicus*, also known as the *Orator*.
3. The *Discobolus*.
4. A conventional Latin formula has been omitted from the transcription.
5. A conventional Latin formula of acceptance has been omitted from the transcription.

DOCUMENT III
RESTORATION

Account of Giuseppe Giorgetti and Lorenzo Ottone for the restoration of the Barberini Faun: BAV, Archivio Barberini, Cardinal Francesco Barberini Senior, Giustificazioni 12855–12865, no. 12861 (unfoliated)

Segue la figura del fauno

E piu haver fatto quatro troncature alli marmi che sono serviti per fare il sasso e base alla sud[ett]a statua e d[et]ti troncati e fattoci il suo piano che fanno posamento in terra lungo il sud[ett]o piano p[almi] 5. largo p[almi] 2⅔. fatto in traguardo che bagia il mattonato —— s. 3–(2–)[1]

E piu haver fatto il piano per di dietro a tutta altezza alto p[almi] 6⅓ longo p[almi] 5. —— s. 3–50 (–)

E piu per haver stretto insieme il marmo che era di dui pezzi e mesoci spranche sette et impiombate longhe le sud[ett]e cose p[alm]i uno ½. largo once 3½. fanno li grappi once tre ½. e d[ett]e tutte impiombate —— s. 2–50 (1–50)

E piu haver fatta la commisura di sopra d[ett]o sasso dove va a posare la statua fatta la commisura centinata e torta in piu versi per non offendere l'antico e levata l'ameta del marmo che era quadro ridotto a ceppa e levato a forsa de ferri per poter affermar la figura a piombo nella commissura stabilita —— s. 5–80 (4–50)

E piu haver fatto un pezzo di pianta del sud[ett]o sasso lon[go] p[almi] 5. lar[go] p[almi] 1½. e l'altro p[almi] 1. ⅚. commesso il sud[ett]o pezzo nella conformita che gira la statua e fatto il suo piano della med[esim]a longhezza e larghezza —— s. 2–80 (2–)

E piu haver fatti dui tasselli uno delli d[ett]i longo p[almi] uno largo once 6. ⅕. e l'altro tassello triangolo lon[go] p[almi] 1½. largo. ⅚. e d[ett]i tasselli commessi incassati attacati con gesso —— s. 2–30 (1–80)

E piu haver fatto un pezzo de base per di dietro fattoci il suo piano che va a commettere al pezzo grosso e il piano per posamento che posa sopra il matonato longo il d[ett]o pezzo p[almi] 5. largo once 5. alto p[almi] 1 fatti tutti dui li sud[ett]i piani —— s. 1–40 (1–20)

E piu haver fatto il posamento sotto la sud[ett]a statua lavorato a scoglio in diversi modi con erbe fiori fronde tronchi d'albero con un ramo d'ellera che gira attorno il sud[ett]o tronco fattoci il suo instrum[en]to sonoro che sonano li silvano con sua fettuccia et altri lavori lavorato per di dietro e da tutte quatro le bande —— s. 46–(34–)

E piu haver fatta la base sotto al sud[ett]o sasso con piano e tondo et intaccature e gola roversa e tondino lon[go] p[almi] 5. largo p[almi] 4 once 5. fanno d[ett]ti pezzi p[almi] 1. ⅓. in tutto fa p[alm]i 24. —— s. 9–60 (9–90)

E piu haver lavorato a scoglio il sasso antico che era rustico lavorato per accompag[namen]to del moderno —— s.–80 (–60)

E piu haver messo tre spranche che tengono assieme la statua sopra il sasso due delle d[ett]e fattoci li bugi con stampa a coda di rondine e d[ett]e incassate et impiombate e coperte di gesso —— s.–80 (–45)

E piu haver speso scudi uno e b[aiochi] 63. in verzelli filo di ferro et altri per fare l'armatura delli bracci e gambe e sassi et altri della sud[ett]a statua —— s. 1–63 (1–63)

E piu haver fatto n[umer]o 14 bugi con stampa nella sud[ett]a statua di marmo gregio fondi 10. delli d[ett]ti p[almi] 1. ¼. e gli altri quatro fondi p[almi] 1. che in tutto fa p[almi] 16. ½. et impiombati li ferri per far la sud[ett]a armatura per metter la calce e stucco —— s. 8–25 (4–95)

E piu haver fatte tutte due le gambe di stucco cioe una delle d[ett]e fattaci tutta la sua coscia e affermatoci dui piedi di gambe di marmo della sud[ett]a statua affermati con gran difficolta perche non havevano ne attacco ne posamento —— s. 9–(8–)

E piu haver fatto il braccio manco con la sua mano et alcuni sassi dove posa il braccio e le sue gambe e fattoci il gomito dritto e molti diversi pezzi —— s. 4–80 (3–50)

E piu haver speso scudo uno e b[aiocchi] 65. in calce e gesso et altre materie per far li sud[ett]ti pezzi di stucco —— s. 1–65 (1–65)

E piu haver dato l'antico a tutti li sud[ett]ti pezzi moderni con aqua forte et altra materia et alli pezzi di stucco dato l'antico con chiara d'ovo et altro —— s. 1–50 (1–)

1. The figures in brackets (on the original these are in the left margin) represent the sum as adjusted by Angelo Torrone, Cardinal Francesco Barberini's architect.

BIBLIOGRAPHY

ADEMOLLO, Alessandro, *I Teatri di Roma del secolo decimosettimo*, Rome, 1888

AGULLÓ, Mercedes, and PÉREZ SÁNCHEZ, Alfonzo E, 'Juan Bautista Moreli', *Archivo español de arte*, XLIX, 1976, pp. 109–120

ALUMNI CANTABRIGIENSES, compiled by John Venn and J. A. Venn, part I, vol. I, Cambridge, 1922

AMELUNG, Walther, 'Di Statue antiche trasfomate in figure di santi', *Mittheilungen des Kaiserlich Deutschen Archaeologischen Instituts, römische abtheilung*, XII, 1897, pp. 71–4

ANSALDI, Giulio R., see LAVAGNINO, Emilio

ANTONAZZI, Giovanni, *Il Palazzo di Propaganda*, Rome, 1979

ARCHEOLOGIA NEL CENTRO STORICO (exhibition catalogue), Rome, 1986

ASHBEE, Charles R., *The Treatises of Benvenuto Cellini on Goldsmithing and Sculpture*, ed. of New York, 1967

AULANIER, Christine, *Histoire du Palais du Louvre et du Musée du Louvre: La Petite Galerie, Apartement d'Anne d'Autriche, Salles Romaines*, Paris, 1955

AVERY, Charles, and KEEBLE, K. Corey, *Florentine Baroque Bronzes and Other Objects of Art* (exhibition catalogue), Toronto, 1975

AZZOPARDI, John, *The Museum of St Paul's Collegiate Church, Wignacourt College, Rabat, Malta*, Rabat, 1987

BAGLIONE, Giovanni, *Le Vite de' pittori scultori et architetti. Dal pontificato di Gregorio XIII. del 1572. in fino a' tempi di Papa Urbano Ottavo nel 1642*, Rome, 1642

BAKER, Malcolm, 'That "most rare Master Monsii Le Gros" and his "Marsyas"', *Burlington Magazine*, CXXVII, 1985, pp. 702–706

BALDINUCCI, Filippo, *Notizie dei professori del disegno da Cimabue in qua . . .* , ed. Ferdinando Ranalli, Florence, 1845–7

Vocabolario toscano dell'arte del disegno, Florence, 1681

Vita di Gian Lorenzo Bernini, ed. Sergio Samek Ludovici, Milan, 1948

BARTOLOTTI, Franco, *La Medaglia annuale dei romani pontefici da Paolo V a Paolo VI, 1605–1967*, Rimini, 1967

BARTSCH, Adam, *Le Peintre graveur*, nouv. ed., Leipzig, 1854–76

BATTAGLIA, Roberto, *La Cattedra berniniana di San Pietro*, Rome, 1943

Crocifissi del Bernini in S. Pietro in Vaticano, Rome, 1942

BAUDRY, Marie-Thérèse, and BOZO, Dominique, *La sculpture: méthode et vocabulaire*, Paris, 1978

BAUER, George C., *Bernini in Perspective*, Englewood Cliffs (New Jersey), 1976

BAUER, George C., and Linda, 'Bernini's Organ Case for S. Maria del Popolo', *Art Bulletin*, LXII, 1980, pp. 115–23

BAYERISCHE ROKOKOPLASTIK. VOM ENTWURF ZUR AUSFÜHRUNG (exhibition catalogue), Munich, 1985

BEAN, Jacob, *17th Century Italian Drawings in the Metropolitan Museum of Art*, New York, 1979

BECANUS, Guglielmus, *Serenissimi Principis Ferdinandi Hispaniarum Infantis . . . triumphalis Introitus Flandriae metropolim Gandavum*, Antwerp, 1636

BECKER, Wilhelm Gottlieb, *Augusteum ou description des monumens antiques qui se trouvent à Dresde*, Leipzig, 1804–11

BELLI BARSALI, Isa, *Ville di Roma*, Milan, 1970

BELLORI, Giovan Pietro, *Le Vite de' pittori, scultori e architetti moderni*, ed. Evelina Borea, Turin, 1976

BENTIVOGLIO, Enzo, and VALTIERI, Simonetta, *Santa Maria del Popolo*, Rome, 1976

BERLINER, Rudolf, *Die Weihnachtskrippe*, Munich, 1955

BERNINI IN VATICANO (exhibition catalogue, Vatican City, Braccio di Carlo Magno, May-July 1981), Rome, 1981

BERNINI, Domenico, *Vita del Cavalier Gio. Lorenzo Bernino*, Rome, 1713

BERSHAD, David L., 'The Contract for Antonio Montauti's St. Benedict in St. Peter's, Vatican', *Antologia di belle arti*, N.S. XXIII/XXIV, 1984, pp. 76–9

'The Newly Discovered Testament and Inventories of Carlo Maratti and his Wife Francesca', *Antologia di belle arti*, N.S. XXV/XXVI, 1985, pp. 65–84

BETHE, Helmuth, 'Ein Pseudoantike des Cinquecento und ihr Echo in der Kunst des XVII. und XVIII. Jahrhunderts', *Zeitschrift für bildende Kunst*, LXIV, 1930–31, pp. 181–4

BERTOLOTTI, Antonio, *Artisti bolognesi, ferraresi ed alcuni altri del già stato pontificio in Roma nei secoli XV, XVI e XVII*, Bologna, 1885

Artisti lombardi a Roma nei secoli XV, XVI e XVII . . ., Rome, 1881

BIAŁOSTOCKI, 'The Door of Death. Survival of a Classical Motif in Sepulchral Art', *Jahrbuch der hamburger Kunstsammlungen*, XVIII, 1973, pp. 7–32

BIANCA DI GIOIA, Elena, see *ARCHEOLOGIA NEL CENTRO STORICO*

BIRINGUCCIO, Vannoccio, *The Pirotechnia of Vannoccio Biringuccio*, transl. C. S. Smith and M. T. Gnudi, Cambridge (Mass.)/London, 1966

BJURSTRÖM, Per, 'Baroque Theatre and the Jesuits', in *Baroque Art: The Jesuit Contribution*, ed. Rudolf Wittkower and Irma B. Jaffe, New York, 1972, pp. 99–110

Drawings in Swedish Private Collections, 2: French Drawings, Sixteenth and Seventeenth Centuries, Stockholm. 1976

Feast and Theatre in Queen Christina's Rome (*Analecta reginensia* III), Stockholm, 1966

BLUNT, Anthony, *The Paintings of Nicolas Poussin: A Critical Catalogue*, London, 1966

Supplement to the Catalogues of Italian and French Drawings with a History of the Royal Collection of Drawings [in Edmund Schilling, *The German Drawings in the Collection of Her Majesty the Queen at Windsor Castle*], London, 1971

BLUNT, Anthony, and COOKE, Hereward L., *Roman Drawings of the XVII and XVIII Centuries in the Collection of Her Majesty the Queen at Windsor Castle*, London, 1960

BOCHIUS, Joannes, *Historica Narratio profectionis et inaugurationis Serenissimorum Belgii Principum Alberti et Isabellæ, Austriæ Archiducum . . .*, Antwerp, 1602

BORBONI, Giovanni Antonio, *Delle Statue*, Rome, 1661

BORRELLI, Gian Giotto, 'Domenico Antonio Vaccaro autore di modelli per argenti', *Antologia di belle arti*, N.S. XXI/XXII, 1984, pp. 127–35

BORSI, Franco, LUCINAT, Cristina A., and QUINTERIO, Francesco, *Gian Lorenzo Bernini: Il testamento, la casa, la raccolta dei beni*, Florence, 1981

BOSELLI, Orfeo, *Oservazioni della scoltura antica*, ed. Phoebe Dent Weil, Florence, 1978

BOTTARI, Giovanni, and TICOZZI, Stefano, *Raccolta di lettere*, Milan, 1822–5

BOUSQUET, Jacques, *Recherches sur le sèjour des peintres français à Rome au XVIIème siècle*, Montpellier, 1980

BOZO, Dominique, see BAUDRY, Marie-Thérèse

BRAHAM, Allan, and HAGER, Hellmut, *Carlo Fontana: The Drawings at Windsor Castle*, London, 1977

BRANCATI, Antonio, *Una Statua un busto e una fontana di Lorenzo Ottoni*, Pesaro, 1981

BRAUER, Heinrich, and WITTKOWER, Rudolf, *Die Zeichnungen des Gianlorenzo Bernini*, Berlin, 1931

BRESC–BAUTIER, Geneviève, and PINGEOT, Anne, *Sculptures des jardins du Louvre, du carrousel et des Tuileries* (Notes et documents des Musées de France, 12), Paris, 1986

BREZZI, Paolo, *Storia degli Anni Santi da Bonifacio VIII ai giorni nostri*, Mursia, 1975

BRIGANTI, Giuliano, *Pietro da Cortona o della pittura barocca*, Florence, 1982

DIE BRONZEN DER FÜRSTLICHEN SAMMLUNG LIECHTENSTEIN (exhibition catalogue), Frankfurt am Main, 1986

BROOK, Anthea, 'La Scultura fiorentina tra il Giambologna e il Foggini', in *Il Seicento fiorentino: arte a Firenze da Ferdinando I a Cosimo III* (exhibition catalogue), Florence, 1986, I (*Pittura*), pp. 71–6

BROSSES, Charles de, *Lettres d'Italie*, ed. Fréderic d'Agay, Paris, 1986

BRUAND, Yves, 'La Restauration des sculptures antiques du Cardinal Ludovisi (1621–1632)', *Mélanges d'archéologie et d'histoire*, LXVIII, 1956, pp. 397–418

BRUNETTI, Gino, *Cucina mantovana di principi e di popolo*, Mantua, 1963

BUILDERS AND HUMANISTS. THE RENAISSANCE POPES AS PATRONS OF THE ARTS (exhibition catalogue), Houston, 1966

BULLE, Heinrich, 'Der barberinische Faun', *Jahrbuch des Kaiserlich Deutschen Archäologischen Instituts*, XVI, 1901, pp. 1–18

BUNT, Cyril G. E., see CHURCHILL, Sidney J. A.

BURSCHE, Stefan, *Tafelzier des Barock*, Munich, 1974

CAETANO, Ruggiero, *Le Memorie de l'Anno Santo M.DC.LXXV*, Rome, 1691

CAGIANO DE AZEVEDO, Michelangelo, *Il Gusto nel restauro delle opere d'arte antiche*, Rome, 1948

CALZA, Raissa, ed., *Antichità di Villa Doria Pamphilj*, Rome, 1977

CAMETTI, Alberto, *Il Teatro di Tordinona poi di Apollo*, Tivoli, 1938

CAMPORI, Giuseppe, *Memorie biografiche degli scultori, architetti, pittori ec. nativi di Carrara ed altri luoghi della provincia di Massa . . .*, Modena, 1873

CANCELLIERI, Francesco, *Storia de' solenni possessi de' Sommi Pontefici . . .*, Rome, 1802

CANEVAZZI, Giovanni, *La Scuola militare di Modena*, Modena, 1914–20

CAPECCHI, Gabriella, 'La Collezione di antichità del Cardinale Leopoldo dei Medici: i marmi', *Atti e memorie dell'Accademia. . . . La Colombaria*, LIV, N.S. XXX, 1979, pp. 123–45

CARANDINI, Silvia, see FAGIOLO DELL'ARCO, Maurizio

CARÊME, Marie Antonin, *Le Pâtissier pittoresque*, Paris, 1842

CASANOVA, Maria Letizia, *S. Maria di Montesanto e S. Maria dei Miracoli* (Le Chiese di Roma illustrate, no. 58), Rome, n.d.

CELLINI, Benvenuto, *The Life of Benvenuto Cellini Written by Himself*, ed. John Pope-Hennessy, Oxford/New York, 1949

See also ASHBEE, Charles R.

CHARPENTIER, René, *Cabinet du Sr. Girardon*, n.p., n.d.

CHIARINI, Marco, Letter to the Editor, *Burlington Magazine*, CXVIII, 1976, pp. 700–701

CHURCHILL, Sidney J. A., and BUNT, Cyril G. E., *The Goldsmiths of Italy: Some Account of their Guilds, Statutes, and Work*, London, 1926

COLE, Bruce, *The Renaissance Artist at Work, from Pisano to Titian*, London, 1983

COLTON, Judith, 'Pigalle's *Voltaire*: realist manifesto or tribute *all'antica*?', *Studies on Voltaire and the Eighteenth Century*, CXCIII, 1980, pp. 1680–87

CONDIVI, Ascanio, *Vita di Michelangiolo*, ed. Emma Spina Barelli, Milan, 1964

CONFORTI, Michael, 'The Lateran Apostles', Ph.D. thesis, Harvard University, 1977

　'Pierre Legros and the Rôle of Sculptors as Designers in late Baroque Rome', *Burlington Magazine*, CXIX, 1977

　'Planning the Lateran Apostles', in *Studies in Italian Art and Architecture, 15th through 18th Centuries*, ed. Henry Millon, Cambridge (Mass.), 1980, pp. 243–55

COOKE, Hereward L., see BLUNT, Anthony

CORTI, Guido, *Galleria Colonna*, Rome, 1937

CROPPER, Elizabeth, *The Ideal of Painting, Pietro Testa's Düsseldorf Notebook*, Princeton, 1984

CUGNONE, Giuseppe, 'Appendice al "Commento della vita di Agostino Chigi il Magnifico"', *Archivio della Società Romana di Storia Patria*, VI, 1883, pp. 497–539

CUZIN, Jean-Pierre, *La Diseuse de bonne aventure de Caravage* (Les dossiers du Département des Peintures, 13), Paris, 1977

DAVIES, Randall R. H., *Chelsea Old Church*, London, 1904

DAVIS, Bruce W., *The Drawings of Ciro Ferri*, Ann Arbor, 1982

DE LOTTO, Maria Teresa, *L'Attività di Cosimo Fancelli fino al 1669* (unpublished thesis of the Università degli Studi di Roma, 1978–9)

DE LUCA SAVELLI, Maddalena; see *FRANCESCO MOCHI*

DEN BROEDER, Frederick, 'A Drawing by Domenico Guidi for a Monument to Innocent XII', *Burlington Magazine*, CXVII, 1975, pp. 110–13

　'The Lateran Apostles. The Major Sculpture Commission in eighteenth-century Rome', *Apollo*, LXXXV, 1967, pp. 360–65

DIZIONARIO BIOGRAFICO DEGLI ITALIANI, Rome, 1960–[in progress]

DOCUMENTI INEDITI PER SERVIRE ALLA STORIA DEI MUSEI D'ITALIA, Florence/Rome, 1878–80

D'ONOFRIO, Cesare, *Castel S. Angelo*, Rome, 1971

　Gli Obelischi di Roma, Rome, 1965

　Roma nel Seicento, Florence, 1969

　Roma vista da Roma, Rome, 1967

DONY, E, 'François Duquesnoy: sa vie et ses oeuvres', *Bulletin de l'Institut Belge de Rome*, II, 1922, pp. 87–127

DORATI, Maria Cristina, 'Gli Scultori della Cappella Paolina di Santa Maria Maggiore', *Commentari*, XVIII, 1967, pp. 231–60

DRAWINGS BY GIANLORENZO BERNINI FROM THE MUSEUM DER BILDENDEN KÜNSTE, LEIPZIG (exhibition catalogue), Princeton, 1981

DREYER, Peter, *Römische Barockzeichnungen aus dem berliner Kupferstichkabinett, Staatliche Museen Preussischer Kulturbesitz* (exhibition catalogue), Berlin, 1968

DUSSIEUX, Louis, *et al.*, *Mémoires inédits sur la vie et les ouvrages des membres de l'Académie Royale de Peinture et de Sculpture . . .*, Paris, 1854

DÜTSCHKE, Hans, *Die antiken Marmorbildwerke der Uffizien in Florenz (Antike Bildwerke in Oberitalien, III)*, Leipzig, 1878

ELLIS, Henry, *The Townley Gallery of Classic Sculpture, in the British Museum*, London, 1846

ENGGASS, Robert, *The Paintings of Baccicio, Giovanni Battista Gaulli, 1639–1709*, University Park (Pennsylvania), 1964

　'New Attributions in St. Peter's: The Spandrel Figures in the Nave', *Art Bulletin*, LX, 1978, pp. 96–108

　'Un problème du baroque romain tardif: Projets de sculptures par des artistes non sculpteurs', *Revue de l'art*, 31, 1976, pp. 21–32

FAGIOLO DELL'ARCO, Maurizio and Marcello, *Bernini: Una introduzione al gran teatro del barocco*, Rome, 1967

FAGIOLO DELL'ARCO, Maurizio, and CARANDINI, Silvia, *L'Effimero barocco, strutture della festa nella Roma del '600*, Rome, 1977–78

FALDI, Italo, 'Note sulle sculture borghesiane del Bernini', *Bollettino d'arte*, XXXVIII, 1953, pp. 140–46

FASOLO, Furio, 'Carlo Rainaldi e il prospetto di S. Andrea della Valle a Roma', *Palladio*, N.S. I, 1951, pp. 34–8

　L'Opera di Hieronimo e Carlo Rainaldi (1570–1655 e 1611–1691), Rome, 1960

FEA, Carlo D. F. I., *Miscellanea filologica, critica e antiquaria*, Rome, 1790

FEHL, Philipp. See KIRWIN, W. Chandler

FRANCESCO MOCHI, 1580–1654, (exhibition catalogue), Florence, 1981

FERRARI, Oreste, 'L'Iconografia dei filosofi antichi nella pittura del sec. XVII in Italia', *Storia dell'arte*, LVII, 1986, pp. 103–181

FRANZ-DUHME, Helga N., *Angelo De Rossi. Ein Bildhauer um 1700 in Rom* (doctoral dissertation for the Frei Universität Berlin), Berlin, 1986

FRASCHETTI, Stanislao, *Il Bernini: la sua vita, la sua opera, il suo tempo*, Milan, 1900

FRÉART DE CHANTELOU, Paul, *Journal de voyage du Cavalier Bernin en France*, ed. Ludovic Lalanne, Paris, 1981

　Diary of the Cavaliere Bernini's Visit to France, ed. Anthony Blunt, Princeton, 1985

FURTWÄNGLER, Adolf, *Beschreibung der Glyptothek König Ludwig's I. zu München*, Munich, 1900

FUSCONI, Giulia, *Disegni decorativi del barocco romano*

(exhibition catalogue), Rome, Gabinetto dei Disegni e delle Stampe, Villa La Farnesina, 1986

'Disegni decorativi di Johann Paul Schor', *Bollettino d'arte*, ser. VI, LXX, 1985, 33–34, pp. 159–180

'Per la storia della scultura lignea in Roma: le carozze di Ciro Ferri per due ingressi solenni', *Antologia di belle arti*, N.S. XXI–XXII, pp. 80–97

GABORIT, Jean-René, 'A propos de l'Hercule de Fontainebleau', *Revue de l'art*, 36, 1977, pp. 57–60

GALLERIA GIUSTINIANA DEL MARCHESE VINCENZO GIUSTINIANI, Rome, n.d.

GALLI, Romeo, 'I Tesori d'arte di un pittore del Seicento (Carlo Maratta)', *L'Archiginnasio*, XXII, 1927, pp. 217–38; XXVIII, 1928, pp. 59–78

GARMS, Jörg, *Quellen aus dem Archiv Doria-Pamphilj zur Kunsttätigkeit in Rom unter Innocenz X*, Rome/Vienna, 1972

THE J. PAUL GETTY MUSEUM, Handbook of the Collections, Malibu, 1986

GIANNATIEMPO, Maria, *Disegni di Pietro da Cortona e Ciro Ferri* (exhibition catalogue), Rome, 1977

GIGLI, Giacinto, *Diario romano (1608–1670)*, ed. Giuseppe Ricciotti, Rome, 1958

GIOVANNINI, Laura, *Lettere di Ottavio Falconieri a Leopoldo de' Medici*, I, (Carteggio d'artisti dell'Archivio di Stato di Firenze, X), Florence, 1984

GIUSTINIANI, Vincenzo, *Discorsi sulle arti e sui mestieri*, ed. Anna Banti, Florence, 1981

GLASSER, Hannelore, *Artists' Contracts of the early Renaissance*, Ann Arbor, 1973

GODEFROY, Théodore, *Le Cérémonial françois. . . . Recueilly par Théodore Godefroy . . . et mis en lumière par Denys Godefroy . . .*, I, Paris, 1649

GÖTZ-MOHR, Brita von, 'Die neue Umgang mit der Antike: Merkur und Apollo von François Duquesnoy', in *Die Bronzen der Fürstlichen Sammlung Liechtenstein* (exhibition catalogue), Frankfurt am Main, 1986, pp. 87–95

GOLZIO, Vincenzo, *Documenti artistici sul Seicento nell'archivio Chigi*, Rome, 1939

'Le Chiese di S. Maria di Montesanto e di S. Maria dei Miracoli a Piazza del Popolo in Roma, *Archivi (Archivi d'Italia e rassegna internazionale degli archivi)*, Ser. II, VIII, 1941, pp. 122–48

'Lo "Studio" di Ercole Ferrata', *Archivi (Archivi d'Italia e rassegna internazionale degli archivi)*, Ser. II, II, 1935, pp. 64–74

GRAMACCINI, Norberto, 'Das genaue Abbild der Natur – Riccios Tiere und die Theorie des Naturabgusses seit Cennino Cennini', in *Natur und Antike in der Renaissance* (exhibition catalogue), Frankfurt am Main, 1985, pp. 198–225

GUIDE RIONALI, ed. Carlo Pietrangeli, Rome, 1969– [in progress]

GÜTHLEIN, Klaus, 'Quellen aus dem Familienarchiv Spada zum römischen Barock. 1 Folge', *Römisches Jahrbuch für Kunstgeschichte*, XVIII, 1979, pp. 173–246; '2 Folge', *ibid.*, XIX, 1981, pp. 173–243

HAGER, Hellmut, 'Zur Plannungs- und Baugeschichte der Zwillingskirchen auf der Piazza del Popolo: S. Maria di Monte Santo und S. Maria dei Miracoli in Rom', *Römisches Jahrbuch für Kunstgeschichte*, XI, 1967–68, pp. 189–306

See also BRAHAM, Allan

HAGER, Werner, *Die Ehrenstatuen der Päpste*, Leipzig, 1929

HARRIS, Enriqueta, 'La Misión de Velázquez en Italia', *Archivo Español de arte*, XXXIII, 1960, pp. 109–136

Velázquez, Oxford, 1982

HASE, Heinrich A., *Verzeichniss der alten und neuen Bildwerke in Marmor und Bronze in der Sälen der Kgl. Antiken-sammlung zu Dresden*, Dresden, 1829

HASKELL, Francis, and PENNY, Nicholas, *Taste and the Antique: The Lure of Classical Sculpture 1500–1900*, New Haven/London, 1981

HAUS, Andreas, *Der Petersplatz in Rom und sein Statuenschmuck. Neue Beiträge*, Berlin, 1970

HAUTECOEUR, Louis, *L'Histoire des Châteaux du Louvre et des Tuileries . . .*, Paris/Brussels, 1927

HEIMBÜRGER RAVALLI, Minna, *Architettura scultura e arti minori nel barocco italiano: Ricerche nell'archivio Spada*, Florence, 1977

HELBIG, Wolfgang, *Führer durch die Öffentlichen Sammlungen klassischer Altertümer in Rom*, 4th edition, ed. Hermine Speier, Tübingen, 1963–72

HESS, Jacob, 'Notes sur le sculpteur François Duquesnoy (1594–1643)', in *Kunstgeschichtliche Studien zu Renaissance und Barock*, Rome, 1967, pp. 129–137, 401–403

HIBBARD, Howard, *Carlo Maderno and Roman Architecture 1580–1630*, London, 1971

HIRST, Michael, 'The Chigi Chapel in S. Maria della Pace', *Journal of the Warburg and Courtauld Institutes*, XXIV, 1961, pp. 161–185

HOOGEWERFF, Godefridus J., *Nederlandsche Kunstenaars te Rome, 1600–1725*, The Hague, 1942

HOOGEWERFF, Godefridus J., and ORBAAN, Johannes A. F., *Bescheiden in Italië omtrent nederlandsche Kunstenaars en Gelerden*, The Hague, 1911–17

HORACE, *Satires, Epistles, Ars poetica*, transl. H. Rushton Fairclough, London, 1926

HOWARD, Seymour, 'Identity Formation and Image Reference in the Narrative Sculpture of Bernini's Early Maturity: *Hercules and the Hydra* and *Eros Triumphant*', *Art Quarterly*, N.S. II, 1979, pp. 140–171

'Pulling Herakles' Leg: Della Porta, Algardi, and Others', in *Festschrift Ulrich Middeldorf*, Berlin, 1968, pp. 402–407

INCISA DELLA ROCCHETTA, Giovanni, 'Del Ciborio di Ciro Ferri alla Vallicella', *L'Oratorio di S. Filippo Neri*, XIX, October 1962, pp. 1–6

'Frammenti di una carozza secentesca', *Colloqui del sodalizio*, II, 1951/2–1953/4 (1956), pp. 135–139

'Notizie sulla fabbrica della chiesa collegiata di Ariccia (1662–1664)', *Rivista del Reale Istituto d'Archeologia e Storia dell'Arte*, I, 1929, pp. 349–77

See also NOEHLES, Karl
ITALIAN DRAWINGS OF THE SEVENTEENTH AND EIGHTEENTH CENTURIES FROM THE WITT COLLECTION (exhibition catalogue), London, 1971

JONES, Roger B. S., and PENNY, Nicholas, *Raphael*, New Haven/London, 1983

JONES, Roger B. S., see KRAUTHEIMER, Richard

JOSEPHSON, Ragnar, *Tessin: Nicodemus Tessin d.y., Tiden, Mannen, Verket*, Stockholm, 1930

JOUANNY, Charles, *Correspondance de Nicolas Poussin* (Archives de l'art français, Nouv. Pér., V), Paris, 1911

JOUIN, Henry, *Conférences de l'Académie Royale de Peinture et de Sculpture*, Paris, 1883

KARPOWICZ, Marius, 'Nieznane Dzieło Francesca Rossiego', *Biuletyn Historii Sztuki*, XXII, 1960, pp. 378–83

KEEBLE, K. Corey. See AVERY, Charles

KIRWIN, W. Chandler, 'Bernini's Baldacchino Reconsidered', *Römisches Jahrbuch für Kunstgeschichte*, XIX, 1981, pp. 141–71
'Urban VIII and Bernini in St. Peter's: Discovery through Contact', *Eröffnungs- und Plenarvorträge; Arbeitsgruppe 'Neue Forschungsergebnisse und Arbeitsvorhaben'* (25th International Congress for Art History, Vienna, 1983, IX), pp. 125–32

KIRWIN, W. Chandler, and FEHL, Philipp, 'Bernini's *decoro*: Some Preliminary Observations on the Baldachin and on his Tombs in St. Peter's', *Studies in Iconology*, VII–VIII, 1981–2, pp. 323–369

KLAPISCH-ZUBER, Christiane, *Les Maîtres du marbre. Carrare, 1300–1600*, Paris, 1969

KLEMM, Christian, 'Sandrart à Rome', *Gazette des beaux-arts*, pér. 6e, XCIII, 1979, pp. 153–66
Joachim von Sandrart: Kunst-Werke und Lebens-Lauf, Berlin, 1986

KRAUTHEIMER, Richard, and JONES, Roger B. S., 'The Diary of Alexander VII: Notes on Art, Artists and Buildings', *Römisches Jahrbuch für Kunstgeschichte*, XV, 1975, pp. 199–225

KRIS, Ernst, 'Der Stil "rustique". Der Verwendung des Naturabgusses bei Wenzel Jamnitzer und Bernard Palissy', *Jahrbuch der Kunsthistorischen Sammlungen in Wien*, N.F. I, 1926, pp. 137–208

KRUFT, Hanno-Walter, and LARSSON, Lars Olof, 'Entwürfe Berninis für die Engelsbrücke in Rom', *Münchner Jahrbuch der bildenden Kunst*, XVII, 1966, pp. 145–60

LACHENAL, Lucilla de, see PALMA, Beatrice

LAMI, Stanislas, *Dictionnaire des sculpteurs de l'école française sous le règne de Louis XIV*, Paris, 1906

LANCIANI, Rodolfo, *Storia degli scavi di Roma e notizie intorno le collezioni romane di antichità*, IV, Rome, 1912

LANKHEIT, Klaus, *Florentinische Barockplastik: Die Kunst am Hofe der letzten Medici, 1670–1743*, Munich, 1962
Die Modellsammlung der Porzellanmanufaktur Doccia, Munich, 1982

LARSSON, Lars Olof. See KRUFT, Hanno-Walter

LATT, Ljubov' Ja., 'Melchior Kaffá i ego proizvedenija v Ermitaže', *Trudy Gosudarstvennogo Ermitaža*, VIII, 1964, pp. 61–83

LAUBSCHER, Hans Peter, *Fscher und Landleute. Studien zur hellenistischen Genreplastik*, Mainz am Rhein, 1982

LAVAGNINO, Emilio, ANSALDI, Giulio R., and SALERNO, Luigi, *Altari barocchi in Roma*, Rome, 1959

LAVIN, Irving, *Bernini and the Crossing of Saint Peter's*, New York, 1968
Bernini and the Unity of the Visual Arts, Oxford/New York/London, 1980

LAVIN, Marilyn Aronberg, *Seventeenth-Century Barberini Documents and Inventories of Art*, New York, 1975

LEVY, Saul. See MORAZZONI, Giuseppe

LEWIS, Michael, and R.E., *The Engravings of Giorgio Ghisi* (exhibition catalogue), New York, 1985

LIGHTBOWN, Ronald. See POPE-HENNESSY, John

LO VULLO BIANCHI, Simonetta, 'Note e documenti su Pietro e Ferdinando Tacca', *Rivista d'arte*, ser. II, anno III, XIII, 1931, pp. 133–213

LUCINAT, Cristina A, see BORSI, Franco

MACLEHOSE, Louisa S., *Vasari on Technique*, ed. of New York, 1960

MALVASIA, Carlo Cesare, *Felsina pittrice. Vite de' pittori bolognesi*, ed. Giampietro Zanotti, Bologna, 1841
Marmora felsinea, Bologna, 1690

MANILLI, Jacomo, *Villa Borghese fuori di Porta Pinciana*, Rome, 1650

MANSUELLI, Guido A., *Galleria degli Uffizi: le sculture*, Rome, 1958–61

MARTINELLI, Fioravanti. See D'ONOFRIO, Cesare, *Roma nel Seicento*

MARTINELLI, Valentino, 'Il Busto originale di Maria Barberini, nipote di Urbano VIII, di Gian Lorenzo Bernini e Giuliano Finelli', *Antichità viva*, XXVI, 3, 1987, pp. 27–36
Le Statue berniniane del Colonnato di San Pietro, Rome, 1987

MASETTI ZANNINI, Gian Ludovico, 'I Pontefici in Campidoglio', *Capitolium*, 1966, XLI, 6, pp. i–xx

MASSON, Georgina, 'Food as a Fine Art in Seventeenth Century Rome', *Apollo*, LXXXIII, 1966, pp. 338–41
'Papal Gifts and Roman Entertainments in Honour of Queen Christina's Arrival', in *Queen Christina of Sweden: Documents and Studies (Analecta Reginensia I)*, Stockholm, 1966, pp. 244–61

MATZ, Friedrich, and DUHN, Friedrich von, *Antike Bildwerke in Rom mit Ausschluss der grösseren Sammlungen*, Leipzig, 1881–2

MAYOR, A. Hyatt, 'The First Famous Print', *The Metropolitan Museum of Art Bulletin*, IX, 3, 1950, pp. 73–6

McGRATH, Elizabeth, '"Il Senso Nostro": The Medici Allegory Applied to Vasari's Mythological Frescoes in the Palazzo Vecchio', in *Giorgio Vasari tra decorazione ambientale e storiografia artistica*, ed. Gian Carlo Garfagnini (Istituto Nazionale di Studi sul Rinascimento),

Florence, 1985, pp. 117–34

MEESTERS VAN HER BRONS DER ITALIAANSE RENAISSANCE (exhibition catalogue), Amsterdam, 1961

MEMORIE ENCICLOPEDICHE ROMANE SULLE BELLE ARTI, III, 1807

MEZZATESTA, Michael, *The Art of Gianlorenzo Bernini: Selected Sculpture* (exhibition catalogue) Fort Worth, 1982

MERCATI, *De gli Obelischi di Roma*, ed. Gianfranco Cantelli, Bologna, 1981

MICHEL, Olivier, 'L'Accademia', in *Le Palais Farnèse*, Rome, 1981, I, 2, pp. 567–610

MICHELINI TOCCI, Luigi, and WORSDALE, Marc, 'Bernini nelle medaglie e nelle monete', in *Bernini in Vaticano* (exhibition catalogue), Rome, 1981, pp. 281–309

MICHON, Étienne, *Musée National du Louvre, département des antiquités grecques et romaines: Catalogue sommaire des marbres antiques*, Paris, 1922

MIDDELDORF, Ulrich, 'Camillo Mariani, Scultore-Pittore', *Burlington Magazine*, CXVIII, 1976, pp. 500–503

Raccolta di scritti: that is Collected Writings, Florence, 1981

MIDDLETON, Conyers, *A Letter from Rome, Showing an Exact Conformity between Popery and Paganism . . .*, London, 1729

MILIZIA, Francesco, *Dell'Arte di vedere nelle belle arti del disegno secondo i principii di Sulzer e di Mengs*, Genoa, 1786

MINOR, Vernon Hyde, 'References to Artists and Works of Art in Chracas' *Diario ordinario – 1760–1785*', *Storia dell'arte*, XLVI, 1982, pp. 217–77

FRANCESCO MOCHI, 1580–1654 (exhibition catalogue), Florence, 1981

MÖSENEDER, Karl, *Montorsoli. Die Brunnen*, Mittenwald, 1979

MOLA, Giovanni Battista, *Breve racconto delle miglior opere d'architettura, scultura et pittura fatte in Roma et alcuni fuor di Roma descritto . . . l'anno 1663*, ed. Karl Noehles, Berlin, 1966

MONACI, Lucia, 'Alcuni disegni giovanili di Giovan Battista Foggini', in *Kunst des Barock in der Toskana: Studien zur Kunst unter den letzten Medici* (Italienische Forschungen herausgegeben vom Kunsthistorischen Institut in Florenz, Dritte Folge, Band IX), Munich, 1976, pp. 24–32

MONTAGU, Jennifer, *Alessandro Algardi*, New Haven/London, 1985

'Alessandro Algardi and the "Borghese Table"', *Antologia di belle arti*, I, 4, 1977, pp. 311–28

'Alessandro Algardi's Altar of S. Nicola da Tolentino and Some Related Models', *Burlington Magazine*, CXII, 1970 pp. 282–91

'Antonio and Giuseppe Giorgetti: Sculptors to Cardinal Francesco Barberini', *Art Bulletin*, LII, 1970, pp. 278–98

'Architects and Sculptors in Baroque Rome', *Bollettino*

del Centro Internazionale di Studi d'Architettura 'Andrea Palladio', XXIII, 1981, pp. 71–83

'Bernini Sculptures Not by Bernini', in *Gianlorenzo Bernini: New Aspects of his Art and Thought*, ed. Irving Lavin, University Park (Penn.)/London, 1985, pp. 25–61

'A Bozzetto in Bronze by Ciro Ferri', *Jahrbuch der hamburger Kunstsammlungen*, XVIII, 1973, pp. 119–24

'Disegni, Bozzetti, Legnetti and Modelli in Roman Seicento Sculpture', in *Entwurf und Ausführung in der europäischen Barockplastik*, Munich, 1986, pp. 9–30

'Un Dono del Cardinale Francesco Barberini al Re di Spagna', *Arte illustrata*, IV, 43–44, 1971, pp. 41–51

'The Graphic Work of Melchior Cafà', *Paragone Arte*, 413, 1984, pp. 50–61

'A Model by Francesco Mochi for the "Saint Veronica"', *Burlington Magazine*, CXXIV, 1982, pp. 430–7

'Il Primo rilievo in marmo del Foggini', *Arte illustrata*, LV–LVI, 1973, pp. 331–38

'Two Small Bronzes from the Studio of Bernini', *Burlington Magazine*, CIX, 1967, pp. 566–71

MONTAIGLON, Anatole de, *Correspondance des directeurs de l'Académie de France à Rome avec les surintendants des bâtiments*, Paris, 1887–1912

MOORE, John, *A View of Society and Manners in Italy*, London, 1781

MORAZZONI, Giuseppe, and LEVY, Saul, *Le Porcelane italiane*, 1960

MORELLI, Giorgio, 'Appunti bio-bibliografici su Gaspar e Luigi Vanvitelli', *Archivio della Società Romana di Storia Patria*, XCII (ser. III, XXIII), 1969, pp. 17–136

'Giovanni Andrea Lorenzani artista e letterato romano del Seicento', *Studi secenteschi*, XIII, 1972, pp. 193–251

MORELLO, Giovanni, 'Bernini e i lavori a S. Pietro nel 'diario' di Alessandro VII', in *Bernini in Vaticano* (exhibition catalogue), Rome, 1981, pp. 321–40

'Documenti berniniani nella Biblioteca Apsotolica Vaticana', in *Bernini in Vaticano* (exhibition catalogue), Rome, 1981, pp. 313–20

MORONI, Gaetano, *Dizionario di erudizione storico-ecclesiastico*, Venice, 1860–79

MÜLLER HOFSTEDE, Justus, 'Zur Kopfstudie im Werk von Rubens', *Wallraf-Richartz-Jahrbuch*, XXX, 1968, pp. 223–52

MUÑOZ, Antonio, 'La Scultura barocca e l'antica', *L'Arte*, XIX, 1916, pp. 129–60.

MURRAY, Jame A. H., *A New English Dictionary on Historical Principles*, Oxford, 1888–1928

NEBBIA, Ugo, *La Scultura nel duomo di Milano*, Milan, 1910

NOEHLES, Karl, 'Architekturprojekte Cortonas', *Münchner Jahrbuch der bildenden Kunst*, F.3, XX, 1969, pp. 171–206

La Chiesa dei SS. Luca e Martina nell'opera di Pietro da Cortona; con contributi di Giovanni Incisa della Rocchetta e Carlo Pietrangeli, Rome, 1969

'Das Tabernakel des Ciro Ferri in der Chiesa Nuova zu

Rom', *Miscellanea Bibliothecae Hertzianae zu Ehren von Leo Bruhns, Franz Graf von Metternich, Ludwig Schudt (Römisches Forshungen der Bibliotheca Hertziana, XVI)*, Munich, 1961, pp. 429–36

ORBAAN, Johannes A. F., see HOOGEWERFF, Gode-fridus J.

OLSZEWZKI, Edward J., 'Giovanni Martino Frugone, marble merchant, and a contract for the apostle statues in the Nave of St. John Lateran', *Burlington Magazine*, CXXVIII, 1986, pp. 659–66

OST, Hans, 'Studien zu Pietro da Cortonas Umbau von S. Maria della Pace', *Römisches Jahrbuch für Kunstges-chichte*, XIII, 1971, pp. 231–85

PALMA, Beatrice, *Museo Nazionale Romano, le sculture; I, 4, I marmi ludovisi: storia della collezione*, Rome, 1983

PALMA, Beatrice, and LACHENAL, Lucilla de, *Museo Nazionale Romano, le sculture; I, 5, I marmi ludovisi nel Museo Nazionale Romano*, Rome, 1983

PANOFSKY, Erwin, *Studies in Iconology*, ed. of New York, 1967

PANOFSKY-SÖRGEL, Gerda, 'Zur Geschichte des Palazzo Mattei di Giove', *Römisches Jahrbuch für Kunstgeschichte*, XI, 1967/8, pp. 111–88

PASCOLI, Lione, *Vite de' pittori, scultori, ed architetti moderni*, Rome, 1730–1736

PASSERI, Giovanni Battista, *Die Künstlerbiographien von Giovanni Battista Passeri*, ed. Jacob Hess, Leipzig/Vienna, 1934

PATRIZI, Patrizio, *Il Gigante. Note storiche aneddotiche e chronache*, Bologna, 1897

PECHSTEIN, Klaus, *Staatliche Museen Preussischer Kultur-besitz, Kataloge des Kunstgewerbemuseums Berlin. III: Bronzen und Plaketten von ausgehenden 15. Jahrhundert bis zum Mitte des 17. Jahrhunderts*, Berlin, 1968

PENNY, Nicholas. See JONES, Roger B. S.
See also HASKELL, Francis

PERALI, Pericle, *Prontuario bibliografico per la storia degli Anni Santi*, Rome, 1928

PÉREZ SÁNCHEZ, Alfonso E., see AGULLÓ, Mercedes

PERRY, Marilyn, 'On Titian's "Borrowings" from Ancient Art: A Cautionary Case', in *Tiziano e Venezia*, Vicenza, 1980, pp. 187–91

PESCI, Benedetto, 'Un Atto notarile del 29 marzo 1672 relativo all'altare di S. Sebastiano nella chiesa omonima della via Appia' *Antoniuanum*, XV, 1940, pp. 125–154

PETTORELLI, Arturo, *Francesco Mochi e i gruppi equestri farnesiani*, Piacenza, 1926

PIAZZA, Carlo Bartolomeo, *Eusevologio romano*, Rome, 1698

PIETRANGELI, Carlo. See NOEHLES, Karl

PIGNATTI, Terisio, *L'Opera completa di Giovanni Bellini*, Milan, 1969

PINCELLI, Rosanna. See SUSINI, Giancarlo

PINGEOT, Anne, see BRESC–BAUTIER, Geneviève

PLANISCIG, Leo, *Die Bronzeplastiken: Statuetten, Reliefs, Geräte und Plaketten* (Kunsthistrichen Museum in Wien, Publikationen aus den Sammlungen für Plastik und Kunstgewerbe, IV), Vienna, 1924

POLLAK, Oskar, *Die Kunsttätigkeit unter Urban VIII*, II, Vienna, 1931

POPE-HENNESSY, John, *The Drawings of Domenichino in the Collection of His Majesty the King at Windsor Castle*, London, 1948

POPE-HENNESSY, John, and LIGHTBOWN, Ronald, *Catalogue of Italian Sculpture in the Victoria and Albert Museum*, London, 1964

POPP, Anny E., 'Der barberinische Faun', *Jahrbuch für Kunstgeschichte*, I, 1921/2, pp. 215–35

POZZO, Andrea, *Perspectiva pictorum atque architectorum*, Augsburg, 1706–9

PREIMESBERGER, Rudolf, 'Das dritte Papstgrabmal Berninis', *Römisches Jahrbuch für Kunstgeschichte*, XVII, 1978, pp. 157–181

PRESSOUYRE, Sylvia, *Nicolas Cordier: recherches sur la sculpture à Rome autour de 1600* (Collection de l'École française de Rome, no. 73), Rome, 1984
'Sur la sculpture à Rome autour de 1600, *Revue de l'art*, 28, 1975, pp. 62–77

PRINZ, Wolfram, 'The "Four Philosophers" by Rubens and the Pseudo-Seneca in Seventeenth-Century Painting', *Art Bulletin*, LV, 1973, pp. 410–28

QUINTAVALLE, Armando O., *La Reggia galleria di Parma*, Rome, 1939

QUINTERIO, Francesco, see BORSI, Franco

RADCLIFFE, Anthony F., 'Ferdinando Tacca, the Missing Link in Florentine Baroque Bronzes', in *Kunst des Barock in der Toskana: Studien zur Kunst unter den letzten Medici* (Italienische Forschungen herausgegeben vom Kunsthistorischen Institut in Florenz, Dritte Folge, Band IX), Munich, 1976, pp. 14–23

RAGUENET, François, *Les Monumens de Rome, ou description des plus beaux ouvrages de peinture, de sculpture et d'architecture, qui se voyent à Rome, & aux environs . . .*, Paris, 1700

RÉAU, Louis, *J.-B. Pigalle*, Paris, 1950

RICCÒMINI, Eugenio, *Ordine e vaghezza; la scultura in Emilia nell'età barocca*, Bologna, 1972

RIZZO, Vincenzo, 'Contributo alla conoscenza di Bartolomeo e Pietro Ghetti', *Antologia di belle arti*, N.S. XXI/XXII, 1984, pp. 98–110

ROBERT, Carl, *Die antiken Sarkophag-Reliefs*, III: *Einzel-mythen, 1, Actaeon-Hercules*, Berlin, 1897

ROCCA, Vasco *SS. Trinità dei Pellegrini* (Le Chiese di Roma illustrate, 133), Rome, 1979

ROMA E DINTORNI, (Guida del Touring Club Italiano), Milan, 1962

ROSEROT, Alphonse, *Edme Bouchardon*, Paris, 1910

ROSSI PINELLI, Orietta, 'Artisti, falsari o filologhi? Da Cavaceppi a Canova, il restauro della scultura tra arte e scienza', *Ricerche di storia dell'arte*, XIII–XIV, 1982, pp. 41–56

PETER PAUL RUBENS, 1577–1640. Rubens in Italien, Gemälde, ölskizzen, Zeichnungen; Triumph der Eucharistie, Wandteppiche aus dem kölner Dom (exhibition catalogue), Cologne, 1977

RUGGIERI, Giovanni Simone, *Diario dell'anno del Santissimo Giubileo MDCL ...*, Rome, 1651

SALERNO, Luigi, *Palazzo Rondinini; con un catalogo dei marmi antichi di Enrico Paribeni*, Rome, 1965

SALERNO, Luigi, see LAVAGNINO, Emilio

SANDRART, Joachim von, *Der Teutschen Academie Zweyter und letzter Haupt-Teil, von der edlen Bau- Bild- und Mahlerey-Künste ...*, Nürnberg, 1679

SANTI BARTOLI, Pietro, see FEA, Carlo

SAUERLÄNDER, Willibald, *Jean-Antoine Houdon: Voltaire*, Stuttgart, 1963

SCAMOZZI, Vincenzo, *L'Idea della architettura universale*, Venice, 1615

SCHLEGEL, Ursula, 'I Crocifissi degli altari in San Pietro in Vaticano', *Antichità viva*, XX, 6, 1981, pp. 37–42
'Notizen zu italienischen Skulpturen des Barock', *Antologia di belle arti*, N.S. XXV/XXVI, 1985, pp. 36–55
Staatliche Museen Preussischer Kulturbesitz. Die Bildwerke der Skulpturengalerie Berlin, 1: Die italienischen Bildwerke des 17. und 18. Jahrhunderts in Stein, Holz, Ton, Wachs und Bronze ..., Berlin, 1978
'Zum Grabmal Alexanders VII. (1671–1678)', *Mitteilungen des Kunsthistorischen Instites in Florenz*, XXVIII, 1984, pp. 415–22

SCHNAPPER, Antoine, *Tableaux pour le Trianon de Marbre 1688–1714*, Paris/The Hague, 1967

SCICLUNA, Hannibal P., *The Church of St. John in Valleta*, San Martin (Malta), 1955

SEELIG 1955, Lorenz, *Studien zu Martin van den Bogaert gen. Desjardins (1636–1694)*, doctoral dissertation, Hamburg, 1980
'Zu Domenico Guidis Gruppe "Die Geschichte Zeichnet die Taten Ludwigs XIV. Auf"', *Jahbuch der Hamburger Kunstsammlungen*, XVII, 1972, pp. 81–104

SEYMOUR, Charles Jr., '"Fatto di sua mano". Another Look at the Fonte Gaia Drawing Fagments in London and New York', *Festschrift Ulrich Middeldorf*, Berlin, 1968, pp. 93–105

SIRÉN, Osvald, *Nicodemus Tessin d.y:s studieresor*, Stockholm, 1914

SOMIGLI, Guglielmo, *Notizie storiche sulla fusione del Perseo*, Milan, 1958

SOUCHAL, François, 'La Collection du sculpteur Girardon', *Gazette des beaux-arts*, pér. 6e, LXXXII, 1973, pp. 1–98
French Sculptors of the 17th and 18th Centuries. The Reign of Louis XIV, Oxford, 1977–[in progress]

SPAGNESI, Gianfranco, *Giovanni Antonio De Rossi architetto romano*, Rome, 1964

SPEAR, Richard, E., 'The Cappella della Strada Cupa: A Forgotten Domenichino Chapel', *Burlington Magazine*, CXI, 1969, pp. 12–23
Domenichino, New Haven/London, 1982

STECHOW, Wolfgang, *Rubens and the Classical Tradition*, Cambridge (Mass.), 1968

STEFANI, Bartolomeo, *L'Arte di ben cucinare, et instruire i men periti in questa lodevole professione ...*, Mantua, 1662 (ed. Gino Brunetti, as *Cucina mantovana ...*, Mantua, 1963)

SUSINI, Giancarlo, and PINCELLI, Rosanna, *Le Collezioni del Museo Civico di Bologna: Il lapidario*, Bologna, 1960

TESSIN, Nicodemus, 'Traité de la décoration intérieure', Stockholm, Kungliga Biblioteket, Ms. 41

TESORI D'ARTE SACRA DI ROMA E DEL LAZIO (exhibition catalogue), Rome, 1975

THIEME, Ulrich, and BECKER, Felix, *Allgemeines Lexikon der bildenden Künstler*, Leipzig, 1907–50

TICOZZI, Stefano, see BOTTARI, Giovanni

TITI, Filippo, *Ammaestramento utile e curioso di pittura, scoltura e architettura nelle chiese di Roma*, Rome, 1686
Studio di pittura, scoltura, et architettura, nelle chiese di Roma, Rome, 1674

TOMKIEWICZ, Władisław, 'Francesco Rossi i jego Działalność Rzeźbiarska w Polsce', *Biuletyn Historii Sztuki*, XIX, 1957, pp. 199–217

TREVISANI, Filippo, 'Carlo Rainaldi nella chiesa di Gesù e Maria al Corso', *Storia dell'arte*, XI, 1971, pp. 163–71

THE TWILIGHT OF THE MEDICI: LATE BAROQUE ART IN FLORENCE, 1670–1743 (exhibition catalogue), Detroit, 1974

UTZ, Hildegard, *Der wiederentdeckte Herkules des Michelangelo*, Munich, 1975

VALTIERI, Simonetta, see BENTIVOGLIO, Enzo

VASARI, Giorgio, *Le Vite de' più eccellenti pittori scultori ed architetti*, ed. Gaetano Milanesi, Florence, 1878–85
see also MACLEHOSE, Louisa A.

THE VATICAN COLLECTIONS (exhibition catalogue), New York, 1982

VATICAN SPLENDOUR (exhibition catalogue), Ottawa, 1986

VENN, John, see ALUMNI CANTABRIGIENSES

VESME, Alexandre de, *Etienne Della Bella*, 4th edition, ed. Phyllis Dearborn Massar, New York, 1971

VISCONTI, Ennio Quirino, *Opere*, Milan, 1818–49

VISONÀ, Mara, 'La Via Crucis del Convento di San Pietro d'Alcantara presso la villa l'Ambrogiana a Montelupo Fiorentino', in *Kunst des Barock in der Toskana: Studien zur Kunst unter den letzten Medici* (Italienische Forschungen herausgegeben vom Kunsthistorischen Institut in Florenz, Dritte Folge, Band IX), Munich, 1976, pp. 57–69

VITZTHUM, Walter, *I Disegni dei maestri: Il Barocco a Roma*, Milan, 1971

WACKERNAGEL, Martin, *Lebensräum des Künstlers in der florentinischen Renaissance*, Leipzig, 1938
The World of the Florentine Renaissance Artist, transl. Alison Luchs, Princeton, 1981

WATSON, Katharine J., 'Sugar Sculpture for Grand Ducal Weddings from the Giambologna Workshop', *The Connoisseur*, CLXXXXIX, 1978, pp. 210–26

WAŻBIŃSKI, Zygmunt, 'La Prima mostra dell'Accademia del Disegno a Firenze', *Prospettiva*, 14, 1978, pp. 47–57
'Lo Studio – la scuola fiorentina di Federico Zuccaro',

Mitteilungen des Kunsthistorischen Institutes in Florenz, XXIX, 1985, pp. 275–346

WEIL, Mark S., 'The Devotion of the Forty Hours and Roman Baroque Illusionism', *Journal of the Warburg and Courtauld Institutes*, XXXVII, 1974, pp. 218–48

The History and Decoration of the Ponte S. Angelo, University Park (Penn.)/London, 1974

WEIL, Phoebe D., 'Contributions toward a History of Sculpture Techniques: I. Orfeo Boselli on the Restoration of Antique Sculpture', *Studies in Conservation*, XII, 3, 1967, pp. 81–101

WESTIN, Robert H., *Antonio Raggi: A Documentary and Stylistic Investigation of his Life, Work and Significance in Seventeenth-Century Roman Baroque Sculpture* (doctoral thesis), Ann Arbor, 1978

'Antonio Raggi's "Death of St. Cecilia"', *Art Bulletin*, LVI, 1974, pp. 422–9

WIBIRAL, Norbert, 'Die Agnesreliefs für S. Agnese in Piazza Navona', *Römische historische Mitteilungen*, III, 1958/59–1959/60, pp. 255–78

WIND, Edgar, 'Shaftesbury as a Patron of Art, with a Letter by Closterman and Two Designs by Guidi', *Journal of the Warburg Institute*, II, 1938–39, pp. 185–8

WITTKOWER, Rudolf, *Gian Lorenzo Bernini*, 2nd edition, London, 1966

'Melchiorre Cafà's Bust of Alexander VII', *The Metropolitan Museum of Art Bulletin*, XVII, 8, 1959, pp. 197–204

'The Role of Classical Models in Bernini's and Poussin's Preparatory Work', in *Studies in Western Art: Latin American Art, and the Baroque Period in Europe. Acts of the Twentieth International Congress of the History of Art,* III, Princeton, 1963, pp. 41–50

Sculpture: Processes and Principles, London, 1977

Studies in the Italian Baroque, London, 1975

'The Vicissitudes of a Dynastic Monument: Bernini's Equestrian Statue of Louis XIV', *De Artibus opuscula XL*, New York, 1961, pp. 497–531

See also BRAUER, Heinrich

WORSDALE, Marc, 'Bernini inventore', in *Bernini in Vaticano* (exhibition catalogue), Rome, 1981, pp. 231–6

'Bernini Studio Drawings for a Catafalque and Fireworks, 1668', *Burlington Magazine*, CXX, 1978, pp. 462–6

'Eloquent Silence and Silent Eloquence in the Work of Bernini and His Contemporaries', in *Vatican Splendour* (exhibition catalogue), Ottawa, 1986, pp. 29–40

See also MICHELINI TOCCI, Luigi

WRIGHT, John Michael, *Ragguaglio della solenne comparsa, fatta in Roma gli otto di gennaio M DC LXXXVII. dall'Illustrissimo, et Eccellentissimo Signor Conte di Castlemaine Ambasciadore Straordinario della Sagra Real Maestà di Giacomo Secondo Rè d'Inghilterra ... alla Santa Sede Apostolica ...*, Rome [1687]

ZAGÓROWSKI, Olgierd, 'Z Działalności Gian Francesco Rossiego w Polsce', *Biuletyn Historii Sztuki*, XXV, 1963, pp. 34–52

ZANKER, Paul, 'Galba, Nero, Nerva. Drei barocke Charakterstudien', in *Studies in Classical Art and Archaeology. A Tribute to Peter Heinrich von Blanckenhagen*, ed. Günter Kopcke and Mary B. Moore, Locust Valley (NY), 1979, pp. 305–14

INDEX OF NAMES AND PLACES

This index contains names of persons (excluding modern authors) and places; it is followed by a separate index of subjects.

Works of art are indexed under the artists, except for works of collaboration, or anonymous works, which are indexed under their present locations. Locations are not indexed for engravings or drawings, except for anonymous drawings.

Material in the footnotes is not indexed when the note merely expands on persons or subjects already indexed in the text to which the note refers; however, additional persons or subjects introduced in such notes are indexed.

Agnesini, Michele: 25, 223
Agostini, Leonardo: 216 n70, n71
Augucchi, Giovanni Battista: 50
Agucchi, Girolamo: 50
Aix-la-Chapelle, peace of: 185
Albani, Annibale: 127
Albani, Francesco: 19
Albano, Capuchin Church, *Christmas Crib*: 176, Fig. 242
Albertino, Innocenzo: 72
Albrici, Orazio: 72, 228
Aldobrandini, Cardinal Ippolito: 25
Aldobrandini, Olimpia: 116, 188, 219 n88
Aldrovandi, Ulisse: 152
Alessandrino, Giovanni: 25
Alexander VII: 44, 78, 121, 122, 125, 134, 188–92, 205 n42, 211 n84, 217 n13, 218 n68, 220 n108
Alexander VIII: 220 n100
Algardi, Alessandro: 1, 4, 6, 11, 14, 16, 19, 25, 18, 29, 30, 41, 48, 58, 62, 67–70, 78, 90, 99–102, 103–4, 107, 115, 116, 119, 121, 140, 142, 151, 152, 182, 197, 202 n66, n67, 206 n88, n3, 209 n5, 210 n47, 213 n7, 220 n104; *Apostles*: 62, Fig. 69; *Athena Ludovisi*: 157, 162, 214 n40; *The Beheading of St Paul*, bronze: 67–70, Figs. 77–80; *The Beheading of St Paul*, marble: 25, 30, 203 n51, n59, 221, Fig. 29; *Busts of St Peter and St Paul*: 14, 21, 28, Fig. 23; *Carlo Barberini*: 155–7, Fig. 208; Catafalque of Carlo Barberini: *see* Rome, Churches, Sta Maria in Aracoeli; Coaches: 188, Fig. 258; *Christ Falling under His Cross*: 195, Fig. 272; *Crucifix (Franzone)*: 62; Design for a finial: 188, Fig. 262; Drawing for a float of the *Pietà*: 175, 195, Fig. 239; Drawing for a float: 175, Fig. 240; Drawings for finials: 116, Figs. 141; Drawings for frames: 116–19, Fig. 142; *The Encounter of Pope Leo the Great and Attila*: 35–6, 41, 46, 57, 126, 127, Figs. 39, 40; *The Flagellation of Christ*: 195, Fig. 273; *Hermes Logios*: 157–8, 162, Fig. 211; High altar for S. Agnese: 202 n66; *Innocent X*: 67, 201 n22, Figs. 75, 76; Memorial to Innocent X: 102, Fig. 126; *St Philip Neri*: 14; *St Michael*: 62; Tabernacle in Savona: *see* Savona, Cathedral; *Tomb of Giovanni Garzia Mellini*: 103–4, Figs. 125, 127; *Tomb of Leo XI*: *see* Vatican, St Peter's; *Torchbearer*: 157, 214 n40; *Trionfi*: 220 n105; Urn of St Ignatius Loyola: *see* Rome, Churches, Gesù
Algardi, Alessandro, Studio of, drawing for a

block of marble: Fig. 30
Altham, Edward: 38–44, 46
Altham, Sir Edward: 203 n74
Altieri (Paluzzo Paluzzi), Cardinal: 195
Anguier, Michel: 127, 128
Anguier, Michel, *The Crucifixion*: 127, Fig. 159; Float of the *Pietà*: 175; Stuccoes in the Palais du Louvre: 208 n46
Ann Arbor, University of Michigan Museum of Art, *The Descent from the Cross*: Fig. 63
Antichi, Prospero (Il Bresciano): 201 n14
Antico (Pier Jacopo Ilari-Bonacolsi), *Mercury*: 158, 162, Fig. 213
Antonio *lustrateur*: 109
Arcucci, Camillo: 211 n19
Ariccia, Sta Maria Assunta: 115, Fig. 139
Arnaldi, Francesco: 14
Artusi, Giovanni: 57, 58, 70, 207 n91, n17
Auden Aerd, Robert van, Engraving of the *Barberini Faun*: 168, Fig. 232

Baglione, Giovanni: 48, 49, 50, 204 n6, 213 n4
Baldinucci, Filippo: 5, 21, 199 n20, n25, n27–8, n30, 200 n80, 204 n26, 205 n56, 206 n2
Baldo *formatore*: 56
Balestra, Pietro Maria: 109
Balsimelli, Jacomo: 212 n30
Bankes, Jerome: 203 n74
Baratta, Andrea: 3, 147; *Religion*: 3; *Charity*: 3, Fig. 5
Baratta, Francesco: 142; *Angels*: 3; *Ecstasy of St Francis*: 3; *River Plate*: 3
Baratta, Giovanni Maria: 18; Altar of St Thomas of Villanova: 18, 36; Holy-water stoups: 2, Fig. 4; S. Nicola da Tolentino: 2, Fig. 3
Barberini, Cardinal Antonio: 116
Barberini, Carlo: 60, 155, 180, 205 n55
Barberini, collection: 201 n15, 204 n23; *Carlo Barberini*: 63–4, Fig. 72
Barberini, family: 24, 173, 201 n15
Barberini, Cardinal Francesco: 57, 58, 84, 86, 116, 163, 165, 167, 169, 176, 178, 217 n13, 227
Barberini, Taddeo: 220 n105
Barnabite Order: 25
Barrière, Dominique, *The Crossing of the Red Sea*: Fig. 246; *Villa Borghese*: Fig. 209
Bassadonna, Domenico: 113–14
Beccheria, Carlo and Giacomo: 115
Bella, Stefano della, *Entry of the Polish Ambassador*: 218 n3
Bellini, Giovanni, *The Drunkenness of Noah*: 217 n80

Bellori, Giovan Pietro: 157, 199 n22, 203 n69, 215 n58, n61, 217 n97
Beltramelli, Antonio: 72
Benamati, Stefano: 208 n35
Benedetti, Elpidio: 205 n34
Benincasa da Gubbio: 208 n35
Bentornati, Curtio: 201 n15
Berlin, Staatliche Museen Preussischer Kulturbesitz (formerly), Candlestick: 204 n8
Bernasconi, Agostino: 213 n19
Bernini, Domenico: 200 n43, 201 n5
Bernini, Gianlorenzo: 1, 3, 5, 6, 7, 9, 10, 14, 15, 16, 25, 28, 29, 30, 31, 38, 40, 41, 44, 52, 55–6, 60, 63, 64, 67, 70–5, 90, 94, 102–3, 104, 109–13, 114, 115, 116, 119, 121, 122, 126, 127, 129–30, 134, 142, 143, 146–50, 151, 152, 161, 162, 163, 167, 169, 171, 175, 178–9, 180–2, 183, 188–90, 197, 223, 204 n26, 205 n43, 206 n3, 209 n64, n6, 213 n6, 217 n34, 218 n67; *Aeneas, Anchises and Ascanius*: 159, 199 n42; *Angel with the Crown of Thorns*: 142, 144–5, Fig. 193; *Angel with the Crown of Thorns, bozzetto*: 144, Fig. 194; *Angel with the Superscription*: 142, 144, Figs. 191, 192; *Apollo and Daphne*: 104–6, 163, Fig. 129; *Baldacchino*: *see* Vatican, St Peter's; *Bozzetto* for the tomb of Alexander VII: 111, Fig. 136; *Bust of Louis XIV*: 21–3, Fig. 26; *Busts of Scipione Borghese*: 21, 201 n6, Figs. 24, 25; *Carlo Barberini*: 155–7, Fig. 208; Catafalque of Carlo Barberini: *see* Rome, Churches, Sta Maria in Aracoeli; Catafalque of Paul V: *see* Rome, Churches, Sta Maria Maggiore; *Cattedra Petri*: *see* Vatican, St Peter's; Colonnade of St Peter's: *see* Vatican, St Peter's; *Constantine*: 197, Fig. 278; *Daniel*, 125, Fig. 158; Design for a coach: 188, Fig. 260; Design for a golden rose: 119; Design for a mirror: 119; Design for firedogs: 119–21; Design for the tomb of Innocent X: 211 n33; Designs for altar furniture: 122–5, Fig. 155, *see also* Vatican, St Peter's; Designs for annual medals: 121; Designs for the incrustation of the nave of St Peter's: 129–34, Figs. 164, 166; Designs for the nave of St Peter's: 130, 137; Designs for organ lofts: 138–9, Fig. 180, *see also* Rome, Churches, Sta Maria del Popolo; Designs for Sta Maria Assunta, Ariccia: 115, Fig. 140, *see also* Ariccia; Designs for the tomb of Alexander VII: 109–10, 112–13, Figs. 133–5; Drawing for a golden rose: 122, Fig. 152; Drawing for *St Mary of*

INDEX OF SUBJECTS

PHOTOGRAPHIC ACKNOWLEDGEMENTS

Photographs were obtained from the institutions credited in the captions, with the following exceptions:

Figs. 6, 29, 31–33, 67, 101–2, 113, 124, 129, 163, 195, 198, 202, 207, 217, 229–30, 233, Alinari. Figs. 28, 68, 74–5, 122, 139, 210, Anderson. Figs. 167–70, 172–3, De Antonis. Fig. 220, Archives Photographiques d'Art et d'Histoire. Figs. 53, 55, Arte Fotografica. Figs. 65–66, 70, 148, James Austin. Fig. 240, reproduced with the permission of the Governing Body, Christ Church, Oxford. Figs. 205, 212, Chuzeville. Fig. 234, Benita Cioppa. Fig. 69, Michael Conforti. Figs. 49, 111, 158, 192–3, Courtauld Institute Figs. 36, 278, Fototeca Unione. Figs. 3, 24–5, 39, 43, 46, 50–1, 60, 71–2, 81–2, 87, 93–4, 96, 103, 112, 123, 125, 149, 178–9, 181–2, 184, 187, 200, 203, 208, 238, Gabinetto Fotografico Nazionale. Fig. 88, Getty Center Photo Archive. Photo Hutzel. Figs. 12, 26, 204, Giraudon. Fig. 218, Hanfstaengl. Figs. 85, 109, 116, 119, 162, 209, 247, 255, Bibliotheca Hertziana. Fig. 54, Monumenti Medioevali e Moderni, Arch. Fotografico. Fig. 64, Patrimonio Nacional. Fig. 117, Silvio Piersanti. Figs. 159–61, Pontifica Commissione di Archeologia Sacra. Figs. 15, 131, 222, Réunion des Musées Nationaux. Fig. 40, Rigamonti. Figs. 10, 37–8, 62, 83–4, 86–7, 132, 137–8, 156, 199, Saskia. Figs. 48, 99, 104–7, Oscar Savio. Figs. 211, 214–16, Soprintendenza Archeologica di Roma. Figs. 1, 2, 9, 274, Soprintendenza alle Gallerie, Florence. Fig. 242, Soprintendenza Beni Artistici Storici, Roma. Fig. 239, Vasari. Figs. 126, 174, Gallerie e Musei Vaticani. Fig. 77, A. Villani. Figs. 44–5, 89, 143, 150–1, 206, 223, 225, 227, 232, 236, 244, 246, 257, 276, 277, Warburg Institute. Figs. 56–8, 92, 110, 134, 140–1, 144, 155, 250, 259, Windsor, Royal Library, © 1989 Her Majesty The Queen.